JEWISH
ART

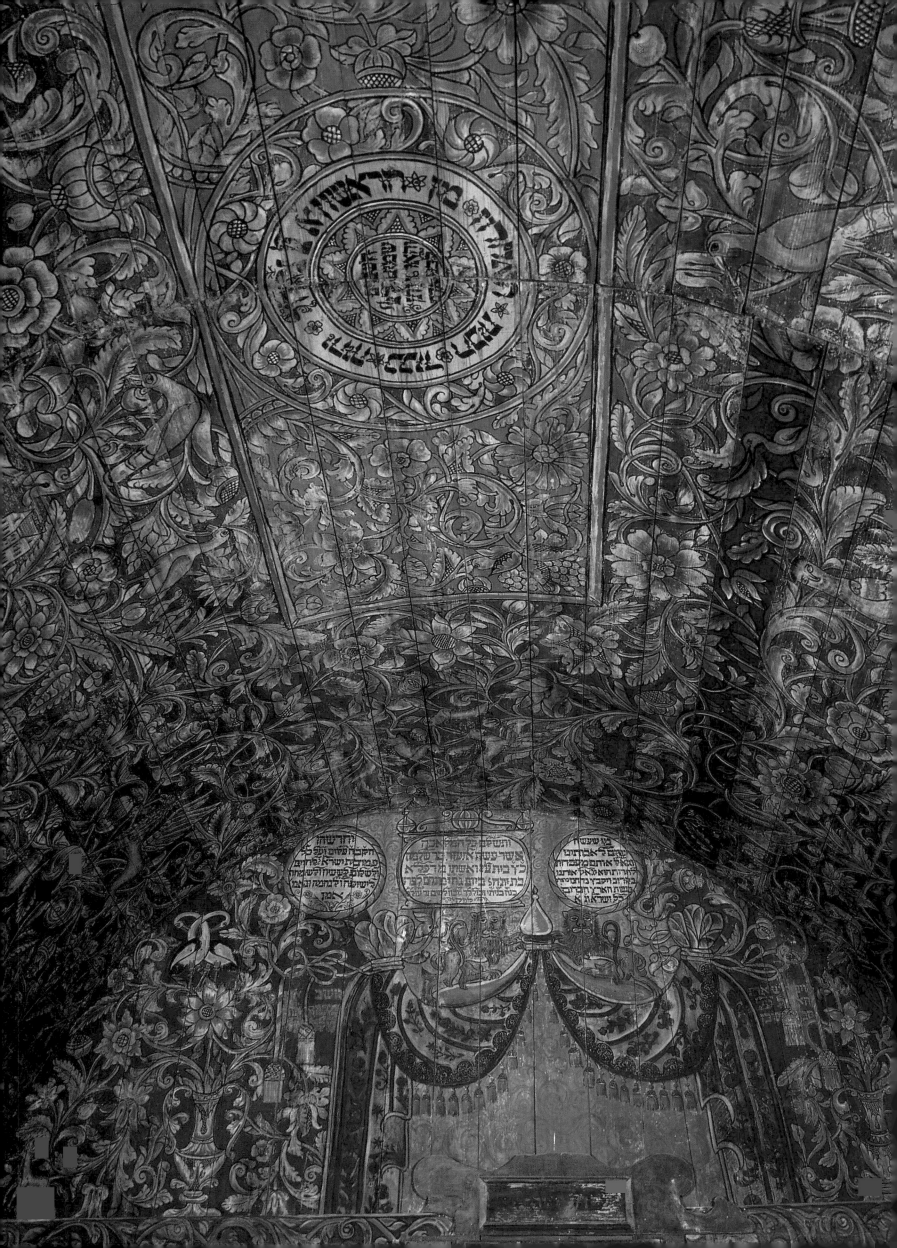

JEWISH ART

Grace Cohen Grossman

HUGH LAUTER LEVIN ASSOCIATES, INC.

Copyright ©1995, Hugh Lauter Levin Associates, Inc.
Design by Philip Grushkin
Photo research by Cynthia Deubel Horowitz
Editorial production by Diane Lawrence
Printed in China
ISBN 0-88363-695-6

(FRONTISPIECE)

ELIEZER SUSSMANN. SYNAGOGUE CEILING. Horb, Germany. 1735. Wood, painted. 84 x 246 x 192 in. (213.4 x 624.8 x 487.7 cm). The Israel Museum, Jerusalem. On permanent loan from the Bamberg Municipality. Reconstructed through a donation from Jakob Michael, New York, in memory of his wife Erna Sondheimer-Michael. *The vaulted ceiling of the Horb Synagogue was painted by Eliezer Sussmann, who has been identified as having painted the interior of at least seven synagogues, of which this is the most complete surviving example. An inscription gives his name and that of his wife, Merela, daughter of Jonah, and the date of completion, the eighteenth of Av 5495 (August 6, 1735). The tapestry-like ceiling includes a profusion of flowers and vines and real and mythological animals, as well as biblical quotations and Jewish and folk symbols. Along one side is a visionary view of Jerusalem. The imagery is characteristic of that found in eastern European wooden synagogues. Fortunately, the ceiling was moved to the Municipal Museum of Bamberg in 1914 and thus saved from probable destruction.*

CONTENTS

ACKNOWLEDGMENTS

Preparing this volume has been a unique opportunity for me and comes at a very special time as I celebrate a quarter of a century working in the field of Jewish art. At this milestone, I feel this book represents the culmination of many years of collegiality and friendship with others who have shared this journey with me—associates in museums and universities and private collectors alike. I could not have prepared this book without their advice and without their tremendous generosity in making so many wonderful images available for publication.

I especially want to thank Nancy M. Berman, Adele Lander Burke, Barbara C. Gilbert, and Susanne Kester, my co-workers at the Hebrew Union College Skirball Museum, whose caring support and careful review of the work in progress helped bring it to fruition. I am very grateful to Hugh Levin, who enthusiastically encouraged me to take on this challenge and who deserves recognition for his vision in publishing so many important books about the Jewish cultural heritage. Levin Associates is made up of very able professionals and I want to thank all of them, especially Ellin Silberblatt, the editor of this book, who diligently and lovingly cared for every detail. Cynthia Horowitz, the picture researcher, deserves special acknowledgment for her incredible commitment and tireless efforts on behalf of this project. A special thank you to Philip Grushkin for his classic design of the book; and to Diane Lawrence and Sheila Schwartz for their careful copy editing, and to Jan Scaglia for her production assistance. And for Ira and our wonderful sons Dov and Ari, who have continuously lived with *Jewish Art*, I wish I could find ways to thank you enough.

As this volume goes to press, it has just been announced by the President of Bosnia Herzegovina that the Sarajevo Haggadah, which escaped the Spanish Inquisition, was spirited away from certain destruction and preserved during the Holocaust, and which was hidden for the past two years as ethnic conflict raged all around, has on this Passover, the festival of freedom, been brought to light to be used at an ecumenical seder in Sarajevo. This treasured medieval manuscript will be returned to the Jewish community. Jewish art is about Jewish life and it is a privilege to serve as its chronicler.

Grace Cohen Grossman

From Holy to Heritage: Collectors and Collections of Jewish Art

IN THE eighteenth century, Alexander David (1637–1765), a Court Jew from Brunswick, formed the earliest known private collection of Judaica which he later presented to his synagogue. But not until just over a century ago was there to be a flowering of interest in the acquisition and study of Judaic art and artifacts.

The field of Jewish art as an academic discipline is a phenomenon of the modern age when an unprecedented change in all aspects of Jewish life was brought about by the Enlightenment along with the process of Jewish emancipation in western Europe. The study of Jewish art emerged as a late offshoot of the *Wissenschaft des Judentums*, the scientific study of Judaism. In the early nineteenth century, the adherents of *Wissenschaft* sought a revolutionary transformation in Jewish study by challenging the bond between Jewish learning and religious piety and attempting to link the examination of Jewish religious and historical developments with the canons of modern critical scholarship. There was also a pragmatic goal. In the pursuit of Jewish political emancipation, the academic study of Judaism endeavored to dissipate centuries-old prejudices and stereotypes with the objective of demonstrating that Judaism was an intrinsic component of Western culture and in so doing elevate the stature of Jews in the community at large. Likewise, collections of Jewish art were to serve as "witnesses to history," which would project an unbiased perspective on the Jewish cultural heritage and the role Jews played in society.

The personal quest of a few pioneers flourished as private collections gave way to popular exhibitions and the establishment of societies for Jewish art, Jewish museums, and collections of Judaica in public museums. At the outset, what all shared as a priority was preservation and documentation. It was seemingly apparent as to what constituted the appropriate criteria: any item related to Jewish existence was relevant—objects of custom and ceremony, memorabilia chronicling the lives of important Jewish personalities and momentous events, as well as paintings and sculptures on Jewish themes and issues of Jewish identity. Jewish art was about Jewish life.

This survey reflects a century of collecting Jewish art. What the individual collectors and the institutions understood as their mandate and articulated as their intent defines the parameters of the field. Moreover, the study of Jewish art is integrally linked with Jewish experience in the twentieth century and has been indelibly marked by the changing circumstances and events which have altered the very course of Jewish life in the past one hundred years. These collections form the resources for the study of the three thousand-year-long history of Jewish artistic creativity from its origins in antiquity to the present, from the biblical artisan Bezalel to artists exploring their Jewish identity today.

Jewish art was displayed to the general public for the first time at the Exposition Universelle at the Trocadéro in Paris in 1878. Here eighty-two items from the Isaac Strauss Collection were exhibited.[1] Isaac Strauss (1806–1888), a musician who was *chef d'orchestre* to Napoleon III, took advantage of his position at court to avidly collect paintings, sculptures, and decorative art objects. However, unlike the nobility with whom he travelled, Strauss also collected Judaica. Strauss did not articulate his personal reasons for acquiring Judaica, but what is significant was that in this great age of international fairs he agreed to display his collection at the Trocadéro among the ethnographic exhibitions of many diverse "exotic" cul

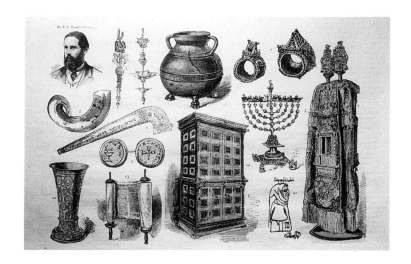

The Anglo-Jewish Exhibition. London. 1887. Courtesy Yeshiva University Museum, New York. *A newspaper of the period pictured some of the objects which were on exhibition at the Royal Albert Hall in 1887. Among the objects shown are the Torah ark and a Hanukkah lamp by Valentin Schuler from the Strauss Collection.*

tures. The Strauss Collection was ultimately purchased for the Musée de Cluny in Paris in 1890 by Baronne Charlotte, wife of Nathaniel de Rothschild.[2]

Yet another milestone was the Anglo-Jewish Historical Exhibition, presented in 1887 at Royal Albert Hall in London, the first major exposition organized to promote the historic preservation of Judaic art and artifacts. The exposition grew out of plans initiated by Lucien Wolf and Alfred Newman to establish an Anglo-Jewish Historical Society. While unsuccessful at first, Newman's efforts to prevent the demolition of the Spanish and Portuguese Bevis Marks Synagogue, built in 1701, galvanized public opinion and brought the issue of historical preservation to the fore. Sir Isidore Spielmann (1854–1925), an organizer of art exhibits, proposed that the best way to accomplish the goal of creating the society was through a major public exposition.[3]

The exhibition was monumental by any standard. Over twenty-five hundred ritual objects, antiquities, paintings, documents, books, and prints borrowed from some three hundred and forty-five lenders, both individuals and institutions, were amassed for the landmark exhibition. Among the private collections of Anglo-Jewish historical materials were those of Newman and Wolf and that of Israel Solomons (1860–1923), bibliophile and collector of Anglo-Jewish books, manuscripts, prints, bookplates, and documents. Paralleling the efforts of other antiquarian collectors of the era, Solomons formed his collection as a basis for historical research and scholarship. As a national, patriotic enterprise, however, its specific goal was to demonstrate Jewish patriotism and the Jewish contribution to modern English history.

Although the focus of the exhibition was originally limited to Anglo-Jewish history, it was decided to highlight Jewish ceremonial art as well, no matter what the country of origin of the objects. The Strauss Collection, brought over from Paris, was now viewed as exemplifying the finest of Jewish ritual artifacts. Also a highlight of the ceremonial art section of the exhibition was the collection of Reuben Sassoon (1835–1905). Sassoon's collection, which lent special prestige to the exhibition, had been purchased, in large part, from Philip Salomons (1796–1867), brother of Sir David Salomons, the first Jewish Lord Mayor of London.[4]

To ensure that their efforts not be categorized solely as a sectarian enterprise, the exhibition planners formed a General Committee which was diverse and ecumenical. The political agenda of the exhibition was to stress the positive aspects of Judaism and dispel stereotypical images of Jews. This intention was addressed by the Reverend Hermann Adler (1839–1911), Chief Rabbi of the United Hebrew Congregations of the British Empire, in a sermon delivered at the Bayswater Synagogue on April 15, 1887, and reprinted in the *London Jewish Chronicle*:

> *The main object of the collection gathered in the Albert Hall is educational and instructive; to*
> *diffuse by means of object lessons some knowledge of Hebrew antiquities generally, and more*

particularly of the history of our race in the British Empire. . . . Had there been less mystery about our religious observances, there would, perhaps, have been less prejudice, certainly less foul aspersion.[5]

The self-conscious effort to reach out to the non-Jewish community in an effort to improve the political status of the Jews was successful, at least in Adler's view, and the original goal of the organizers was achieved when the Anglo-Jewish Historical Society was formed in 1893.

The 1890s mark the birth of more widespread interest in the study and exhibition of Jewish artifacts and the formation of Jewish museums in Europe, the United States and Eretz Yisrael.[6] This growth reflected a general trend in Europe, where numerous ethnographic museums were established in the late nineteenth century. In the period before World War I, there was intense activity in historic preser-vation and an attempt to document the role artistic expression played in Jewish life. In the face of modernity and rapid changes in Jewish life, this effort was also a way to maintain knowledge about traditional Jewish customs and practice as a source for Jewish cultural renewal.

The very notion of "collecting" Jewish ceremonial objects was a radical development. The separation of *tashmishé kiddusha* (implements of holiness) from their functional use in Jewish celebration transformed their meaning. Ceremonial objects lovingly crafted to fulfill the spiritual intention of *hiddur mitzvah*, of enhancing the commandments of Jewish ritual, as well as ethnographic artifacts reflecting Jewish belief and custom, became heirlooms of the Jewish cultural heritage. Now they would be studied and investigated. Questions would be posed about their history, content, and style. The decisions about what was to be collected and how it should be documented, preserved, and interpreted also reveal much about the collector's philosophy, self-image, and identity and what each collector valued. It is also significant to recognize how original intent was modified over time due to a variety of factors, many of which were precipitated by the exigencies of Jewish experience in the twentieth century.

An early contribution to the field of Jewish art was made with the publication in 1898 of the *Sarajevo Haggadah*, the first facsimile edition of a Hebrew illuminated manuscript. After passing through the hands of numerous private owners, this fourteenth-century manuscript, probably produced in Catalonia, came into the possession of the Sarajevo National Museum. The author of the text accompanying the publication was a non-Jewish art historian, Julius von Schlosser. The manuscript contains a wealth of depictions of biblical stories, from the Creation to the blessing of Joshua, and its publication was received with great interest among scholars and the general public. That a Hebrew manuscript could include figural repre-

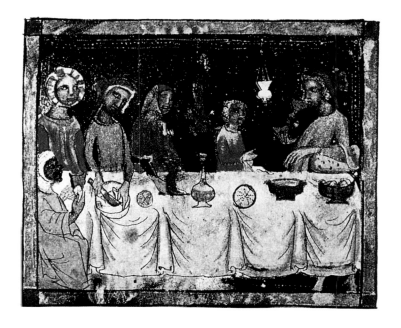

Sarajevo Haggadah. Catalonia, Spain. 14th century. Parchment. 8 3/4 x 6 1/4 in. (22 x 15.9 cm). National Museum, Sarajevo. *The miniatures of the* Sarajevo Haggadah *include an extensive range of subjects—biblical scenes, illustrations of the Temple, Passover preparations and the seder, the interior of a Spanish synagogue, and many illuminated initial-word panels. Depicted here is a scene from the Passover seder.*

sentation was shocking and again raised the question of the Second Commandment prohibition against the making of images in Jewish art. Moreover, though the haggadah had come into the possession of the Sarajevo National Museum just four years earlier, its appearance began a search for other Jewish manuscripts no longer in Jewish hands.

The earliest known formal group to study Jewish art started in Vienna in 1895, the Gesellschaft für Sammlung und Konservierung von Kunst und historischen Denkmälern des Judentums (Society for the Collection and Conservation of Jewish Art and Historic Monuments), which later established a museum. In 1897, the Gesellschaft zur Erforschung Jüdischer Kunstdenkmäler (Society for the Research of Jewish Art Monuments) was founded in Frankfurt-am-Main.[7] Ironically, the Frankfurt society was started by Heinrich Frauberger (1845–1920), a Catholic art historian and director of the Düsseldorf Kunstgewerbemuseum (Museum of Applied Arts). Frauberger was the first trained art historian and museologist to study Jewish art and collect artifacts of the Jewish cultural heritage. Frauberger's concern for the preservation of Judaica is recounted as stemming from a personal incident. Asked about the meaning of a design for a railing around a Jewish grave and unable to find adequate resources to respond to the inquiry, Frauberger determined, so the story goes, to collect artifacts of Jewish cultural heritage and thereby define what was Jewish style. While several public museums had begun acquiring Judaica as a consequence of ethnographic studies and a general interest in religion, Frauberger's plan was much more ambitious.[8] In 1908, at the Düsseldorf Kunstgewerbemuseum, Frauberger curated the first exhibition in Germany of Jewish ceremonial objects.

Whatever Frauberger's original reason for taking an interest in Jewish art, he sold his personal collection of Judaica to Salli Kirschstein (1869–1935), a successful Berlin businessman who dealt in textiles. Kirschstein, who began collecting Judaica around 1890, displayed his vast collection of Judaic manuscripts, books, paintings, prints, drawings, and ceremonial objects in a private museum in his home. In his writings, Kirschstein explained that what spurred him to form a collection of objects of Jewish culture was the lack of representation of Judaica at the Arts and Crafts and Ethnology Museum in Berlin: "In the Ethnology Museum in Berlin, in its all embracing exhibition, in which all the nations of the world, from the most primitive to the most culturally advanced are represented, the Jews alone are absent."[9] Kirschstein maintained that collecting and researching objects representing the Jewish cultural heritage was a vital link to the present and to the future of the Jewish people and a way to counteract anti-Semitism.[10] Despite his concern for Jewish representation in the Berlin museum world, in 1925 Kirschstein sold his collection, numbering some six thousand items, to the Hebrew Union College in Cincinnati, where a museum had been founded in 1913. The acquisition was lauded in the United States as signifying that the "center of Jewish culture had crossed the sea."[11]

Polish-born Lesser Gieldzinski (1830–1910), who settled in Danzig in 1860 and became a successful grain merchant, was a passionate collector with a special antiquarian interest in "Danzigiana."[12] His home became a veritable museum, and he counted among his distinguished guests Kaiser Wilhelm II and Kaiserin Augusta. Gieldzinski also formed a superb collection of Judaica which he donated to the Great Synagogue in Danzig in 1904 to commemorate his seventy-fifth birthday. One of Gieldzinski's aims was to acquire any Judaica which had a Danzig connection, thus synthesizing his dual allegiance.

In Prague, the effort to establish a Jewish Museum was, in London, prompted by the threatened demolition of several historic synagogues. The preservation movement was spearheaded by Salomon Hugo Lieben (1881–1942), a historian who taught religion in Prague German-language schools.[13] Lieben had a nationalist bent and particularly wanted to preserve the cultural heritage of Bohemia and Moravia. Unfortunately, despite his efforts, a number of synagogues were destroyed. Undaunted, in 1906, Lieben created

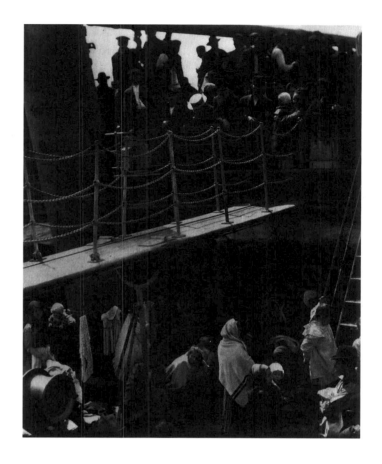

ALFRED STIEGLITZ (1864–1946). *The Steerage*. 1907. Plate IX from *Camera Work*, 36. (October 1911). Photogravure (artist's proof). 7 3/4 x 6 1/2 in. (19.7 x 16.5 cm). The Museum of Modern Art, New York. Gift of Alfred Stieglitz. Copy print. © 1995 The Museum of Modern Art, New York. *Stieglitz's famous scene of immigrants quintessential captures the experience of millions who came to the United States enduring very difficult conditions, all seeking "the promised land."*

the Verein zur Gründung und Erhaltung eines Jüdisches Museums (Society for the Founding and Maintenance of a Jewish Museum [in Prague]) to preserve the artifacts of other synagogues that had fallen into disuse and to seek objects in rural villages. In 1912, the collection of approximately 1,000 ceremonial objects and 1,500 Hebrew books and manuscripts was housed in the former building of the Jewish burial society. Later, as the collection grew, it was moved in 1926 to the Ceremonial Hall in Prague's Jewish Quarter.

Between 1912 and 1914, S. An-Sky (Shlomo Zainwil Rapoport, 1863–1920) organized an expedition to Jewish communities in eastern Europe to document traditional folkways, collect ceremonial artifacts and communal documents and, with the use of a cylinder recorder, to collect thousands of Yiddish folksongs and folktales. An-Sky had a very particular agenda. On the one hand, he was a realist who understood that the encounter with modernity and the mass emigration movement to America was already irrevocably altering life in the shtetl of the Pale of Settlement, and his documentation efforts were motivated by the urgency of rescuing these vestiges of a vanishing world. However, An-Sky was also an idealist who sought to preserve traditional Jewish identity as a source for Jewish cultural renaissance.[14] Indeed, An-Sky's research played a key role as Jewish artists, writers, and musicians, swept up in the nationalist impulses of the time, optimistically believed that they could forge a Jewish cultural rebirth and sought a distinctive Jewish aesthetic.

Surprisingly, the first collection of Judaica to become part of a public national museum was in the United States, at the Smithsonian Institution. The United States National Museum began collecting Jewish ceremonial objects in 1889. This pioneering endeavor was initiated by Cyrus Adler (1863–1940), who held a Ph.D. in Semitics from Johns Hopkins University. Adler served in a professional capacity at the Smithsonian for two decades, rising from the position of Assistant Honorary Curator of the Section of Oriental Antiquities to the distinguished rank of Assistant Secretary of the Museum.

Adler stalwartly adhered to the position that the "authentic" study of Judaism, according to the principles of modern scholarship, would counteract prejudice and gain acceptance for Jews as truly equal

partners in American society. Through his singular efforts, he determined to represent Jewish ceremonial and art objects, in his words, ". . . in a beautiful and dignified" way in the nation's capital, the pinnacle of secular American society.[15] Adler believed that the Smithsonian should develop a department focused on comparative religion. Judaism was therefore collected and interpreted within that framework, albeit with Adler's personal approach that Judaism be considered the "mother" religion and Christianity and Islam the "daughters."[16] The first exhibition of the Section of Religious Ceremonials from the Smithsonian opened at the World's Columbian Exposition in 1893.

What also singled out the Smithsonian Judaica collection from its counterparts in Europe was that the collection was not acquired locally. Rather, Adler relied on antique dealers who had acquired objects in Europe and the Near East and brought them to the United States. Hadji Ephraim Benguiat (d. 1918) was born in Smyrna (Izmir), Turkey. He lived in Damascus, then moved to Gibraltar before emigrating to the United States. According to family lore, Benguiat's ancestors had been in the business of selling antiquities for generations and, as Adler explained, "During this whole period they had made it a practice never to sell an object of Jewish art, with the result that they had brought together one of the most notable collections in the world."[17]

The Benguiat Collection was on loan to the Smithsonian from 1892 to 1924, forming the core of the Judaica exhibition there. During that time, Ephraim Benguiat continued collecting and adding to the Smithsonian loan. In 1924 Cyrus Adler, who had become president of the Jewish Theological Seminary, was instrumental in bringing the Benguiat Collection to the Jewish Museum established at the Seminary in 1904. Fortunately, the collection of Ephraim Deinard (1846–1930), with over five hundred objects, remained on long-term loan at the Smithsonian and was eventually deeded as a gift to the museum. Another colorful personality like Benguiat, Deinard was a bibliophile, Hebrew author, and independent book dealer. Certain he could place them at the Smithsonian, Deinard purchased objects during his buying trips beginning in the 1890s. His intention was to purchase everything that would represent Jewish life from "cradle to grave."[18]

Boris Schatz was a pioneer and visionary who wanted to create a school for Jewish arts and crafts in Eretz Yisrael, where a "Jewish art" would be created by weaving together the cultural threads that had been pulled apart and damaged during the two thousand years Jews had lived in the Diaspora. Schatz (1866–1932) was born in Lithuania, studied art in Paris, and in 1895 became court sculptor to Prince Ferdinand of Bulgaria. In 1903 he met Theodor Herzl and became an enthusiastic Zionist. Schatz would later write that in the course of their conversation, Herzl was receptive to his plan, even inquiring as to the name of the proposed school; to which Schatz responded, "Bezalel, after the first Jewish artist who built

World's Columbian Exposition. 1893. Smithsonian Institution Archives, Washington, D.C. The first exhibition of Judaica in the United States was part of the installation of Religious Ceremonials organized by Cyrus Adler for the Smithsonian. The exhibition was displayed in the United States Government Building at the 1893 World's Fair. A Torah curtain from Turkey can be seen hung prominently on the wall.

a sanctuary in the wilderness."[19] Choosing the name of the biblical artist clearly was an important symbol of continuity of Jewish life for Schatz. Following Herzl's sudden death in 1904, Schatz sought the approval of various Zionist institutions to help make his dream a reality.[20] At the 1905 Zionist Congress, his proposal was accepted and the school was established in Jerusalem in 1906. The school trained artisans in a wide variety of crafts, from silversmithing to rug making, and fostered the nascent fine arts movement in Eretz Yisrael. The Bezalel Museum was founded shortly thereafter, primarily to serve as a resource for the students. The school, which was closed during World War I and again after Schatz died in 1932, was later reopened as the Bezalel Academy of Art and Design.

Another dimension in the study of Jewish art in Eretz Yisrael was the emerging field of archaeology. For centuries, pilgrims to the Holy Land had come to visit and seek ancient sites. From the nineteenth century until World War I, archaeological investigations proceeded in earnest, with surveys such as those conducted by The Palestine Exploration Fund, and at specific sites, such as Sir Charles Warren's famous probes in the area of the Temple Mount between 1867 and 1870. The budding scientific effort, however, went hand in hand with the agenda of linking material culture to the Bible and thus validating religious belief, primarily in the early years, that being Christianity. During the British Mandate, British, German, and American archaeologists carried out large-scale excavations. The scope now ranged well beyond the realm of biblical studies to span the period from the Bronze Age to the Crusaders. At the same time, Jewish scholars from the newly founded Hebrew University, under the auspices of what is now known as the Israel Exploration Society, also made major finds, including the Byzantine era synagogues at Bet Alpha and Hammat Tiberias and the tombs at Bet Shearim.

Jewish art activities in Europe continued to thrive after World War I and heroically persisted even as the Nazis came into power. New museums were established. Berlin in the 1920s became a vital center for the study of Jewish art, one indicator being the publication of the pioneering magazines *Rimon*, in Hebrew, and *Milgrom*, in Yiddish. Rachel Bernstein Wischnitzer (1885–1989), an architect, and the first to teach Jewish art history on a university level, was the art editor of these magazines, which published articles on Jewish art from antiquity to contemporary times as well as on literary topics.

Nearly all of the major Jewish museums in Europe were destroyed or plundered by the Nazis. During World War II, a bizarre fate befell the Prague Jewish Museum when the Nazis designated it to be the repository for all the synagogue treasures from Bohemia and Moravia. Moreover, as Jews were deported, ceremonial objects from their homes as well as other items from artworks and musical instruments to kitchenware were also shipped to the museum. The Nazi plan was for this to ultimately serve as a museum of an extinct people. As a result, the State Jewish Museum in Prague has one of the finest collections of Judaica in the world. Objects from the collection are displayed in the historic Prague synagogues.

A few scholars who managed to escape Germany forged a new era of professionalism for Jewish museums in the United States and Israel. Several European collections were spared, having been taken or sent out of Europe, Dr. Henrich Feuchtwanger and his family left Germany and immigrated to Jerusalem in 1935. Dr. Feuchtwanger deposited his collection of ceremonial objects and folk art at the Bezalel Museum.

An extraordinary plan was devised by the American Jewish Joint Distribution Committee and the Danzig Jewish community to help raise funds for Danzig Jews to emigrate; "in exchange," the Gieldzinski Collection, along with the ceremonial objects of the Great Synagogue of Danzig, were sent for safekeeping to the Jewish Theological Seminary in New York. It was stipulated in the agreement that if after fifteen years, there were no safe and free Jews in Danzig, the objects were to remain in America, as they have, for the education and inspiration of the rest of the world.[21] The Danzig collection arrived at the Jewish Museum in July 1939, just weeks before Hitler's invasion of Poland.

Also in 1939, Benjamin and Rose Mintz managed to escape to America with their collection of eastern European Jewish folk art.[22] The ruse which enabled them to ship the collection was that it would be exhibited at the Palestine Pavilion of the New York World's Fair. The collection was not exhibited since these objects, though representing "Jewish heritage," were not products of Palestine. It was put into storage and, in 1947, several years after Benjamin Mintz's death, Rose Mintz sold the collection to the Jewish Museum.

The most significant growth in the Jewish Museum's collections was primarily due to the incredible vision of Dr. Harry G. Friedman. A graduate of Hebrew Union College, Friedman never held a rabbinical position but became a financier. Beginning in 1941, Friedman daily purchased Judaica from every possible source, including hundreds of objects brought to the United States by fleeing European Jews. In need of money, they were grateful that Friedman purchased the objects for the Jewish Museum. In total, Friedman presented the museum with more than 6,000 items of Jewish ceremonial and fine art and archaeological artifacts, which he collected between 1941 and his death in 1965.

The Jewish Museum in New York also played a vital role in the functioning of the Jewish Cultural Reconstruction, Inc. (JCR). In the aftermath of World War II, it became necessary to distribute Nazi-looted Jewish cultural and religious items which had been recovered by the American, British, and French military authorities. Established under the chairmanship of the eminent historian Dr. Salo W. Baron, the JCR, in an unprecedented act of communal cooperation, represented nearly all the American Jewish organizations. The JCR was empowered by the United States State Department to identify and redistribute all heirless Jewish property found in the American sector. Forty percent of the items were sent to Eretz Yisrael, the remainder distributed to Jewish communities worldwide.[23]

In the decades following World War II, there was some limited activity in Europe, but the major mantle of scholarship in the field of Jewish art became the responsibility of Jewish communities in Israel and the United States. In just a few short years, numerous museums were established in Israel, and Jewish art, ethnography, and folklore became accepted academic disciplines in Israeli universities. Important collections of ceremonial art and ethnography were formed, reflecting the ingathering to the State of Israel of refugees from Europe and Arab lands. Now the vibrant legacy of communities like Afghanistan, Kurdistan, Morocco, Yemen, and of Jews who lived under Ottoman rule could be properly documented along with the European heritage. By 1980, the Centre for Jewish Art of the Hebrew University in Jerusalem, founded by Bezalel Narkiss, had undertaken an ambitious program, including the creation of the Index of Jewish Art, to document and computerize all the visual culture of the Jewish people. There was also an active publications agenda including *Jewish Art*, an annual journal. A new generation of Israeli artisans began creating ceremonial objects and Israeli fine arts came into maturity.

Archaeology has been dubbed the national pastime of Israel. But even as the science of archaeology has developed, with a sophisticated multidisciplinary approach being the norm for a quarter century, controversial political and social issues still abound, and the role of the material legacy of antiquity remains tied to the national consciousness—the quintessential example perhaps being, in the post-Holocaust era, the "never again" mentality recounted in the story of the Jewish zealots at Masada who allegedly committed suicide rather than submit to Roman rule.

After the Six Day War in Israel in 1967, there was a tremendous upsurge in interest in Jewish life and culture. In America, this occurrence paralleled a general preoccupation with ethnicity which emerged at the time and which has profoundly impacted American life. There has been a virtual renaissance in the field of Jewish ceremonial art, with artists working in a wide variety of materials and styles to explore their own Jewish identity by creating contemporary artifacts. One manifestation of the interest in studying Jewish history has been the founding of Jewish museums and historical societies in communities throughout

the United States.[24] Since the late 1970s, the most profound aspect of the emphasis on history as memory has been the building of hundreds of Holocaust memorials and museums.

A critical component in the formation of these institutions has been the contributions of individual collectors of Judaica. Wide-ranging in interests and tastes, a new generation of collectors has played a vital role in stimulating the growth of Jewish museums. In many instances, museum projects were first initiated by a single collector who served as benefactor and prime mover.

Perhaps the most astonishing development in the world of Jewish museums makes the return full-circle to Europe. There has been an incredible revival of Jewish museums in Europe, even in communities most severely affected by the Holocaust.[25] By the late 1980s Jewish museums had been established or reopened in the Netherlands, Germany, Austria, Greece, Italy, Spain, England, Ireland, Scandinavia, France, and Belgium. The collapse of the Soviet Union has brought the rediscovery of several collections thought to have been destroyed during World War II, which are now once again being studied and documented. Serendipitously, the artifacts of the Vienna Jewish Museum, believed lost for half a century, were rediscovered in 1993 in the basement of a Jewish old age home, found in the same crates in which they had been hidden for safekeeping. Wherever there is a Jewish community, preservation is on the communal agenda, and Jewish museums exist in all parts of the world, from Australia to South Africa.

For over a century, collectors of Judaica have been much more than art connoisseurs, and Jewish museums have been more than just repositories of prized artworks. From the outset, these collections have served the purposes of Jewish communal agendas—at times educational, at times political. Whatever the original motivations for collecting these cultural artifacts, whether salvage, sentiment, or scholarship, and however they may have been understood in the past, what is critical is that they have been preserved. Because of the dedication of a few intrepid collectors and curators, they exist to be treasured and interpreted anew in each generation.

This survey of Jewish art chronicles the efforts over the past century to document and collect, preserve and interpret a broad spectrum of objects related to the Jewish cultural heritage. Modern Jewish art, born in the late nineteenth century, had influence from many quarters: the model of antiquarian societies, the techniques of new areas of research such as ethnography and anthropology, and the philosophies of the emerging modern museum. While there have been various definitions of Jewish art, the record of collecting efforts reveals that much was shared, and no matter how narrow the scholarly criteria for Jewish art, societies for the study of Jewish art and Jewish museums tended to be broad in scope. Jewish art, begin-

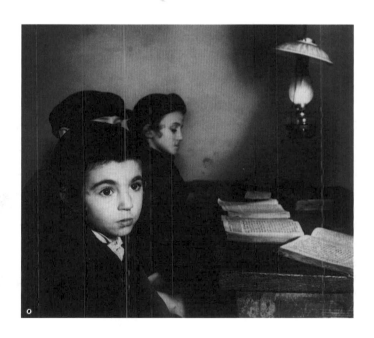

ROMAN VISHNIAC (1897–1990). *Cheder boys, Vrchni apsa.* 1937. Gelatin silver print. The Roman Vishniac Archive at the International Center of Photography, New York. Courtesy Mara Vishniac Kohn. *From 1934 to 1939, Roman Vishniac traveled from the Baltic Sea to the Carpathian Mountains documenting the world of eastern European Jewry. Of the thousands of photographs he took, often under very difficult circumstances, he was able to save about two thousand. When he came to the United States in 1940, some of these were even sewn into his clothing. Others were left behind with his father in a small French village during the war.*

BILL ARON (b. 1941). *Sunrise Hallel Service, Shavuot.* New York. 1978. Gelatin silver print. 18 x 12 in. (45.7 x 30.5 cm). Courtesy of the photographer. *For over two decades, Bill Aron has documented the Jewish experience in various Jewish communities in North America, Europe, and Israel. This photograph was taken at a retreat of the New York Havurah, a community for celebration, study, and prayer.*

ning in antiquity, reflected Jewish life as an ongoing cultural entity, with biblical symbols, stories, and themes providing later inspiration for a uniquely Jewish expression in the illustration of Jewish texts, and in the fashioning objects of ritual and custom used in the synagogue, community, and home for daily life, Sabbath, holidays, and life cycle. Moreover, attention was given these artifacts as exemplars of the Jewish experience as it evolved among many civilizations—adapting to the realities of life and local customs, employing regional styles, and even incorporating "native" symbolic imagery. So, too, was the mission of Jewish art seen to include historical memorabilia of the Jewish experience, documenting the lives of individual Jews and of Jewish communities. In the fine arts, the focus was initially on portraits and genre paintings depicting Jewish life and customs. The artistic movements which flourished from at the turn of the century on had a significant impact on the world of Jewish art. Though there are scores of Jewish artists, works selected for inclusion here are those which consciously explore some aspect of Jewish life and Jewish identity, which is the criterion for acquisitions in many Jewish museums.

In the hundred years since the first Jewish museums were established and documentation efforts begun, history is repeating itself. We too are at a turning point. The "collective memory" of the Jewish people, for centuries so clearly linked to the past, has now, with the specter of increased assimilation, led to a new juncture: the effort now is to define Jewish identity for the future. Jewish artists reflect this in their work seeking meaningful expression for the modern era; and as, with the pioneers a century ago, Jewish museums worldwide and the museums in Israel exist not only as repositories of the material legacy of the Jewish people but as cherished sources for renewing Jewish cultural life.

Many difficult choices had to be made in preparing this survey, which, can only serve as an introduction to the many treasures of Jewish art. The attempt is made in this book to give a broad perspective of the artistic heritage of Judaism by including works from antiquity to the present and providing a sampling of Jewish cultural life in many different lands. It would, however, take many such volumes to fully represent each era in Jewish history, each Jewish community, indeed each artist. We hope that you will let the few stand for the many, those that have been preserved and those that have been lost.

1. M. Straus, *Description des objets religieux hébraïque exposés dans les galeries du Trocadéro à l'exposition Universelle de 1878*, (Poissy, 1878), cited in R.D. Barnett, ed., *Catalogue of the Permanent and Loan Collections of the Jewish Museum London* (London: Harvey Miller; Greenwich, CT: New York Graphic Society, 1974), p. xiii.

2. In his introduction to the Cluny collection, Alain Erlande-Grandenburg makes the observation that what motivated Strauss was nostalgia and a way to relate to the religious observance he had known in his family. Victor Klagsbald, *Catalogue raisonné de la collection juive du musée de Cluny* (Paris: Éditions de la Réunion des musées nationaux, 1981), p. 8. Also see, Richard I. Cohen, on "nostalgic yearning for a vanishing Jewish world," and on the differences in exhibitions, in "Self-Image Through Objects: Toward a Social History of Jewish Art Collecting" in *The Uses of Tradition*, ed. Jack Wertheimer (Cambridge: Harvard University Press, 1993), pp. 212–213.

3. Lucien Wolf, "Origin of the Jewish Historical Society of England," *Transactions of the Jewish Historical Society of England*, 7 (1911–1914), pp. 211–212. Lucien Wolf (1857–1930) was an Anglo-Jewish historian and publicist. Alfred A. Newman (1851–1887), who collected Anglo-Jewish books, pamphlets and portraits, died before the exhibition opened. The items from his collection are 1121a–1250 in Joseph Jacobs and Lucien Wolf, *Catalogue of the Anglo-Jewish Historical Exhibition, 1887*, Royal Albert Hall (London: Office of the Jewish Chronicle, 1888).

4. Barnett, *Catalogue of the Permanent and Loan Collections of the Jewish Museum London*, p. xiii.

5. Hermann Adler, "The Anglo-Jewish Historical Exhibition: A Discourse Preached at the Bayswater Synagogue by the Rev. Dr. H. Adler, on the seventh day of Passover, 5647 (April 15, 1887)," *London Jewish Chronicle*, April 22, 1887, p. 9.

6. In addition to the several museums discussed here, many others were established in the half century between the Anglo-Jewish Historical Exhibition and the outbreak of World War II. Among others, these include Augsburg, Berlin, Budapest, Hamburg, Cracow, and Warsaw prior to World War I and Amsterdam, Breslau, London, Lvov, and Mainz between the wars. Jewish sections were also to be found in secular museums, such as Bamberg, Strasbourg, Würzburg, and Kassel. There were, of course, other supporters and collectors of Jewish art too numerous to be discussed in detail here.

7. The Baron Karl von Rothschild Public Library was established in the Rothschild Palais in 1894 by Hannah Louise von Rothschild. The Jewish Museum was established in Frankfurt in 1922. Looted by the Nazis, the museum reopened in 1988 in the former Rothschild Library. A dedicatory volume issued at the reopening of the museum gives the history of the museum and the Rothschild Palais. *Jüdisches Museum Frankfurt am Main* (Frankfurt am Main: 1988), p. 37.

8. Cohen, "Self-Image Through Objects," p. 230, notes the collection in the Hamburg Museum für Kunst und Gewerbe and the acquisition of Jewish art facts from Alsace-Lorraine in the Strasbourg Museum.

9. Kirschstein's description is cited in Joseph Gutmann, "The Kirschstein Museum of Berlin," *Jewish Art*, 16/17 (1990–91), pp. 172–176.

10. H. Simon, *Das Berliner Jüdische Museum in der Oranienburgerstrasse: Geschichte einer zerstörten Kulturstätte* (Berlin, 1988), pp. 13–14, cited in Gutmann, "The Kirschstein Museum of Berlin," p. 176.

11. Excerpt of untitled, unreferenced article by Adolph Oko in "Report of the National Committee," *NFTS Proceedings*, October 31, 1926. The major growth of the HUC collection resulted from the ambitious acquisition program of HUC Librarian Adolph S. Oko (1883–1944). Four major European collections were procured for HUC by Oko in the 1920s, including a portion of the Israel Solomons Collection as well as the Kirschstein Collection.

12. Elizabeth Cats, "Lesser Gieldzinski," in *Danzig 1939: Treasures of a Destroyed Jewish Community* (New York: The Jewish Museum, 1980), pp. 43–45.

13. The history of the Prague Museum is discussed in Linda A. Altshuler and Anna R. Cohn, "The Precious Legacy," in *The Precious Legacy*, ed. David Altshuler (New York: The Jewish Museum, 1983), pp. 19 ff.

14. On An-Sky and the expedition, see Rivka Gonen, ed., *Back to the Shtetl: An-Sky and the Jewish Ethnographic Expedition, 1912–1914* (Jerusalem: The Israel Museum, 1994).

15. Ira Robinson, ed., Cyrus Adler, *Selected Letters*, ed. Ira Robinson (Philadelphia: The Jewish Publication Society of America; New York: The Jewish Theological Seminary of America, 1985), 1, p. 210. Excerpted from a letter from Adler to Jacob H. Schiff, April 7, 1912.

16. Adler was well aware of the nature of collections of comparative religion in European museums as well as the work of his compatriots in Jewish museums. It is actually possible that Cyrus Adler's work may have had an impact on the developments in Europe. Documents in the Smithsonian archives record that copies of United States National Museum publications were sent by the Smithsonian to Max Grunwald, memorandum dated February 21, 1898, and to the Gesellschaft für Sammlung und Konservierung von Kunst und Denkmälern des Judentums in Vienna, dated July 5, 1899. The Order for Publications indicates that it covered publications on Oriental antiquities already issued and future publications related to this subject. Smithsonian Institution Archives, Record Unit 201, Box 20, Folder 14.

17. Cyrus Adler, *I Have Considered the Days* (Philadelphia: The Jewish Publication Society of America, 1941), p. 173.

18. Deinard was born in Latvia and moved to the United States in 1888. Smithsonian Institution Archives, Record Unit 305, Registrar, Box 1048, Ephraim Deinard Accession File 207992.

19. Cited in "Boris Schatz: Father of an Israeli Art," *Herzl Yearbook*, 7 (1971), p. 404.

20. The history of Bezalel is discussed in Gideon Ofrat-Friedlander, "The Periods of Bezalel: The 'Founding Years' (1903–1907)," in *Bezalel 1906–1929*, ed. Nurit Shilo-Cohen (Jerusalem: The Israel Museum, 1983), pp. 31–52.

21. Joy Ungerleider-Mayerson, "Introduction," in *Danzig 1939*, p. 9.

22. The plan is described in a letter dated February 21, 1950, from Judge Max M. Korshak to Dr. Stephen S. Kayser in the Mintz Collection Accession Files. Judge Korshak initiated the plan.

23. Salo W. Baron, introductory statement, in "Tentative List of Jewish Cultural Treasures in Axis-Occupied Countries," Supplement to *Jewish Social Studies*, 8, no. 1 (1946).

24. For a fuller history, see Alice M. Greenwald, "Jewish Museums in the United States," *Encyclopaedia Judaica Year Book 1988/89* (Jerusalem: Encyclopaedia Judaica, 1989), pp. 167–181.

25. For a survey of Jewish museums in Europe, see Edward van Voolen, "[Jewish Museums] in Europe," *Encyclopaedia Judaica Year Book 1988/89*, pp. 181–188.

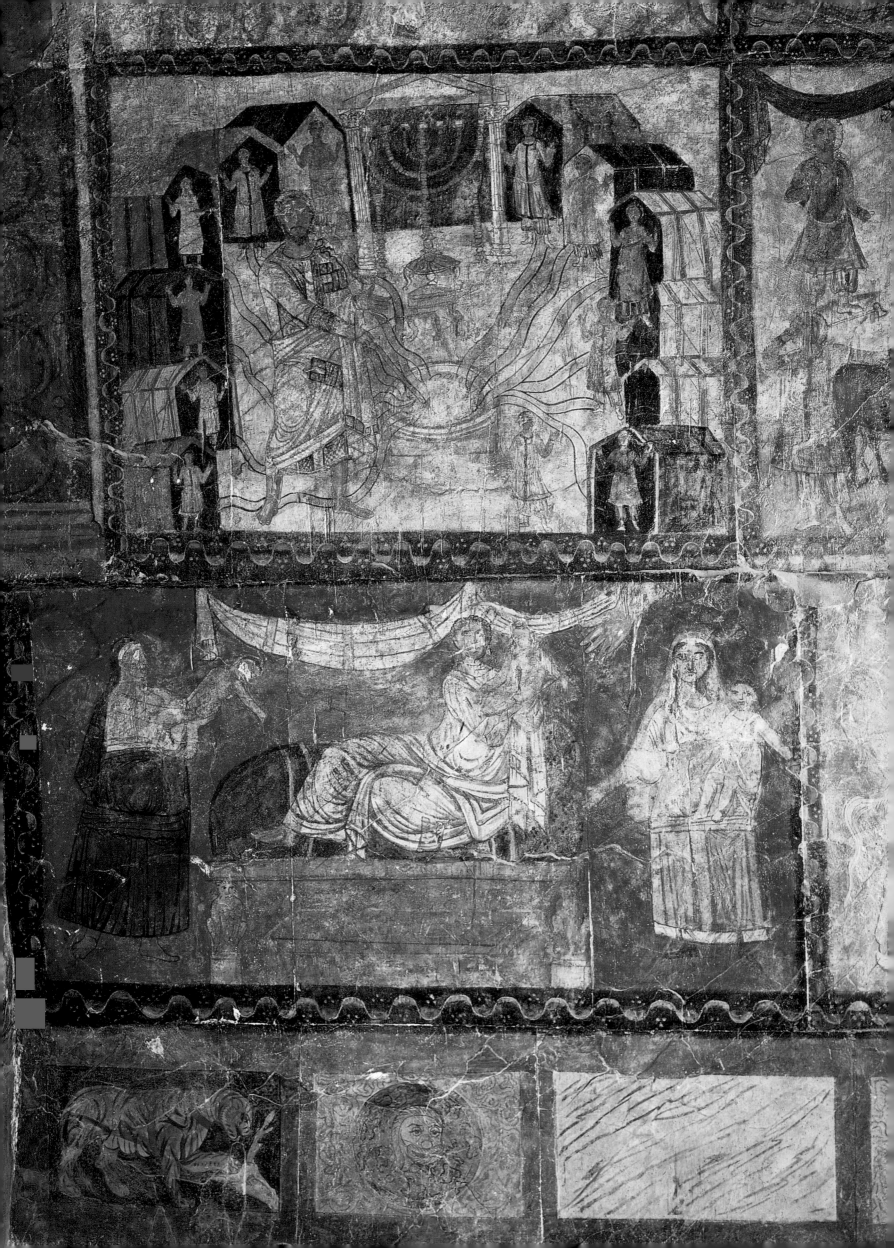

The Origins of Jewish Art
in Antiquity

*You shall not make for yourself a sculptured image, or any
likeness of what is in the heavens above, or on the earth below,
or in the waters under the earth* (EXODUS 20:3–4).

HOW CAN Jewish art exist given the scriptural prohibition against it as expressly stated in the Second Commandment? What response can be given to the persistent challenge to the existence of Jewish art? After all, Jews have been called the people of the Book, with emphasis on the written word, which, it is often assumed, precludes a visual heritage in Jewish life. Yet Jewish art begins with the Bible—the primary source of Jewish culture—through tale and law that reveal the beliefs, values, and practices which have remained integral to living a Jewish life. What has sustained and nourished the Jewish people is the powerful sense of being connected by an unbroken chain to Judaism's ancient roots as revealed in the Hebrew Bible.

To define and understand the role of Jewish art in the Bible is an issue of interpretation, for which it is important to begin at the source and analyze the biblical language.

The Ten Commandments begin with the central tenet of monotheism: "I the Lord am your God who brought you out of the land of Egypt, the house of bondage. You shall have no other gods besides Me." The Second Commandment, with its admonition against graven images, is followed by a warning: "You shall not bow down to them or serve them" (Exodus 20:5). This is clearly intended as a warning to the Israelites that they must not revert to the prevailing practice of idolatry in the ancient world. In a society of idol worshipers, the message was clear, the God of Israel is One.

After the giving of Ten Commandments and the laws (*mishpatim*), the Bible describes Moses's ascent of Mount Sinai to receive the stone tablets and the directive given by God for the place and form of Israelite worship. "And let them make Me a sanctuary that I may dwell among them. Exactly as I show you—the pattern of the Tabernacle and the pattern of all its furnishings—so shall you make it" (Exodus 25:8–9).

Nearly all the remainder of Exodus contains detailed instructions for design and fabrication of a portable sanctuary (*mishkan*) and its appurtenances; for the vestments of the priests (*kohanim*) and of Aaron the High Priest, brother of Moses; and also for the performance of formal ritual to be conducted

(OPPOSITE)

Synagogue Wall Painting. Dura Europos, Syria. 245–256 C.E. Tempera on plaster. National Museum, Damascus. Wall paintings from an ancient synagogue were discovered in 1932 at Dura Europos, a caravan stop on the Euphrates River. Archaeological evidence indicates that Dura was a center for several other religions—Christian, Hellenic, and Persian. Aramaic dedicatory inscriptions date the synagogue to 244–245 C.E. The synagogue was built close to the western city walls, and the paintings were preserved by an effort to strengthen the walls against Sassanian invaders by buttressing them with rubble infill. On the three surviving walls, the paintings are arranged in framed panels in four tiers. The central element of the western wall, which faced toward Jerusalem, is a Torah shrine. The paintings depict biblical episodes and include images based on rabbinic literature interpreting the Bible. The scenes depicted in this detail are the miracle of Moses providing water to the twelve tribes (Exod. 17:1–7) and the prophet Elijah reviving the widow's son (I Kings 17:17–24).

only in this holy place. Most significantly, for a tradition that seemed to prohibit art, there is a tribute to the artisan Bezalel, of whom it is written: "See, I have singled out by name Bezalel, son of Uri, son of Hur, of the tribe of Judah. I have endowed him with a divine spirit of skill, ability, and knowledge in every kind of craft: to make designs for work in gold, silver, and copper, to cut stones for setting and to carve wood—to work in every kind of craft" (Exodus 31:2–6). Nor was Bezalel, whose name in Hebrew means "in the shadow of God," designated to carry out the tremendous task alone. The Bible states that he was assisted by Oholiab and others, "all the skilled persons whom the Lord has endowed with skill and ability to perform expertly all the tasks connected with the service of the sanctuary" (Exodus 36:1).

Within the mishkan was the Tent of Meeting (*ohel mo'ed*), which housed the Ark of the Covenant (*aron haberit*) the chest in which Moses is said to have placed the stone tablets inscribed with the Ten Commandments (*luchot*). Two gilded winged cherubim were at the ends of the ark cover (*kapporet*) and between them is the place where God told Moses, "I will meet with you, and I will impart to you . . . all that I will command you concerning the Israelite people" (Exodus 25:22).

In the tenth century B.C.E., the portable mishkan was replaced when King Solomon built the Temple (the *bet haMikdash*) and centralized Jerusalem as the spiritual and political center. The Ark of the Covenant was placed in the Temple sanctuary designated the Holy of Holies. Only a single object remains from Solomon's Temple, a tiny ivory pomegranate inscribed *Qodeš Kohanim l-beyt [Yahwe]h* (Sacred donation for the priests of [in] the House of Yahweh). The pomegranate was probably a decorative element on a ceremonial scepter used by the priests.

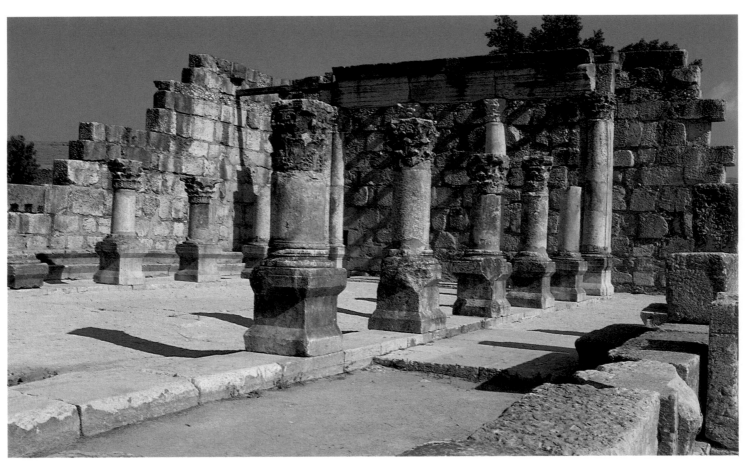

Capernaum Synagogue. Eretz Yisrael. 4th–5th century C.E.. Limestone. 3,240 sq ft. (300 sq m). *Located on the northwest shore of the Sea of Galilee and oriented toward Jerusalem, the synagogue at Capernaum is an example of a Galilean basilica prayer hall. Colonnades along the north, west, and east sides supported a balcony. The Torah shrine was apparently on the southern side between the entrances. The elaborate carvings include palms, acanthus, and other plant forms; geometric motifs, including both five- and six-pointed stars; the remnants of winged figures, later defaced during a period of iconoclasm; and images of the menorah inset on the Corinthian capitals. Along the gallery frieze, the Ark of the Covenant is depicted as a portable Hellenistic temple on wheels.*

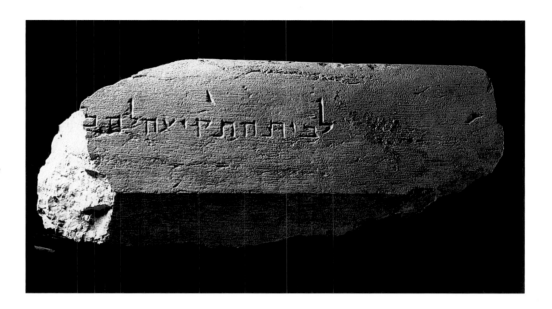

"Place of Trumpeting" Inscription. Jerusalem. 1st century B.C.E. Stone. 12 1/4 X 33 1/8 X 10 1/4 in. (31.1 X 84.1 X 26 cm . Israel Antiquities Authority. Excavations of the Israel Exploration Society and the Hebrew University, Jerusalem. *Discovered during excavations near the Temple mount, this large Hebrew inscription was once part of a huge block of stone that formed part of a parapet of a structure at the southwest corner of the Temple enclosure, one of the few remains of the buildings on the Temple platform.*

In 586 B.C.E. Nebuchadnezzar, King of Babylon, conquered Jerusalem and the Temple was destroyed. During the period of the Babylonian captivity, the exiles, needing to invent an alternative form of worship, began to pray together, to read from the Law, and to resolve communal affairs. The Talmud cites the prophet Ezekiel (11:16) in reference to these places of study and worship: "Although I have removed them far among the nations and have scattered them among the countries, yet I have been to them as a little sanctuary (*mikdash me'at*) in the countries where they have gone." When King Cyrus of Persia conquered Babylonia in 538 B.C.E. he permitted the Judeans to return. Under the leadership of Ezra and Nehemiah, the Temple was rebuilt, and the Second Temple then too became the center of national, communal, and religious life.

In 63 B.C.E. the Romans conquered Israel, and subsequently there was a major "refurbishing" of the Temple by Herod, who became the Roman-appointed ruler in 37 B.C.E. Extensive excavations in Jerusalem have contributed significantly to the understanding of Herod's massive building program in Jerusalem. The streets leading to the Temple, buildings in the Temple courtyard, as well as secular architecture provide valuable insight into the domestic life of the priestly families and aristocracy who lived adjacent to the Temple. Little remains of the buildings that actually stood on the Temple platform; however, a large inscription, which reads "to the place of trumpeting" was discovered. Trumpeting on the shofar, the ram's horn, by the priests proclaimed the start of the Sabbath and holidays.

Chafing under the oppressive Roman rule and unwilling to accommodate to the imposition of Greco-Roman culture, a Jewish revolt began in 66 C.E. Coins are an important resource for understanding the politics of the period. Those minting the coins used symbols and inscriptions to further their cause. The coins from the Siloam Hoard found in a bronze pyxis date to the time of the outbreak of the Jewish revolt. Included is a Jewish shekel proudly dated "Year One" and "Holy Jerusalem," depicting a Temple vessel on one side and a branch with three pomegranates on the other, replacing the previously used images on Tyrian shekels, a head of Heracles and an eagle.

The Romans destroyed the Second Temple in the year 70 C.E. marking a major turning point in the history of the Jewish people. With only fragments of an economic, social, and religious system remaining, the crisis was severe. There was no immediate clear answer or agreement as to how Judaism could be reconstructed. The Temple still retained its status not only as a spiritual center but as a symbol of Jewish nationhood as well. From this critical juncture, Jewish life was to evolve in many lands and to adapt its customs and ceremonies as Jews dispersed and encountered many different societies. Yet even as Jewish life was influenced by the diversity of communities in which Jews lived, there were common bonds and

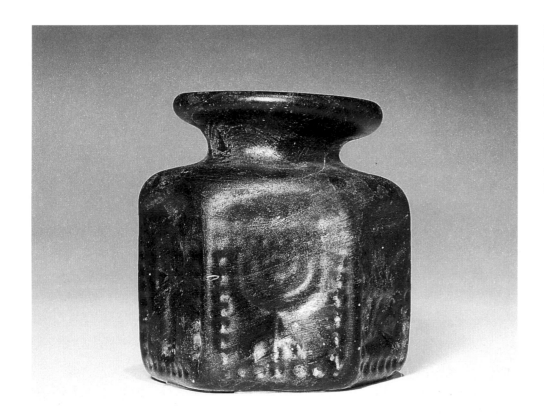

Pilgrim Flask. Eretz Yisrael. 6th–7th century C.E. Glass, mold blown, intaglio decoration. 3 1/8 x 2 7/8 in. (7.9 x 7.3 cm). The Jewish Museum, New York. Benguiat Collection. *This type of flask, hexagonal or octagonal in shape, with Jewish or Christian symbols, was probably used for consecrated oil from the holy places in and around Jerusalem.*

shared symbols. These stories and symbols served as a visual manifestation of the powerful link to the past; in often difficult circumstances, they provided hope for the future, specifically for the messianic age when the Temple would be restored.

While scholars disagree on the origins of the synagogue, aspects of synagogue functions did in fact coexist with Temple worship. With the destruction of the Temple, the synagogue became its spiritual successor. However, there were major differences. Leadership was no longer limited to a hereditary priestly class, and the sacrificial cult was replaced by prayer. In contrast to the Temple, the synagogue as an institution could be established anywhere. God was no longer conceived of as dwelling in a specific place, but just as the Temple housed the chest with the Ten Commandments symbolizing God's covenant, the synagogue ark held the scrolls of the Law, the word of God as preserved in the Bible. The centrality of the new Torah shrine and its importance are evidenced in a unique remnant of an ancient synagogue, a section of a third-century pediment of a synagogue ark from Nabratein in the Upper Galilee region, with lifelike lions carved in high relief astride the gabled roof. It is surmised that a chain for a perpetually burning oil lamp hung from a carved L-shaped hole above the scalloped shell, another link to the biblical Tabernacle (Exodus 27:20; Leviticus 24:1–4).

The synagogue developed to fulfill several purposes and became the central religious and social institution in Jewish life, representing the concept of community (*klal yisrael*) through worship, mutual aid, and legal responsibility. Reference to these functions is found as early as the first century C.E. on a dedicatory stone from the Theodotus synagogue in Jerusalem. These roles are defined as a *bet tefilah* (house of prayer); the *bet knesset* (place of communal assembly), also known as the synagogue, from the Greek word meaning "assembly"; and a *bet midrash* (house of study).

The *bet tefilah* continues the tradition of religious gatherings and ceremonies, celebrating the richness of Jewish spirituality through reading of the Torah, prayer, and observance of the appointed seasons of God (Leviticus 23:1–2).

The *bet knesset* or *bet am* (house of the people) has served multiple functions, not only as a type of community center for Jews living in a particular geographic area but also as a haven for Jewish travelers. The *bet knesset* also served as the seat of the *bet din*, the court which mediates religious matters.

The *bet midrash* represents the significance of ongoing study and interpretation of the Torah as an integral aspect of Jewish life. In the course of the next few centuries, the Talmud, completed in 500 C.E., was compiled by the rabbis and established the standards for the new normative Judaism. The importance of contemporaneous written sources is clear from the tremendous amount learned from the manuscripts comprising the Dead Sea Scrolls, which include all twenty-four books of the Hebrew Bible except Esther, as well as commentaries, community documents, and other religious literature still being studied.

In 324 C.E., Constantine became the first Christian ruler of the Roman Empire and developed a great interest in the Holy Land. Many synagogues were built during the Byzantine period, including the Galilean basilica-type prayer hall at Capernaum, with its elaborate carved stone ornamentation. A number of synagogues have intricate mosaic floors. At the same time, mosaic pavements were found in abundance in churches and secular buildings. At Bet Alpha from the sixth century, there is a well-preserved mosaic floor with several panels. It includes detailed representations of Temple imagery, and has a dedicatory inscription in Greek. But what is most surprising and has been the subject of much study is the central panel with the four seasons in the corners and the signs of the zodiac surrounding Helios the sun god riding his celestial chariot. The Bet Alpha floor also includes a depiction of the *akeda*, the story of the binding of Isaac.

While the synagogue became the locus of the Temple's spiritual legacy, the visual legacy of the Temple

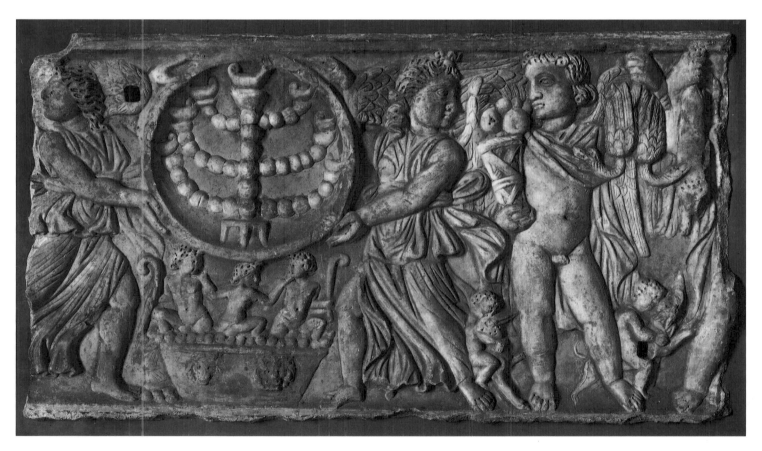

Sarcophagus with Menorah. Rome. Late 3rd century C.E. Marble. 28 3/8 x 49 5/8 in. (72.1 x 126 cm). Museo Nazionale Romano delle Terme, Rome. *Sarcophagi, with seasons and putti representing salvation and eternal life, were available from pagan Roman stonecutting workshops and were personalized with the portrait of the deceased. This section of what was the front of a Four Seasons sarcophagus is decorated instead with a seven-branched menorah. The portrait of the deceased would be carved in the shield held by two winged Victories. Under the menorah, three putti tread grapes in a vat. Of the personifications, only Autumn, a figure carrying a basket of fruit and a pair of geese, remains intact.*

was widespread. In Eretz Yisrael and in communities established in the Diaspora, images of the objects of Temple ritual are found among a range of artifacts from the time of the Temple's destruction onward— the Ark of the Covenant; the seven-branched menorah; the bronze laver; the table of shewbread; and the altar; as well as the shofar and the *lulav* and *etrog*, the palm and the citron.

Implements of Temple ritual are found on objects of daily life which reflect similar cultural and religious trends. Like many pottery lamps, a fifth- or sixth-century bronze oil lamp incorporates a menorah in its design. There are also examples of Roman glass found with Jewish symbols, along with others of the same period with Christian symbols.

An amuletic plaque against the Evil Eye from the fifth century, once inlaid with a mirror, is similar to examples with Christian or pagan motifs primarily found in tombs. Use of these powerful symbols in burials is found in the catacombs of Bet She'arim, where a menorah is carved in relief along the wall. These amulets bears witness to the hope for both personal and national salvation.

Important finds have also been made in Jewish burial sites in Rome, painted on the walls of catacombs. A sarcophagus from the Vigna Randanini catacomb from the third century depicts a menorah in a roundel held by two winged Victories where normally there would be a portrait of the deceased. Also portrayed are images of the seasons, partly lost, and in the basin beneath the shield, three satyrs. As was often the case with Jewish art in later periods, the work was not made by a Jew, but in this instance was purchased from a pagan workshop which made many such sarcophagi. Gold-glass bases of vessels have also been found at burial sites. This custom developed from the Hellenistic tradition of making luxury items of glass decorated with gold leaf. Given their small size, it is extraordinary that they became a veritable compendium of Temple symbols.

Despite the extensive use of Temple imagery and examples of mosaic like the akeda scene at Bet Alpha, few representations of biblical episodes in Jewish art have survived from antiquity. There is but a single extant series of wall paintings from the synagogue of Dura-Europos, a trade city on the Euphrates, dating from about 245 C.E. These remarkably preserved murals with their representations of human figures provide a valuable resource for studying the centrality of biblical interpretation as rabbinic Judaism emerged.

As many of these artifacts have been discovered in the past few decades of archaeological investigation, the interpretation of these finds and their imagery is continuously being reevaluated as the body of available comparative material increases and as the finds are analyzed together with literary sources. As scholars attempt to understand the period after the destruction of the Temple, what is evident is that even at the early stage in the development of artistic expression, characteristic features of Jewish art are apparent. Jewish art typically embraces the local aesthetic in terms of style, and the iconography often synthesizes Jewish symbols with those of the surrounding civilization. Also, the Second Commandment was variously defined in different times and places, sometimes strictly adhered to and in other instances ignored or ingeniously circumvented. These interpretations arose in the context of varying circumstances in the local community, rights granted to Jews, and restrictions placed upon them.

(OPPOSITE)

Pomegranate. 8th century B.C.E. Ivory. Height: 1 11/16 in. (4.3 cm); diameter: 13/16 in. (2.1 cm). The Israel Museum, Jerusalem. *Inscribed "Belonging to the Temple of the Lord, holy to the Priests," this tiny, gracefully carved pomegranate is the only known object attributed to King Solomon's Temple.*

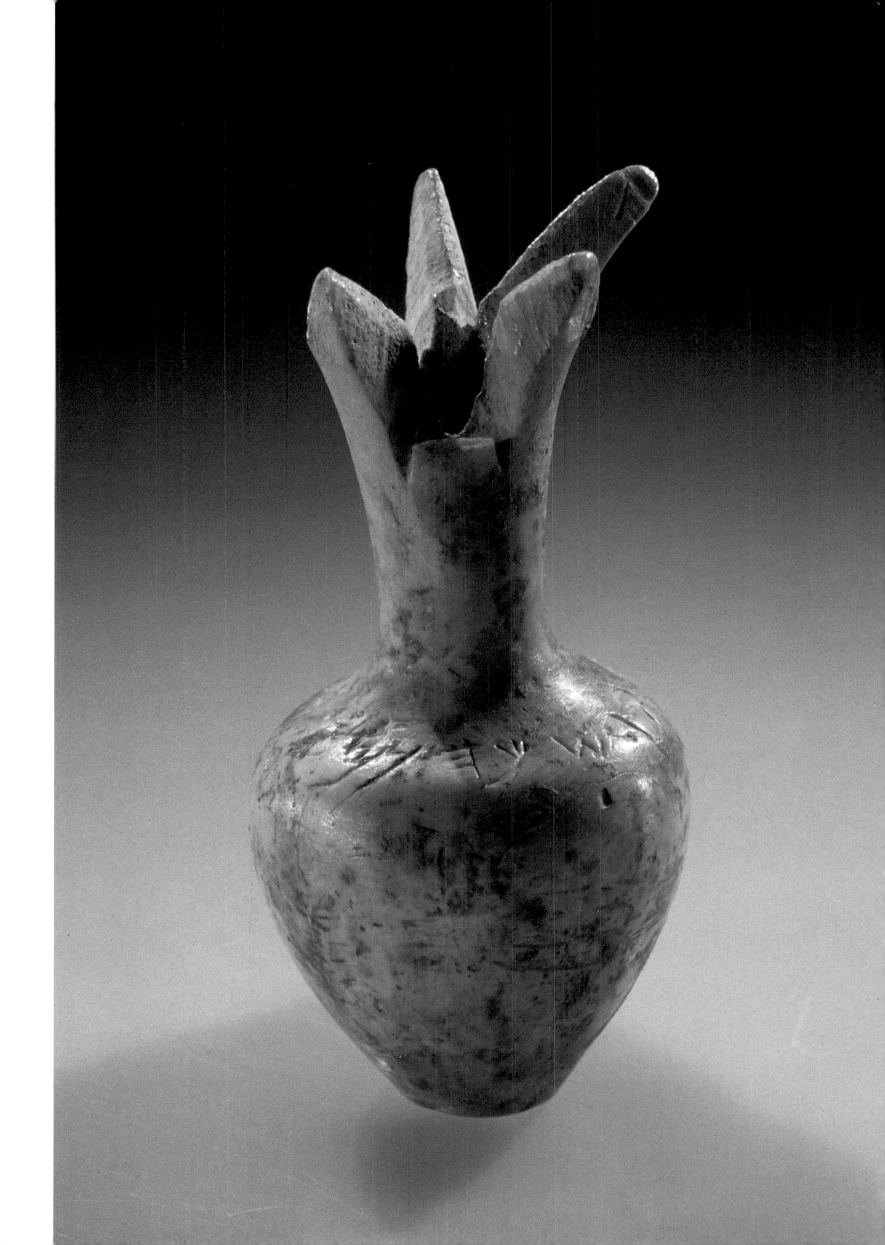

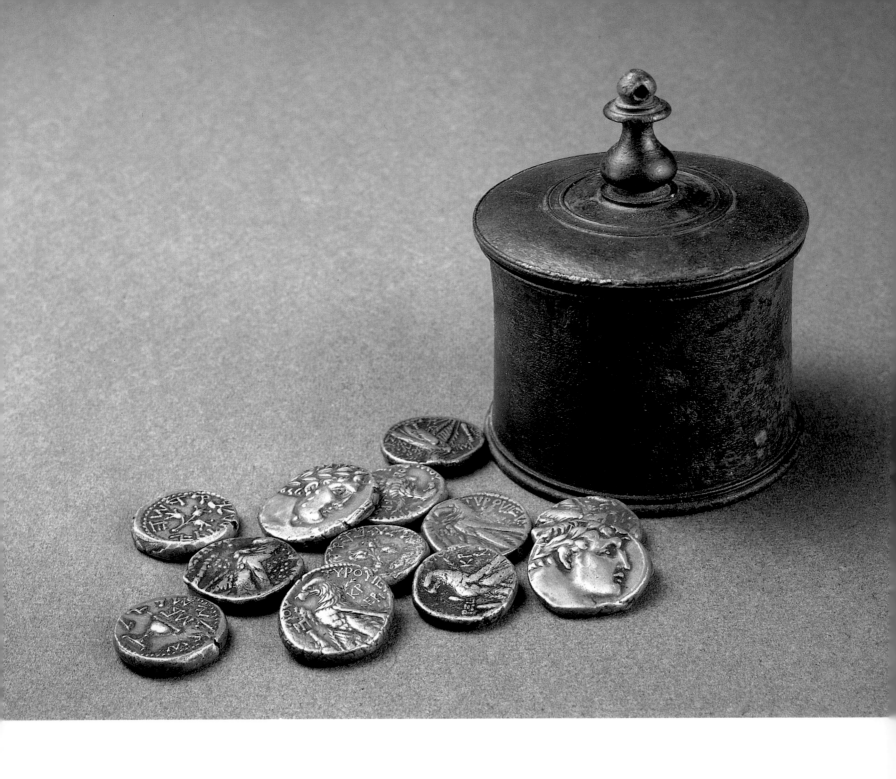

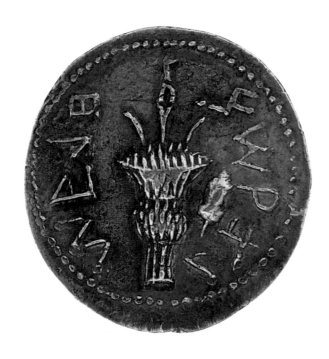

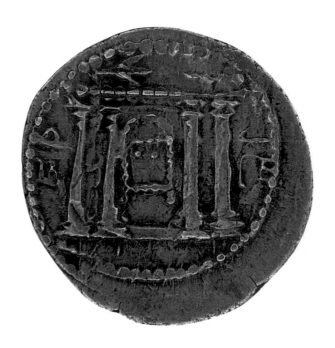

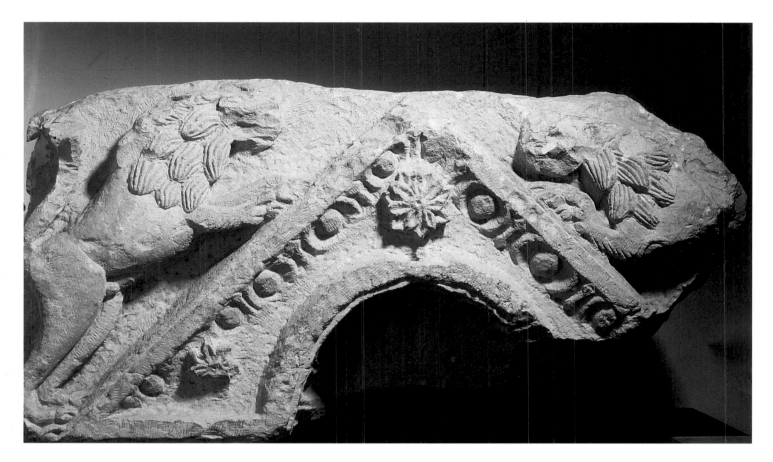

Fragment of a Torah Ark. Nabratein, Eretz Yisrael. Second half of the 3rd century C.E. Limestone. 19 5/8 x 51 1/8 x 19 5/8 in. (49.8 x 129.9 x 49.9 cm). Israel Antiquities Authority. *The Torah shrine has been the central focus of the synagogue since antiquity. This section of a pediment with lifelike lions carved in high relief from a Galilean synagogue at Nabratein is a unique remnant of the period.*

(OPPOSITE, ABOVE)

The Siloam Hoard. Jerusalem. 66–70 C.E. Bronze pyxis and 12 silver coins. Pyxis: Height, 3 1/2 in. (8.9 cm); diameter, 3 in. (7.6 cm). The Israel Museum, Jerusalem. On loan from the Reifenberg Family, Jerusalem. *The origins of this find are unclear. The pyxis with twelve coins came into the possession of Professor A. Reifenberg in Jerusalem about 1950, acquired from a dealer who had already sold other coins from the group. Though no longer actually minted in Tyre, but by the Jewish authorities, Herod, and the High Priest in Jerusalem, "Tyrian shekels," the only money accepted by the Temple in Jerusalem, ceased to be minted at the outbreak of the Jewish war against Rome in 66 C.E. The first Jewish shekel, dated "Year One," then appears. The latest coin in this hoard is a Jewish shekel dated "Year Two."*

(OPPOSITE, BELOW)

Coin (Tetradrachm) from the Second Jewish Revolt. Eretz Israel. 132–135 C.E. Silver. The Israel Museum, Jerusalem. *The three-year revolt led by Bar Kokhba against Rome was a heroic attempt to reestablish Jewish sovereignty in Jerusalem. These were the last Jewish coins ever minted in ancient times. The obverse side of this coin depicts the facade of the Temple and bears the inscription "Shime'on." On the reverse are a lulav and etrog and the inscription "To the freedom of Jerusalem."*

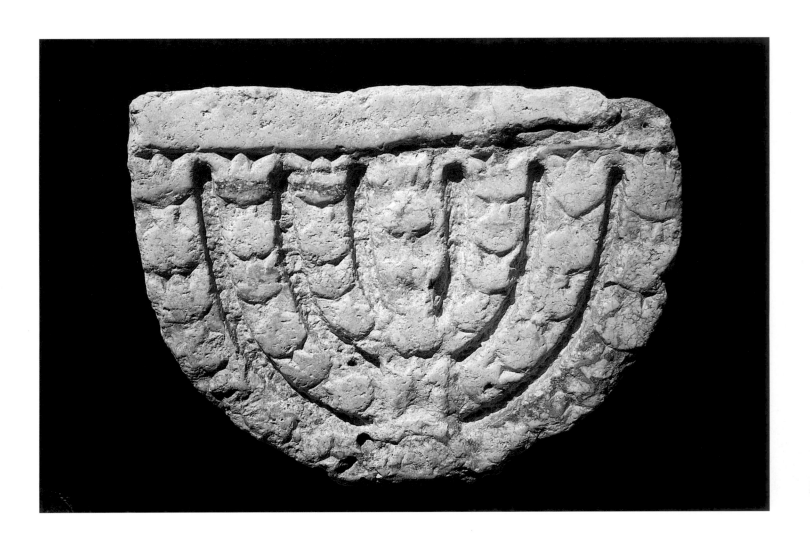

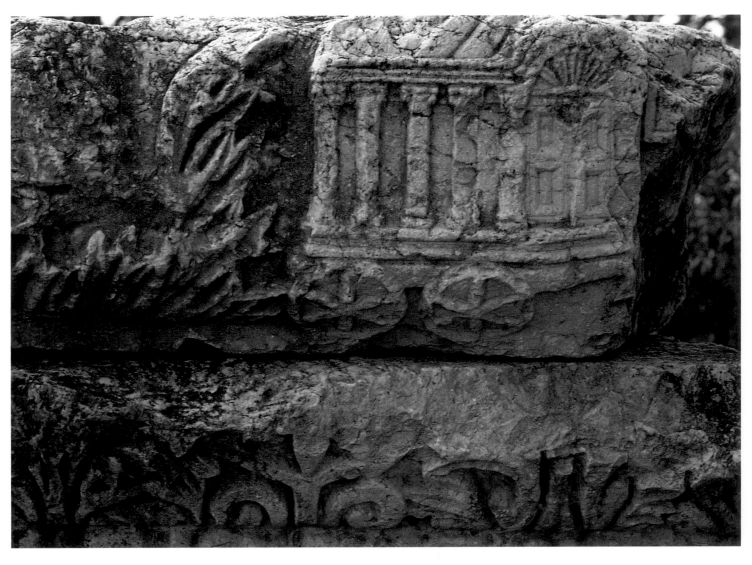

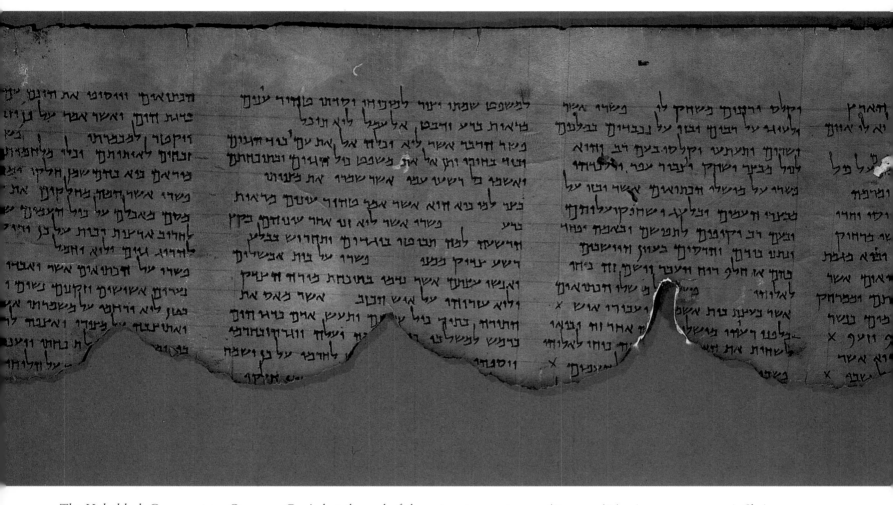

The Habakkuk Commentary. Qumran. Copied at the end of the 1st century B.C.E. 5 3/8 x 55 7/8 in. (13.7 x 141.9 cm). Shrine of the Book, The Israel Museum, Jerusalem. *The Habakkuk scroll was the first commentary to be discovered and is the best preserved of this group. The scroll has survived almost in its entirety. A type of commentary which was a typical literary genre of the Dead Sea sect, the Habakkuk scroll interprets the Bible with reference to the history of the sect, its future, and its leaders and political foes.*

(OPPOSITE, ABOVE)

Synagogue Menorah. Hammat, Tiberias. 4th–5th century C.E. Limestone. Height, 18 1/8 in. (46 cm). The Israel Museum, Jerusalem. *This menorah was found in the excavation of a synagogue in Hammat, by Tiberias in 1921. The carved menorah was apparently not just a decorative element in the synagogue, because at the top of each branch there is a shallow hollow, which it is presumed held ceramic oil lamps or glass beakers. The naturalistic carving of flowers and knops reflects the biblical description of the menorah.*

(OPPOSITE, BELOW)

Capernaum Synagogue. Lintel with the Ark of the Covenant. Eretz Yisrael. 4th–5th century. C.E. Limestone.

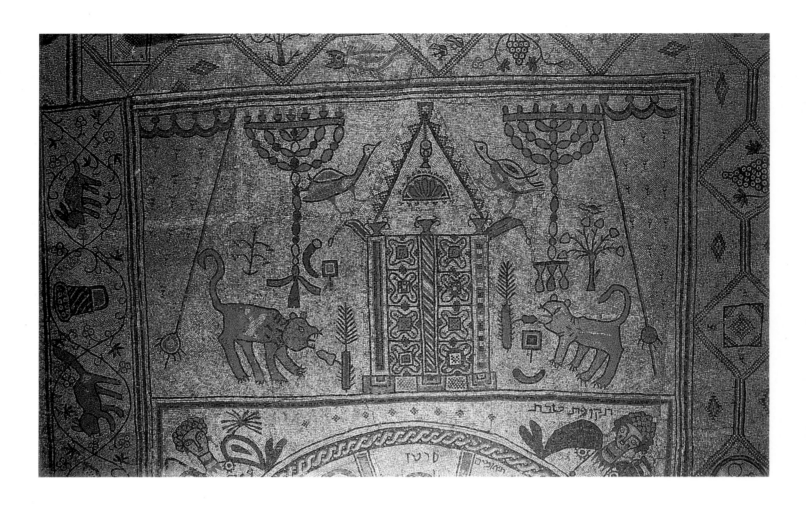

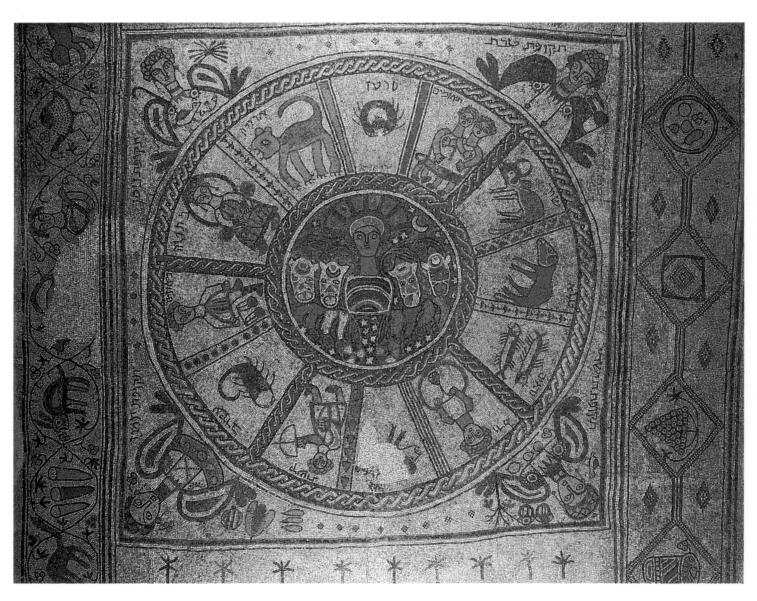

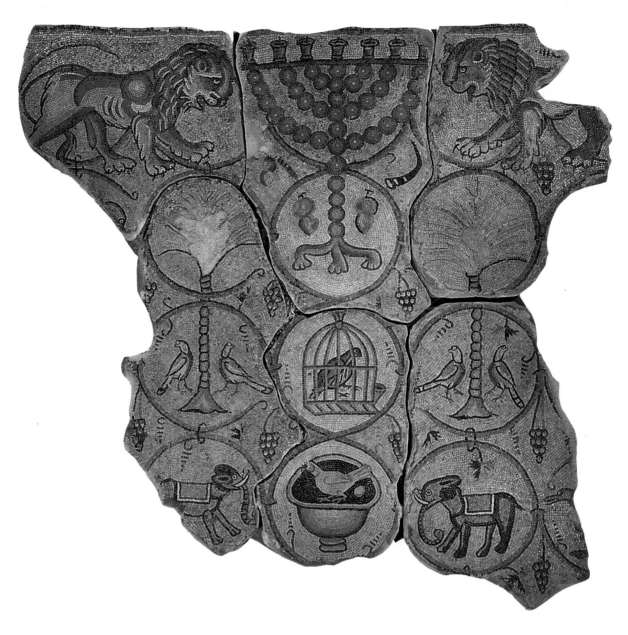

Maon Synagogue Floor. Eretz Yisrael. c. 530 C.E. Mosaic. The Israel Museum, Jerusalem. *The design of the synagogue floor at Maon is a later type of Byzantine mosaic, characterized by the organization of space into a series of medallions. Here the standard symbols of the menorah flanked by lions, a shofar, the lulav represented by palm trees, and an etrog as well as grape vines are accompanied by the unusual images of a caged bird, a hen laying an egg, and a pair of elephants. While elephants are not native to Eretz Israel or its environs, the Bible makes mention of ivory imported from the East, and elephants are described in the Book of Maccabees as being used by the Syrian Greeks against the Jewish fighters. These elephants are shown with saddles, indicating that they were domesticated.*

(OPPOSITE, ABOVE AND BELOW)

Bet Alpha Synagogue Floor. Eretz Yisrael. 6th century C.E.. Mosaic. *The best-preserved synagogue floor with a tripartite composition, Bet Alpha is also significant because the artist is identified. An inscription states that Marianos and his son Hanina made this floor during the reign of Emperor Justinian (518–527). The liberal approach to making art at the time is evidenced by the elaborate iconographic program and the use of the human figure. The mosaic includes a depiction of the binding of Isaac, the zodiac cycle, and an iconographic program with the Ark of the Covenant and Temple implements.*

31

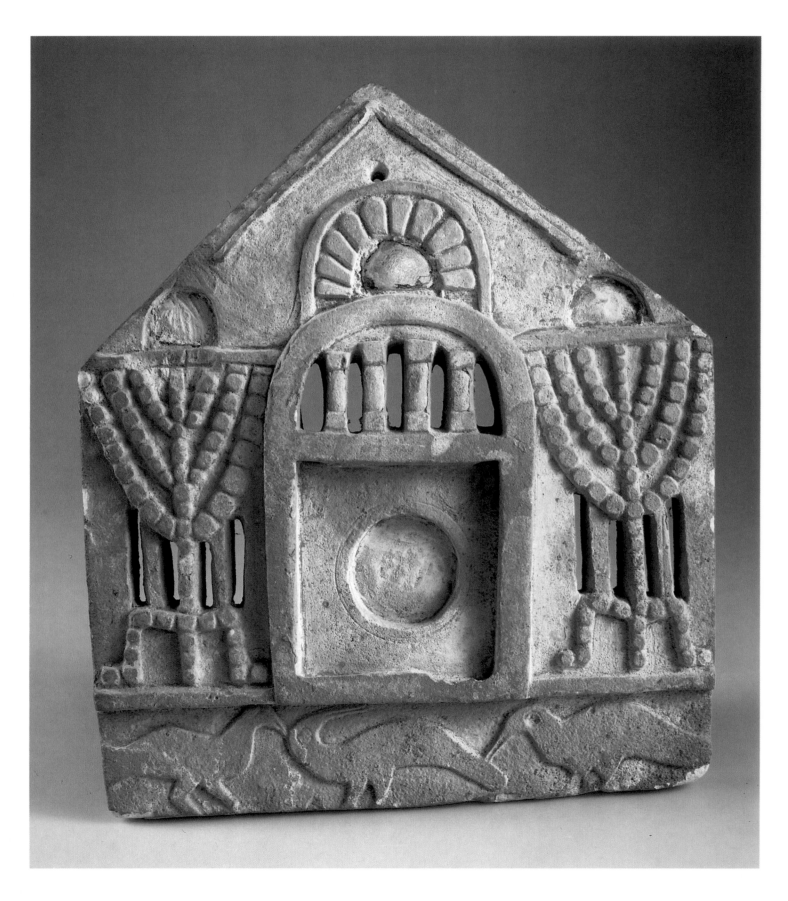

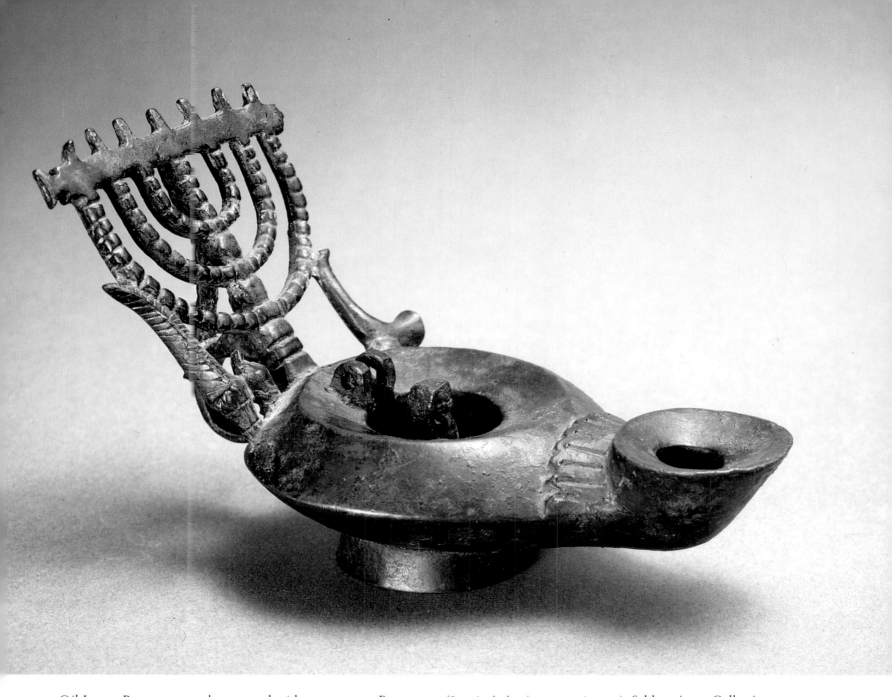

Oil Lamp. Provenance unknown. 5th–6th century C.E. Bronze. 4 3/8 x 6 1/2 in. (11.1 x 16.5 cm). Schloessinger Collection, Institute of Archaeology, The Hebrew University, Jerusalem. *While most oil lamps are pottery, a few bronze lamps have survived. Cast in a single piece, this lamp is the only known example of its kind. Since the lamp is bronze, it was possible to cast the symbols of the menorah, lulav, and etrog so that they appear prominently three-dimensional.*

(OPPOSITE)

Plaque Against the Evil Eye. Provenance unknown. 5th century C.E. Limestone. 12 3/8 x 10 7/8 in. (31.4 x 27.6 cm). Collection of the Institute of Archaeology, The Hebrew University, Jerusalem. *A number of stone and clay plaques inlaid with mirrors have been found, mostly in tombs. The identity of the owners is surmised from the use of Jewish, Christian, or pagan symbols. The gabled architectural design of this plaque, with its shrinelike central element flanked by menorahs, is yet another reference to the Temple in Jerusalem. The meaning of the three birds along the base is unknown. It has been suggested that the birds embody personal salvation just as the other symbols refer to national salvation.*

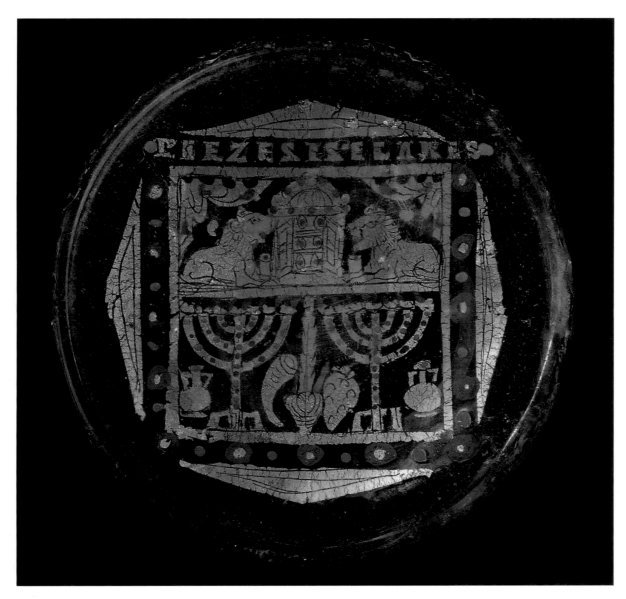

Gold-Glass Base of Vessel. Roman catacombs. 4th century C.E. Glass and gold leaf. Height, 3/8 in. (1 cm); diameter, 3 7/8 in. (9.8 cm). The Israel Museum, Jerusalem. Gift of Jakob Michael in memory of his wife Erna Sondheimer-Michael. *Found in catacombs in Rome, the gold-glass bases were perhaps used to identify those entombed there. The bases were made by incising the design in gold leaf on one disk and then encasing it by blowing a glass bubble above. In a concise, compact format, the design includes motifs commemorating the Temple and its ceremonies, including the menorah, shofar, lulav, and etrog. The biblical Ark of the Covenant, in the upper register, with open doors revealing three shelves of scrolls, is likely a reference to contemporary synagogues.*

(OPPOSITE)

Bet She'arim Catacomb. Eretz Yisrael. 3rd century C.E. Carved stone. *Bet She'arim was founded, probably by the Hasmonean kings, sometime after 161 B.C.E. in the Galilee and remained a Jewish agricultural community even under Roman rule. The population increased significantly after the Bar Kokhba revolt. Among those settling there were many leaders and scholars, and according to the Talmud, it became the seat of the Sanhedrin, the council and tribunal of the Jews. Because Rabbi Judah HaNasi, the redactor of the Mishna, was interred at Bet She'arim, it became a favored burial site. There are many symbolic carvings at Bet She'arim. This relief of a man supporting a menorah on his head is found at the entrance of a passageway leading into one of the rooms of the extensive catacombs.*

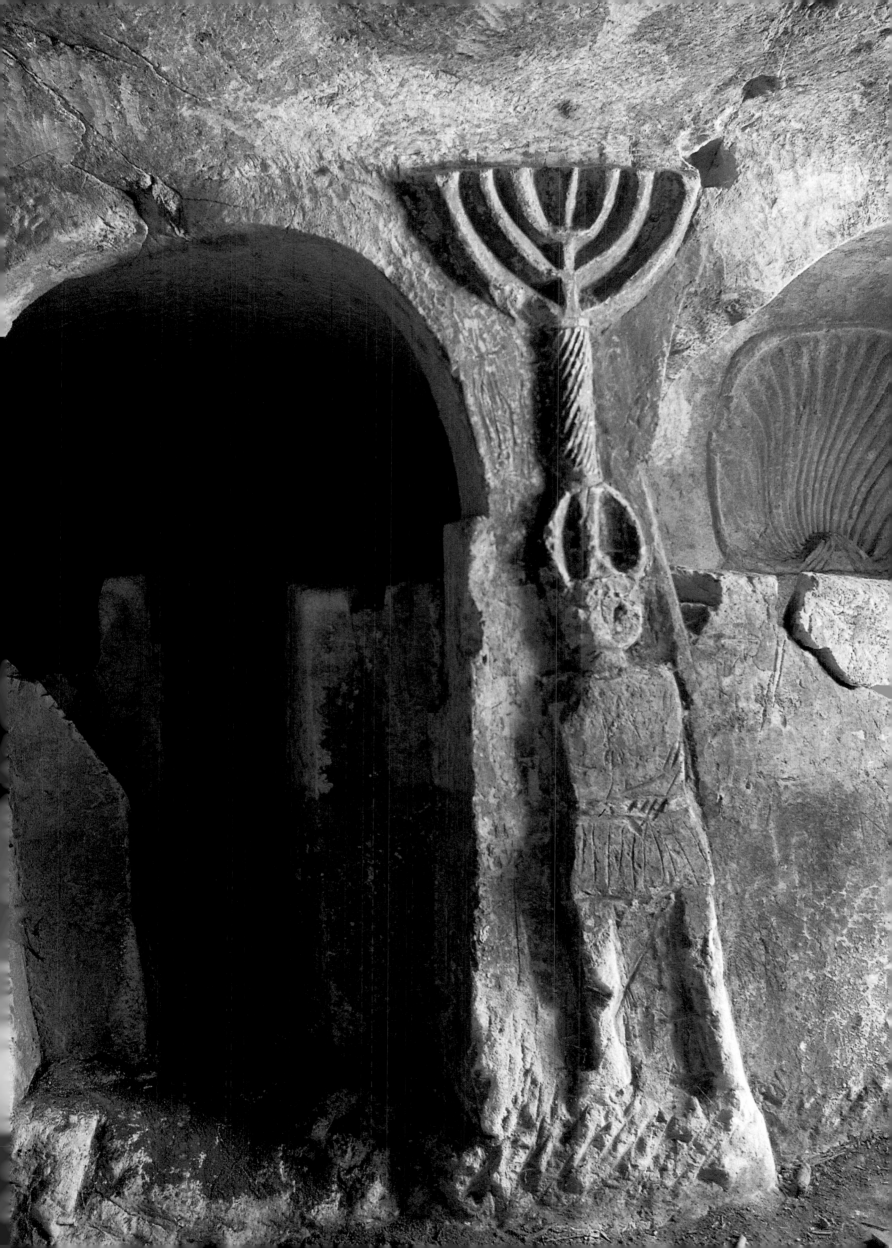

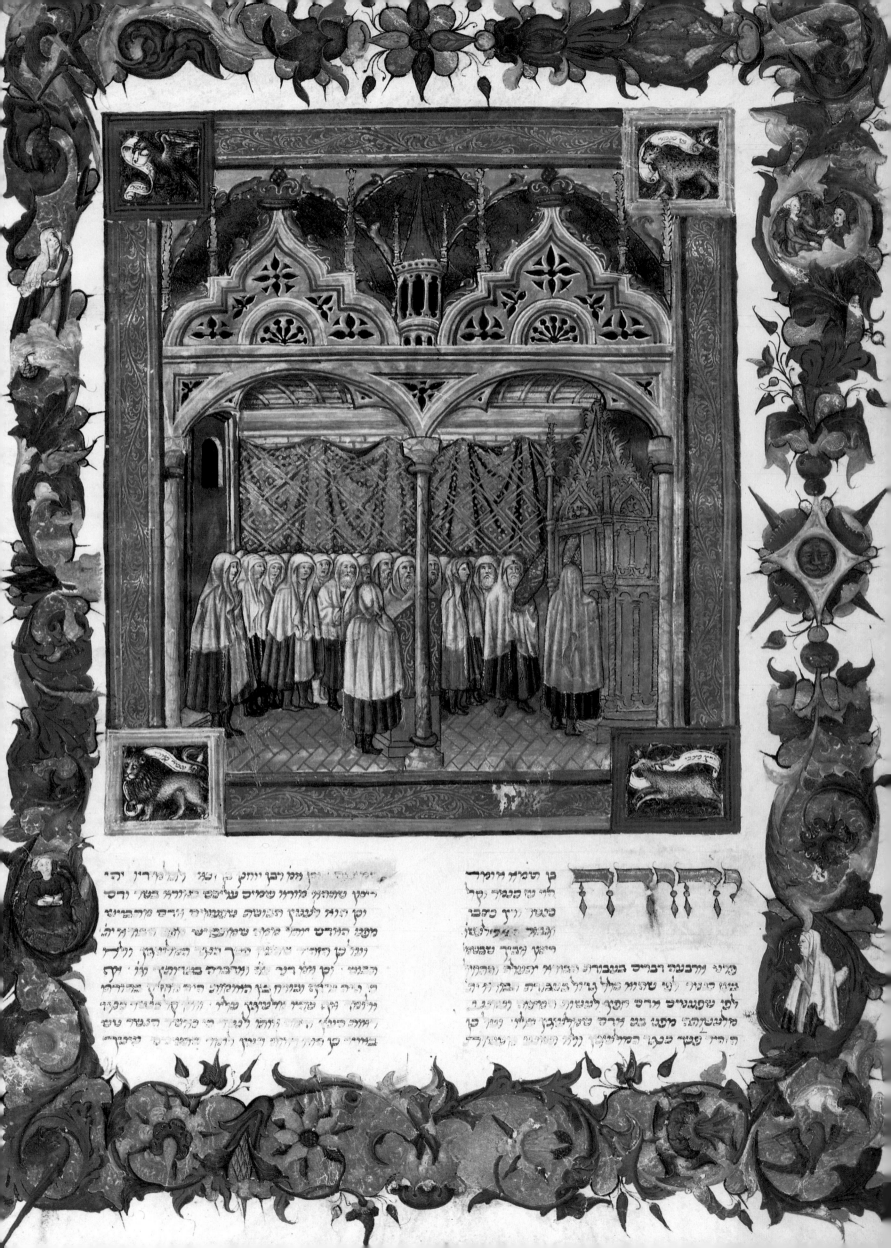

כהנים ולוים וכל ישראל נתחברו ובאו אל הלשכה לשמע תורת ה'.

מרבעה רבעים בנבורה הכמו הוא ישפחה ונפלה
את הימי לוי שמור סול נדול בנבורה והלו לוים
לכי שספניש ארש ההץ לנשוף וראשי וספכב
קלשתהנג מתנן נען מרה שעליהן בעלי ומר קן
היהי פטר כהן המילין ולא הפורעה ישחוא

יורה ומורה
היות קנדי סל
פנד וחן קרכי
אנסל ואליוקן
האן נהן שלטן

יאמרש ורק ישחק של יאנל לבורין ידי
ריסן שהאו מורעו שמיש עליהש בוורא הסי ורסי
יסך הוא לשניו חבוטה שהנונוים ורכם ברבוינט
מקנ הורט יהל שמה שורבנויש ולהם המומיל
וווס קן פסהיר שלטן דיך הנר המלטדוהן ילד
הבנוי לקן תסי דיר של ומרברה בטרוטן וני וף
ה. הוד הדינ ותויר בן המלמה הוה מלוחי הלוחד
ורקומן קן שעדי אמניטוןן פעלי מוך קר לנטוד עפך
ומזל היסל. שיי ברויקה וחיוי לבוד קי בהנור הנגר תש
שוירה קן בנ הרוקה ולוון רומל הסש כשהבוים

Hebrew Illuminated Manuscripts: Portraying Medieval Jewish Life

Make thy books thy companions, Let thy cases and shelves be thy pleasure grounds and gardens. Judah Ibn Tibbon (c. 1120–1190).

THOUGH SEVERAL medieval synagogues survive and recent research has uncovered other remnants of Jewish life in the Middle Ages, manuscripts, in Hebrew and Aramaic and Judeo languages such as Ladino (Judeo-Spanish), are the primary material legacy of Jewish experience for five hundred years, from the tenth century to the advent of Hebrew printing in the late fifteenth century. Interestingly, the tradition of manuscript writing persisted well after this time and even had a renaissance in central Europe in the eighteenth century, notably for private commissions such as the haggadah text for the Passover seder. A broad range of manuscripts has been preserved: Bibles and biblical commentary; rabbinic literature; liturgical books; poetry; folk tales; texts on mysticism, philosophy, and grammar; and secular volumes. These manuscripts provide a rich resource for learning about the development of Judaic scholarship, customs, and ceremonies in different communities and even about secular aspects of Jewish life. Providing a vital visual dimension to this understanding are Hebrew illuminated manuscripts.

The earliest known dated Hebrew manuscript fragments, including a decorated Book of Prophets, found in the Cairo *genizah* (hidden place), were written in the ninth century. These fragments were saved because of the prohibition against destroying any text with the divine name, and thus these writings were kept in a special area in the synagogue, called the *genizah*. Although the Cairo genizah had been identified in the eighteenth century, the legend of disaster befalling anyone who disturbed the sacred pages discouraged their removal. However, in 1896, Solomon Schechter was permitted to take about half of the two hundred thousand fragments to Cambridge, England, to begin research.

The commissioning of Hebrew illuminated manuscripts, which became common in the thirteenth century, followed the changed pattern in the production of Christian manuscripts. Until the rise of the universities and the new middle class in the twelfth century, most manuscripts were produced for the church and royalty in monastic scriptoria or writing shops. Although the scriptoria survived, it became the practice for wealthy individuals to commission illustrated manuscripts from lay guilds. By the time luxurious

(OPPOSITE)

ISAAC BEN OBADIAH (SCRIBE). *Vatican Arba'ah Turim.* Mantua. 1435. Parchment. 13 1/8 x 9 1/8 in. (33.3 x 23.2 cm). Cod. Rossiana, Ms. 555, fol 12v. Biblioteca Apostolica Vaticana. Vatican City. *The Arba'ah Turim is a legal code written by German-born Jacob ben Asher, who lived in Toledo, Spain, during the fourteenth century. This magnificently illuminated manuscript from Renaissance Italy, when the art of the miniature was at its peak, was written for Rabbi Mordecai ben Avigdor. Each of the four sections of the book begins with an illustration. Depicted here is the interior of a fifteenth-century Italian synagogue, the illumination for the first section,* Orah Ḥayyim (The Path of Life), *which deals with prayer, ritual, the Sabbath, and holidays. The Torah scroll is about to be returned to the Ark. The image is within a frame. In the corners are the animals referred to in the* Ethics of the Fathers 5:23: *"Be strong as the leopard and swift as the eagle, fleet as the gazelle and brave as the lion to do the will of your Father who is in heaven." The other border of vine scrolls contains a wealth of wonderful images, including figures, assorted flowers and even a fire-breathing dragon.*

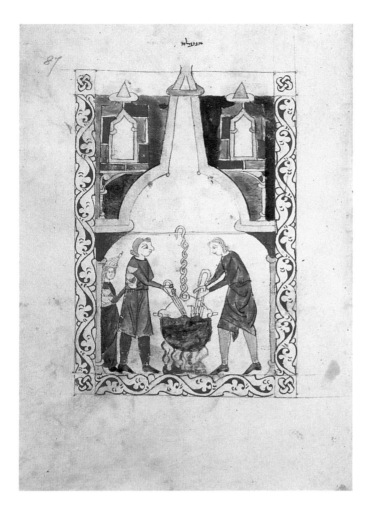

Cleaning the Utensils for Passover. From *the Hispano-Moresque Haggadah.* Castile, Spain. Late 13th–early 14th century. Vellum. 6 3/8 x 4 7/8 in. (16.2 x 12.4 cm). Ms. Or. 2737, fol 87r. The British Library, London. *Illustrated here is the ritual cleaning of utensils prior to Passover. The objects are brought to the communal cauldron, held by a chain over a burning fire, and dipped in boiling water. A woman is shown bringing cups and bowls to the two men who will immerse them in the water and then remove them with tongs.*

Hebrew illuminated manuscripts came to be commissioned, farflung Disapora communities were already well-established.

The two dominant cultural traditions that emerged were the Ashkenazi, from the medieval Hebrew name for Germany, later to include Jews from central and eastern Europe, and the Sephardi, from the Hebrew name for Spain, and later their descendants, who settled in many different communities after the expulsion from Spain in 1492. Italy, where Jewish life can be traced back to the second century B.C.E., also had distinctive customs and a rite of its own that would later exist side by side with those traditions of Jews who migrated there from other communities. The term *Edot Mizrach* is used to describe the many oriental or eastern communities where Jews settled, each of which developed a rich local tradition of observance.

There is a gap of nearly a millennium in our knowledge of the development of Hebrew script between the period of the Dead Sea Scrolls and the earliest dated genizah fragment from the ninth century. It is immediately evident from these earliest manuscripts that characteristic styles of Hebrew script developed in different communities. What does remain distinctive is the *k'tav meruba*, the square script used for the Torah scroll, which has only slight regional variations. One important difference is the diversity of writing implements used, resulting in distinct types of strokes. The Sephardim and the majority of scribes in most oriental communities used reed pens, which were more rigid and formed more regular strokes. An example of oriental script, with horizontal and vertical strokes of the same width, is found in a manuscript with the single biblical section of *Shelah Lekha* (Numbers 13–15) written in Egypt in 1106–07. The decoration of this manuscript resembles examples of the Koran, sacred Muslim writings, of the same period. Ashkenazi scribes used quill pens, which were more flexible and produced strokes that varied in width, as seen in the large-format *Mahzor* (prayer book with the festival liturgy) from southern Germany dated 1345.

The Hebrew letter has also undergone unusual transformation for use in manuscript decoration. Many manuscripts employ micrography, writing in minuscule script. Micrography has its roots in antiq-

uity, in the tradition of using the written word itself as ornamentation. Micrograms can be incredibly elaborate, sometimes incorporating entire books of the Bible or all of the Psalms. The imagery ranges from simple geometric motifs to complicated scenes.

The tradition of the carpet page originated in Spanish Bibles and was used as the decorative page preceding each division of the Bible. A carpet page from the *Burgos Bible,* dated 1260, is an example of micrographic design comprised purely of foliate scrolls and geometric interlacings. Much more complex is an ornate architectural setting, influenced by cathedral design and replete with grotesque animals and birds, found on a late thirteenth-century Pentateuch from Bavaria.

Another characteristic feature of Hebrew manuscript illustration derives from the absence of capital letters in Hebrew. The unique practice of emphasizing the initial word is found in the *Duke of Sussex Pentateuch,* which has elaborate full-page decorations at the beginning of each of the five books. Hebrew letters are also sometimes zoomorphic in form, constructed of grotesque creatures, such as the elaborate colophon, where pertinent information on the production of the publication is made, identifying Joseph

King and Seer. Mesha' ha-Kadmoni (The Ancient Proverb). Southern Germany. 1450. Watercolor on paper. 10 5/8 x 6 5/8 in. (27 x 16.8 cm). Ms. Opp. 154, fols 44v–45r. Bodleian Library, Oxford. *This is one of the earliest manuscripts of a collection of fables in rhyme based on I Samuel 24:14, written by Isaac ben Solomon ibn Abi Sahulah, a physician and Hebrew author who lived in Spain in the thirteenth century. His motivation to write the book was his concern that Jews were too preoccupied with reading Greek philosophy and Arabic texts, and he wanted to give those readers a collection of fables and aphorisms from the Jewish tradition.*

ha-Zarefati as the artist of the *Cervera Bible*. From early fourteenth-century Spain, this manuscript is best known for the very beautiful, lyrical miniature illustrating the vision of the prophet Zachariah (4:11–14). A pair of olive trees, symbolic of the priestly and kingly lineage, envelops the menorah and provides oil lamps which kindle it.

The preciousness of the manuscripts is reflected in the arduous steps that it took to create them and in the costly materials used in their manufacture. The scribe was the overall supervisor of the making of the manuscript. His responsibilities began with selecting sheets of the very finest parchment or paper, of the proper height but double the width desired. The sheets were then carefully folded in half, making a bifolio with two leaves, or four pages. The front surface of the manuscript leaf on the right side of a two-page opening is called the recto; the back is referred to as the verso. Several of the bifolios are then stitched together in the center, making a quire. In Hebrew manuscripts, the number of sheets per quire varies; usually there are four or five, sometimes as many as fourteen, but typically a consistent number is used within a manuscript.

The next task was to lay out the page, a critical step since the illuminations were added after the text was copied. Before the scribe could begin writing, the physical space was organized by making prickings in one or both margins, and then the page was ruled by drawing horizontal lines. Finally, the parchment was ready for the scribe to write out the text. Hebrew script has no representations of vowels; if these were to be included, they were then added by the vocalizer. Then the manuscript was given to the illuminator. In most cases, with some notable exceptions, a separate individual did the artwork, although the scribe often decorated the initial-word panel. The artist first drew the image on the page. A major feature of many illuminated manuscripts is the use of gold leaf, and this was applied next. The designated areas were covered with a mixture of gesso and clay, called bole, to form a raised surface for the gold. A variety of specially prepared pigments were used to complete the painting of the miniatures. Lastly, the finished manuscript was bound by a bookbinder.

There is no unique style which developed in the illustration of Hebrew manuscripts; rather, the manuscripts reflect the illuminations of regional schools in the places where Jews settled. Perhaps more surprising is that local attitudes and standards influenced the Jewish approach to using representational images; more so, it seems, than the biblical restriction concerning graven images. In Islamic countries, where the Koran prohibits all use of human figures, Hebrew manuscript illuminations likewise avoid anthropomorphic forms. In a Pentateuch from San'a, Yemen, dated 1469, within a field of arabesques, a central circular motif—five pairs of intertwining fish encircling a six-pointed rosette—is clasped by twin mountain-like shapes made of fish-scale motifs at the top and bottom. The design reflects the artistic influence of oriental Mamluk metalwork.

In the Ashkenazi community in southern Germany there was also opposition to the use of figures, but there is no apparent consistent prohibition. It was the opinion of Rabbi Meir ben Barukh of Rothenberg (1215?–1293) (*Tosafot* to Babylonian Talmud, Yoma 54b) that illustrations should not be allowed in prayer books because they might distract the worshiper. In the thirteenth and fourteenth centuries, distorted and rather strange, animal-headed figures appear in such Ashkenazi Hebrew manuscript illuminations as the *Bird's Head Haggadah*. Yet in some manuscripts, no such images are found.

In fifteenth-century Spain the climate was such that the scholar Profiat Duran declared:

> *The contemplation and study of pleasing forms, beautiful images, and drawing broadens and stimulates the mind and strengthens its facilities. . . . As God, who wanted to beautify His holy place with gold, silver, jewels and precious stones, so it should be with His holy books* (Ma'ase Efod, 19).

In Italy artists were influenced by the tradition of illustration in Latin and Greek manuscripts, where representational art was the norm, and Hebrew manuscripts made extensive use of such imagery. The title page of Proverbs from the *Sifrei Emet* from Florence, dated 1467, includes a cartouche with a miniature depicting the Judgment of Solomon and has a lavish border with a series of elements which spring forth from an urn at the corner of the page. The components include foliate motifs, a stag, and a pair of putti, each lifting an arm toward a peacock at the top corner of the page. The richness of the border is embellished by circlets of gold that echo the form of the peacock's feathers. It should be noted that in Italy not only were many Hebrew manuscripts illuminated by Christian artisans, but there are also instances of Hebrew manuscripts being made for Christian Humanists. Such is the case of a fifteenth-century Psalter with scenes from the life of David, where the image of God is depicted in three of the miniatures. Various examples, beginning in antiquity, make it clear that except for an occasional oblique portrayal, such as a hand of God, the Second Commandment clearly meant that portraying God in any anthropomorphic fashion was not acceptable in Jewish contexts.

Certainly nowhere is the issue of "graven images" as perplexing as in the illumination of Bibles. And yet, a rich heritage of Bibles has been preserved. As with the artifacts made in the aftermath of the destruction of the Temple, the primary subject matter used in illustrating Bibles is the symbolic imagery associated with the Temple and the illustration of biblical stories. Indeed, in Spain, beginning in the fourteenth century, it became customary to refer to the Bible as *mikdashyah*, the sanctuary of God. The earliest example of what would become a prevalent iconographic tradition appears in the inscription framing the detailing of the sanctuary vessels in a Spanish Bible from Perpignan, Aragon, dated 1299. The implements depicted were used in the Temple, and they represent the ongoing hope for the coming of the Messiah and the rebuilding of the Temple "speedily and in our days." As is typical, the images reflect regional styles, such as the Gothic portrayal of Aaron lighting the menorah and the childlike cherubim hovering above

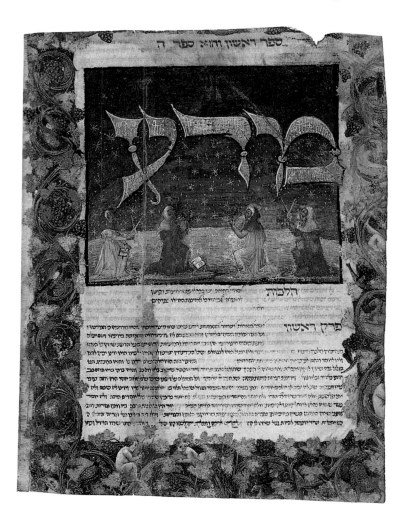

Mishnah Torah. Lombardy. Late 15th century. Vellum. 9 x 6 7/8 in. (22.9 x 17.5 cm). Cod. Rossiana, Ms. 498, fol 13. Biblioteca Apostolica Vaticana, Vatican City. *The scene with the Hebrew word* ma'dah *(science) depicts Jewish astronomers looking up to the heavens on a beautiful, starry night and using astrolabes and compasses to make their calculations.*

the Ark of the Covenant in the *British Museum Miscellany*, a thirteenth-century manuscript from northern France.

Biblical subjects, such as the synagogue wall paintings from Dura-Europos, reflect the ongoing theological interpretation of the biblical message. The frontispiece to the *Schocken Bible* from southern Germany, dated around 1300, that begins with the initial word *bere'shit*, "in the beginning," includes forty-six medallions with illustrations of Bible stories, from Adam and Eve to Balaam and the angel in the book of Deuteronomy. The pattern of the medallions is reminiscent of stained-glass church windows. Biblical stories are not only subject to the stylistic interpolation of the individual artist but, significantly, also include depictions of the *aggadah* and *midrash*, from rabbinic legends and religious writings, stories which further expound on the biblical text.

Given the dearth of ceremonial objects that have survived from medieval times and a very limited number of securely dated artifacts prior to the sixteenth century, Hebrew illuminated manuscripts afford a unique look at contemporary life. To be sure, a fuller understanding of the imagery is gained when the manuscripts are studied both in tandem with literary sources and in the context of the period and place in which they were made. A magnificent example from the Renaissance is Maimonides's fifteenth-century *Mishnah Torah* from northern Italy. Each book begins with a miniature. The bold, sculptural quality of lettering follows similar designs of Christian manuscripts. Moreover, an illustration of a text about the love of God depicts a jousting scene, perhaps relating to courtly love epitomized by knighthood. The illustrations provide a tangible record of aspects of communal life. Images in the fifteenth-century *Arba'ah Turim* from Lombardy include depictions of a synagogue interior with worshipers at prayer, the Jewish court, and a wedding ceremony. Shared community resources such as the ritual bath, kitchen, and bakery are illustrated in a fourteenth-century Spanish manuscript in the British Library. Based on assumptions from more contemporary experience, some of these illustrations provide surprises. A synagogue scene in the *Barcelona Haggadah*, dating to the fourteenth century, shows the *ḥazzan* (reader) holding aloft a Torah case with both men *and* women present together.

Similarly, it is possible to glean information about domestic life—what home interiors looked like, what people wore, even what tableware they used. Also illustrated are various occupations, including Jewish involvement in certain secular professions such as astronomy and medicine. A manuscript from Barcelona dated 1348 of Maimonides's *Moreh Nevukhim (Guide for the Perplexed)* depicts an astronomer holding an astrolabe. An Italian fifteenth-century manuscript with a Hebrew translation of Avicenna's *Canon of Medicine* depicts a physician with his patients.

Given the nature of the Jewish experience, it is ironically fitting that Jews should have been cartographers. One of the most sumptuous maps known from the Middle Ages is from the *Catalan Atlas*, believed by scholars to be the work of Abraham Cresques, a well-documented Majorcan cartographer. Dated 1375, the map was meant to be a complete "picture" of the world at that time; in fact, it was not suited for navigational purposes but only satisfied the curiosity of its owner.

All these examples from the medieval period reinforce the essence of the study of Jewish art: for a fuller understanding, it is critical to evaluate the subject matter and the aesthetics of the work from a perspective which not only addresses the religious aspect of the Jewish experience, but treats all facets of Jewish life as a minority within a variety of majority cultures. At the core of the matter is what choices Jews could and did make in adapting to the larger society. This pattern was to remain the norm in Jewish cultural expression until contemporary times.

Shelaḥ Lekha. Egypt. 1106–07. Parchment. Ms. Heb. 8° 2238, fols 3v–4r. The Jewish National and University Library, Jerusalem. *This manuscript contains only the weekly Torah reaaing wtih the text of Numbers 13–15. Manuscripts with only a single Torah portion are rare but not unknown.*

Maḥzor. Southern Germany. Dated 5106 (1345).
Parchment. 19 x 13 5/8 in. (48.3 x 34.6 cm). Vat.
ebr. 438, fol 107v. Biblioteca Apostolica Vaticana,
Vatican City. *Beginning in the mid-thirteenth century
in Germany, it became the practice to use large-format
illuminated prayer books in the synagogue for public
use. Animals, birds, and human figures are illustrated
in the manuscripts. Often, fantastic beasts and
grotesqueries are found within the letters, as they
are here in the initial-word panels. This page is the
opening of the morning liturgy for Yom Kippur
and so the crouching seminude figures, one wearing a
Jew's hat, may possibly be interpreted as sinners who
carry the weight of the portal of judgment on their
backs, or perhaps they represent Adam and Eve, who
have already learned the penalty for disobeying God.*

Burgos Bible. Spain. 1260. Parchment. 11 7/8 x 9 3/8 in.
(30.2 x 23.8 cm). Ms. Hebr. 4° 790, fols 309v–310r. The
Jewish National and University Library, Jerusalem. *This
Bible is also sometimes referred to as the "Damascus Keter
("crown")," because it once was in the possession of a
Damascus synagogue. The manuscript, which contains the
entire Hebrew Bible, was copied by Menaḥem ben Avraham
ibn Malek for Yitzḥak ben Avraham Ḥadad. The carpet
pages that precede each of the major sections are framed by
a border of text in bold script between two lines of text
written in micrography. The ornamentation of the carpet
pages varies slightly—on one page the interlacing scrollwork
painted in gold has a stylized flower, the second, palmettes.
The scrollwork is outlined with micrography as well. This
page precedes the* Kethuvim, *the Writings.*

(OPPOSITE)

MOSES EBERMANNSTADT (SCRIBE). *Pentateuch.* Bavaria. 1290. Vellum. 15 1/2 x 11 5/8 in.
(39.8 x 29.5 cm). Cod. Hebr. XI, fol 104v. Department of Hebraica and Judaica. The
Royal Library, Copenhagen. *The ornate, fanciful structure, embellished with foliage and
grotesque animals, relates to the architectural design of south German cathedrals. The
micrographic illustration is the beginning of Leviticus, with a verse written in Hebrew,
followed by an Aramaic translation. The text above is I Kings 8:1–11, from the haftorah,
a section recited from the Prophets which accompanies the reading of the Torah portion
on the Sabbath and holidays.*

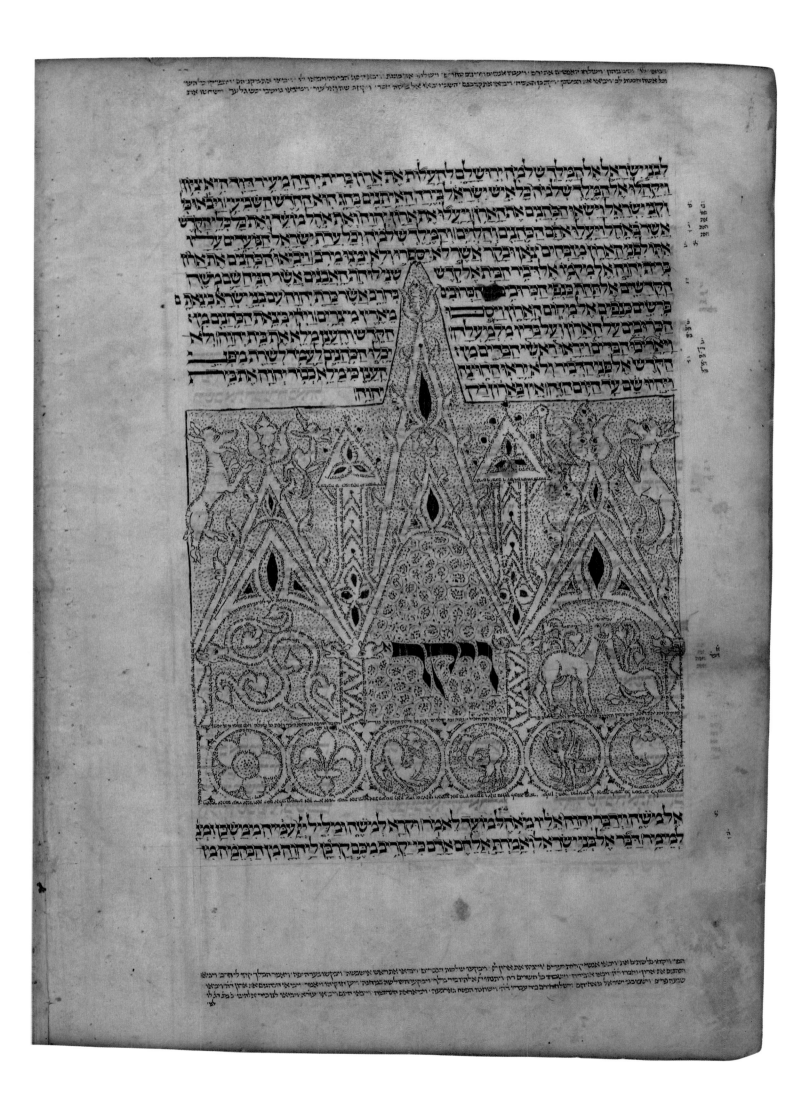

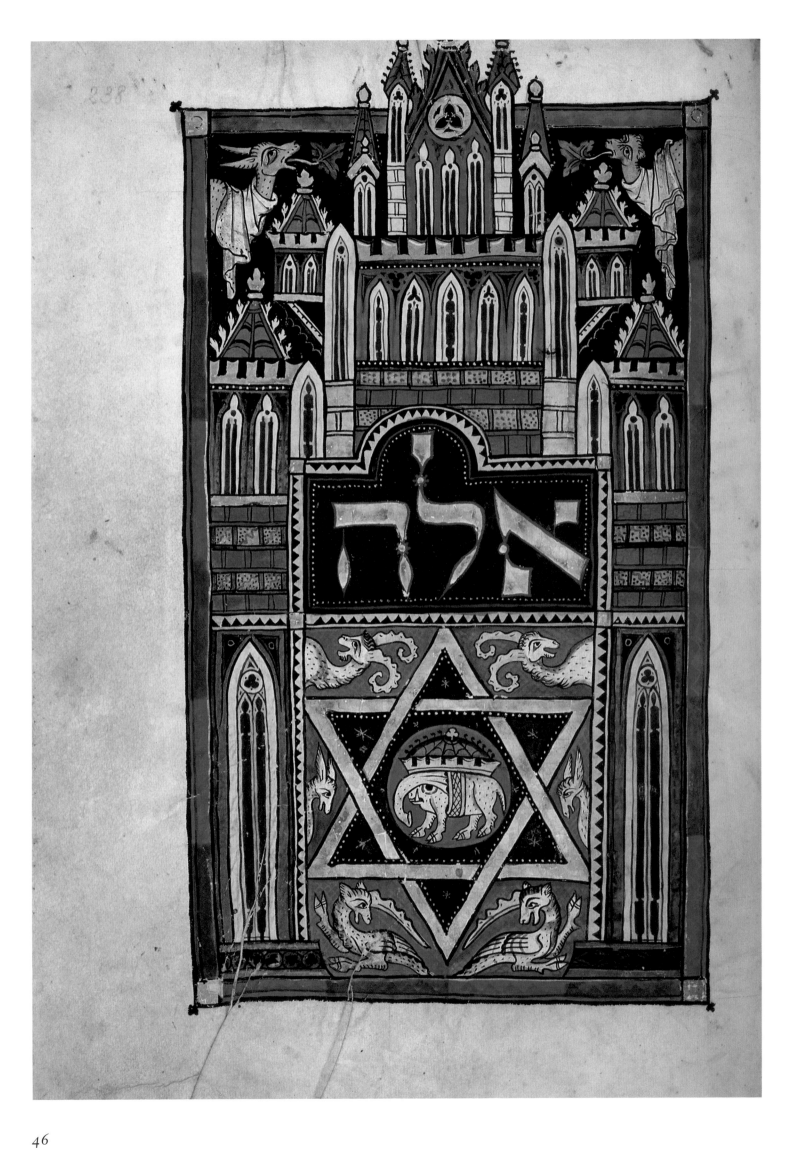

46

(OPPOSITE)

Duke of Sussex Pentateuch. South Germany.
c. 1300. Vellum. 9 x 6 3/8 in. (22.9 x 16.2 cm). Add.
Ms. 15282, fol 238v. The British Library, London.
*An initial-word panel begins each of the five books
in this Pentateuch, here "Eleh," the first word of
Deuteronomy. The elaborate Gothic architectural
setting is based on contemporary church architecture.
The six-pointed star was not an exclusively Jewish
symbol at this time, although it did have significance
as a mystical image. The elephant with its crown-
shaped saddle is an interesting element that has been
the subject of scholarly debate as to whether it is
purely decorative or has a specific meaning. The
Pentateuch was produced in the workshop of the
scribe Ḥayyim.*

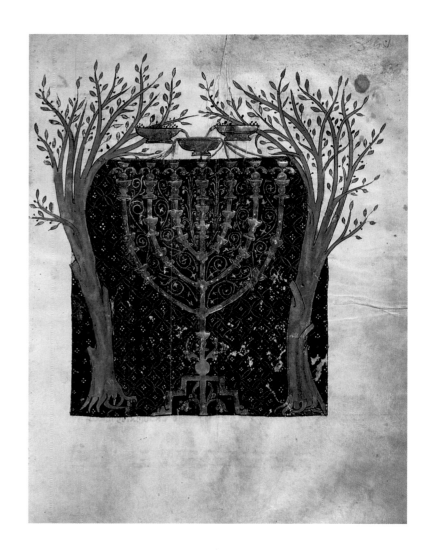

(ABOVE)

SAMUEL BEN ABRAHAM IBN NATHAN (SCRIBE). JOSEPH
HA-ZAREFATI (ARTIST). *Cervera Bible*. Cervera, Spain.
1300. Parchment. 11 1/8 x 8 1/2 in. (28.3 x 21.6 cm).
Ms. 72, fol 316v. National Library, Lisbon. *The
Cervera Bible is an example of early Castilian
Hebrew illuminated manuscripts. It also contains a
grammatical compendium, The artist included both
purely ornamental decorations as well as text
illustrations. Depicted here is the vision of the
prophet Zachariah. The restored Jewish state,
symbolized by the image of the menorah, receives
oil from two olive trees representing the renewed
lineage of King David and of the High Priest.*

(RIGHT)

SAMUEL BEN ABRAHAM IBN NATHAN (SCRIBE). JOSEPH
HA-ZAREFATI (ARTIST). *Cervera Bible*. Cervera, Spain.
1300. Parchment. 11 1/8 x 8 1/2 in. (28.3 x 21.6 cm).
Ms. 72, fol 449. National Library, Lisbon. *The
inscription of the artist's colophon reads "I, Joseph
ha-Zarefati ["the Frenchman"] illustrated this book
and completed it." While the scribe recorded that he
wrote the manuscript in the small town of Cervera, it
is likely that the illustrations were done in a larger
Jewish community. The technique of using grotesque
zoomorphic letters was well known as early as the
ninth century in Carolingian art and was used from
the twelfth century in Armenian and Islamic art.
The illustrations of the Cervera Bible influenced the
decoration of other manuscripts, most notably the
fifteenth-century Kennicott Bible.*

47

BENAYAH BEN SE'ADYAH. *Pentateuch*. San'a, Yemen. 1469. Paper. 16 1/4 x 11 in. (41.5 x 27.9 cm). Ms. Or. 2348. The British Library, London. *The carpet page is composed of micrographic writing of verses from Psalms 119 and 121, but there is no relationship between the text and the illustration. Joseph Gutmann has suggested that the composition may, however, relate to Psalm 104:5–6 "He established the earth upon its foundations that it shall never totter. Tehom (ocean) covered it like a garment. The waters stood against the mountains." The design is similar to oriental metalwork from Egypt, Syria, and Persia.*

(OPPOSITE, ABOVE)

Bird's Head Haggadah. Germany. c. 1300. Vellum. 10 5/8 x 7 1/8 in. (27 x 18.1 cm). Ms. 180/57. The Israel Museum, Jerusalem. *The* Bird's Head Haggadah *is the oldest extant illuminated haggadah from Germany. The use of birdlike features was possibly a way of grappling with the Second Commandment prohibition of graven images, though Rabbi Meir of Rothenberg (c. 1215–1293) permitted depiction of human figures in two-dimensional works. Though he believed they were a distraction, he said they did not violate the Second Commandment because they were not concrete or sculptural. The men wear pointed Jews' hats as they were required to do beginning in the thirteenth century in Germany and other lands of the Holy Roman Empire. Illustrating the song "Dayyeinu" is a scene with manna and quails falling from heaven and Moses receiving the two Tablets of the Law, which transform to five, alluding to the five books of the Pentateuch.*

(OPPOSITE, BELOW)

Book of Psalms, Job, and Proverbs (Sifrei Emet). Florence. 1467. Ink, gouache, and gold leaf on vellum. 4 5/16 x 3 in. (11 x 7.6 cm). Ms. 409. Beinecke Library, Yale University, New Haven. *This page, with its ornate border that includes a miniature of the Judgment of Solomon, begins the book of Proverbs. According to the colophon, the manuscript was written for Signor Jacob Jacomo, the son of Rabbi Benjamin, and was completed on July 5 in the year [5]227 (1467). Unfortunately, the name of the scribe has been erased.*

ולא שקע צרינו
בתוכנו דיינו
אילו שקע צרינו
בתוכנו
ולא ספק צרכינו במדבר
ארבעים שנה דיינו
אילו ספק צרכינו במדבר
ארבעים שנה
ולא האכילנו
את המן דיינו
אילו האכילנו
את המן

Left page:

ולא נתן לנו
את השבת דיינו
אילו נתן לנו
את השבת
ולא קרבנו לפני
הר סיני דיינו
אילו קרבנו לפני
הר סיני
ולא נתן לנו
את התורה דיינו
אילו נתן לנו
את התורה

משלי

משלי שלמה בן דוד מלך ישראל: לדעת חכמה
ומוסר להבין אמרי בינה: לקחת מוסר
השכל צדק ומשפט ומישרים: לתת
לפתאים ערמה לנער דעת ומזמה:
ישמע חכם ויוסף לקח ונבון תחבלות
יקנה: להבין משל ומליצה דברי חכמים
וחידתם: יראת יי' ראשית דעת חכמה
ומוסר אוילים בזו:

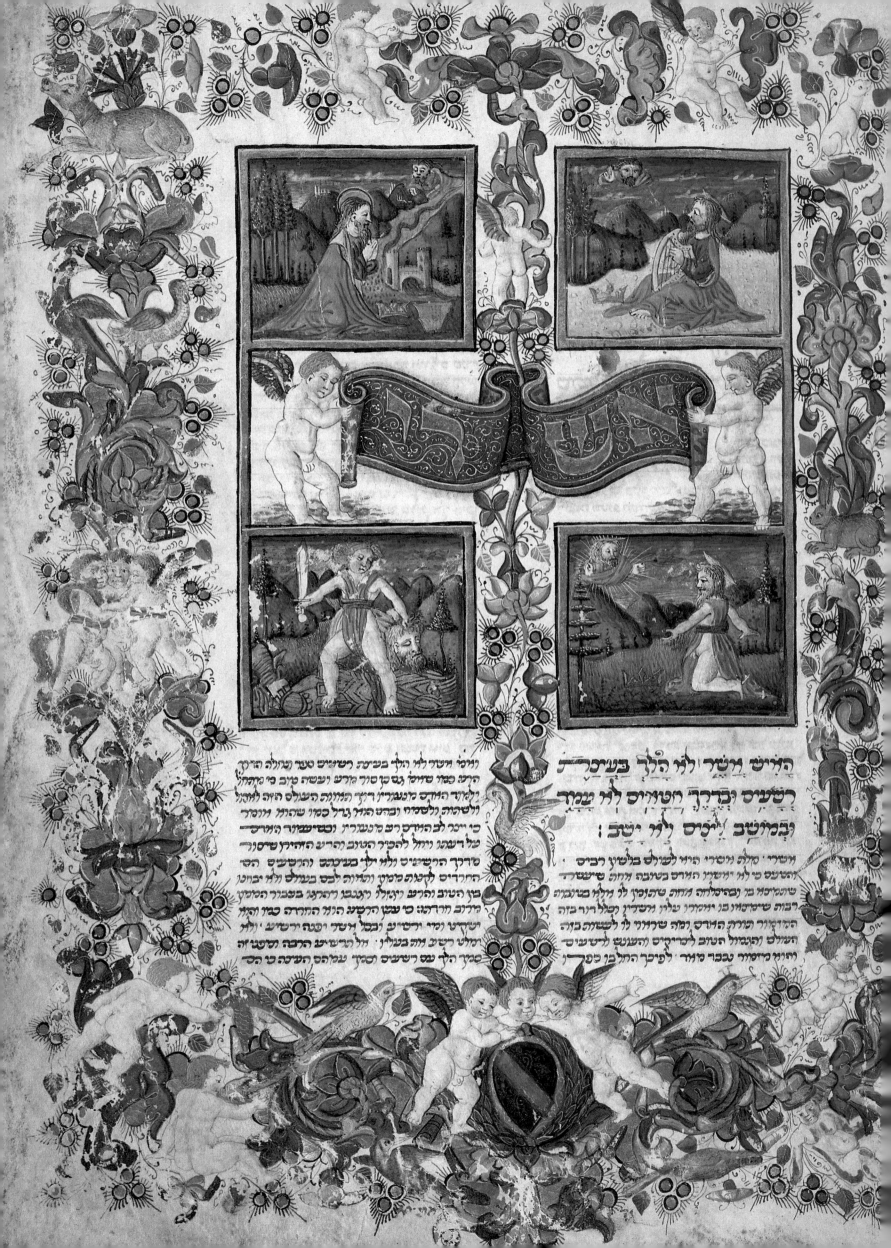

הדיש אשר ולו הלך בעיצרת
רשעיס ובדרך חטויס לו עמד
ובמושב ליציס ולו ישב ·

ויוסי יוטר לו הלך בעישת רטווים יטר בחילה הרק
הרעה פבו שויר גם סן סור מרע ועשה טוב פי יחחל
ילחור חומק מנטבריו דרך חמיוה העולם הזה לחקל
ולשתוה ולשחדיו ובהט הודר סמו שחול מורד
סי יוסר לב החרים רב מנטבריו וכטיטמור המרך
על דעתו נזול להקיר הטוב חרע החיין שרסור
מדרך הרשטיס ולו ילך בעטבטב והשטש הס
החרדיס לקטת כמן ותהיה לבס בטול ולו יבחנו
בין טוב וחרע וינזול וקטבו ורחרג בטבור המטן
מרב חרדהב סי עטן הרשע הנוי החרדה כמו והל
ישטט וסי רדי ורשע ובבל אשר יפטה ירשיב · ולו
ומלט רשע מה בטולין · ולחרשיע הרבה ושטו זה
סמך הלך עס רשעיס וסך עלוה העדה טו הס

וטסרי · מלת נוסרי חוי לשנל בלשון רביס
והטעיס פי לו יוושני חורס בטובה ולהה שיטשה
שתמרישו בו בפוישלותה מוחת שהופן לי מילו מטובה
רבות שירטמוון בן יונטרו עליו ומשדין וכטל רנר בזה
הסדוטר תורה · חורס · נמה שרטור לו לשטוטה בזה
העולס · והנמול הטוב לברייס והטנטט לרטטיס
והוו מיסורי טבר מרו · לפיכך החלבן בפרן

Commentary on the Bible by Solomon ben Isaac (Rashi). Ashkenazi. 13th century. Parchment. 20 5/8 x 13 7/8 in. (52.4 x 35.2 cm). Vat. ebr. 94, fol 175r. Biblioteca Apostolica Vaticana, Vatican City. The commentary of Rashi (1040–1105) on the Bible and Talmud is the basic and standard curriculum of traditional Jewish education. This image is a depiction of the Temple in Jerusalem and the placement of the tribes in the messianic age according to the interpretation in chapter 48 of Ezekiel.

(OPPOSITE)

Book of Psalms. Italy. 15th century. Berlin, Staatsbibliothek Preussischer Kulturbesitz. Orientabteilung. Hamilton Ms. 547, fol 1r. There are numerous examples of the use of figures in Hebrew illuminated manuscripts. Still, the Second Commandment injunction against the use of images clearly persisted in respect to any illustrations of God, except for an occasional reference such as the "hand of God." In Italy, from the mid-fifteenth century, there were Hebrew manuscripts commissioned by Christian Humanists, of which this is an example. Here, the first page of a Book of Psalms depicts scenes from the life of King David, with God pictured in three of the miniatures.

SOLOMON BEN RAPHAEL. *Bible*. Perpignan, Aragon. 1299. Parchment. 12 5/8 x 9 1/4 in. (32.1 x 23.7 cm). Ms. hébr. 7, fols 12v, 13r. Bibliothèque Nationale, Paris. *The manuscript was written by Solomon ben Raphael and possibly illuminated by him as well. It is the earliest known example of the tradition which began in Spain of illustrating the Temple implements in Bibles.*

(OPPOSITE)

Aaron Pouring Oil into the Menorah. From the *British Museum Miscellany.* Amiens, France. c. 1280. Vellum. 6 3/8 x 4 3/4 in. (16.2 x 12.1 cm). Add. Ms. 11639, fol 114r. The British Library, London. *With almost 750 leaves, this manuscript is composed of a large number of texts and illuminations. There are four series of full-page miniatures which differ in style, indicating that several different artists did the illustrations. The lithe and delicately featured Aaron, with finely modeled drapery, parallels figural examples in High Gothic manuscripts.*

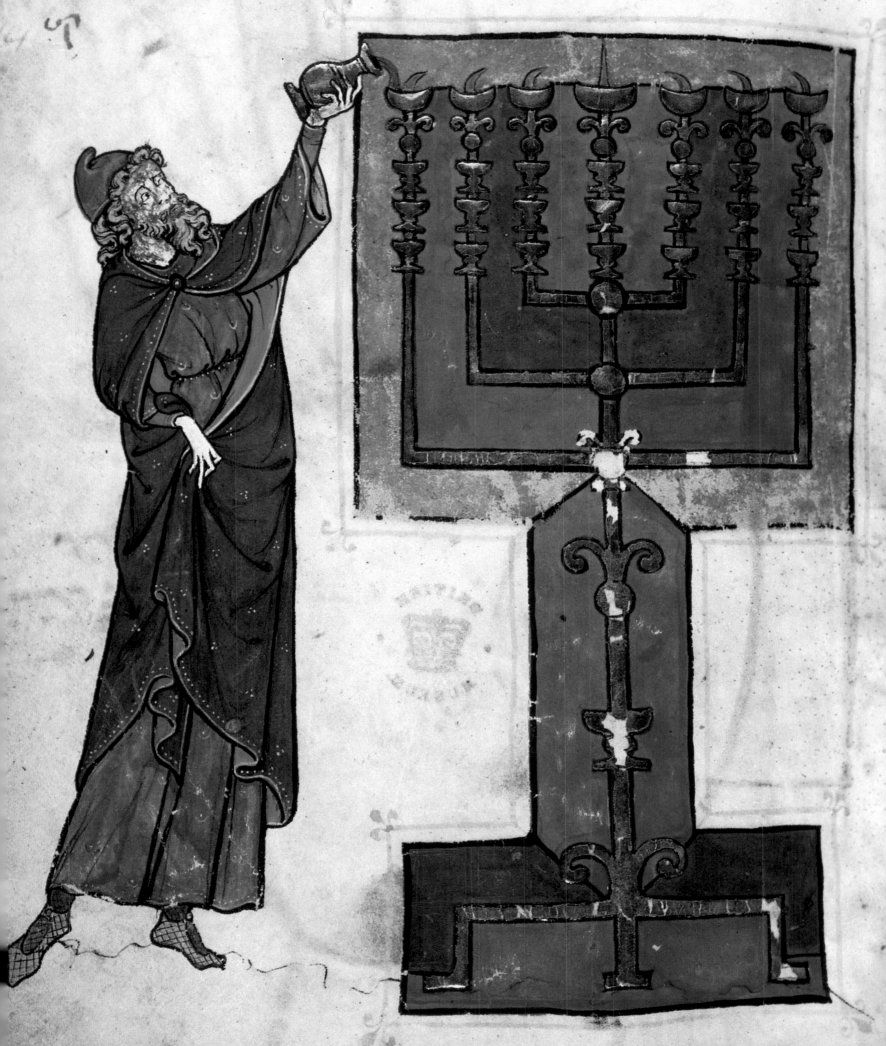

זה המערה ואהרן הטתן שמן בנירות

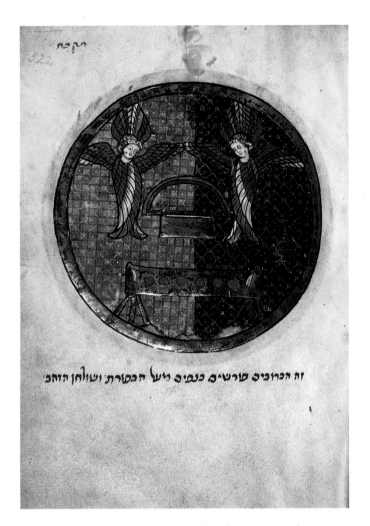

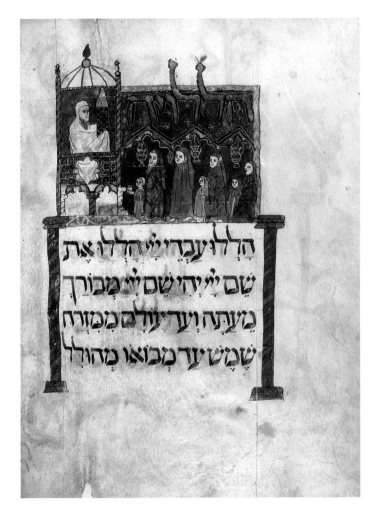

Ark of the Covenant and the Cherubim. From the *British Museum Miscellany.* Amiens, France. c. 1280. Vellum. 6 3/8 x 4 3/4 in. (16.2 x 12.1 cm). Add. Ms. 11639, fol 522. The British Library, London. *In a second type of illumination in the* British Museum Miscellany, *the image is set against a repetitive, geometrically patterned background, here half red and half blue, within a roundel banded by a gold frame. The winged cherubim with childlike faces hover above the Ark of the Covenant, which itself seems to float above the golden table of the shewbread.*

Barcelona Haggadah. Spain. 14th century. Vellum. 10 7/8 x 7 1/4 in. (27.6 x 18.4 cm). Add. Ms. 14761, fol 65v. The British Library, London. *The miniature, which illustrates Psalm 113, is actually an initial-word panel supported by two columns. The reader, cloaked in a prayer shawl, is shown on a raised platform, as was the style in Spanish synagogues. He holds aloft the Torah scroll in its case. While this is generally described as a worship scene, that is unlikely, as there is but a single man with three women and three children, one of whom extends his hand holding a small container. The true meaning of the scene is uncertain.*

(OPPOSITE)

"Bere'shit." From the *Schocken Bible.* Southern Germany. c. 1300. Vellum. 8 3/8 x 6 in. (21.3 x 15.3 cm). Ms. 14940. The Schocken Institute for Jewish Research of the Jewish Theological Seminary of America, Jerusalem. *Produced in the workshop of the scribe Hayyim, this manuscript contains thirty-five illuminated initial-word panels, one at the opening of each book of the Bible. The frontispiece with the initial word of Genesis (Bere'shit) is surrounded by forty-six medallions with biblical illustrations of episodes from Adam and Eve to the story of Balaam in the book of Numbers.*

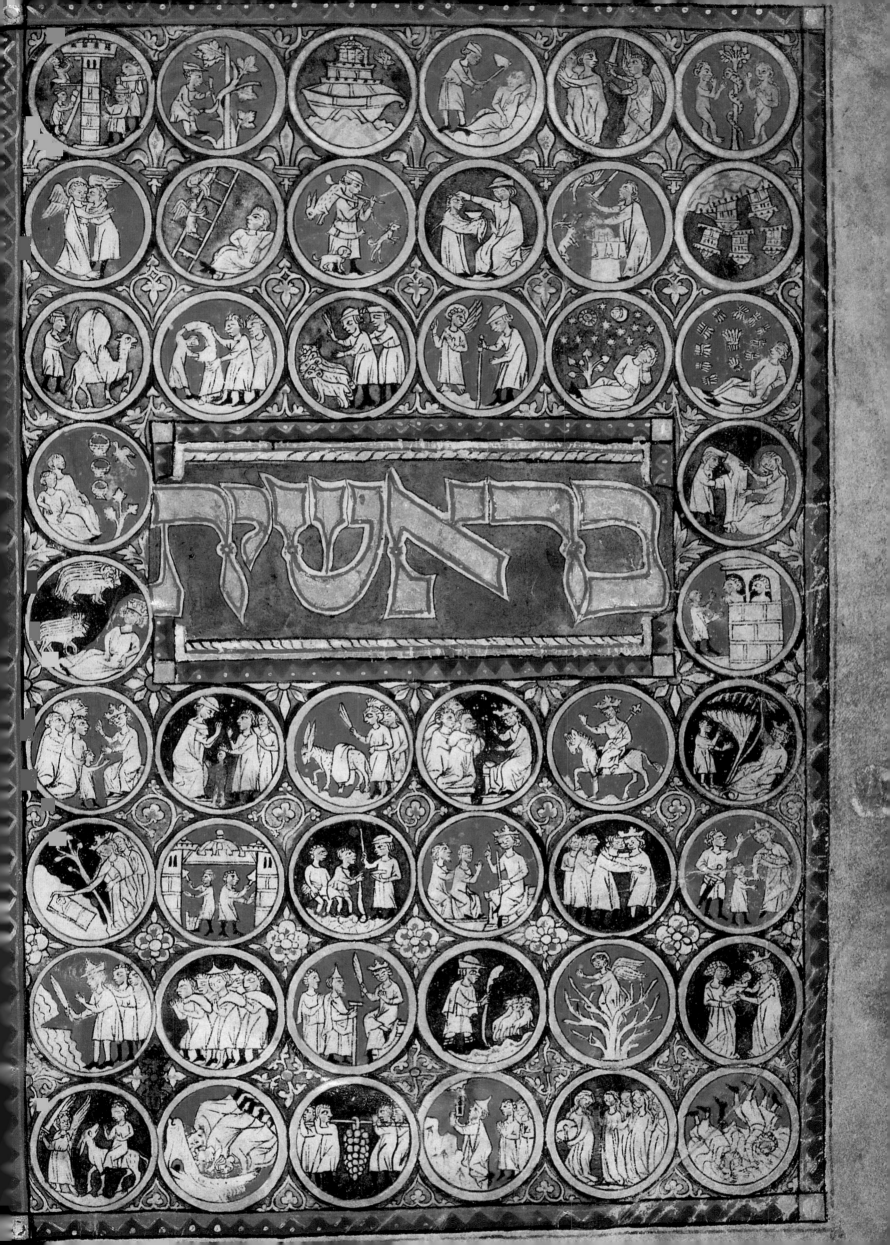

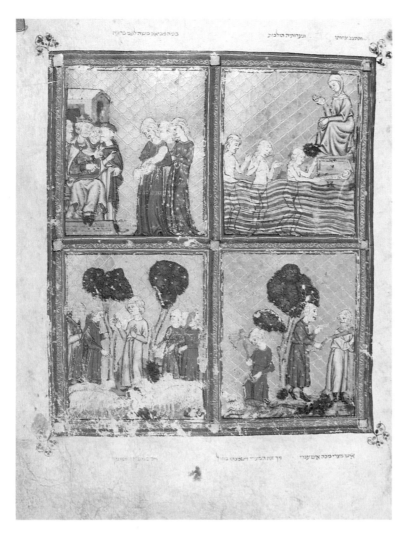

Golden Haggadah. Barcelona. Early 14th century. Vellum, ink, gold leaf. 9 3/4 x 7 3/4 in. (24.8 x 19.7 cm). Add. Ms. 27210, fol 9v. British Library, London. *One of the earliest surviving Spanish haggadahs, this manuscript derives its name from its rich gold-burnished background. There are fourteen full-page miniatures, with episodes from the Bible beginning with Adam and ending with the Song of Miriam in Exodus. Each of the miniatures is divided into four panels separated by a delicate vine motif. The illustrations reflect the fourteenth-century Catalan school and were influenced by the Gothic school of illumination in Paris. Two artists are responsible for the miniatures. Illustrated here are scenes from the early life of Moses: Pharoah's daughter rescues him from the Nile; the baby Moses is brought to Pharoah, which is from rabbinic literature and not the biblical text; Moses smites the Egyptian and is about to bury him; finally, Moses is seen admonishing two shepherds who planned to drive Jethro's sheep from the well.*

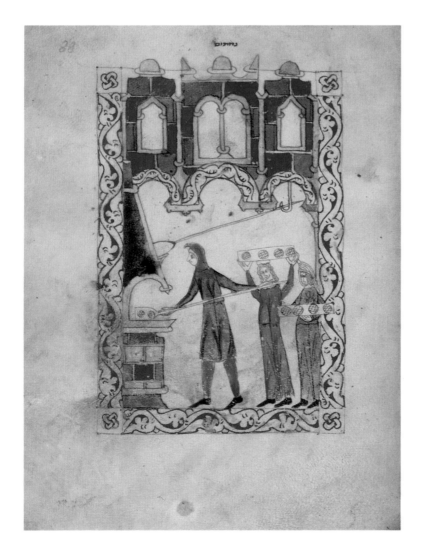

Baking the Matzah. From the *Hispano-Moresque Haggadah.* Castile, Spain. Late 13th–early 14th century. Vellum. 6 3/8 x 4 7/8 in. (16.2 x 12.4 cm). Ms. Or. 2737, fol 88r. British Library, London. *This haggadah also contains the biblical portions read on Passover as well as* piyyutim, *liturgical poems added to the regular prayers, read on Passover according to the Sephardi rite. Depicted here is the baking of round matzah in the communal oven.*

Ashrei Ha'ish. From the *Rothschild Miscellany.* Northern Italy. 1450–80. Vellum, pen and ink, tempera, gold leaf. 8 1/4 x 6 1/4 in. (21 x 15.9 cm). Ms. 180/51, fol 103a. The Israel Museum, Jerusalem. Gift of James A. de Rothschild, London. *The* Rothschild Miscellany *is the one of the most sumptuous of all the medieval Hebrew illuminated manuscripts. Commissioned about 1450 by Yekutiel ha-Kohen, it was planned as a lavish book. Large in scope, with 948 pages, the* Rothschild Miscellany *comprises thirty-seven literary units, including the biblical books of Psalms, Proverbs, and Job; a prayer book for the entire year, including a haggadah; midrashic texts; books on Jewish law, ethics, and philosophy; and even secular works, including moralistic and scientific treatises. The text appears to have been written by a single scribe, except for the biblical books. The manuscript was decorated by Christian artists, apparently in the workshops of Bonifacio Bembo and Cristoforo de Predis, and is the work of a number of hands. "Ashrei Ha'ish," ("Happy is the man . . .") is the beginning of the Book of Psalms. Here, King David, to whom authorship of the Psalms is ascribed, is playing his lyre in the midst of a bucolic setting.*

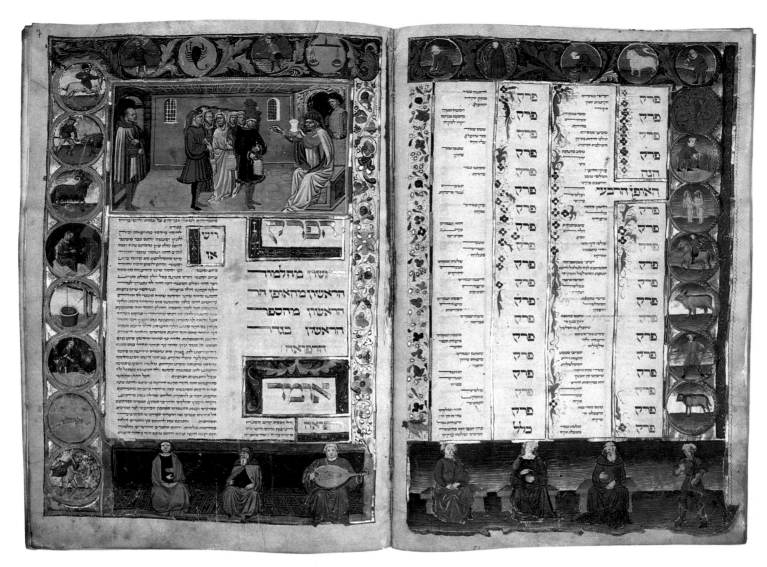

Canon of Avicenna. Northern Italy. 15th century. 17 x 11 1/2 in. (43.2 x 29.2 cm). Ms. 2197, fol 7r. Biblioteca Universitaria, Bologna. *This manuscript is a Hebrew translation of an eleventh-century work,* The Canon of Medicine, *by Avicenna (Ibn Sina). The first chapter of each book is illustrated with a framed decorative border. Here, at the beginning of the first book, a physician is shown with a group of patients, each of whom carries a specimen to be examined. The inclusion of the signs of the zodiac may relate to Avicenna's theories about the effects of the seasons on the body.*

(OPPOSITE)

Isaac ben Obadiah (Scribe). *Vatican Arba'ah Turim.* Mantua. 1435. Parchment. 13 1/8 x 9 1/8 in. (33.3 x 23.2 cm). Cod. Rossiana, Ms. 555, fol 293. Biblioteca Apostolica Vaticana, Vatican City. *This miniature accompanies the beginning of the fourth section* Hoshen Mishpat *(The Breastpiece of Justice) and depicts the* Bet Din, *the Jewish court of law.*

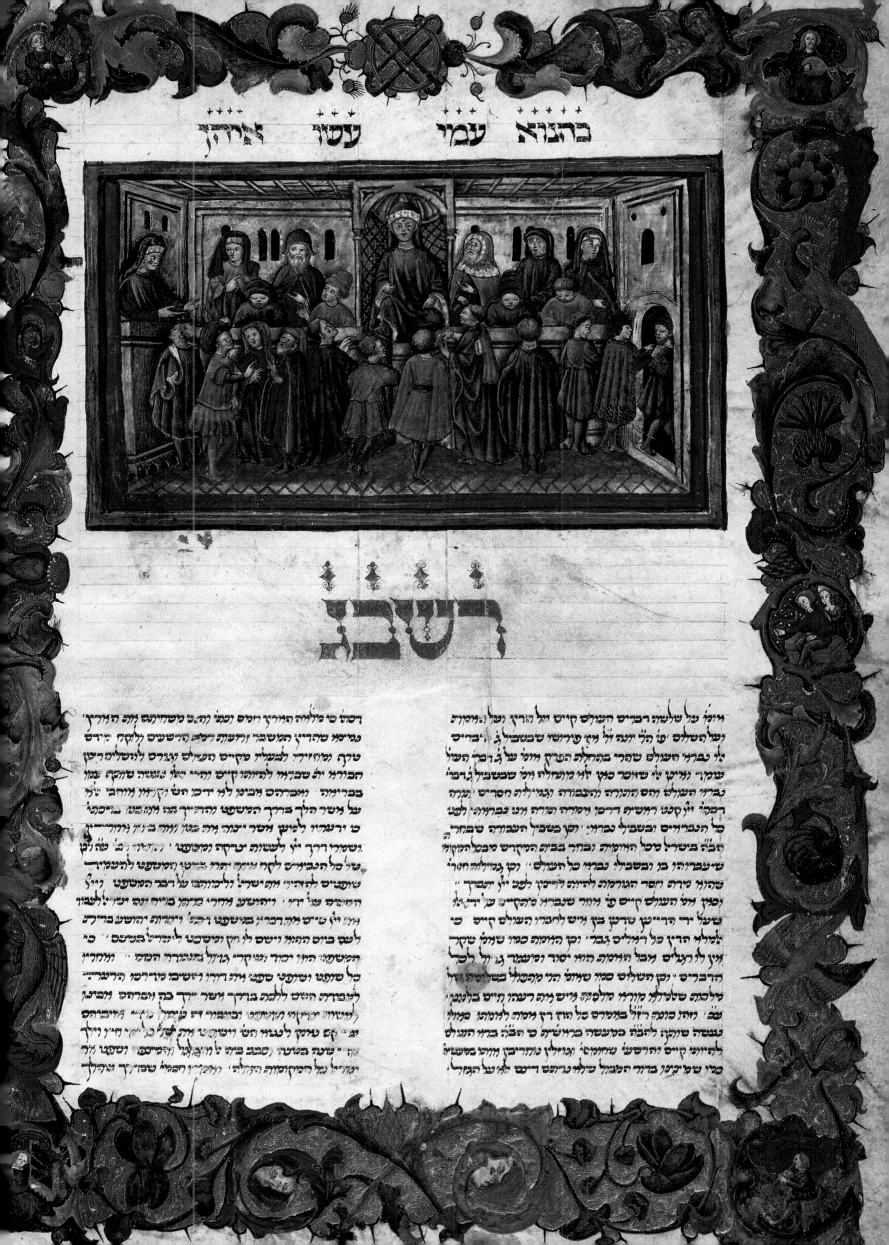

רשב"י

ריהי על שלשה דברים העולם קיים יגל הארץ ועל המשחת דכתב כי מלריה הארץ חמס וכפי' להב"ב משחיתם מה הארץ וכל השלום ספו הל' יונה זל' מן פירושו שבטביל ג' דבריס כמיסא שהדריי המשובר זלעונת דרבה הרשעים לוקח הרדס ין כברא העולם שהדי בהחלת התרק ויסי על ג' דבר העול טרף ומחזירי לבעלי סקיס העליש וגרס לחשלים ריבן עמך' מרטן ט' שחוסר מכן זלי מתחלה ויפי שבטביל ג רמבי הבוריא יב שבדמור לחליות קיס והרי יכל גמגור שהקה שמר כברא העולש וחס התורה להגבורה וגמילת חסדיש ונ טה בברימה ימברהס ימביו לם דרכ הטי וקן מן מורהב שלי דכסי ילן שטו רמשה דרפו ומדרה תורה יתו בברמיו לשמ על אשר הלך בדרך המשפט והרי יך בנו מהבט בשכפ כל חברודיס ובשביל' שברו ' וכן בשביל העבורה שבחר ה כב ירגורני לפיעש ושר יכור מה בזן ומה בזן וגומרדים הבה בישראל מכל האומה ובחר בבית המקדש מבל המקומ ושמדרי דרך יי לעשות לדקה ומשפט ' וסדעיי ב פח יבן שעברוהו בן ובשביל עברי כל הנברודיס לקח אבזר יבטע יקר ומטפט להעבודי שהדרי מרה חסר הגגורמה להחוה לישוט לשמי יי יכברן שוטעיש לדההי ומטל ישראל ולכמורתה על רבר המטפט ' וכאן מל העולש קיס ס' י יוחר שנברא מהמקיין על ידי גל המשפט פל י ידי ' וידצטע מדרי מימט בריה ומה וכן ישי ן לחטבו שעל ידי הדריף שרמן בן יות לחברין העולש קיס כ מן יי ט"יס מלך דברי מימטפט ומל ימטפט ולב יהושפט בדיך ימלא הדין כל רמליש גבר ' וכן המימה ספו שמי שקר לשב בים החוד ישיס לו חן ומשפט לישראל בשמש כי מן לי רגליס מבל הדומה הוי יסר ופרשבהר ג' על לכל המשתויי החז יתר ובבי שדרי גכזל ' בגומרה המא ' מלחרי הדברים ' וכן השלוש כמי שמי מהקליל בשלומהב ואל כל שוטפט ושטפט שכש ואל דירי ושטיכו מדרוס הרי לכות שלהמלי מורדי הלכ יס מיש מה רשמו חיס בלעמי לעבורה הוסי ללרה בדרך ימי ירך בה וימברהס יבי שב' וזהן כונת רזל במדרס על תוה דין ישמ ה סמלי ליפורה ירמו לזמיסי ובמורי דב בומל לברח מינברס טכשה שוסן לחבה במעשה בראשית כ הבה ברמי העולש יח ' אה טרסק לקברש לשם וישיכושי ' וקן תשל כל שמי חיס ויך' לההיום קיס יהדרשע' שהחוסי וגוילי נוהרבין מורחו מטשמיח שן ' טרנה בשטה ' ובב בוה ל' מרב'ל ובדרשפם ושטפו מר כבי שם יבלו בדור הנבול שלמו ערהרבס לשמ ליל על הנבר מזרוזי' וכל ריבהומנות ההלב' ' ולחר' ו רבהי שבי יעהל

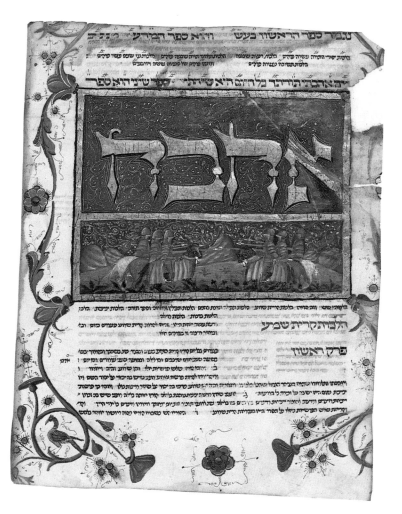

Mishnah Torah. Lombardy. Late 15th century. Vellum. 9 x 6 7/8 in. (22.9 x 17.5 cm). Cod. Rossiana, Ms. 498, fol 43v. Biblioteca Apostolica Vaticana, Vatican City. *The miniature here is the opening of* Sefer Ahavah *(The Book of Love) which is the second of the fourteen books of the* Mishnah Torah *by Maimonides. While the text is about the love of God which can be attained through prayer and study, the artist depicts a jousting scene, perhaps alluding to courtly love epitomized by the knights.*

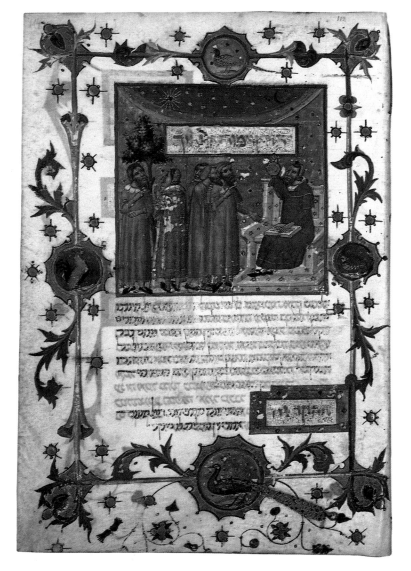

LEVI BAR ISAAC "HIJO" CARO (SON OF CARO) (ARTIST-SCRIBE). *Moreh Nevukhim (Guide for the Perplexed).* Salamanca, Barcelona. 1348. Vellum. 7 5/8 x 5 1/4 in. (19.4 x 13.3 cm). Cod. Hebr. 37, fol 114r. Department of Hebraica and Judaica, The Royal Library, Copenhagen. *This richly illuminated manuscript is one of six known that are stylistically related, one other of which has the same Hebrew text, though the artist-scribe identified is only in this manuscript. The* Guide for the Perplexed *was written by the great medieval scholar Maimonides, Rabbi Moses ben Maimon (1135–1204) and was translated from the original Arabic by Samuel ibn Tibbon (1160–c. 1230). In what was a controversial work, Maimonides bridged the philosophy of Aristotle and the Jewish belief in revelation. The illustration of a seated figure holding an astrolabe accompanies the introduction to a text dealing with the philosophical propositions to prove God's existence. According to an inscription in the colophon, this manuscript was written for the physician Menahem Bezalel. The volume passed through papal censorship twice, in 1597 and 1619.*

ATTRIBUTED TO ABRAHAM CRESQUES. *Catalan Atlas* (detail). Spain. 1375. Twelve vellum sheets mounted on seven wooden panels. Each panel, 25 5/8 x 9 7/8 in. (65.1 x 25.1 cm). Ms. espagnol 30, fol 2v–6r. Bibliothèque Nationale, Paris. *Although this map is anonymous, it is likely the work of Abraham Cresques, a well-documented Majorcan cartographer. From 1368 until his death in 1387, Cresques served the court, working for Pearo IV, king of Aragon and for the Infante Don Juan, the future Juan I. The elaborate map, which includes all of the known world at the time, was not designed as a navigational guide but rather as a luxury item. It was owned by Charles V of France and was listed in an inventory compiled before 1380.*

Among the Nations:
Jewish Art in Distant Lands

And seek the welfare of the city to which I have exiled you and pray to the Lord in its behalf; for in its prosperity you shall prosper (JEREMIAH 29:7).

Adaptability has been the byword of the Jewish experience. A fascinating aspect of the social history of the Jewish people is the curious liturgical custom of Jews living in the Diaspora, who recited special prayers and wrote poems of homage to the local government and its leaders. The rationalization for these prayers was that the fate of the Jewish community was tied to the well-being of the secular government. The standard prayer is called *ha-noten teshua l'melachim*, "May he who dispenses victory to kings . . . and asks for God's blessing to preserve and guard, aid and extol, magnify and exalt on high our Sovereign . . . prolong his life . . . and deliver him from all sorrow, trouble, and loss; may he subject nations to this sway and cause his foes to fall before him; and may he prosper in all his undertakings. . . ." This prayer was recited after the Torah reading on Sabbath mornings, at which time another prayer was recited on behalf of the Jewish community. There are also prayers honoring a ruler on a special occasion.

Since antiquity, the Jews maintained strong ties to tradition. Yet it was characteristic that as they lived among the nations, they also found ways to adapt to the outside environment. But there was a tension and ambivalence. While one source in the *Mishnah* admonishes, "Seek not intimacy with the ruling power" (Pirke Avot 1:10), another concedes "Pray for the welfare of the government, since but for the fear thereof men would swallow each other alive" (Pirke Avot 3:2). It is in this light that we can best understand the context for the numerous examples of documents and objects which demonstrate an attempt by the Jewish community, as well as individual Jews, to pay tribute to, and thus have a positive influence on, the reigning leader, king or sultan, pope or czar. There was the hope that maintaining good relations with a stable government would somehow avert persecution and might help to promote good will and favorable treatment of Jews.

Loyalty was demonstrated both in the presentation of special gifts to government leaders and by incorporating national emblems on a variety of Jewish ceremonial objects and in illuminated Hebrew manuscripts. In Rome, homage was often paid to cardinals and popes, both on behalf of the local community and in the hope that the Church would intercede in matters pertaining to Italian Jews. In 1769, a *Book of Emblematic Vignettes* was presented to Cardinal Lorenzo Ganganelli when he arrived in Rome to assume

Section of Synagogue Grillwork. Prague. 2nd half of the 18th century. Wrought iron. 45 7/8 x 23 1/4 in. (116.5 x 59.1 cm). The Jewish Museum in Prague. *This was a section of the grill-work for the reader's desk in the Cikanova Synagogue. Prague is known for its use of decorative ironwork.*

the papacy as Clement XIV. Each page cites a biblical quote in both Hebrew and Latin and is decorated with a pertinent scene. An interesting custom in northern Italy was to make Hanukkah lamps embellished with the crest of the cardinal or local ruler as a presentation piece. In turn, Jews sometimes received special privileges and dispensations. The *Ambron Family Privilege* is one of a number of special documents issued to this family in Rome, the first of which is dated 1687. Another testimony to a rare privilege is the medical diploma of Emanuel Colli, dated 1682. Colli was one of the few Jews permitted to attend the University of Padua. The diploma not only includes his portrait but also a family crest.

The Jews were expelled from England in 1290 and were not permitted to return until 1656 through the mediation of Oliver Cromwell and the Dutch Jewish scholar Menasseh ben Israel. For a century, beginning in 1679, the Jews of London maintained an annual tradition of giving silver presentation trays to the Lord Mayor. Most of the trays include the seal of the historic Bevis Marks Synagogue—an image of the Tent of Assembly in the Wilderness with a guard posted at its entrance. Jews, however, were not alone in giving such items to the Lord Mayor. Other minority groups, the Dutch Reform and French Protestant churches, did the same.

The primary symbol representing the Jewish people today is the six-pointed star. Though generally referred to as the *magen David* (shield of David), there is no biblical or talmudic reference for this association. Widely used as a geometric and often amuletic motif in many cultures, the six-pointed star was first officially used as a Jewish symbol in Prague in 1354, when Emperor Charles IV granted the Jews the privilege of displaying their own flag on state occasions. In recognition of their valiant defense of the city against the Swedes, Ferdinand II presented the Jewish community in 1629 with a special flag and an insignia which became the official emblem of the Prague Jewish community—a Swedish cap in the center of the Star of David. Ornate grillwork from an eighteenth-century Prague synagogue incorporates this motif in its design. A triangular flag with the six-pointed star is still hung in the Altneuschul in Prague.

Jews had served rulers of many nations in many diverse advisory capacities, and there were always

Jews with special "protected" status. Simon Wolff Brandes, one such *Schutzjude* living in Berlin, composed a special homage to Prussian King Friederich I in honor of his coronation. The more organized institution of the *Hofjude*, the Court Jew, emerged especially in central Europe from the sixteenth through the eighteenth century. Over the course of time, Court Jews were accorded assorted titles and received various rights. Their responsibilities varied, but centered about finance, commerce, and diplomacy. Because Court Jews maintained a privileged position, they often acted on behalf of the Jewish community.

Some ceremonial objects were not made as presentation gifts to the ruler but to pay tribute or commemorate a particular event. A Hanukkah lamp made from a Prussian grenadier's hat plate was apparently made as a gesture of respect and loyalty. An image resembling Maria Theresa, Empress of Austria, is depicted on an Esther scroll among the scenes from the Purim story. Joseph II became Austria's emperor in 1765 and in 1782 issued an Edict of Toleration for the Jewish community. In commemoration, a Hanukkah lamp was cast with his image and the royal seal with the double-headed eagle on the backplate. The double-headed eagle, also the heraldic emblem of the czars, became an oft-used symbol on Jewish ritual objects through the nineteenth century.

An interesting *lubok*, a folk art print, from the western Ukraine from the late nineteenth or early twentieth century bravely reveals the true feelings of its maker about the oppression of the government. The scene is of David and Goliath. David is depicted as a young yeshiva student, a group of Hasidim in their traditional garb and representing the Israelites stand behind him. The Philistines and Goliath are dressed in fanciful military uniforms; Goliath's is an elaborate dress uniform replete with sash and gold epaulets resembling those of the French army in the early nineteenth century.

Napoleon was the subject of many forms of tribute from the Jewish community. An engraving recog-

Engraving Commemorating the Edict of Toleration. Undated. Collection of Mr. and Mrs. Norman Rosen, New Jersey. *In this engraving, a beam of light shines on the emperor and a quote about King David from Psalms 89 is rendered in German and used to refer to the emperor. Despite this characterization of the emperor as a beneficent ruler, Joseph II issued the Edict of Toleration primarily for pragmatic reasons: he wanted Jews to become better educated and thus earn more money which, in turn, would provide the state with greater revenue.*

nizes Napoleon for convening the Assembly of Jewish Notables in 1806. Napoleon on horseback, wearing his three-cornered hat, is depicted on a *ketubbah* (marriage contract) from Fiorenzuola dated 1832, apparently in gratitude for the liberation of the Jewish community from the ghettos when the French army entered northern Italy in 1797.

From the mid-nineteenth century, a frequent sign of allegiance was to incorporate a country's flag on ceremonial objects, often as part of decorated wedding contracts. A ketubbah from a wedding performed in Rome in 1857 is of particular interest because two flags are illustrated. The groom, Daniel Joseph Benoliel, who was actually from a Moroccan Jewish family, served both the French government and the Ottoman sultan. Thus, the ketubbah is decorated with both the flags of the Ottoman Empire and of the French Republic. Another ketubbah with a distinctive national emblem is from Isfahan, dated 1898. The image of a lion with a rising sun at its back, usually depicted with a drawn sword, was used as a symbol of royalty in Persia since antiquity and became a national symbol as the image on the flag of Iran.

The great wave of immigration to the United States, beginning in the mid-nineteenth century, produced a myriad of items, including patriotic images of the American flag, the American eagle, the Liberty Bell, and later the Statue of Liberty. An American eagle perched on a shield of flag bunting is found on a *mizrah* made in Cincinnati, Ohio, in 1850 by Moses H. Henry. A poem was written in the form of a Torah scroll in honor of the centennial of "The Star-Spangled Banner." In honor of the celebration of the hundredth anniversary of the Statue of Liberty in 1986, Manfred Anson made a Hanukkah lamp, casting from the original souvenir, which had been used to raise funds for the base of the statue.

In 1948, when President Chaim Weizmann wanted to find an appropriate way to pay homage to President Harry Truman for all of his efforts on behalf of the State of Israel, the decision was made to present Truman with a Torah as the symbol of the Jewish people and their heritage. A modern Torah case based on the traditional model was created by Ludwig Wolpert, using Hebrew letters as ornamentation.

These are all ways in which the Jewish community found a means to adapt to the Diaspora experience. In surveying Jewish artifacts, the variations that resulted from the social, political, and economic rights and restrictions faced in particular communities are very significant. For instance, not all Jewish ceremonial art was crafted by Jews. Prior to the era of emancipation, in central and western Europe, Jews were not allowed to work in certain guilds, and many of the finest objects were commissioned from non-Jews. However, by the seventeenth century, Jews in eastern Europe were able to form their own guilds. In Islamic countries, where metalworking was not a well-regarded occupation, Jews became skilled in the craft. The Jews of Yemen were renowned as fine silversmiths. Iconography was influenced as well. As demonstrated with the Hebrew illuminated manuscripts, the Islamic prohibitions against the use of figural representation created an artistic condition which influenced the character of Jewish artwork in oriental communities.

What emerges in a study of Jewish celebration in the synagogue and home for the Sabbath, holidays, life cycle events, and daily life is both the unity and diversity of the Jewish cultural heritage. Though the primacy of Jewish law and the emphasis on cohesiveness of the Jewish community remained a constant priority, the encounter with diverse peoples and places often led to a convergence between the native norm and the Jewish way of life, resulting in significant distinctions among Jews who lived geographically apart. As Jewish life evolved in different communities, the basic ritual may have remained the same, but the styles of ceremonial objects were transformed in response to the cultural milieu in which they were created. Moreover, many customs developed over time which are distinctive to particular communities, giving rise to the use of special ethnographic artifacts. Despite the differences, there is a very strong bond to the tradition that links Jews to one another.

(RIGHT)

Book of Emblematic Vignettes Presented to Pope Clement XIV.
Rome. 1769. Ink, gouache, gold leaf on vellum. 10 7/8 x 7 7/8 in
(27.6 x 20 cm). Beinecke Library, Yale University, New Haven.
*The Jews of Rome served a special role in the Italian Jewish
community because of their proximity to the Papal See. They
used the occasion of the investiture of a new pope to gain his
favor. This volume was presented to Cardinal Lorenzo Ganganelli
when he arrived in Rome to assume the papacy as Clement XIV.
Each of the pages contains a biblical motto in Hebrew and Latin
and an image appropriate to the verse.*

(BELOW)

Ambron Family Privilege. Rome. 1687. Ink and gouache on
parchment. 12 1/2 x 16 in. (31.8 x 40.6 cm). Ms. L2. Library
of the Jewish Theological Seminary of America, New York.
*This testimonial was sent to Gabriele Ambron and his brothers
from Roger "Ruggerio" Palmer, special ambassador of King
James II of England to Pope Innocent XI. It was presented to
the Ambrons in gratitude for their faithful service as suppliers
of furnishings for Palmer's residence in Rome.*

ביאור הנבואה האלהית של המלך דוד אשר היה
מרמז על המלכות של אדונינו המלך והדוכס האדיר
והחסיד פרידרייך השלישי מברנדיבארג יר'ה אס:

*Title Page in Honor of the Coronation of the Prussian
King Friedrich I. Berlin. 1701. Watercolor. 13 3/4 x
10 7/8 in. (34.9 x 27.6 cm). Berlin, Geheimes Staatsarchiv
Preussischer Kulturbesitz. On January 18, 1701, in
Königsberg, the elector Friedrich III was crowned
Friedrich I, King of Prussia. This document was written
by the* Schutzjude *(Protected Jew) Simon Wolff Brandes
in honor of the coronation. Using Psalm 21, he com-
posed "A Divine Secret Revealed" in which,
on behalf of the Jewish community, he expressed the
hope that the new king be granted power, glory, and
a long life.*

ALOYSIUS FOPPA. *Medical Diploma of Emanuel di
Isaaco Colli. Padua. September 18, 1682. Ink and
gouache on vellum. 9 3/8 x 6 3/4 in. (23.8 x 17.1 cm).
Judah L. Magnes Museum, Berkeley. Gift of Mr. and
Mrs. Frederic Weiss in honor of Mrs. Leon Mandelson.
The Jews who were permitted to attend the University
of Padua's medical school were a very exclusive
group—there were only two hundred and fifty Jewish
graduates from the period 1517 to 1721. Care was
taken by the university to secularize the diploma,
which begins in Latin, "In the name of the Eternal
God" instead of the standard "In Christi Nomine
Aeterni." As was typical in northern Italian
universities, the diploma is in the form of a small book.
Emanuel Colli's portrait appears, as does his family's
coat of arms. Colli means hills in Italian, and the
seabird suggests the port of Ancona, which was his
home. Above Colli's portrait is a roundel with two
older bearded men, perhaps a rabbi and a doctor.*

JOHN RUSLEN. *Lord Mayor's Tray*. London. 1708–09. Silver, repoussé and engraved. 21 3/8 x 26 1/2 x 3 1/4 in. (54.3 x 67.3 x 8.3 cm). The Jewish Museum, New York. Gift of Mrs. Felix M. Warburg. *For a century, beginning in 1679, the congregation of Bevis Marks Synagogue commissioned silver trays to be given to London's Lord Mayor. A similar custom was maintained by the Dutch Reform and French Protestant churches, who were also minorities. The image of the Tent of Assembly in the Wilderness, with a guard at its entrance and surmounted by a cloud of glory, is the seal of Bevis Marks. In fashioning the tray, Ruslen, a well-known English silversmith, utilized a sumptuous, ornate style which was considered appropriate for commissions of presentation silver.*

Hanukkah Lamp Made from Soldier's Hat Plate. Prussia. 18th century. Embossed brass sheet. 9 1/2 x 13 1/2 in. (24.1 x 34.3 cm). The Gross Family Collection, Tel Aviv. Hanukkah lamps with the insignia plates from military hats were apparently made as a sign of respect for and loyalty to the Prussian King Friedrich II.

Hanukkah Lamp. Austria. c. 1782. Brass, cast. Collection of Mr. and Mrs. Norman Rosen, New Jersey. *On January 2, 1782, Austria's Emperor Joseph II enacted the Edict of Toleration. This Hanukkah lamp pays tribute to Joseph II by incorporating his profile and the double-headed eagle, symbol of the monarchy, on the backplate.*

(OPPOSITE)

Hanukkah Lamp. Austrian Empire. 19th century. Pewter, cast, engraved, cut out.
5 1/4 x 10 3/4 x 2 3/4 in. (13.3 x 27.3 x 7 cm). The Jewish Museum in Prague.
The central motif of this Hanukkah lamp is a double-headed eagle, symbolic of the Austrian Empire. The Hebrew inscription reads, "A remembrance of the miracle of Hanukkah."

דִּינָ֣ה בִּימֵ֣י אֲחַשְׁוֵר֔וֹשׁ ה֣וּא אֲחַשְׁוֵר֗וֹשׁ הַמֹּלֵ֤ךְ מֵהֹ֙דּוּ֙ וְעַד־כּ֔וּשׁ שֶׁ֖בַע
וְעֶשְׂרִ֣ים וּמֵאָ֑ה מְדִינָֽה בַּיָּמִ֣ים הָהֵ֔ם כְּשֶׁ֧בֶת הַמֶּ֛לֶךְ אֲחַשְׁוֵר֖וֹשׁ עַ֧ל
כִּסֵּ֣א מַלְכוּת֗וֹ אֲשֶׁ֖ר בְּשׁוּשַׁ֣ן הַבִּירָ֑ה בִּשְׁנַ֤ת שָׁלוֹשׁ֙ לְמׇלְכ֔וֹ עָשָׂ֣ה
מִשְׁתֶּ֗ה לְכׇל־שָׂרָיו֙ וַעֲבָדָ֔יו חֵ֣יל ׀ פָּרַ֣ס וּמָדַ֗י הַֽפַּרְתְּמִ֛ים וְשָׂרֵ֥י
הַמְּדִינ֖וֹת לְפָנָֽיו בְּהַרְאֹת֗וֹ אֶת־עֹ֙שֶׁר֙ כְּב֣וֹד מַלְכוּת֔וֹ וְאֶ֨ת־יְקָ֔ר
תִּפְאֶ֖רֶת גְּדוּלָּת֑וֹ יָמִ֣ים רַבִּ֔ים שְׁמוֹנִ֥ים וּמְאַ֖ת י֑וֹם וּבִמְל֣וֹאת ׀ הַיָּמִ֣ים
הָאֵ֡לֶּה עָשָׂ֣ה הַמֶּ֣לֶךְ לְכׇל־הָעָ֣ם הַנִּמְצְאִים֩ בְּשׁוּשַׁ֨ן הַבִּירָ֜ה
לְמִגָּד֧וֹל וְעַד־קָטָ֛ן מִשְׁתֶּ֖ה שִׁבְעַ֣ת יָמִ֑ים בַּחֲצַ֕ר גִּנַּ֖ת בִּיתַ֥ן הַמֶּֽלֶךְ
ח֣וּר ׀ כַּרְפַּ֣ס וּתְכֵ֗לֶת אָחוּז֙ בְּחַבְלֵי־ב֣וּץ וְאַרְגָּמָ֔ן עַל־גְּלִ֥ילֵ֖י כֶ֑סֶף
וְעַמּ֣וּדֵי שֵׁ֔שׁ מִטּ֣וֹת ׀ זָהָ֣ב וָכֶ֗סֶף עַ֛ל רִֽצְפַ֥ת בַּהַ֣ט וָשֵׁ֑שׁ וְדַ֥ר וְסֹחָֽרֶת
וְהַשְׁק֗וֹת בִּכְלֵ֣י זָהָ֔ב וְכֵלִ֖ים מִכֵּלִ֣ים שׁוֹנִ֑ים וְיֵ֥ין מַלְכ֖וּת רָ֑ב כְּיַ֥ד
הַמֶּֽלֶךְ וְהַשְּׁתִיָּ֥ה כַדָּ֖ת אֵ֣ין אֹנֵ֑ס כִּי־כֵ֣ן ׀ יִסַּ֣ד הַמֶּ֗לֶךְ עַ֚ל כׇּל־רַ֣ב בֵּית֔וֹ
לַעֲשׂ֖וֹת כִּרְצ֥וֹן אִ֥ישׁ וָאִֽישׁ ׃ גַּ֚ם וַשְׁתִּ֣י הַמַּלְכָּ֔ה
עָשְׂתָ֖ה מִשְׁתֵּ֣ה נָשִׁ֑ים בֵּ֚ית הַמַּלְכ֔וּת אֲשֶׁ֖ר לַמֶּ֥לֶךְ אֲחַשְׁוֵרֽוֹשׁ
בַּיּוֹם֙ הַשְּׁבִיעִ֔י כְּט֥וֹב לֵב־הַמֶּ֖לֶךְ בַּיָּ֑יִן אָמַ֡ר לִ֠מְהוּמָ֠ן בִּזְּתָ֙א
חַרְבוֹנָ֤א בִּגְתָא֙ וַאֲבַגְתָ֔א זֵתַ֖ר וְכַרְכַּ֑ס שִׁבְעַ֤ת הַסָּרִיסִים֙ הַמְּשָׁ֣רְתִ֔ים
אֶת־פְּנֵ֖י הַמֶּ֣לֶךְ אֲחַשְׁוֵרֽוֹשׁ ׃ לְהָבִ֞יא אֶת־וַשְׁתִּ֧י הַמַּלְכָּ֛ה לִפְנֵ֥י
הַמֶּ֖לֶךְ בְּכֶ֣תֶר מַלְכ֑וּת לְהַרְא֨וֹת הָֽעַמִּ֤ים וְהַשָּׂרִים֙ אֶת־יׇפְיָ֔הּ כִּֽי
טוֹבַ֥ת מַרְאֶ֖ה הִ֑יא ׃ וַתְּמָאֵ֞ן הַמַּלְכָּ֣ה וַשְׁתִּ֗י לָבוֹא֙ בִּדְבַ֣ר הַמֶּ֔לֶךְ
אֲשֶׁ֖ר בְּיַ֣ד הַסָּרִיסִ֑ים וַיִּקְצֹ֤ף הַמֶּ֙לֶךְ֙ מְאֹ֔ד וַחֲמָת֖וֹ בָּעֲרָ֥ה בֽוֹ ׃
וַיֹּ֣אמֶר הַמֶּ֔לֶךְ לַחֲכָמִ֖ים יֹדְעֵ֣י הָעִתִּ֑ים כִּי־כֵן֙ דְּבַ֣ר הַמֶּ֔לֶךְ
לִפְנֵ֕י כׇּל־יֹדְעֵ֖י דָּ֣ת וָדִ֑ין ׃ וְהַקָּרֹ֣ב אֵלָ֗יו כַּרְשְׁנָ֤א שֵׁתָר֙ אַדְמָ֣תָא
תַרְשִׁ֔ישׁ מֶ֥רֶס מַרְסְנָ֖א מְמוּכָ֑ן שִׁבְעַ֣ת שָׂרֵ֣י ׀ פָּרַ֣ס וּמָדַ֗י רֹאֵי֙ פְּנֵ֣י
הַמֶּ֔לֶךְ הַיֹּשְׁבִ֥ים רִאשֹׁנָ֖ה בַּמַּלְכֽוּת ׃ כְּדָת֙ מַה־לַּעֲשׂ֔וֹת בַּמַּלְכָּ֖ה
וַשְׁתִּ֑י עַ֣ל ׀ אֲשֶׁ֣ר לֹֽא־עָשְׂתָ֗ה אֶֽת־מַאֲמַר֙ הַמֶּ֣לֶךְ אֲחַשְׁוֵר֔וֹשׁ בְּיַ֖ד
הַסָּרִיסִֽים ׃ וַיֹּ֣אמֶר מְמוּכָ֗ן לִפְנֵ֤י הַמֶּ֙לֶךְ֙ וְהַשָּׂרִ֔ים
לֹ֤א עַל־הַמֶּ֙לֶךְ֙ לְבַדּ֔וֹ עָוְתָ֖ה וַשְׁתִּ֣י הַמַּלְכָּ֑ה כִּ֤י עַל־כׇּל־הַשָּׂרִים֙

זה המלחמה נלוית
הפלשתי עם דוד המלך

ישראל ורוס

David and Goliath Lubok. Volyhn Podolia, Western Ukraine. 1880–1910. Watercolor on paper.
12 3/4 x 16 in. (32.5 x 40.8 cm). Collection of the State Ethnographic Museum in St. Petersburg. *This
folk art print was collected as part of the An-Sky ethnographic expedition. In portraying David and
Goliath, the artist identifies David with the Jewish community and Goliath and the Philistines, who
are wearing military uniforms, with the powerful, oppressive government.*

(OPPOSITE)

Esther Scroll. Austria, possibly Vienna. 18th century. Vellum. Private collection. *The megillah includes
scenes from the Esther story. One of the figures bears a marked resemblance to the Empress Maria
Theresa of the Hapsburg dynasty. The borders along the top and bottom are filled with such animals
as lions and leopards and more exotic species such as unicorns against a background of an overall
pattern of flowering vines.*

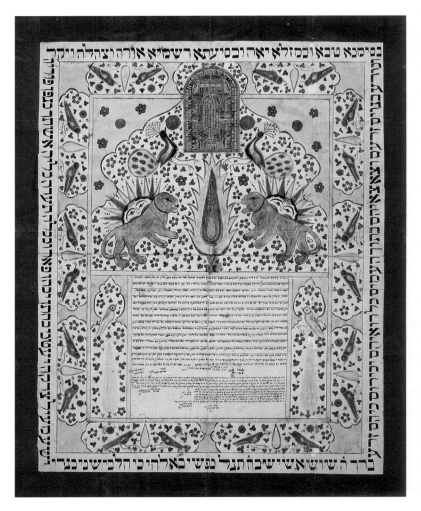

Ketubbah. Fiorenzuola. 1832. Parchment, cutout, watercolor, ink. 31 7/8 x 78 3/4 in. (81 x 200 cm). Hebrew Union College, Skirball Museum, Los Angeles. Museum purchase from Isaiah Sonne; conserved with funds from Judy Orlansky. *The figure at the top of the ketubbah has been identified as Napoleon, wearing his characteristic tricornered hat. Zemah, son of the late Zechariah Mazzal-Tov Ottolenghi, was the groom; Mazzal-Tov, daughter of Abraham Jehiel Soavi, was the bride.*

Ketubbah. Isfahan, Persia. 1898. Paper, watercolor, pen and ink, colored paper band frame. 38 3/8 x 31 1/4 in. (97.5 x 79.4 cm) 179/157; B92.811. The Israel Museum, Jerusalem. *This is the standard form of the Isfahan ketubbah of the late nineteeth century. The page is divided into two sections, with the text in the lower section. The upper part is decorated with an overall floral background within a multifoil Islamic arch. In the center, a cypress tree is flanked by the distinctive national symbol of Isfahan, a lion with a sun rising at its back. Above the lion is a pair of peacocks. This ketubbah also includes a shiviti plaque, so-called from the verse Shiviti Adonai le-negdi tamid, "I am ever mindful of the Lord's presence" (Psalm 16:8).*

(OPPOSITE)

Ketubbah. Rome. 1857. Parchment, watercolor, tempera, pen and ink. 36 7/8 x 24 5/8 in. (93.7 x 62.5 cm). The Israel Museum, Jerusalem. *Both the texts and the motifs on illuminated marriage contracts can be highly informative about the bridal couple. In this case, the groom, Daniel Joseph, son of Judah Benoliel, is referred to with a number of honorifics, "respected, magnified, extolled, wise, perfect and universal, prince and captain, decorated for heroism by the French and Ottoman kingdoms." It is because of his service to the French and to the Ottoman sultan that the flags of these governments appear. Apparently, things did not work out so well with his bride, Oro, called Boulisa, daughter of Moses ben Zonana, as the ketubbah is cut, indicating that they were later divorced.*

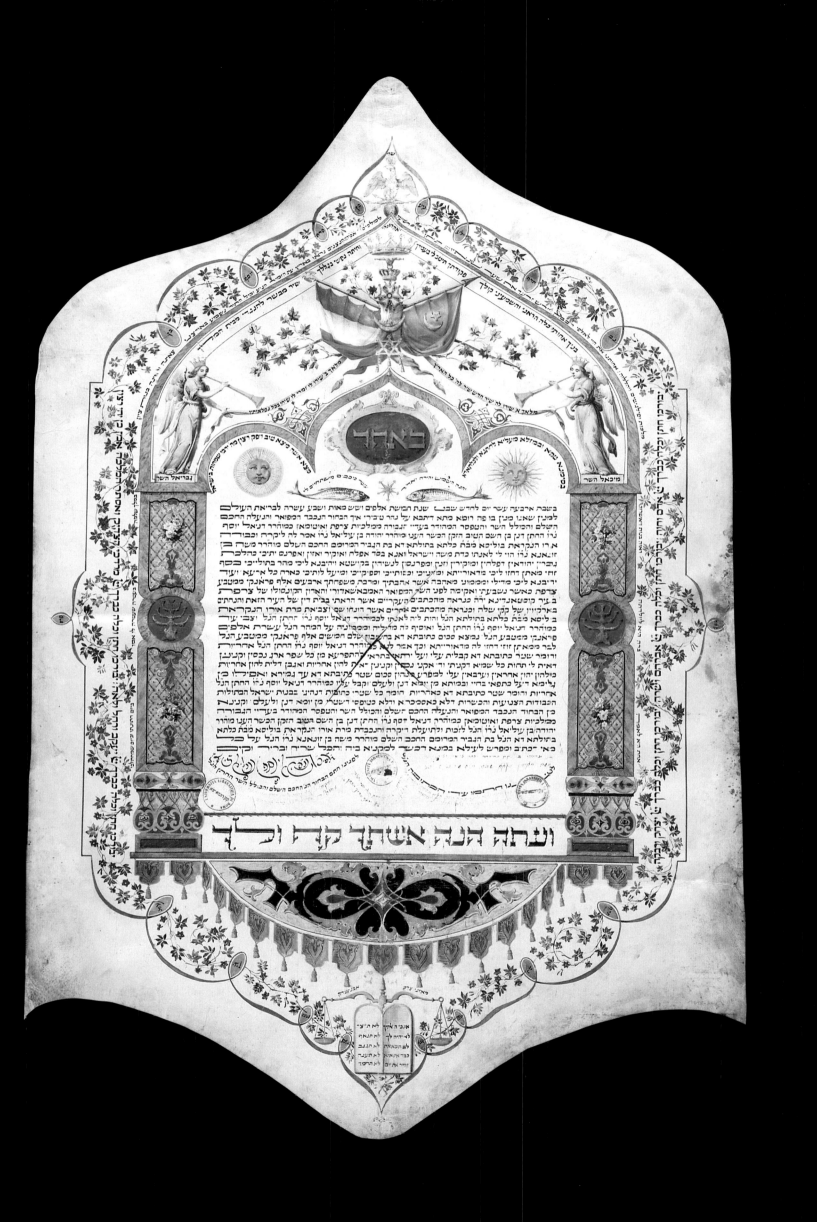

MOSES H. HENRY. *Mizraḥ*. Cincinnati, Ohio. 1850. Ink on paper. 25 5/8 x 37 1/2 in. (65.1 x 95.3 cm). Hebrew Union College, Skirball Museum, Los Angeles. Gift of Mrs. Jacob Goldsmith. *Placed on the eastern wall, the mizraḥ serves as a symbolic orientation toward Jerusalem in remembrance of the Temple. Therefore, many mizraḥs include visual and literary references to the Temple building and implements. This highly complex mizraḥ combines such references with the patriotic motif of the American eagle astride a shield and bunting of the Stars and Stripes. Included in the government. The mizraḥ is also an omer calendar to count the days between Passover and Shavuot.*

Torah Binder. Trinidad, Colorado. 1889. Linen and polychrome pigments; silk thread edging. 9 1/2 x 141 in. (24.1 x 358.1 cm). Hebrew Union College, Skirball Museum, Los Angeles. Gift of Gilbert Sanders. *The binder was made for "Kalonymous, son of Isaac Sanders, born on the ninth of Tammuz [5]659. The English name and date "Gilbert Sanders, July 8, 1889" also appear. With its American flag, this wimpel represents the transfer of a European tradition to the United States. Trinidad was a silver mining center in the late nineteenth century and one of the earliest Jewish communities in Colorado.*

(OPPOSITE)

Torah Shield. Frankfurt-am-Main. 1890. Gilded silver, embossed and chased; castings, enameling, lapis, semiprecious stones, niello. 15 3/4 x 11 3/8 in. (40 x 28.9 cm). Congregation Emanu-El of the City of New York. Gift of Jacob H. and Therese Schiff, 1890. *This Torah shield, along with a pair of Torah finials and a pointer, was commissioned from Lazarus Posen Witwe, Silversmiths, to be presented to Congregation Emanu-El by the Schiffs in honor of the confirmation of their daughter Frieda. Despite the fact that the style attests to its Germanic roots and is made in the neo-Gothic style characteristic of Posen ware, the cast eagle bearing an American shield and grasping the Ten Commandments is clearly designed to signify the synthesis of American and Jewish culture.*

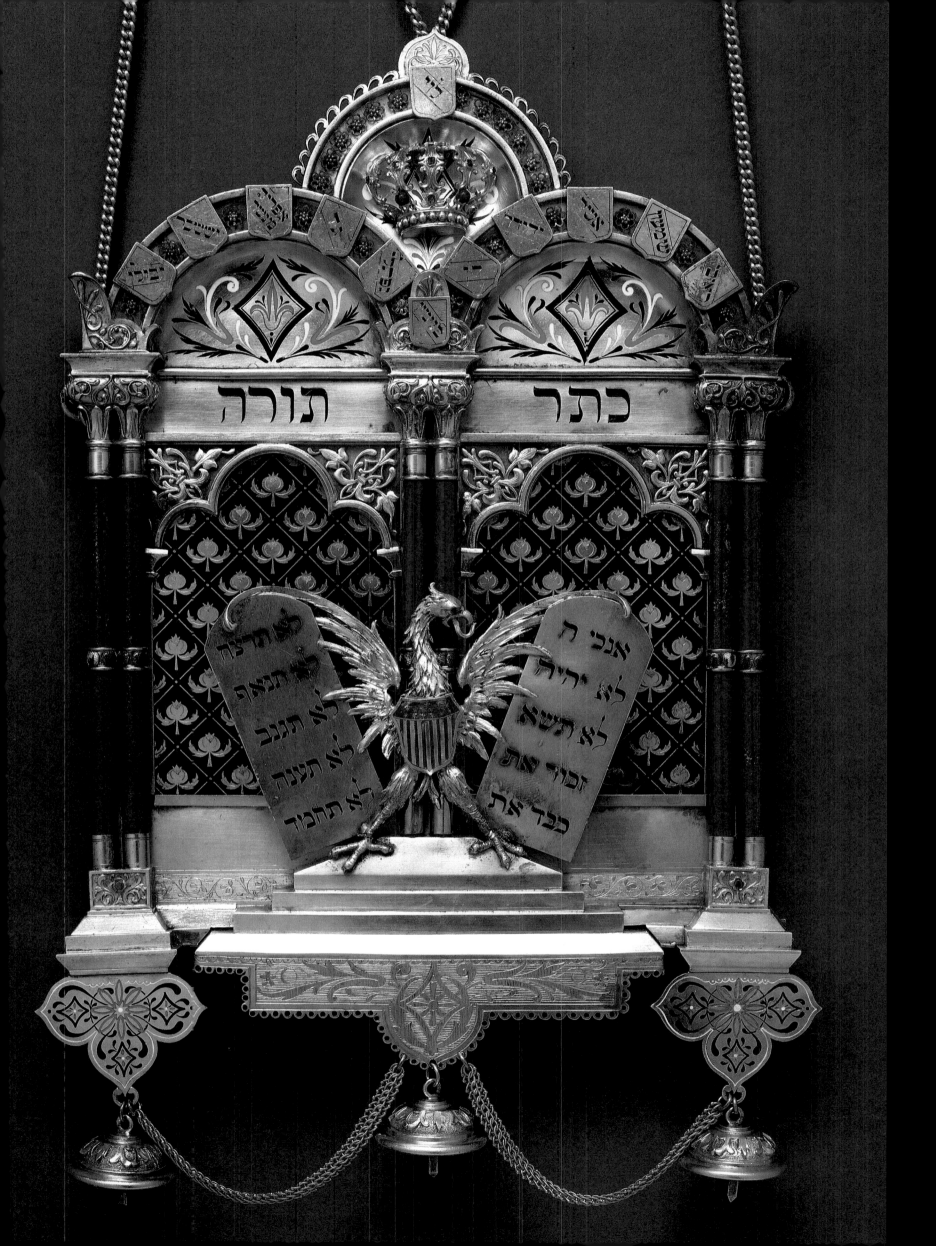

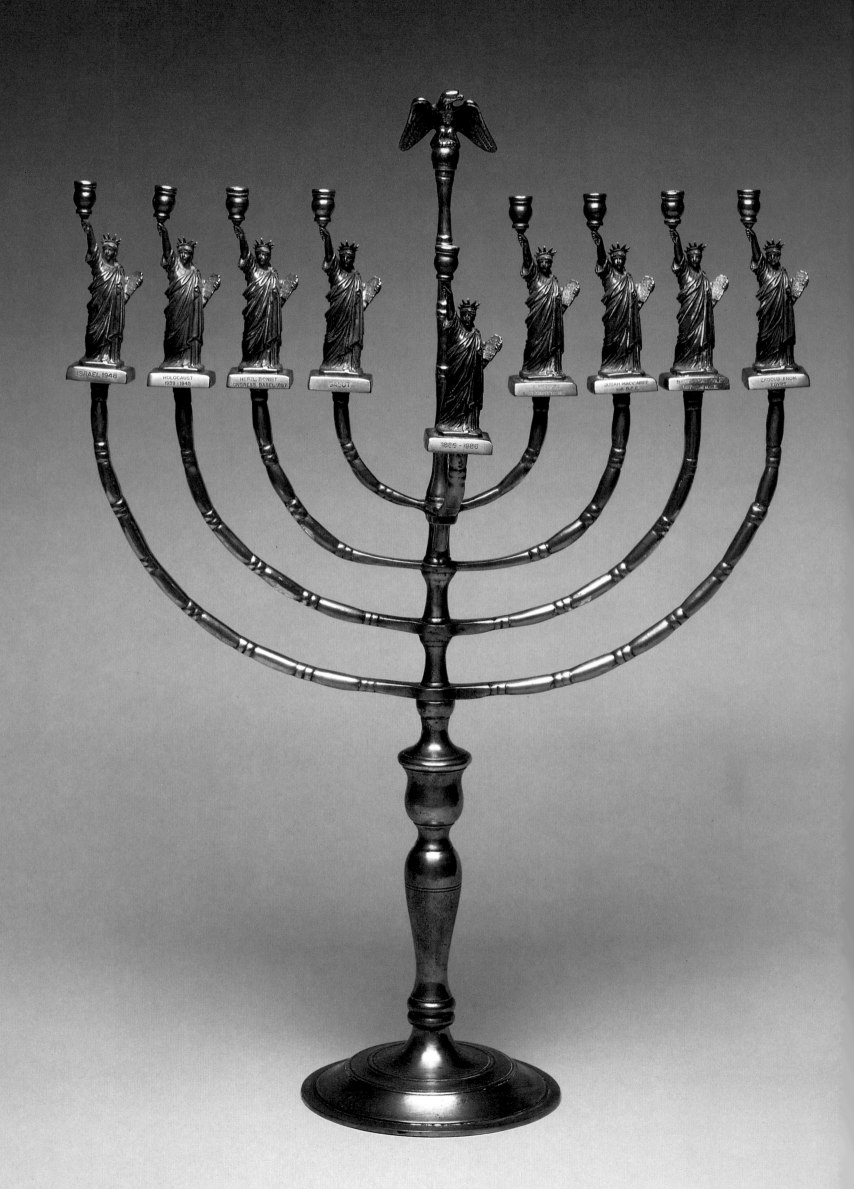

(OPPOSITE)

MANFRED ANSON. *Statue of Liberty Hanukkah Lamp*. New Jersey. 1986. Brass, cast, engraved. Height, 23 in. (58.4 cm); width, 16 1/2 in. (41.9 cm); diameter of base, 7 in. (17.8 cm). Hebrew Union College, Skirball Museum, Los Angeles. Museum purchase with Project Americana Acquisition Funds provided by Peachy and Mark Levy. *Manfred Anson crafted this Hanukkah lamp in honor of the centennial of the Statue of Liberty. The individual statues were cast from the original nineteenth-century souvenir used to raise funds for a base for the statue. As a teenager, Anson escaped Nazi Germany along with several other young men in a rescue effort by the Australian Jewish community and later came to the United States. This Hanukkah lamp both expresses his gratitude for the safe haven and represents the traditional message of the Hanukkah holiday, the triumph of right over might, with inscriptions naming the villains who sought to destroy the Jews on the pedestals beneath the statues.*

(RIGHT)

LUDWIG YEHUDA WOLPERT (1900–1981). *Torah Case*. Jerusalem. 1948. Copper and silver. Height, 36 in. (91.4 cm); diameter, 12 in. (30.5 cm). Truman Library Collection, Independence, Missouri. *On May 25, 1948, President Chaim Weizmann visited the White House and gave President Harry Truman a Torah scroll as a symbol of Israel's gratitude for American recognition of and support for the new nation. A modern version of the traditional Torah case was made by Ludwig Wolpert to house the scroll. Characteristic of his work, Wolpert's design grows from his creative use of the Hebrew letter. The silver letters encircling the ark are from Psalm 19: 7–9. The name of God, Adonai, as written with two letters, is repeated in a single row along the entire length of the case. The verse from Exodus referring to the burning bush is used to form the crown.*

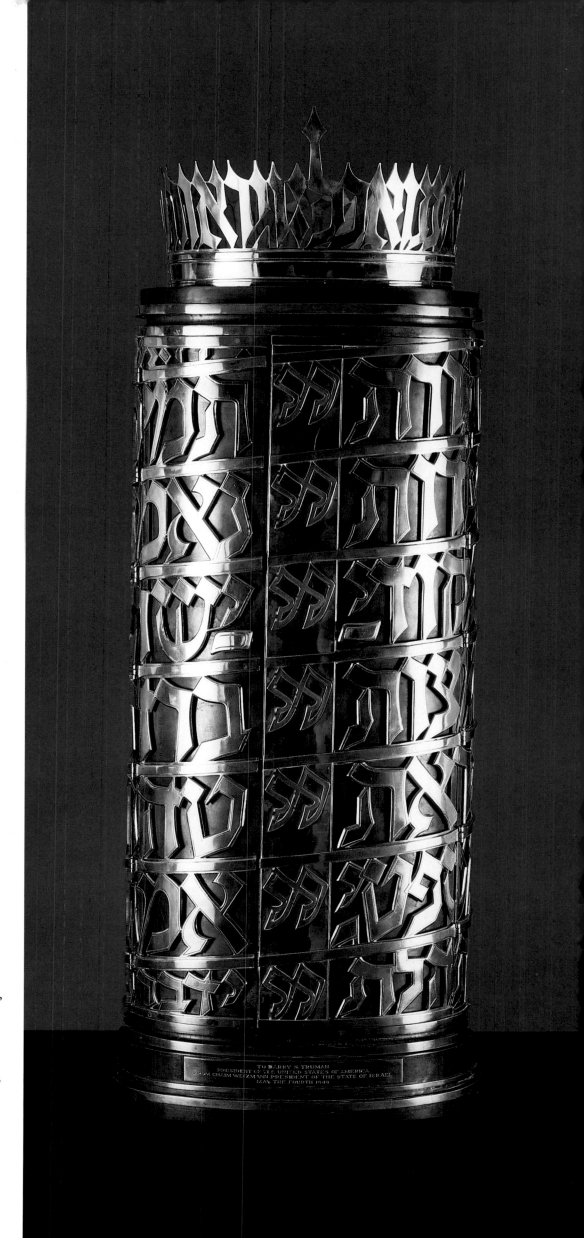

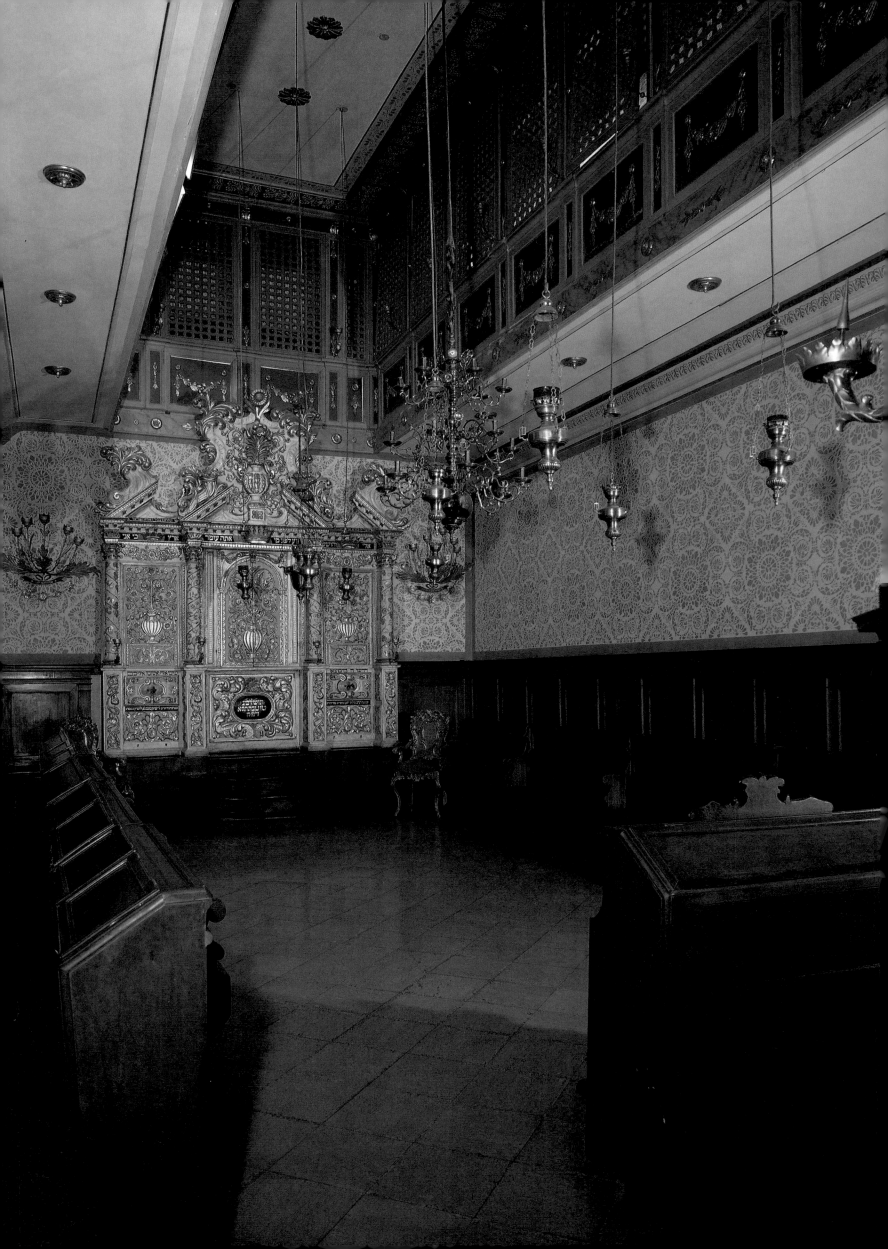

The Realm of Torah

*Moses received the Torah on Sinai, and handed it down to Joshua;
Joshua to the elders; the elders to the prophets; and the prophets
handed it down to the Men of the Great Assembly. They said
three things: Be deliberate in judgment; raise up many disciples;
and make a fence around the Torah.* (PIRKE AVOT 1:1)

THIS OPENING VERSE from the *Sayings of the Fathers*, which describes the direct lineage in Judaism from the revelation to Moses on Mount Sinai to the rabbis who codified Jewish law in the Talmud, affirms the significance of the continuity of Jewish tradition and is thus a guide to maintaining the tie to our spiritual ancestors. The giving of the Torah at Mount Sinai and its acceptance by the Israelites gave Jews a way of life, a belief, and a value system. The Torah scroll contains the first five books of the Hebrew Bible, but Torah literally means teaching and has come to have many other meanings. Torah can refer to both written and oral interpretations of the Bible and can encompass all aspects of a Jewish way of life, for the unfolding of Jewish history is found in the Torah, as are laws pertaining to all aspects of observances, from the ordinary to the extraordinary, from daily life to the Sabbath, holidays, and life cycle events.

The Torah scroll, or *Sefer Torah*, literally the book of the Torah, has been a physical as well as spiritual link from antiquity to the present. A portion of the Torah is read during the course of synagogue worship on Sabbath mornings and afternoons and Monday and Thursday mornings, as well as on festivals. The annual cycle of Torah readings is divided into fifty-four *parashot*, as established in the Babylonian Talmud. A triennial cycle, as determined in the Palestinian Talmud, is followed in certain communities today, with only one third of the weekly *parashah* being read. Specific readings for the holidays are likewise fixed. The identical portion is read in synagogues throughout the world.

Each Torah scroll is handwritten by a trained *sofer* (scribe) on specially prepared sections of *klaf* (parchment or vellum) carefully sewn together using *gidin* (threads of sinew from a kosher animal). The parchment is sewn to two rods. According to the Talmud, to emphasize its uniqueness the Torah is rolled toward its middle (Baba Batra 14a) while other scrolls were wound end to end. The rods are called *azei hayyim* (trees of life). The Torah itself is referred to as a Tree of Life (Proverbs 3:18). When a Torah scroll is *pasul*, worn out or damaged beyond repair, it is either properly buried in a cemetery or placed in a genizah.

(OPPOSITE)

Torah Ark from the Vittorio Veneto Synagogue. Italy. 1700. Wood, gilt, brass, silver. 408 x 228 in. (1036.3 x 579.1 cm). The Israel Museum, Jerusalem. Transferred and installed in the museum through a gift of Jakob Michael, New York, in memory of his wife Erna Sondheimer-Michael. *The carved and gilt wood Torah ark resembles the interiors of Italian Baroque churches, fusing architectural design and highly ornate sculptural decoration, as in the vibrant detailing of the broken pediment and the lush vine motifs. The synagogue was used by the Ashkenazi community of Vittorio Veneto for more than two hundred years; indeed, an inscription on the ark indicates that the gilding was restored in 1842. However, by World War I, the population had dwindled and the synagogue was no longer in use. The entire interior and its furnishings were transferred to Jerusalem in 1965.*

The text of the Torah is written without punctuation. Though there is a rich tradition in Judaism of illuminating Bibles, the Torah scroll is never illustrated or decorated. The only ornamentation are crownlets, *taggin*, added above thirteen of the twenty-two letters of the Hebrew alphabet. Due to strict guidelines governing the writing, the appearance of the Torah scroll remains unchanged. Only variations in the script identify the scribe's regional lineage. The strength of this bond is evident in a seventeenth-century Torah scroll from China that retains the form of all other Torah scrolls even though, by the time it was written, the Chinese Jewish community had been isolated from the rest of the Jewish world since the sixteenth century.

Because of the special status of *kedushah* (sacredness) of the Torah scroll, much loving attention has been paid to the Torah appurtenances (*klei kodesh*), implements of holiness. As a sign of respect, the Torah is always covered when not being used. The Torah coverings and ornaments are of the finest materials available to the community. The divergent paths of the Jews fostered the development of very different styles of ceremonial objects according to contemporary taste. Over time, certain iconographic styles developed that were characteristic of specific communities. The purpose of making ceremonial objects, regardless of the circumstances, is to express *hiddur mitzvah* (enhancement of the commandment). This concept derives from the talmudic interpretation of the biblical verse, "This is my God and I shall glorify Him" (Exodus 15:2). The Talmud explains, [How can one beautify God?] "Beautify yourself before him in *mitzvot*. Make before Him a beautiful *sukkah*, a beautiful *lulav*, a beautiful *shofar*, beautiful *tzitzit*, a beautiful *sefer Torah*, and write in it for His sake with beautiful ink, a beautiful pen by a skilled scribe, and wrap it in a beautiful wrapper" (Babylonian Talmud, *Shabbat* 133b). The striving for hiddur mitzvah refers both to artisans themselves and to donors who participate in the enhancement of the commandment by providing for the needs of the synagogue, from funds for the building to the dedication of Torah ornaments. Very few Torah accessories survive from before the seventeenth century. Our knowledge of the type of ornaments used earlier is primarily learned from antiquities, texts, and illustrations in manuscripts. Of great benefit to historians of Jewish art is that many of the donor inscriptions include places and dates as well as names.

Though it is legally permissible for a quorum of ten to pray anywhere, the synagogue serves as the locus of Jewish worship. The size and form of synagogue structure has been dependent on the status of the Jewish community within the general population, and the design parallels other aspects of Jewish art in that the architectural style is very much reflective of the local environment. The El Transito Spanish synagogue (c. 1360) built by Samuel Halevi Abulafia, finance minister and adviser to King Pedro the Cruel of Castile, reflects Mudéjar architecture in the liveliness of its ornate plasterwork, similar to that found on Christian and Islamic buildings of the same time. The splendor of Italian Baroque organic integration of sculptural form and architecture is the stylistic paradigm for the Vittorio Veneto Synagogue, which dates from 1700. The simplicity of Protestant meeting houses influenced the design of the Spanish Portuguese Synagogue in Amsterdam, built between 1671 and 1675, the Bevis Marks Synagogue in London, and the Touro Synagogue in Newport, Rhode Island, dedicated in 1763. None of the architects of these buildings was Jewish. The architect of the Spanish Portuguese Synagogue was Elias Bouman, a Christian contractor who had also worked on the Great Synagogue of the German Jewish community, completed in 1671. The builder of Bevis Marks was Joseph Avis, a Quaker carpenter; the Touro was designed by Peter Harrison, a leading Colonial-era architect.

As evidenced in archaeological finds, the synagogue became the spiritual successor to the Temple. The legacy is emphasized by the using the nomenclature of the Temple for aspects of the synagogue. Use of biblical terms reinforces the concept of the synagogue as a *mikdash me'at* (small sanctuary), both as a reminder of the Temple in Jerusalem and as a hope for the renewal of the Temple in the messianic age.

The focal element of the synagogue is the *aron haKodesh* (the holy ark), which makes the link to the biblical Ark of the Covenant. Another term used in Sephardi and eastern communities for the ark is *heikhal*, a connection to the Jerusalem Temple. Traditionally, the Torah ark is placed on the wall facing toward Jerusalem In some ancient synagogues, such as Dura-Europos, it appears that the Torah niche only housed the scrolls during the service; afterwards they were stored elsewhere. Often, the ark is integrated into the architecture of the synagogue, a precedent preserved as early as the carved stone ark in the medieval Altneushul in Prague, the oldest extant synagogue in Europe.

Some arks developed as freestanding cabinets, such as an ark dated 1472 from Modena, Italy, similar in design to secular furniture cupboards of the time. Many freestanding arks are elaborately made. A brightly painted carved pinewood eighteenth-century Torah ark from Bavaria was made by a craftsman who creatively simulated fine materials from simpler ones. A late nineteenth-century ark from the community of Ernakulam, India, demonstrates a highly sophisticated use of carved, painted, and gilt wood in an elaborate decorative style influenced by western European design. A Torah ark made in Sioux City, Iowa, in 1899 was inspired by the design of the wooden synagogues. The intricacy and vitality of Polish carving techniques and the integration of symbolic content into the design can be seen in a pair of ark doors illustrating the animals from the verse, "Be strong as a leopard, light as an eagle, fleet as a hart, and strong as a lion, to do the will of thy father in heaven" (Pirke Avot 5:23), set among the red-tiled roofs of Krakow architecture.

Covering the ark with a *parokhet* (Torah curtain) in most Ashkenazi and some Sephardi communities is part of the biblical injunction (Exodus 26:31) to veil the ark and is yet another link to the tabernacle and the Temple. Early examples of how the parokhet was apparently used is found on Byzantine mosaic floors in Eretz Yisrael as well as on gold-glass from the Jewish catacombs in Rome. A *kapporet* (valance), which also has a biblical antecedent (Exodus 26:34), is often used with the curtain. A late nineteenth-century ark curtain from Turkey derives its design from an Islamic prayer rug with a portal format, embroidered with an image of the *ner tamid* (eternal light), hung above the Torah ark as a reminder of the imperative to maintain a continuously burning light outside the Tabernacle (Exodus 27:20–21). Another Sephardi example, made in Vienna in 1887 by fourteen women of the Russo family, also uses the portal motif and a Moorish-style hanging lamp, here combined with Art Nouveau ornamentation.

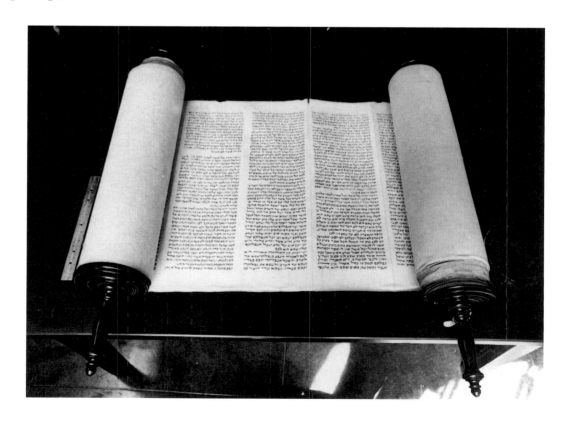

Torah Scroll. Kaifeng, China. 17th century. Library of the Jewish Theological Seminary of America, New York. No matter where a Torah scoll is written, its basic form is the same, linking all Jewish communities. There are some variations in the script, and here it is possible to see the type of lettering found on the surviving Hebrew texts from Kaifeng. The synagogue in Kaifeng was rebuilt and rededicated in 1653. At that time there were thirteen scrolls which were numbered in Hebrew. This Torah scroll is number seven.

One of the oldest known Torah curtains, dedicated in Prague in 1602, includes a medallion with three crossed carps, the donor's coat of arms, and typifies the pride taken in the presentation of ceremonial objects to the synagogue. The finest possible fabrics, silks and velvets, have always been sought for textiles to dress the Torah. The central panel of this curtain is made from sections of silk pieced together.

Clothing was often fashioned into synagogue textiles. Sometimes it was because of a tradition to make a vow in times of illness or problems during childbirth to donate one's best clothing to the synagogue upon recovery. The appropriateness of this practice is discussed as early as the fourteenth century by the Maharil, (Rabbi Jacob Mölln), a noted German rabbinical authority. Providing that the original form was changed, the rabbis generally permitted the practice of reusing garments, and thus the phenomenon of "wardrobe to worship" evolved. In European countries, fine clothing, primarily women's dresses and men's waistcoats, was reused in the design of Jewish ceremonial textiles. Apparently, this apparel was procured by Jewish dealers in secondhand clothes from aristocrats who continuously sold outmoded fashions to purchase the latest styles. In the Ottoman Empire, in addition to reworking garments, beautiful embroidered fabrics from bridal dowries, originally intended as bedspreads or pillow covers, have also been transformed for use in the synagogue.

Two different traditions evolved for Torah covers. A textile mantle, called a *me'il*, is used to dress the Torah in Ashkenazi and some Sephardi communities. The form of the mantles varies: Ashkenazi mantles generally have a stiff top which fits over the Torah staves; the Sephardi type usually has a soft top and conical shape. The style of Torah mantles from North Africa is more form-fitting, resembling the shape of Torah cases. Ashkenazi mantles generally include some type of symbolism and often a dedicatory inscription. A Torah mantle from Prussia (c. 1713–50) synthesizes Jewish imagery of a crown and the Hebrew initial letters for "crown of Torah" with the heraldic shield of Friedrich Wilhelm I, who ruled Prussia from 1713 to 1740. Sephardi mantles do not as a rule have inscription or symbols but are simply made of the finest brocades, silks, velvet, and satin available. The Portuguese Jews of Amsterdam were involved in the textile trade and were able to procure very fine fabrics, such as a silk brocade used for a Torah mantle. The stand on which the Torah is placed for reading, called the *bimah* in Ashkenazi communities and *tevah* in Sephardi and among the *Edot Mizrach* is also covered with a textile.

In oriental communities and among some Sephardim, the Torah scroll is housed within a case called a *tiq*. Scholars have generally dated the origin of this custom to tenth-century Iraq. The earliest documentary evidence of a tiq is a listing in the Cairo genizah dating from the tenth to the twelfth century. Torah cases are generally made of wood which is then ornamented. The two extant Torah cases from eighteenth-century China are painted with a characteristic Chinese lacquer technique. Some cases are covered with fabric and decorated with metal appliqués, like the case with crown and shield made in the Ottoman Empire in 1874, or entirely overlaid with metal, usually silver, like the case dedicated in 1916 in India in the Iraqi style. There are also regional variations in the shape of the Torah cases: Some are round, like the case from India; some are faceted like a carved wood case and finials from North Africa; some have flat tops, others bulbous-shaped domes, such as those from Persia; and some are banded by an *atarah* (crown) along the top edge of the case. The Torah is read directly from the tiq, which is placed upright on the reader's desk.

As a pragmatic measure to avoid damage to the parchment, the Torah is wrapped with a Torah binder, also called a *mappa* or *mitpahat*. In most communities, the binders are made of fine cloth; in Italy and examples from the Ottoman Empire, they are decorated with floral motifs. Often there is an inscription with the name of donor. Beginning in Germany in the seventeenth century, it became customary to make Torah binders, there called wimpels, upon the birth of a child. While most wimpels were made by the child's mother or grandmother, sometimes they were commissioned from professionals, such as the Torah binder

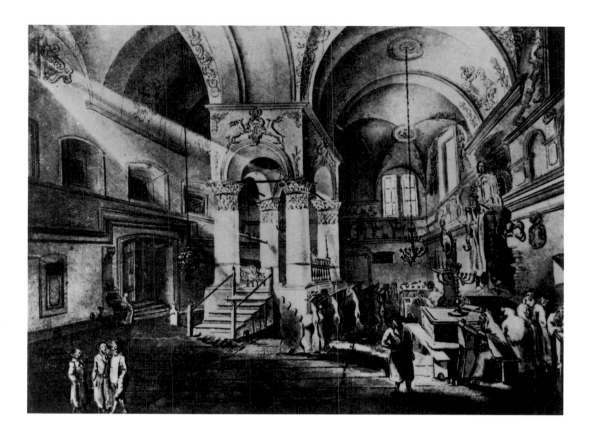

ZYGMONT VOGEL. *Lancut Synagogue*. Lancut, Galicia, Poland. Late 18th century. Watercolor. Courtesy of Beth Hatefusoth, The Museum of the Diaspora, Tel Aviv. *Dating back to the medieval period, the* bimah *was placed in the center of the synagogue. In some instances, the* bimah *actually became a built-in feature of the architecture. Here, four barrel arches spring from the large, central tabernacle form of* bimah. *This work is part of a series of views of towns and castles in southern Poland commissioned by King Stanislaw Augustus.*

made by Koppel Heller for Menachem Mendel Lilienthal, who later became a prominent reform rabbi in the United States.

The staves of the Torah scroll are decorated with finials, commonly called *rimmonim*, Hebrew for pomegranates. Often, the finials are decorated with bells. While there is no rabbinic source to confirm the association of pomegranates and bells, reference is now often made to the biblical description of the robes of the High Priest which had the design of a golden bell and a pomegranate all around the hem of the robe (Exodus 28:33). The rimmonim are believed to be among the oldest Torah ornaments, and literary evidence exists dating their use as early as the twelfth century. Maimonides mentions "silvers and gold rimmonim, and the like that are made for the beauty of the Torah scroll" (Mishnah Torah, Hilkot Sefer Torah, 10:4). There is a single extant pair of tower-form finials from the fifteenth century, now in the Cathedral Treasure of Palma de Majorca, transformed for use in the church as stave ornaments. The form of Torah finials varies widely, with regional types evolving. A tiered-tower pair of finials from eighteenth-century Germany combines architectural structure with the fantastic by placing grotesques at the corners. When a Torah tiq is used, there are often ornamental rimmonim placed on rods which protrude from the top of the case; six individual finials adorn an Afghani Torah case.

A Torah crown, *keter* or *atarah*, is sometimes used in place of the rimmonim. The use of crowns is also a very early practice, documented as early as the twelfth century in the Cairo genizah. Known crowns are primarily from Ashkenazi communities. A crown made in Lemberg (Lvov) in the eighteenth century reflects the ark designs and painted ceilings of wooden synagogues, like the synagogue paintings of Eliezer Sussmann, effusively filling every possible space. The tiered crown is virtually covered with architectural and ornamental elements and real and mythical animals. It includes a band with the signs of the zodiac and two separate dedicatory inscriptions. A variation pairing the crown with finials is documented in the fourteenth-century *Sarajevo Haggadah* from Barcelona. The Sephardi tradition continued in Italy and is also found in examples from Holland and the Ottoman Empire.

The Torah shield (*tas*) is an ornamental plaque hung from the staves of the Torah. Torah shields were first used in Germany in the mid-sixteenth century. This Ashkenazi custom grew out of the practice of

RIKAH POLACCO. *Torah Binder.* Florence (?). 1662–63. Linen embroidered with silk and metal threads. 6 1/2 x 110 3/4 in. (16.5 x 281.4 cm). The Jewish Museum, New York. Gift of Cora Ginsburg. *It is customary to give honor to those who help care for the needs of the congregation by reciting a special blessing. In Italy there is an additional prayer recited on the Sabbath and festivals for "every daughter of Israel who makes a mantle or cover in honor of the Torah." Rikah Polacco made this beautiful binder, with its naturalistic flowers, of needlepoint, integrating her name and the date in the design.*

contributing Torah scrolls to the synagogue as an act of piety; a large synagogue might have quite a number of scrolls. Depending on the liturgy for the day, corresponding to the Sabbath, holidays, new month or any confluence of these, two or even three scrolls may be used for the separate sections of the Torah to be read. To avoid confusion, a pragmatic solution was developed of using a Torah shield with interchangeable panels indicating to which portion the Torah was rolled. Torah shields often became highly ornate. A tas attributed to Michael Gross includes figures of Moses, Aaron, David, and Solomon, as well as a scene of the binding of Isaac. In time, the tas often lost its functional purpose. In Italy, the shield developed only as a decorative element, often in the shape of a half crown.

As ancient law forbids touching the sacred text (Babylonian Talmud, Shabbat 14a), a *yad* (hand) is used as a pointer when reading from the Torah scroll. The earliest known example is from Italy from the late fifteenth century. From the eighteenth century, known Ashkenazi examples typically include at the end of the central shaft a cuffed sleeve from which a small hand protrudes with the index finger extended. A group of Torah pointers from Prague reveals a variety of materials and styles.

The sanctity of the Torah places Torah ornaments in a special category of ceremonial object. They are not simply vessels used to carry out a ritual act, like a Sabbath lamp, but adorn the Torah which is itself holy. The spiritual intent of providing implements of holiness is the same for a wealthy patron commissioning a fine silversmith or a folk artist working with simple materials. The tremendous diversity of Torah ornaments is testimony both to the dedication of the donors and the creativity of the artists who made them.

Torah Tiq. Kaifeng, Honan Province, China. 17th century. Wood, lacquer, gilt; bronze hinges. Height, 30 in. (76.2 cm); diameter, 11 1/4 in. (28.6 cm). Hebrew Union College Skirball Museum, Los Angeles. *Around 1000 C.E., Jews presumed to be silk traders from Persia, settled in central China. Long unknown to the West, the first renewed contact was made with Chinese Jews by Jesuit missionaries in 1605. The tradition of using a cylindrical case for the Torah scroll, gilt-lacquered in the Chinese fashion, is further evidence of the interaction between religious heritage and the stylistic influence of the dominant culture. The Jewish community of Kaifeng eventually became completely assimilated, its remaining Torah scroll, manuscripts, and several artifacts sold to the West.*

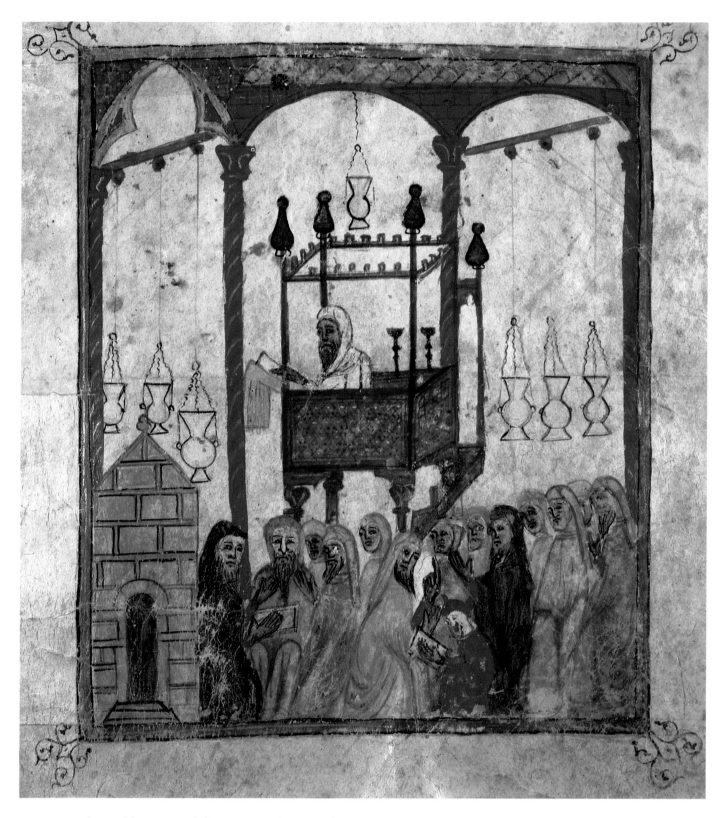

"Sister" to the Golden Haggadah. Spain. 14th century. Parchment. 9 1/8 x 7 1/2 in. (23.2 x 19.1 cm). Or. Ms. 2884, fol 17v. The British Library, London. *In a Spanish synagogue, a ḥazzan reads the haggadah to members of the community. The wood carving of the raised platform on which he stands reflects the ornate stucco work of the Mudéjar style, which developed after the Christian reconquest of Spain and draws from both Christian and Islamic artistic traditions. This influence can be seen in the surviving Spanish synagogues, Santa Maria La Blanca from the thirteenth century and El Transito, built about 1360.*

(OPPOSITE)

Torah Ark. Modena, Italy. 1472. Wood, carved, inlaid. 104 1/4 x 51 1/8 x 30 5/8 in. (264.8 x 129.9 x 77.8 cm). Musée national du Moyen Age-Thermes de Cluny, Paris. Don Rothschild collection, Strauss N°1. *Made in the form of a cabinet, this is the only Torah ark to have survived from western Europe from the Middle Ages. At the time, Torah arks were called a fortress (migdal) as is alluded to by the architectural form of this ark. The middle section of the lower frieze opens to form a shelf, on which there is a marquetry "tree of life" motif. The Hebrew inscription includes biblical quotations, one of which has highlighted letters whose numerical equivalent identifies the date the ark was made [5]232 (=1472) and the donor's name, Elhanan Raphael, son of Daniel.*

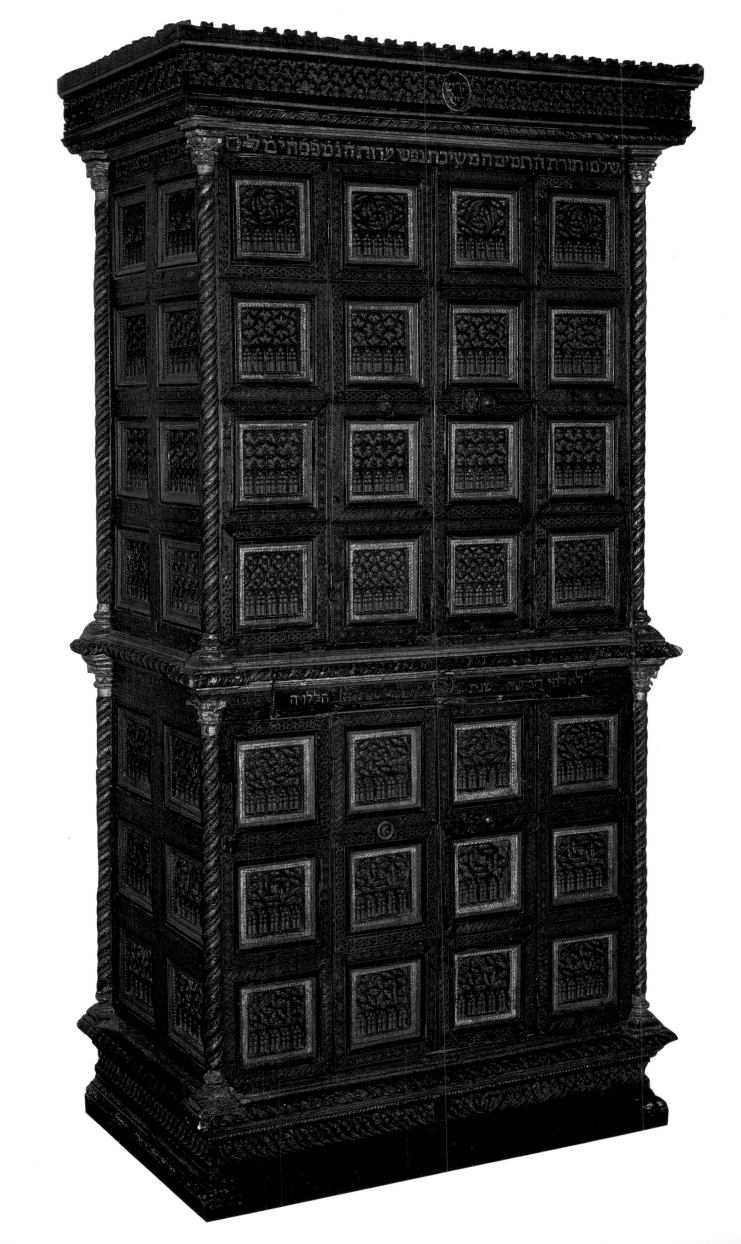

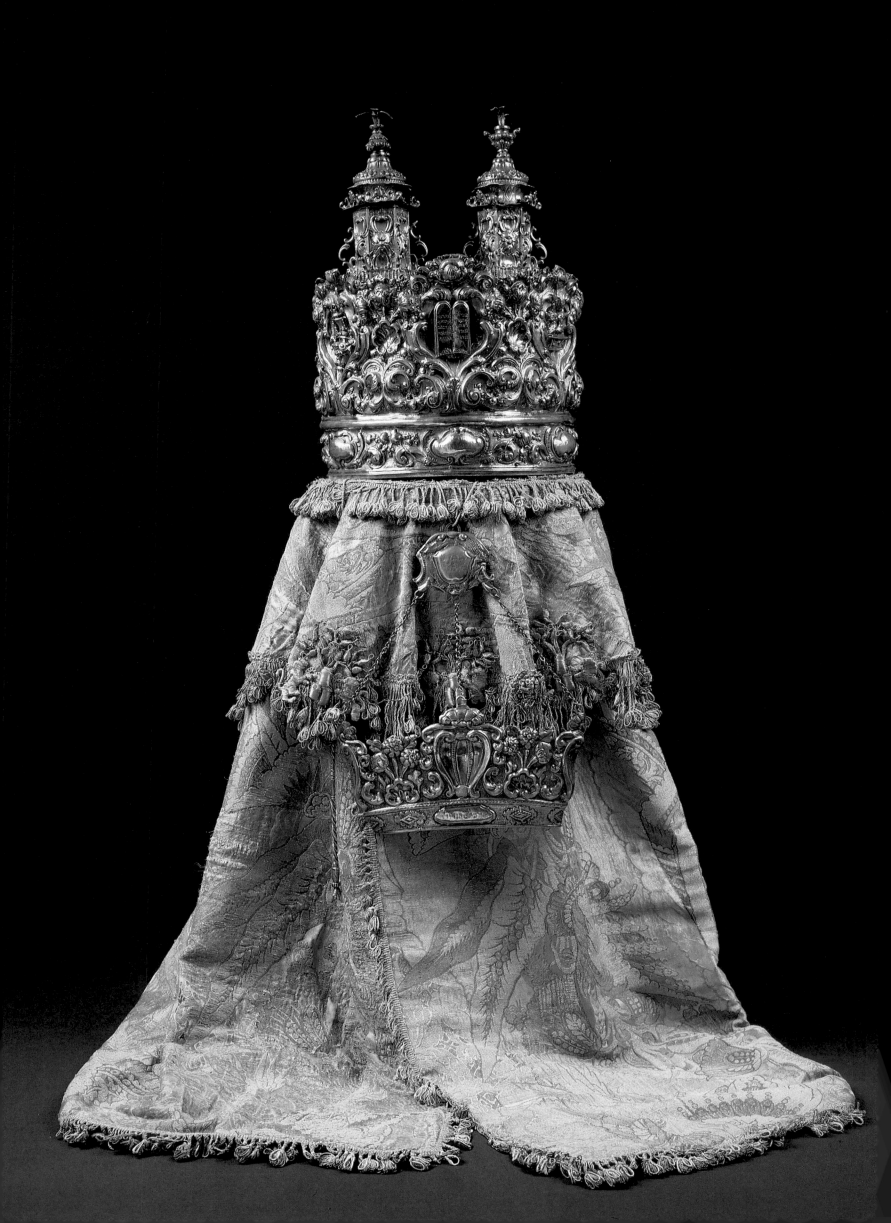

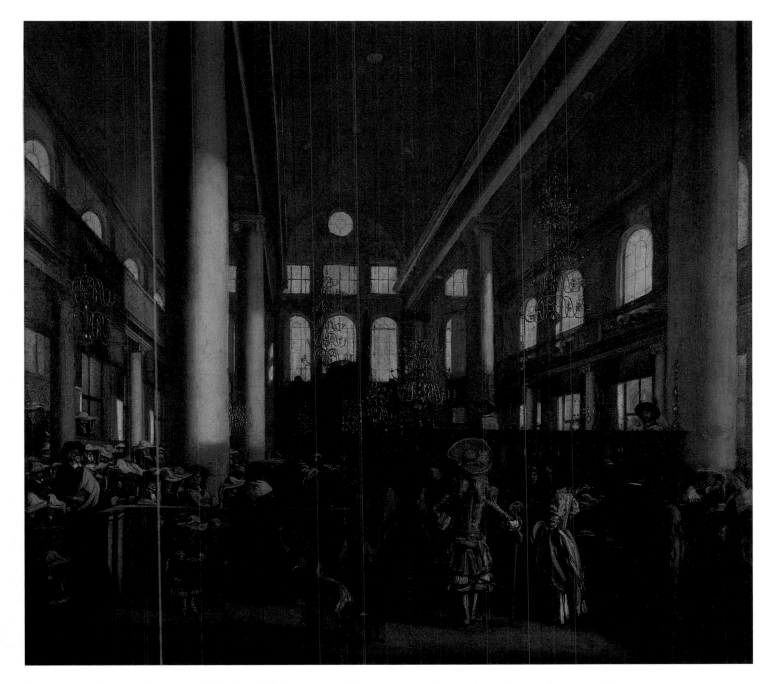

EMANUEL DE WITTE. *Interior of the Spanish Portuguese Synagogue in Amsterdam.* Amsterdam. c. 1680. Oil on canvas. 43 1/4 x 49 1/4 in. (109.9 x 125.1 cm). The Israel Museum, Jerusalem. *The historic Spanish Portuguese Synagogue in Amsterdam, designed by architect Elias Bouman and completed in 1675, immediately became a city landmark and served as the inspiration for eighteenth-century Sephardi synagogues built in London, Curaçao, and Newport, Rhode Island. The perspective of the painting is that of the notables pictured in the foreground, watching as the worship service progresses, yet it is the beauty and grandeur of the building which is highlighted, the figures dwarfed by the monumental scale of the interior.*

(OPPOSITE)

Italian Dressed Torah. Mantle. The Israel Museum, Jerusalem. Mantle, finials, and pointer gift of Jakob Michael, New York, in memory of his wife Erna Sondheimer-Michael. *Torah ornaments from Italy are especially rich and handsome. The textiles are made of rich brocades or metal thread embroideries. The Torah ornaments also have distinctive features. In Italy it is customary to use both finials and a crown on the scroll, and the shield is generally in the shape of a half crown.*

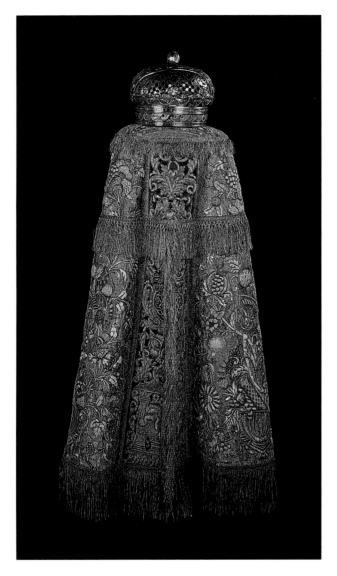 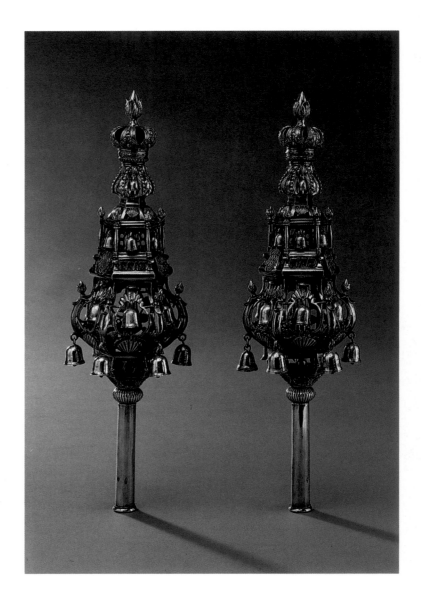

(ABOVE, LEFT)

Amsterdam Dressed Torah. Torah mantle. c. 1715. Velvet, silk brocade, gold and silver metal thread. Height: 30 1/4 in. (76.8 cm). WILHELMUS ANGENENDT. *Torah Crown.* Dated 1775. Silver and gold. Diameter: 9 in. (22.9 cm). Collection of the Jewish Historical Museum, Amsterdam. On loan from the Portuguese Community of Amsterdam. *The richly embroidered Sephardi Torah mantles in Amsterdam have a distinctive conical shape, soft top, and often a fringe about a third of the way down. They are designed with a split on one side, also fringed, for easier placement on the scroll. The Portuguese Jews of Amsterdam were involved in the textile trade, making it possible for them to acquire the very finest of fabrics from Italy, France, and England. The custom in Amsterdam was for crowns to dress the Torah only on Yom Kippur and Simchat Torah; at other times, finials were used.*

(ABOVE, RIGHT)

WILLEM ROSIER (?) *Mendez da Fonseca Torah Finials.* Amsterdam. 1717. Silver, partial gilt, cast, embossed, chased. Height: 18 1/4 in. (46.4 cm). Congregation Emanu-El of the City of New York. Gift of Mr. and Mrs. Henry M. Toch, 1928. *These* rimmonim *bear the crests and monograms of Mendez and Da Fonseca, two well-known Sephardi families in Amsterdam. That two family emblems appear suggests that these finials may have been a gift to the synagogue in honor of a marriage. The form with the lower tier, a pomegranate surmounted by a tower and spire, is typical of early eighteenth-century Dutch Torah finials.*

(OPPOSITE)

PETER HARRISON (ARCHITECT). *Touro Synagogue.* Newport, Rhode Island. 1763. *Built for the Sephardi congregation Jeshuat Israel in Newport, Rhode Island, the synagogue was named in honor of its first spiritual leader, Isaac Touro, who died in 1784. Designed by a leading New England architect, Touro is the oldest surviving synagogue building in America and one of the most significant examples of eighteenth-century architecture in America.*

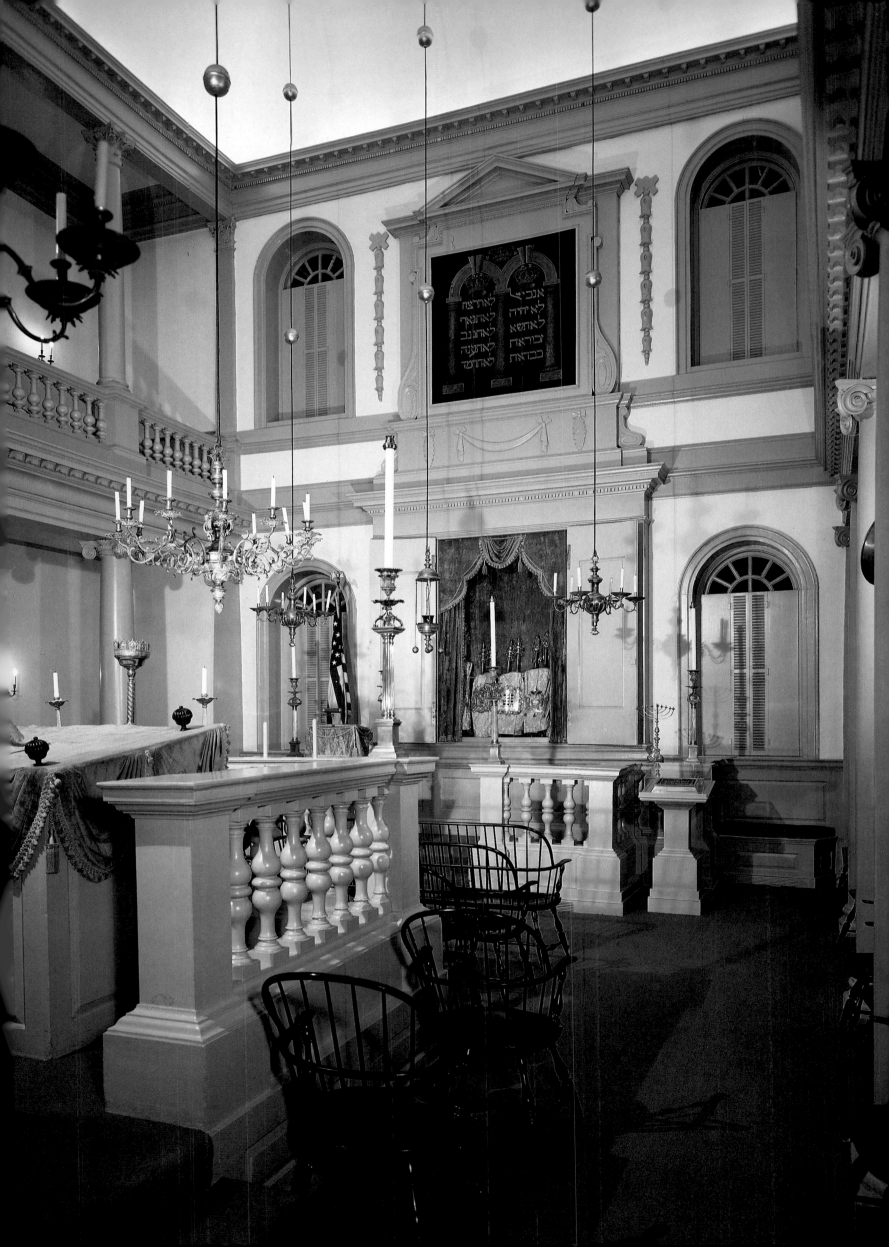

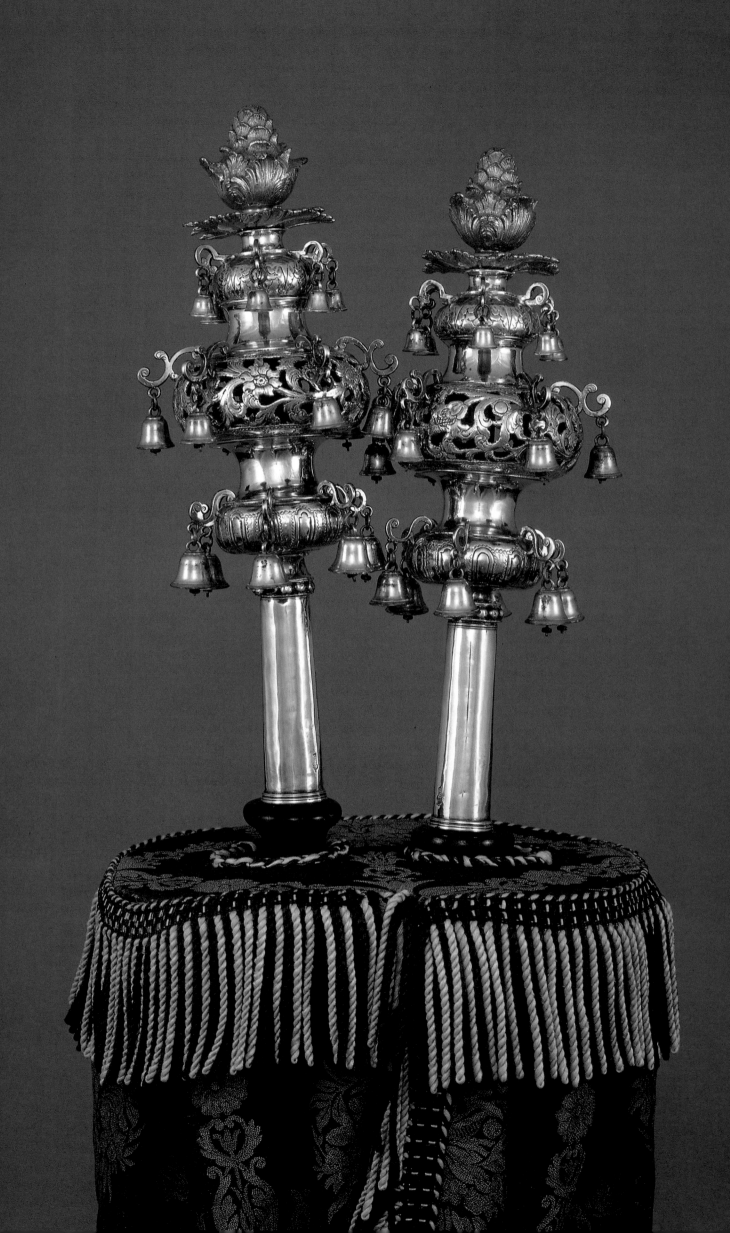

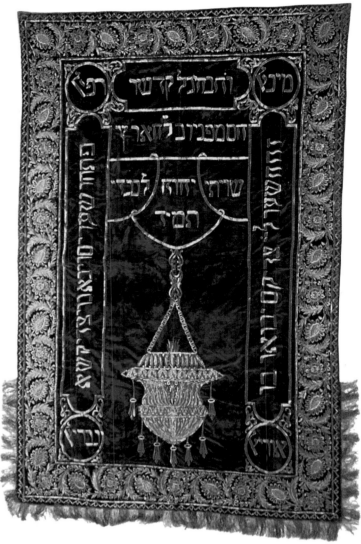

Torah Ark Curtain. Vienna. 1887. Silk, embroidered with silk and lamella. 137 x 89 1/8 in. (348 x 226.4 cm). Collection of Mr. and Mrs. Abraham Halpern, New York. *Made by fourteen women of the Russo family, this Torah curtain was donated for the dedication of the new Sephardi synagogue in Vienna on September 17, 1887. Masterfully designed and executed, the Torah curtain includes a lengthy inscription with each of the women's names. The Viennese Sephardi community was largely of Turkish origin, and the curtain displays the influence of Ottoman design, such as the portal composition and the Islamic-type hanging lamp.*

Torah Ark Curtain. Ottoman Turkey. Late 19th century. Velvet, satin, couched metal-thread embroidery. 110 x 72 1/2 in. (279.4 x 184.2 cm). Smithsonian Institution, Washington, D.C. Museum purchase. *The iconographic composition of a portal and hanging lamp is widely used on Torah ark curtains from the Ottoman Empire, its style derived from Islamic prayer rugs. The motif acquires a Jewish meaning with the addition of biblical verses relating to the Temple and the sacred sha'ar or gateway. This Torah ark curtain was purchased just prior to the World's Columbian Exposition in 1893 and was included in the landmark Smithsonian Exhibition on Comparative Religion on display in the United States Government Building.*

(OPPOSITE)

MYER MYERS (1723–1785). *Torah Finials.* New York. 1772. Silver. Height: 13 in. (33 cm). Congregation Mikve Israel, Philadelphia. *Myers was a well-known silversmith of the Colonial era. He was also an active member of the Jewish community and made Torah finials for Congregation Shearith Israel in New York, Touro Synagogue in Newport, Rhode Island, and Congregation Mikve Israel in Philadelphia. Myers was from a Dutch Sephardi family, and his rimmonim strongly reflect the Dutch style of finials.*

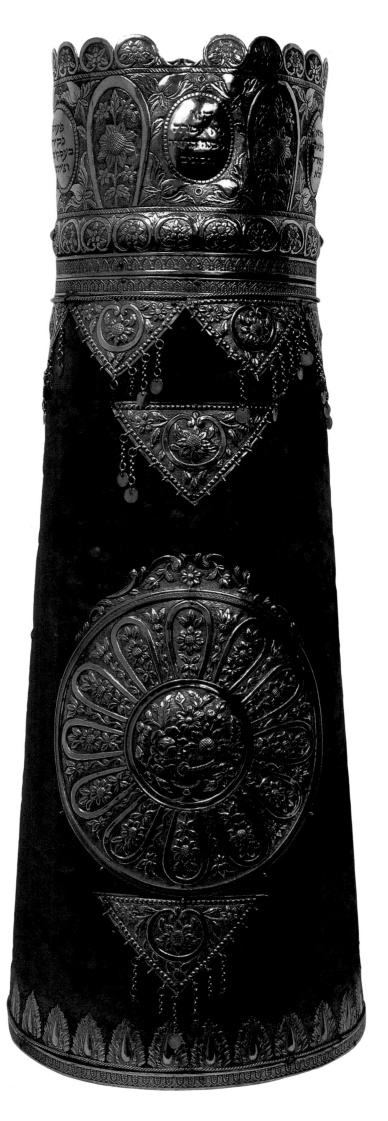

Ottoman Torah Case, Crown, and Shield. Ottoman Empire. 19th century. Wood, velvet covered, silver repoussé, engraved. Height, 33 5/8 in. (85.4 cm); diameter, 8 7/8 in. (22.5 cm). The Israel Museum, Jerusalem. *In this example, a velvet-covered case emulates a textile Torah mantle adorned with a Torah shield and crown. It is probable that secular objects such as mirror covers were refashioned to make the plaques on the case.*

Torah Binders. Ottoman Empire. 19th century. The Israel Museum, Jerusalem (top to bottom):

Brocade. 64 3/4 x 6 3/4 in. (164.5 x 17.1 cm).

Brocade. 59 7/8 x 7 1/2 in. (152.1 x 19.1 cm).

Silk, multicolored silk-thread embroidery, chain stitch. 44 1/2 x 6 in. (113 x 15.2 cm).

Linen, reversible multicolored silk-thread embroidery. 33 7/8 x 7 in. (86 x 17.8 cm).

Satin, couched metal-thread embroidery. 46 1/4 x 7 1/2 in. (117.5 x 19.1 cm).

The long, narrow binders, often embroidered with silk and sometimes metal thread, are used to wrap the rolled Torah scroll before it is covered with a Torah mantle. Traditionally, Torah bindings were associated with childbirth, with the mother presenting a binder to the synagogue when she returned for the first time after giving birth.

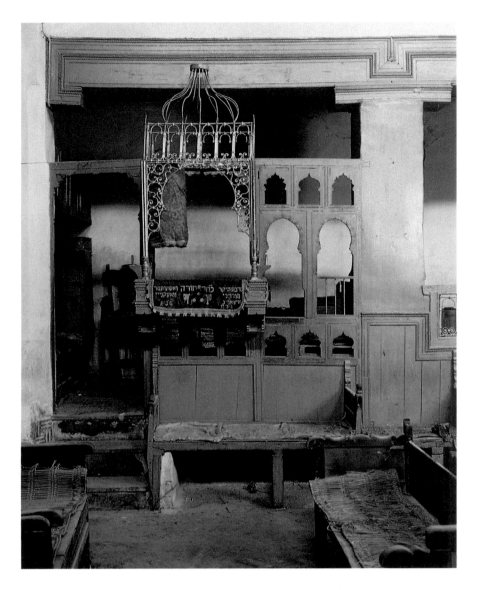

Synagogue of Rabbi Shlomo Ibn Danan. Fes, Morocco. 17th century. Masonry, stucco, wood. 264 x 432 in. (670.6 x 1097.9 cm). Courtesy of The Jewish Heritage Council, World Monuments Fund. *The distinctive elements of the synagogue, a simple rectangular room, are the* heikhal *(ark) for the Torah scrolls and the* tevah *or reader's stand. The wall of the* heikhal *is faced with ornamental stucco above a wainscotting of blue and white ceramic mosaic tile. The* tevah *is a wooden platform with a wrought iron canopy, a light framework made of Islamic arches and floral decoration, culminating in a crown. Once one of the largest and most important in Fes, this synagogue is now abandoned.*

(OPPOSITE)

North Africa Dressed Torah. Mantle: Morocco. 19th century. Velvet with gold and silver thread embroidery. Height: 24 3/4 in. (62.9 cm). Finials: North Africa. 19th century. Silver, parcel gilt, enamel. Height: 14 1/2 in. (36.8 cm). The Israel Museum, Jerusalem. *The overall stylized floral design of the mantle symbolizes the Tree of Life. The form of the* rimmonim, *with the keyhole shaped openings, is similar to minarets, but they have also been influenced by European architecture.*

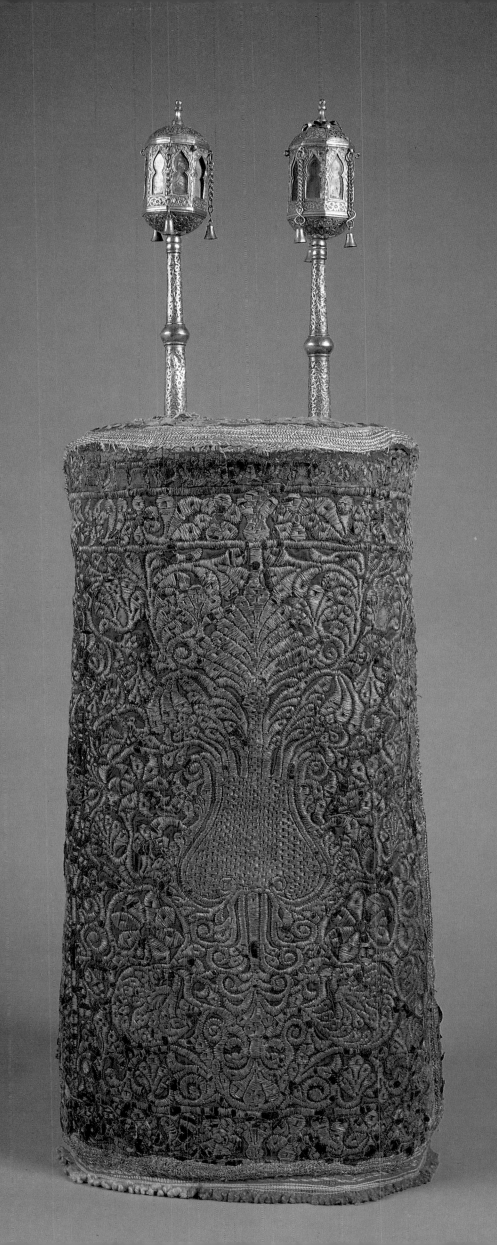

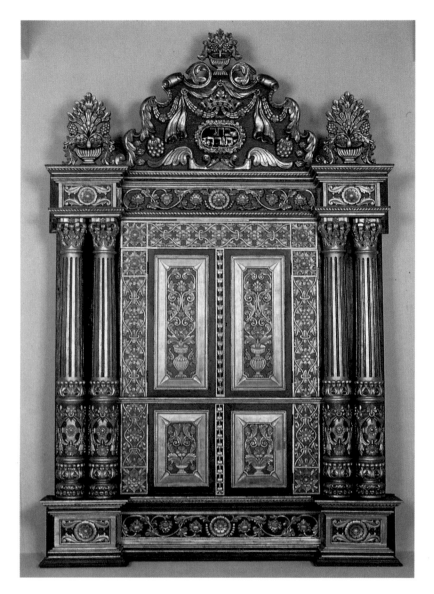 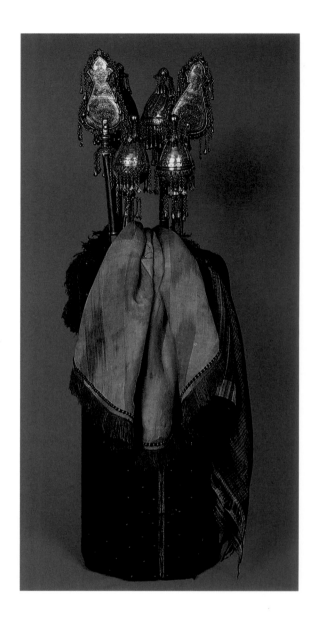

(ABOVE, LEFT)

Torah Ark. Ernakulam, India. 19th century. Wood, carved, gilded, painted. Height: 228 in. (579.1 m). The Judah L. Magnes Museum, Berkeley, California. Gift of the Jewish community of Ernakulam, India. *The Jewish community of Ernakulam was second in size to that of Cochin. The highly ornate ark is based on European models.*

(ABOVE, RIGHT)

Afghanistan Dressed Torah. Afghanistan. 19th–20th century. Case: Wood, cotton velvet, metallic ribbons. Height, 24 in. (61 cm); diameter, 11 in. (27.9 cm). Lent by Moshe Na'amat, Tel Aviv. Finials: Silver, repoussé, semiprecious stones. Height: 15 in. (38.1 cm). Lent by Moshes Na'amat, Tel Aviv; Ovadia Rothschild of Holon in memory of his father; and a gift of Sha'arei Ratzon Synagogue, Holon. Malbush and kerchiefs: Silk, Ikat. Diameter, 37 in. (94 cm). Gift of the Yeshuah ve-Rahamim Synagogue, Jerusalem. The Israel Museum, Jerusalem. *The ornamentation of Torah scrolls from Afghanistan and eastern Persia, where many Afghan Jews originated, is unique. The top of the Torah case is decorated with three pairs of finials: a pair of flat finials calles* ketarim *(Hebrew for crowns) mounted above the Torah staves and two pairs of* rimmonim, *globular finials, on the front and back. Afghan Jews place a round, silk cloth bordered by a strip of tassels called a* malbush *(Hebrew for garment) between the finials. The malbush was added for decorative purposes and was often embroidered. This one reads "Rebekah, daughter of Miriam." The Torah was also adorned with a* dastmal *(kerchief) used to cover the parchment when the Torah was not being read—for instance, when the blessings before and after the Torah readings were recited—and to prevent contact between the reader's hand and the scroll.*

Torah Tiq. Tunisia. 19th century. Wood, carved, gessoed, painted, gilt. Case: height, 35 in. (88.9 cm); diameter, 14 in. (35.6 cm). Finials: height, 16 in. (40.6 cm); diameter, 4 in. (10.2). Smithsonian Institution, Washington, D.C. Deinard Collection. *This Torah tiq is especially remarkable because the case and finials, made by the same artisan, have been preserved, thus maintaining the natural integration between the openwork crest representing the* keter, *the crown of Torah, and the carving of the* rimmonim.

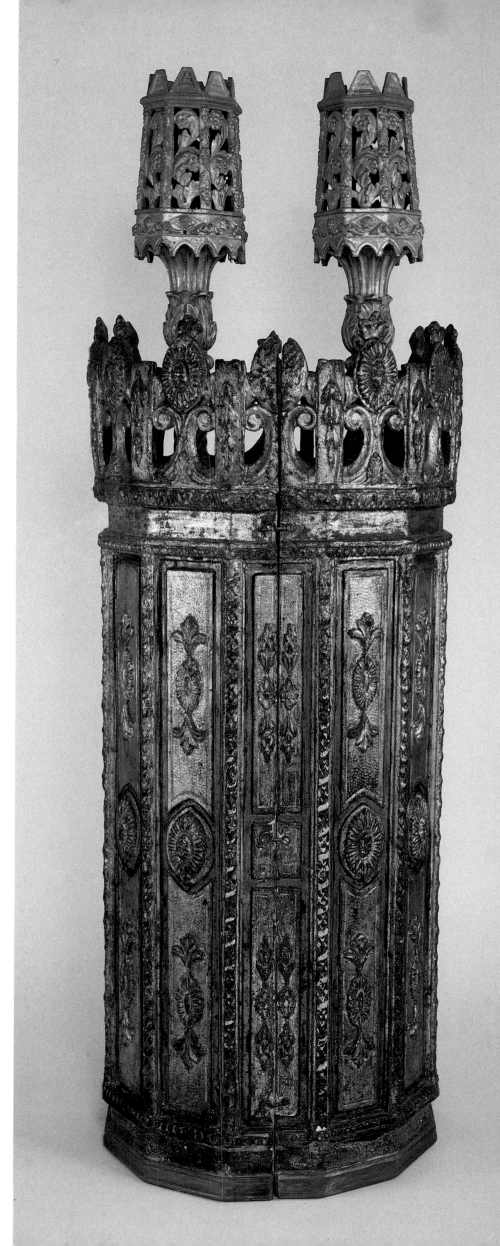

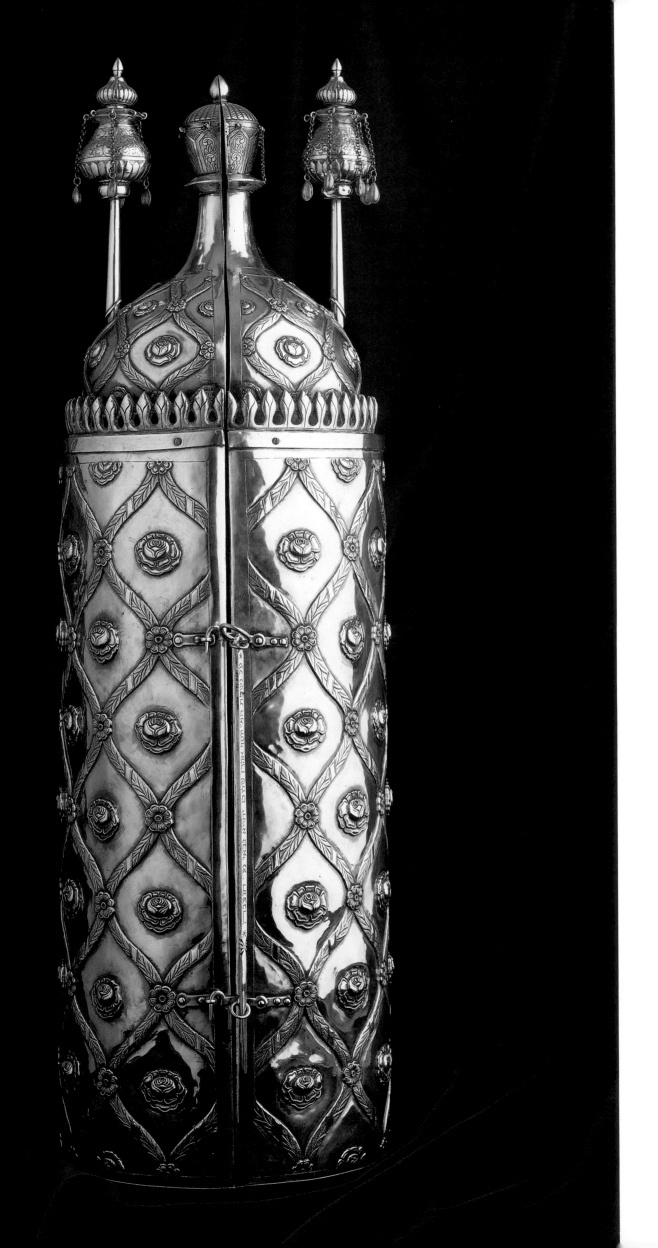

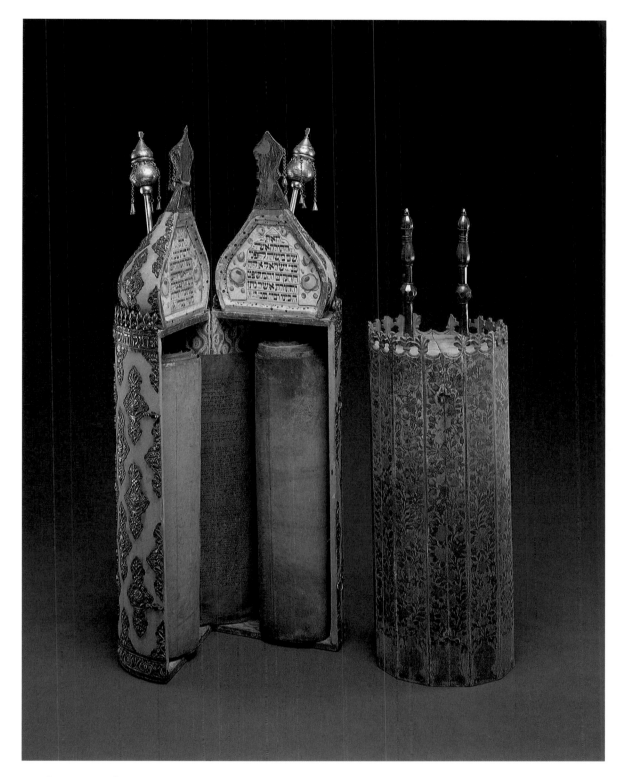

Torah Cases. Left: Iran, 1874. Wood, cotton, and silver; *rimmonim*, Iran, 19th century, silver.
Right: India, 19th century (?), painted wood; *rimmonim*, Yemen, 19th-20th century, brass. The
Israel Museum, Jerusalem.

(OPPOSITE)

Torah Case, Finials, and Pointer. India. Late 19th–early 20th century. Case: silver, chased, die-
stamped; wood, painted. Height, 33 1/2 in. (85.1 cm); diameter, 10 in. (25.4 cm). Finials: silver,
chased, parcel gilt. Height, 7 7/8 in. (20 cm); diameter, 2 1/2 in. (6.6 cm). Pointer: silver. Length,
12 5/8 in. (32.1 cm); diameter, 3/8 in. (1 cm). Hebrew Union College, Skirball Museum, Los
Angeles. Museum purchase with funds provided by The Maurice Amado Foundation at the
behest of the Tarica Family. *The Torah case was made in India in the Iraqi style, with a bulbous
dome-shaped "crown," which culminates in a central finial, banded by a pierced arcade. It is
exquisitely crafted with a rhythmic, interlacing pattern of abstracted leaves, a single rosette within
each section. According to an inscription, the case was dedicated in 1916 in memory of Jacob
Meir Abraham Aaron Ha Cohen. The Torah finials appear to be somewhat older than the case.*

Portion of a Synagogue Wall. Persia. 16th century. Faience tile mosaic. 104 x 186 in. (264.2 x 472.4 cm). The Jewish Museum, New York. Gift of Adele and Dr. Harry G. Friedman, Lucy and Henry Moses, Miriam Schaar Schloessinger, Florence Sutro Anspacher, Lucille and Samuel Lemberg, John S. Lawrence, Louis A. Oresman, and Khalil Rabenou. *The rich arabesques of the synagogue wall reflect the influence of Islamic design, as does the*

inclusion of a biblical verse modeled on the use of quotes from the Koran in Arabic integrated into mosque decoration. The two quotes in Hebrew here are from the Psalms, "But I through your abundant love, enter your house; I bow down in awe at your holy temple" (Psalm 5:8) and "This is the gateway to the Lord, the righteous shall enter through it" (Psalm 118:20).

A. KOHN. *Altneuschul Interior.* Prague. c. 1910. Oil on paper. 15 1/8 x 12 1/4 in. (38.4 x 31.1 cm). The Jewish Museum in Prague. *The Altneuschul in Prague, completed about 1265, is the oldest extant European synagogue. The main room is divided into two naves by two octagonal piers, between which is the* bimah, *with its wrought iron enclosure which dates to the fifteenth century. The limestone ark has been restored several times.*

(OPPOSITE)

Torah Finials. San'a, Yemen. c. 1900. Silver, gilt, repoussé, pierced; fabric and paste. Height, 14.in. (35.6 cm); diameter, 2 1/4 in. (5.7 cm). The Israel Museum, Jerusalem. Gift of Moshe and Charlotte Green, Jerusalem and New York, in memory of their mothers, Bracha Green and Chaia Appel. *According to an inscription, these Torah finials were commissioned by Ḥayim Ben Shalom Keysar for his synagogue, and the silversmith was probably Yeḥudah Giyath, well-known for his beautiful craftsmanship. Though similar in form, with three distinct shapes, these finials are much more ornate than most Yemenite* rimmonim, *which are worked of smooth brass. The ball, pear, and onion shapes here are fabricated in a densely ribbed pattern of metal sheets.*

JOSEPH VOGEL. *Synagogue Clock.* Pisek, Bohemia.
c. 1870. Wood, carved, painted, parcel gilt; seven clock
faces; glass. 28 x 18 x 4 1/2 in. (71.1 x 45.7 x 11.4 cm).
The Jewish Museum in Prague. *What is normally
a utilitarian object, a clock to display the times for
services on weekdays, Sabbath, and the festivals, has
become in this synagogue clock a truly magnificent
work of decorative art, with its handsome blue
background and beautifully carved frame highlighted
with gold.*

THOMAS HOPFEL (1793–1847). *Torah Shield.* Prague. 1831.
Silver, repoussé, hammered, and engraved. 8 x 6 1/2 in.
(20.3 x 16.5 cm). The Jewish Museum in Prague. *The
inscription indicates that the shield was donated in the will
of Hayyim Ber Lichtenstern. The artist was extremely
inventive. What was basically a simple Torah shield with
columns surmounted by a crown is transformed by a pair
of intertwined dragons whose very shape becomes the form
of the shield and who completely envelop the columns, also
creating a nice interplay of textures.*

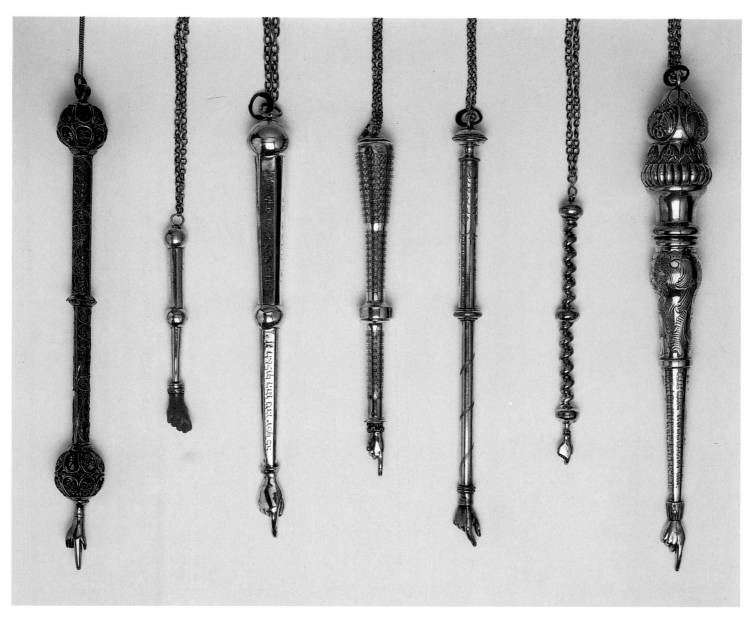

Torah Pointers. (From left). Eastern Europe. Early 19th century. Brass, filigree, silvered copper. 13 3/8 in. (34 cm). Russia. 19th century. Silver, hammered, parcel gilt; coral. 6 1/8 in. (15.5 cm). Prague. 1810–11. Silver, cast and engraved. 11 3/4 in. (30 cm). Vienna. 1867–72. Silver, cast and machine-engraved. 9 5/8 in. (24.5 cm). Moravia. 1902. Brass, partially silvered and engraved. 11 3/4 in (30 cm). Moravia. 1800. Silver, cast and engraved. 7 1/2 in. (19 cm). Vienna. 1867–70. Silver, cast, chased, engraved, and hammered. 13 1/2 in. (34.5 cm). The Jewish Museum in Prague. *As was customary, several of these Torah pointers have dedicatory inscriptions.*

Torah Curtain. Prague. 1601–02. Silk velvet appliquéd with silk and embroidered with metal threads, seed pearls, sequins, glass stones, metal foil; silk damask (replacement); metallic ribbons. 84 1/2 x 52 in. (214.6 x 132.1 cm). The Jewish Museum in Prague. *According to the inscription, this Torah curtain was donated by Nathan ben Issachar, called Karpel Zaks (and) Hadassi, daughter of Moses of blessed memory, in [5]362 (=1601/2), making it one of the earliest known examples. It was a gift to the Altneuschul in Prague, one of several extant of this period with portal imagery. The magnificent embroidery and appliqué work have a real sense of liveliness and give a feeling of dimensionality to the columns. The coat of arms of the donor, a medallion with three crossed carps, is on the top border of the curtain.*

(OPPOSITE)

ELHANAN OF NAUMBERG. *Torah Ark Curtain.* Germany. 1723. Velvet, embroidered with silk and metal thread, glass stones. 80 1/2 x 48 1/2 in. (204.5 x 123.2 cm). The Moldovan Family Collection, New York. *Elhanan was born in Gross-Glogau, then part of Austria. His name is taken from the small town of Naumberg. Both he and his father were cantors. An artistic as well as a musical talent, he gained prominence for his magnificent embroidered Torah curtains. This curtain was made for the community of Kriegshaber. It was donated by Judah Loeb, son of the late president and director of the Jewish regional district, Simon Ulma, among whose family were many Court Jews, and by Judah's wife, Guendele, daughter of Issachar Beer, also a regional officer. It has been suggested that the design of the Torah curtain, a portal motif with twisted columns, was influenced by the title pages of Hebrew books. Originally, there was a matching valance with symbols of the Tabernacle/Temple. When the community of Kriegshaber diminished, the curtain was given to the nearby town of Augsburg. During World War II, the valance was lost. The curtain was smuggled to Eretz Yisrael and rediscovered many years later.*

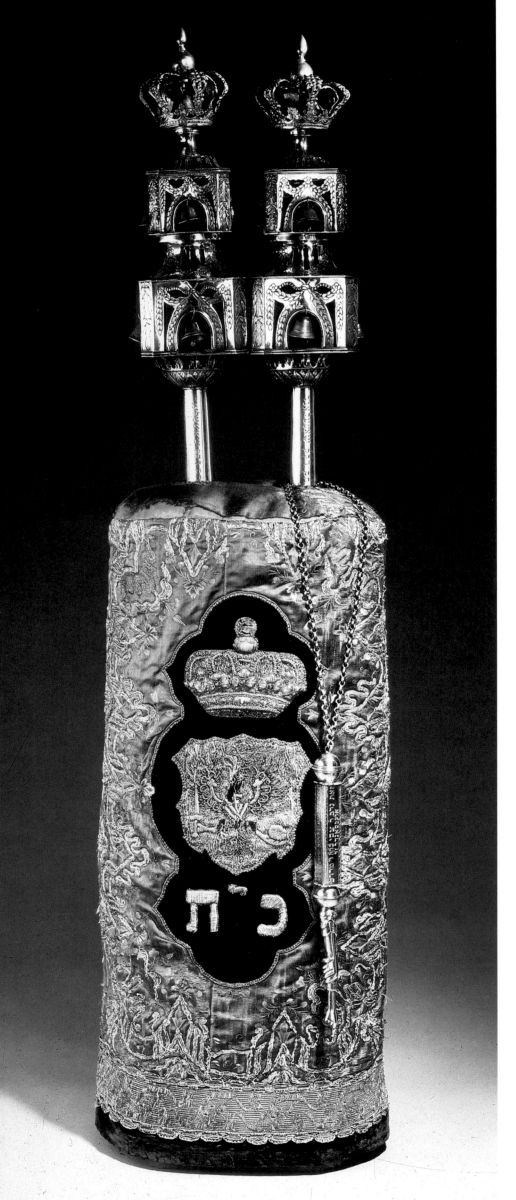

Dressed Ashkenazi Torah Scroll. Mantle: Prussia. 1713–50. Satin, embroidered with silks and metallic thread; lower edge, metallic braid and velvet. 26 x 15 in. (66 x 38.1 cm). Signed AG, probably August Ferdinand Gentzmer. Finials: Berlin. 1788–1802. Silver, cast, cut out, chased, engraved, hammered, parcel gilt. 27 1/2 x 16 in. (69.9 x 40.6 cm). JOHANN CHRISTIAN FRANCK (?). Pointer: Danzig. 1766–1812. Silver, cast and engraved. Length: 11 in. (27.9 cm). The Jewish Museum, New York. Gift of the Danzig Jewish Community. *The Torah scroll is "dressed" in the standard Ashkenazi fashion with a mantle, finials, shield, and pointer. All these Torah ornaments were used in the Great Synagogue in Danzig.*

(OPPOSITE)

JEREMIAS ZOBEL (1670–1741). *Torah Finials.* Frankfurt-am-Main. 1720. Silver, cast, repoussé, stippled, engraved, gilt. Height, 18 in. (45.7 cm); diameter, 7 in. (17.8 cm). The Jewish Museum, New York. Gift of Dr. Harry G. Friedman. *Jeremias Zobel was one of the master silversmiths of Frankfurt crafting Judaica in the eighteenth century. In the typical Baroque manner, Zobel has synthesized the architectonic with the organic— the tower forms emerge from a bulbous base, the shaft and body are decorated with a profusion of leafy vines, and grotesques are added at each tier.*

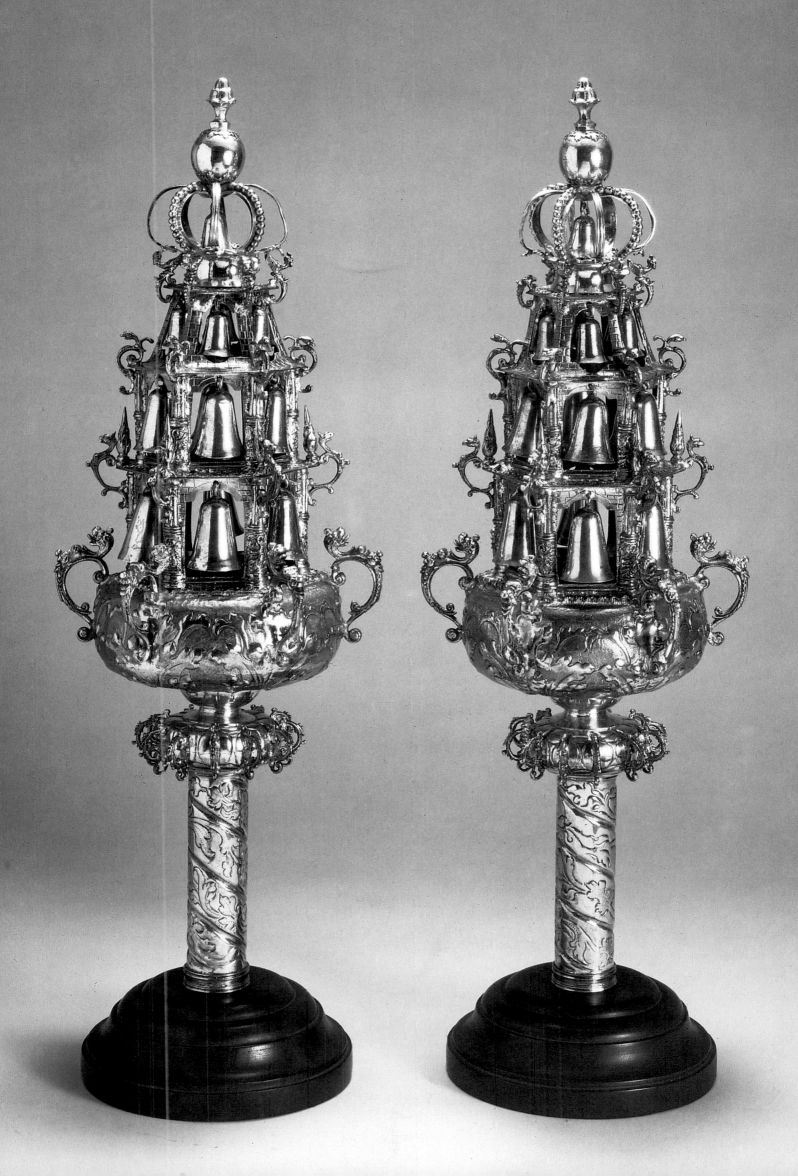

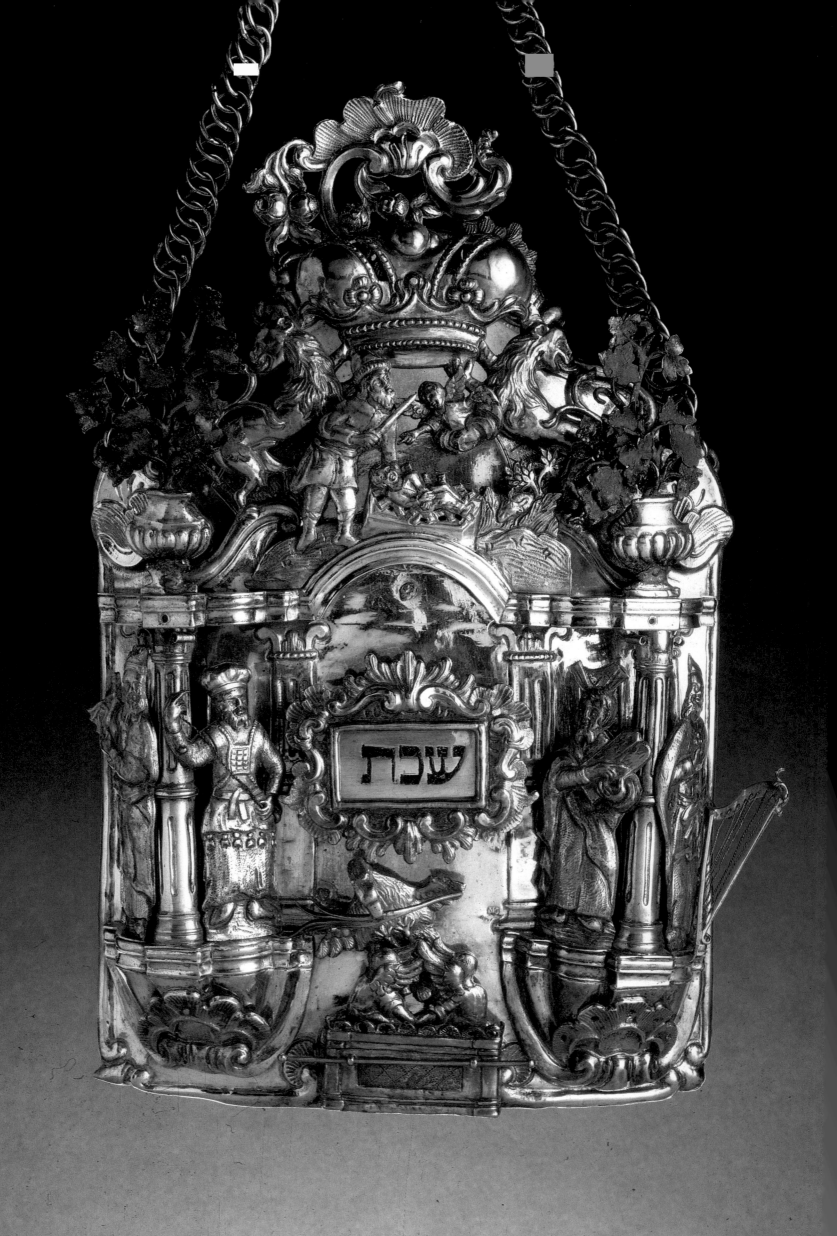
שבת

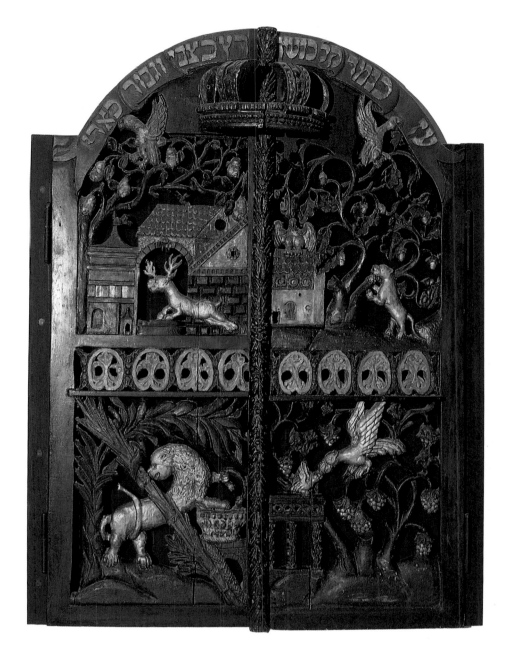

Torah Ark Doors. Cracow, Poland. 17th century. Wood, carved and painted. Collection of Sir Isaac and Lady Edith Wolfson Museum, Hechal Shlomo Synagogue, Jerusalem. *The tradition of painting the interiors of eastern European synagogues was also echoed in elaborately carved and painted arks and reader's stands. On this pair of doors from the Torah ark of the Wolff Poper (Butzian) Synagogue, the animals of the verse from the* Sayings of the Fathers *(5:23) "strong as a leopard . . .," which is inscribed bannerlike across the top, are set among the red-tiled roofs of Cracow.*

(OPPOSITE)

MICHAEL GROSS (?). *Torah Shield.* Hermannstadt, Hungary. 1778. Silver, parcel gilt, cast, repoussé, appliqué. 12 3/4 x 7 3/4 in. (32.9 x 19.8 cm). The Jewish Museum, New York. Gift of Mr. B.W. Huebsch. *This abundantly ornate and incredibly lively Torah shield is perhaps the most elaborate example known of a type developed in Germany in the eighteenth century with the figures of Moses and Aaron, here shown along with Kings David and Solomon. In addition, there is a detailed depiction of the binding of Isaac with a very realistic angel swooping down to stop Abraham. At the base is the Ark of the Covenant capped by the winged cherubim. While highly decorative, this shield still maintains its practical use, with a plaque inscribed* Shabbat *to indicate that the scroll has been wound to the weekly Torah portion. Extremely unusual is that a matching pair of Torah finials is also in the museum's collection.*

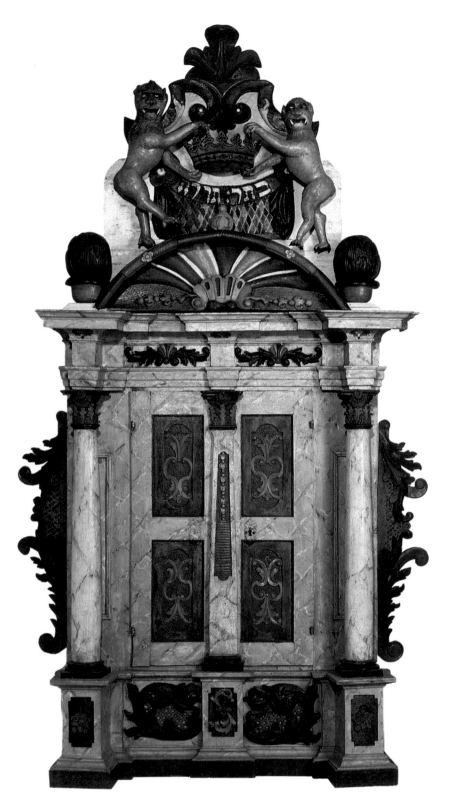

Torah Ark. Westheim bei Hassfurt, Bavaria. 18th century. Pinewood, carved and painted; fabric, embroidered with metallic threads. 113 x 63 in. (287 x 160 cm). The Jewish Museum, New York. Gift of Arthur Heiman. *The folk artist who made this ark was extremely creative in his carving and painting, which simulate very fine and precious materials—marble and inlays of colored stone. He also transformed the Neoclassical cabinet by adding heavily articulated scrollwork "wings" on either side. But the most powerful element is atop the ark, where the customary pair of lions flanking a Torah crown comes alive. The two lions are quite ferocious looking and the whole very monumental. This ark was salvaged by the donor from the synagogue in Westheim bei Hassfurt, Bavaria, and was first deposited in the museum in Würzburg. Since the ark was kept in storage, Heimann convinced the museum to return it to him, and he brought it to the United States when he emigrated from Germany in 1934.*

(OPPOSITE)

ABRAHAM SCHULKIN. *Torah Ark from Adath Jeshurun Synagogue.* Sioux City, Iowa. 1899. Carved pine, stained, gold-colored bronze paint. 125 x 96 x 30 in. (317.5 x 243.8 x 76.2 cm). The Jewish Museum, New York. Gift of the Jewish Federation of Sioux City, Iowa. *Though not formally trained as an artist, Abraham Schulkin carved a monumental Torah ark in the eastern European tradition for Adath Jeshurun, founded in 1895, the first synagogue in Sioux City, Iowa. The ark was the gift of Simḥah, daughter of Rabbi David Davidson. The ark is constructed in three sections. The cabinet for the scrolls rests on a base with Gothic arches. The doors are carved with dense foliage which emerges from a vase-shaped container. On the side panels the foliate motif meshes with a menorah surmounted by a Star of David. The uppermost section includes imagery of the Ten Commandments, hands representing the priestly blessing, and a Torah crown. Along the side panels, the openwork carving continues with stags in the foliage. Schulkin also included a number of three-dimensional birds perching on the ark and the whole is surmounted by a stylized dove with outstretched wings.*

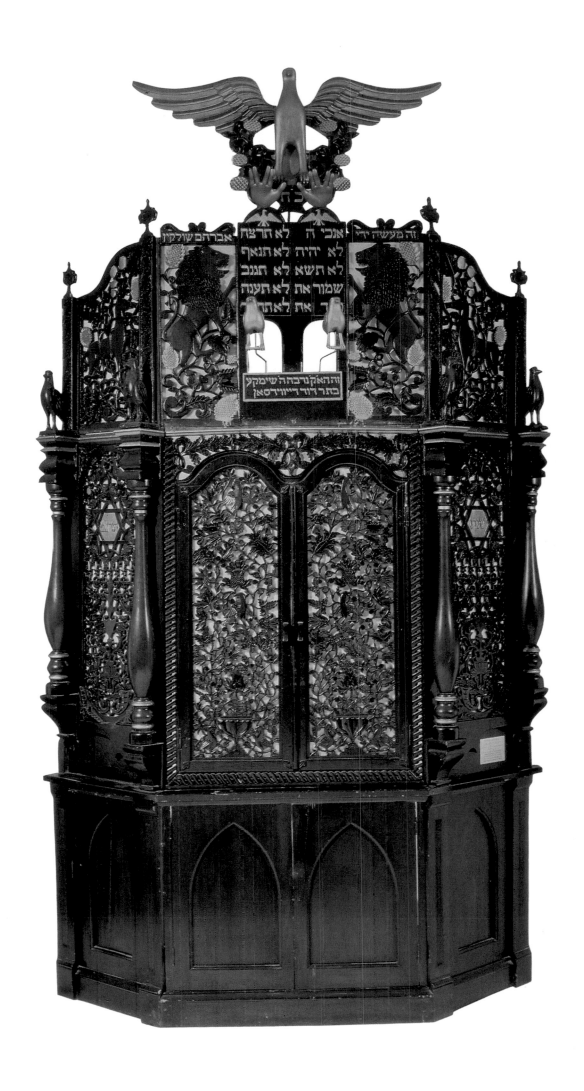

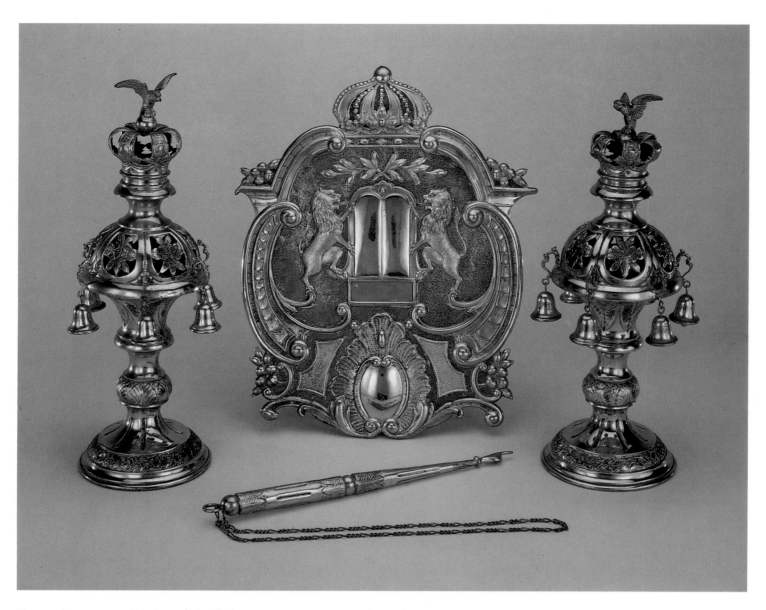

FRANZ ALEXANDER (?). *Set of Torah Ornaments.* Vienna. Early 20th century. Silver, parcel gilt. Shield: 15 x 11 1/2 in. (38.1 x 29.2 cm). Finials: Height, 14 in. (35.6 cm). Pointer: length, 12 1/4 in. (31.1 cm). Smithsonian Institution, Washington, D.C. Deinard Collection. *This set of Torah ornaments is representative of Austro-Hungarian examples of the late nineteenth to early twentieth century, with a cartouche-shaped Torah shield with rampant lions supporting the Ten Commandments surmounted by a Torah crown; bulbous openwork Torah finials hung with bells and a crown finial on which an eagle alights; and a Torah pointer with a tapering shaft ornamented with acanthus leaves. It is likely that Ephraim Deinard purchased them directly from the maker for his collection.*

(OPPOSITE)

Torah Crown. Lemberg (Lvov), Galicia. 1764/65–73. Silver, repoussé, cast, cut out, engraved, parcel gilt; semiprecious stones; glass. Height, 19 1/4 in. (48.9 cm); diameter, 8 5/8 in. (21.9 cm). The Jewish Museum, New York. Gift of Dr. Harry G. Friedman. *The vitality of decoration in eastern European synagogues is also reflected in Torah ornaments. This crown is completely covered with a profusion of detail: scroll and shell forms; plants and animals, the real, such as the lion, stag, and rabbit, and the imaginary, including griffins and double-headed eagles; and Hebrew inscriptions. The zodiac cycle is depicted on the central tier. This type of multistoried crown became standard for many eastern and central European Torah crowns well into the twentieth century.*

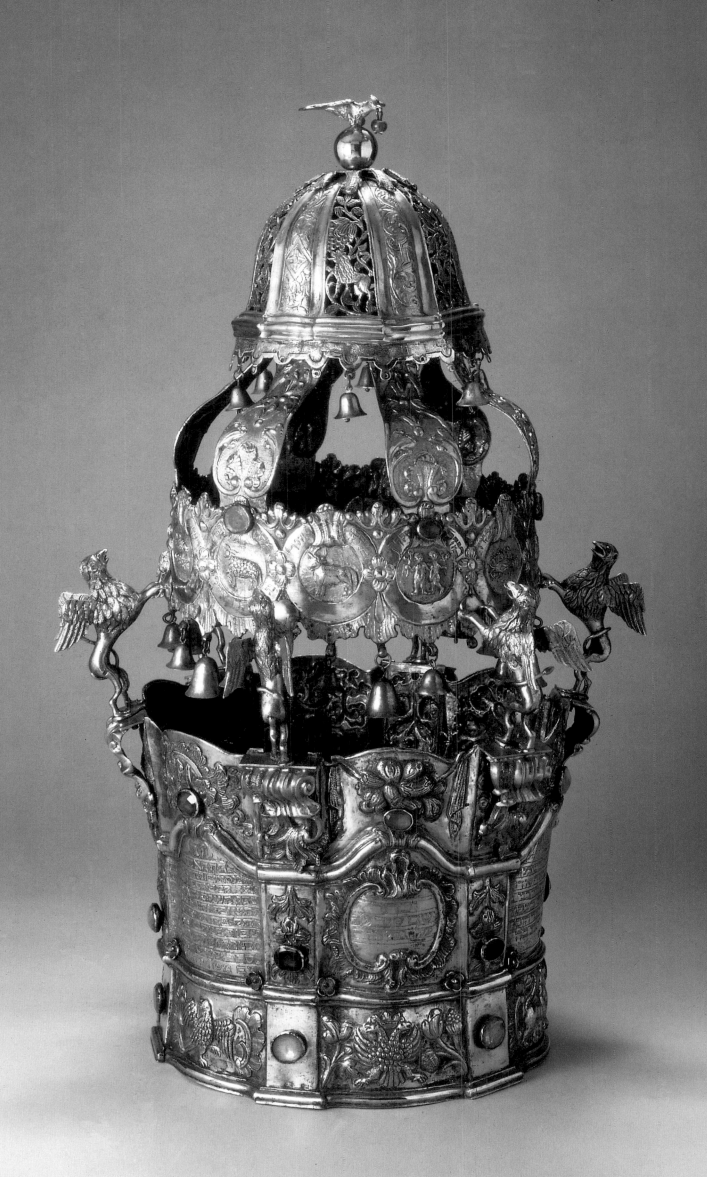

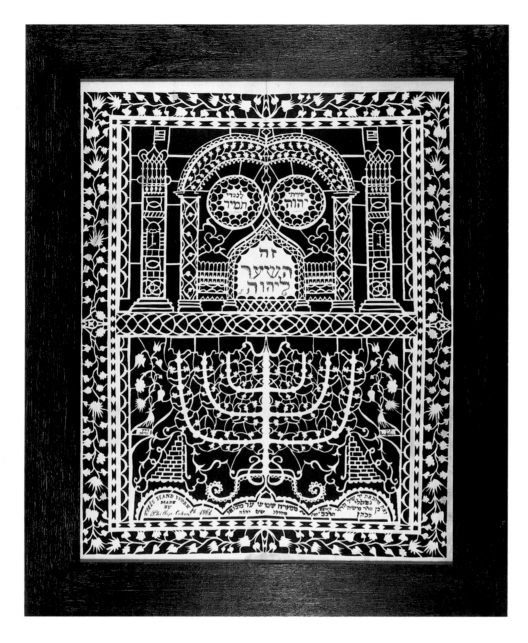

PHILLIP COHEN. *Shiviti*. United States. 1861. Cut paper and ink. 25 1/4 x 19 3/8 in. (64.1 x 49.2 cm). Hebrew Union College, Skirball Museum, Los Angeles. *Many papercuts are the work of anonymous folk artisans. Most fortunately, Phillip Cohen signed his name both in Hebrew and English and dated his beautiful work. The design refers to Temple imagery, prominently featuring a portal and a menorah. An ogee-shaped arch in the center includes the verse, "This is the gateway to the Lord . . ." (Psalm 118:20). Shiviti plaques were often made for the synagogue, the name derived from the Hebrew "I am always mindful of God's presence" (Psalm 16:8). Cohen proudly demonstrated his allegiance to America by including American flags atop each of the columns.*

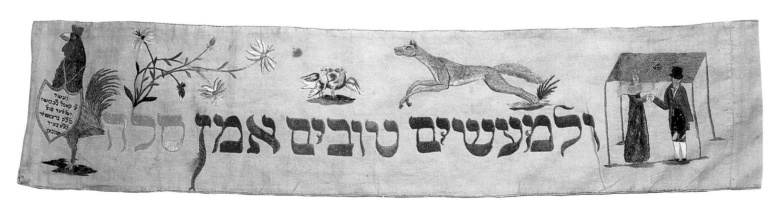

KOPPEL HELLER. *Rabbi Lilienthal Torah Binder*. Munich, Bavaria. 1815. Linen embroidered with silk. 7 1/8 x 124 in. (18.1 x 315 cm). The Judah L. Magnes Museum, Berkeley, California. Gift of Mr. and Mrs. Theodore Lilienthal. *While most binders (wimpels) are made by a family member, usually the mother or grandmother, there are examples such as this which were made professionally. There are twenty-four separate subjects depicted—Jewish symbols and a Bar Mitzvah boy, and a wedding ceremony, as well as various animals and birds and the zodiac sign of Scorpio. The wimpel was made for Max Lilienthal, who had a colorful and controversial career in Russia and then in the United States, where he became a prominent advocate for Reform Judaism.*

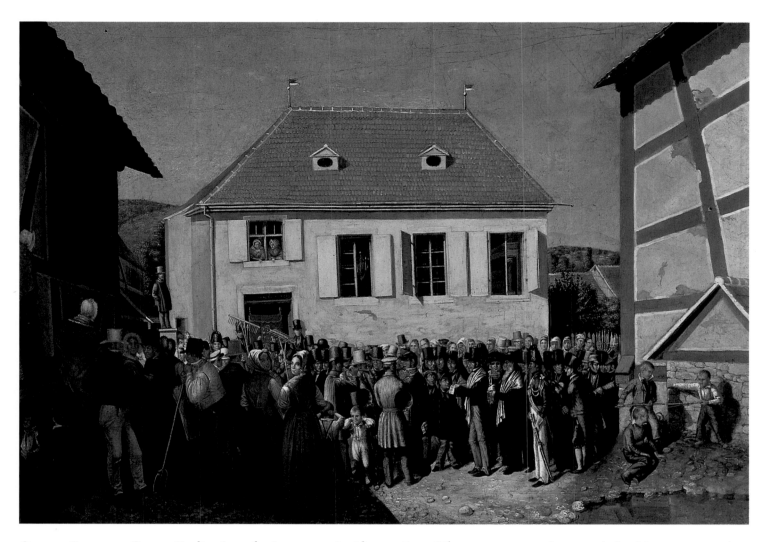

GEORGE EMANUEL OPITZ. *Dedication of a Synagogue in Alsace.* 1820. Oil on canvas. 24 1/2 x 35 1/2 in. (62.2 x 90.2 cm). The Jewish Museum, New York. *What is unusual about the portrayal by Opitz, a non-Jew, of the consecration ceremony for a new synagogue in Alsace, is that he has recorded the participation of the entire community, the villagers celebrating along with their Jewish neighbors. While local dignitaries carry out the formalities, there is a relaxed, festive air in the crowd. Opitz's genre paintings are characteristic of the Biedermeier style of the era, with significant "realistic" detail, yet conveying a romantic mood.*

Passages: Marking the Life Cycle in the Jewish Tradition

You shall be holy, for I, your God am holy (LEVITICUS 19:2).

THE CONCEPT of holiness, emulating God's holiness, is the basis from which the all-encompassing Jewish way of life originates. Jewish values and beliefs are expressed through laws, customs, and a long tradition of interpreting the Bible. By striving to be holy, the Jewish people mark time, daily life, and the life cycle passages. The sense of holiness is what transforms the ordinary into extraordinary, creating sacred moments in time. According to the Talmud, each day a person must recite one hundred blessings. To achieve this lofty goal, it is necessary to have a heightened awareness of the sacredness of every act that one performs, from witnessing a spectacular rainbow to elevating routine activities such as arising in the morning and eating. Taking the moment to say a blessing sanctifies that time and makes it holy. Vignettes depicting different types of blessings are found in illustrated prayer books.

The Talmud enumerates 613 *mitzvot* (commandments) which every Jew should follow. Some are positive precepts, and some are negative. The mitzvot deal with all aspects of Jewish life; in fact, some cannot be fulfilled at all in contemporary times, for they include laws which could only be carried out in the time of the Jerusalem Temple. Nonetheless, the goal of striving to do as many mitzvot as possible is epitomized by the notion of endeavoring to carry out the 613 commandments. The mitzvot and the beliefs and values which they represent suffuse all aspects of life, from birth to death, from the most mundane to the most profound. While many mitzvot refer to specific acts, like saying a particular blessing, many represent the general Jewish values, which stress justice, mercy, and compassion.

Each child is officially welcomed into the Jewish community when named. Boys are named when they are eight days old at the time of their circumcision ceremony. The *berit milah* (covenant of circumcision) is the sign of the sacred covenant between God and Abraham and is performed by a *mohel*, trained in the ritual and surgical aspects of the procedure. Manuscripts and books with the rules and prayers for circumcision are often illustrated with images of the circumcision ceremony. In some instances, the mohel has used the little volume as his record book, providing a wonderful document of the children in the community where he served. *A Book for a Mohel*, printed in Amsterdam in 1745, includes a contemporary scene of the ceremony depicting the moment the mother brings in the swaddled baby, who is greeted with the words *Baruch ha'ba*, "Blessed is the one who has entered." The special instruments used by the mohel were sometimes ornamented. A set of precious gilt cups from the Weil family was inscribed with blessings

(OPPOSITE)

ISIDOR KAUFMANN (1853–1921). *Portrait of a Boy.* Probably Vienna. End of the 19th century. Oil on panel. 14 5/8 x 11 5/8 in. (37.1 x 29.5 cm). The Jewish Museum in Prague. *Kaufmann, born in Hungary, studied art in Budapest and then in Vienna, where he settled in 1876. He traveled to Galicia, Poland, and the Ukraine and documented the life of the eastern European shtetl in a series of portraits and genre paintings. These paintings of Orthodox Jews were a nostalgic link to the past for the urban, assimilating Jews who purchased them. Kaufmann, with great clarity and sensitivity, portrays the young Bar Mitzvah boy who appears overwhelmed by his new adult responsibilities, symbolized by the tallit and fox-trimmed streimel.*

from the berit milah. The cups and the original leather case were preserved in the family for over two centuries. A set of circumcision instruments and a box of filigree work were made for the Torres family in The Netherlands. The name Jacob Nehemias Torres appears on the shield and is dated 1826/27; the special case, rack, and other implements were made in 1866.

The prophet Elijah is described in Malachi 3:1 as the "messenger of the Covenant," which is traditionally associated with the covenant of circumcision. The belief that Elijah is present at each berit milah gave rise to the custom of providing a symbolic place for him on a special chair. A carved chair made in Rheda, Westphalia, in 1803 is typical of a double-seat circumcision chair, one for the *sandek* who holds the infant and the other for Elijah.

Girls are named at a service when the Torah scroll is read, traditionally on the fourth Sabbath after the birth, when the mother returned to the synagogue for the first time after her confinement. Because there is no parallel ceremony for receiving girls into the covenant, a variety of folk practices has emerged in different communities. A Sephardi naming ceremony for girls is called *seder zeved habat*, the celebration for the gift of a daughter. In the synagogue the mother recites a blessing of thanksgiving for her recovery, reads a quote from the Song of Songs, and recites a blessing which somewhat parallels the blessing recited for boys. Another Sephardi ceremony is called *Las Fadas*. The rabbi blesses the child, and she is passed around to the family and friends who wish her and her family well. The custom seems to have originated as an adaptation of the Spanish rite of asking that the baby be blessed by good fairies. *Fadas* derives from the Spanish word for fairies.

A very old Ashkenazi custom, *Hollekreisch*, was known as early as the twelfth century, when it was called *shem arisa* (the cradle name). The custom spread among Jews in the Rhineland and Alsace and was still practiced well into the twentieth century. A naive painting by Alis Guggenheim portrays the practice of inviting all the local children to the baby's home, where they surrounded and three times lifted up the cradle, calling out "Hollekreisch, what shall the baby be named?" They then shouted out the child's name. While they are doing so, biblical verses are read by the rabbi. For their participation, the children were rewarded with fruit and candy. There are several interpretations of the meaning of the term *Hollekreisch*: one is that it comes from the German meaning "to cry out the profane," since the children call out the child's secular as opposed to Hebrew name; another is that it derives from the name of the German goddess Holle or Hulda, who attacks newborns before they are named; a third is that it is from the French "haut la creche," meaning "lift up the cradle." An illustrated manuscript from southern Germany dated 1589 shows a variation of the ceremony, with two men lifting the cradle and the mother preparing refreshments.

In addition to this type of folk naming custom, there are many amuletic devices associated with pregnancy and birth, a time that was fraught with danger for both the mother and child. Amulets are widely used in folk religion and take a variety of forms, typically influenced by the customs of the local community. Many amulets used at the time of childbirth are to protect against Lilith, the mother of all demons, who according to Jewish mysticism was the first wife of Adam. Since Lilith was created at the same time as Adam, she demanded equal rights. When Adam rejected her, she deserted him and created her own kingdom. All the children of Eve are considered to be susceptible to Lilith's evil powers. Boys were especially watched until their circumcision and girls until they were twenty days old.

According to Jewish mystical belief, it is possible to protect against the Evil Eye through the power of the *shemot* (the names of God and of the angels) and through the use of various biblical verses. There are many amulets with a complex formulation of these elements. The inscriptions are typically encoded in particular patterns of abbreviation, called *notarikon* and *temurah*, or letter substitutions, such as the first letter of the alphabet exchanged for the last. Also popular is the use of *gematria*: Since each Hebrew letter

has a numerical equivalent, whole words can be exchanged with others of the same numerical value. For example, the letters for one name for God, *Shaddai*, are identical in value to *metatron*, the name of one of the archangels, so that substitution can be made. An amulet from Afghanistan is inscribed with an amuletic formula with substituted letters. Some amulets include imagery from the Temple, as on an eighteenth-century amulet from Italy with the Ten Commandments, a seven-branched menorah, and the hat of the High Priest, depicted as a bishop's miter.

It is customary to have another ceremony called the *pidyon ha-ben* for firstborn sons when they are a month old. In observance of an ancient rite, the baby is symbolically "redeemed" from service by an offering of the equivalent of five shekels to a *kohen*, a descendant of the priestly family who once served in the Temple in Jerusalem. The money is contributed to charity. Special decorative plates were sometimes made for this festive event, and many are illustrated with the Binding of Isaac.

A very special custom associated with circumcision began in the seventeenth century in southern Germany. The linen swaddling cloth used to wrap the eight-day-old baby boy at his circumcision ceremony was later cut into strips and sewn together to form a long band to be used as a Torah binder. Called a *wimpel,* from the German word for binding, the cloth is embroidered or painted, usually by the mother or grandmother, with the child's name, birth date, and the prayer recited at the circumcision ceremony, which asks that the child grow to study Torah, to be married and to do good deeds. Each wimpel is personalized with an inventive variety of images, often including references to the child's name, his zodiac sign, and elaborate scenes for the Torah and wedding canopy. As depicted by Moritz Oppenheim in *Das Schuletragen*, the wimpel was presented to the synagogue when the young child came for the first time with his father and used on that day to wrap the Torah scroll. It was then kept as a type of birth record and used again to wrap the scroll on the day of the boy's Bar Mitzvah. In some communities, it was also traditional to use it once again when the young man was called to the Torah prior to his wedding. The wimpel serves as a remarkable link of the life cycle passages and serves literally and symbolically to bind them to the Torah.

The strength of the Jewish community is measured by the success in linking *me dor le dor*, "from generation to generation," and it is through study of the Torah that Jewish ethical and religious teachings are preserved and transmitted. An illustration in the *Leipzig Mahzor* from southern Germany, dated 1320, depicts the initiation of Jewish boys into the study of Torah. The child was brought to the teacher, who reads from a slate on which is written the Hebrew alphabet; the verse "When Moses charged us with the teaching [the Torah] as the heritage of the congregation of Jacob" (Deut. 33:4) and the first few verses of Leviticus. The child repeated the words, then honey was spread on the slate and the child licked it off, making the introduction to Jewish learning a sweet experience.

The education of girls differed from that of boys, as the emphasis was on learning what was needed to maintain a Jewish home. Women were given their own domain of influence, under the instruction of their mothers. The handed-down tradition was considered very significant in its own sphere and had its own weight and merit. Until the nineteenth century, girls generally did not have a formal education. There were some exceptions, as illustrated in the illumination from the fifteenth-century *Darmstadt Haggadah*. However, many women were literate and there are special *tkhines* (private prayers) considered mainly for women. Many have been attributed to women authors and were published as early as the sixteenth century in printed Yiddish texts. A woman reciting a private prayer in Hebrew before reciting the *Shema* is portrayed in *Seder Berakhot* from Vienna, dated 1724.

In Judaism, the passage to adulthood is celebrated by an act of personal religious adherence and commitment when a boy is thirteen and a girl is twelve and they become a Bar or Bat Mitzvah. These terms,

BENJAMIN SENIOR GODINES (ARTIST). ALBERTUS MAGNUS (PRINTER). *Second Title Page of Seder Berakhot (Order of Benedictions).* Paper, copper engravings. Bibliotheka Rosenthaliana, Amsterdam. *This Sephardi compilation of blessings in Hebrew with Spanish translation depicts prayers related to the five senses, among them hearing the shofar; and smelling the havdalah spices. The image at the bottom, illustrating a biblical verse, refers to the patron, R. Isaac Aboab.*

Selihot. Frankfurt-am-Main. 1740. Ink on parchment. Private collection. *The title page of this* Selihot *(Penitential Prayers) manuscript from the burial society in Frankfurt shows all the scenes of life from cradle to grave. Symbolically, the tree on the left is lush with leaves with a marriage scene, representing the beginning of a union which will bring new life; the tree to the right with a burial scene is barren. An interesting aspect of this type of illustration is the wealth of information it provides about Jewish costume of the period.*

translated as "son and daughter of the commandment," reflect the traditional view that the young person has reached the age of legal maturity and is responsible for fulfilling all of the mitzvot and accepting adult responsibility. Actually, public ceremonies marking the transition are relatively recent. Bar Mitzvah celebrations began in the fifteenth century. The observance of Bat Mitzvah in a synagogue service began in the twentieth century and is a phenomenon of liberal Judaism, with most Bat Mitzvah ceremonies taking place at age thirteen. In very recent years, some Orthodox communities have instituted a public commemoration of Bat Mitzvah as well. The nature of the Bar and Bat Mitzvah observance varies according to the religious affiliation of the synagogue, Reform, Conservative, Reconstructionist, or Orthodox. But they all have a common link in that the young person participates in the service. Girls as well as boys read from the Torah, except among the Orthodox, with rare exceptions and then only when the Bat Mitzvah service is limited to a congregation of women. Each Bar or Bat Mitzvah is also expected to give a *derashah*, an interpretive explanation of the Torah portion, to demonstrate their new adult intellectual role.

Das Schuletragen (Child's First Visit to the Synagogue). Frankfurt-am-Main. 1882. Photoengraving. Hebrew Union College, Skirball Museum, Los Angeles. Gift of Henry and Louise Plaut in honor of their son Henry Steven Plaut, 1947. *The illustration of the baby being brought into the synagogue for the first time is from Moritz Oppenheim's series,* Scenes from Traditional Jewish Life. *The baby, held by his father, extends his hand toward the Torah, the mantle of which is open to reveal the wimpel wound about the entire length of the scroll. The artist's name is found on a partly unrolled wimpel that rests on the edge of the bimah. This copy of the portfolio was found by Henry Plaut at the end of World War II in former Gestapo headquarters, Mannheim, Germany.*

For boys, another transitional act of religious commitment is the donning of *tefillin*, worn during the morning prayer service except on the Sabbath and holidays. Tefillin are worn in fulfillment of the biblical imperative: "It shall be a sign upon your hand and as a symbol on your forehead that with a mighty hand the Lord freed us from Egypt" (Exodus 13:16). The tefillin are rectangular black leather boxes containing four biblical passages from Exodus (13:1–10; 11–6) and Deuteronomy (6:4–9; 11:13–21) written by a scribe on parchment. Long leather straps bind the tefillin to the forehead and the inside of the left arm or the right for the left-handed.

In certain communities, it was also the practice for the Bar Mitzvah to begin to wear a *tallit*, the traditional prayer shawl. In other communities, the custom is that only married men wear a tallit. While the typical prayer shawl is white with black or blue stripes, it may be made of any color. The important element of the tallit is the tzitzit, ritually knotted fringes attached to each of the four corners of the tallit as prescribed by ritual law: "The Lord said to Moses: Speak to the Israelite people and instruct them to make for themselves fringes on the corners of their garments throughout the ages . . . look at it and recall all the commandments of the Lord and observe them" (Numbers 15:37–39). Around the upper portion of the tallit is a decorative band called an *atarah* (crown), which is around the neck when the tallit is worn. The atarah is often inscribed with the blessing recited when the tallit is put on. Orthodox men and boys wear a form of the tallit under their clothing at all times. One of the terms for this garment is *tallit qatan* (small tallit). Another name is *arba kanfot*, referring to the four corners with the tzitzit. In a fifteenth-century manuscript from Germany, a youth holding a large book is depicted with his arba kanfot over his robe. In contemporary times, some women have adopted the wearing of tallit and tefillin.

In Judaism, marriage is celebrated both as a joyous event and a sacred act. The Hebrew word used for the wedding is *kiddushin*, which comes from the verb *le-kadesh*, "to make holy." Furthermore, in traditional ceremonies, as the groom places the ring on the bride's finger he states, "Behold you are consecrated to me with this ring according to the Law of Moses and Israel." While today it is common for the couple to exchange rings, it was traditional only for the groom to give the bride a ring. Some unusual examples from Italy of gold with filigree and enamel work are fashioned with a small structure on top, which may symbolize the home the couple will share or perhaps the Temple.

A myriad of diverse customs are observed in different communities for all of the events surrounding the engagement and wedding. In communities like Yemen and Morocco, the brides wore highly elaborate gowns and jewelry and the ritual of dressing of the bride was taken very seriously. Other localized customs have to do with the gifts given to the bride and groom and the couple to one another, such as marriage belts and silver book covers. Despite these differences, however, there are certain integral elements which are common to all Jewish weddings. The wedding takes place under a *huppah*, a canopy, which represents the home that the couple will share. The huppah may be a tallit, or it may be a specially made textile. During the course of the ceremony, after the appropriate blessings are recited, the bride and groom each take a sip of wine from the same cup. Since two blessings are recited, sometimes double cups fitted together in a barrel shape were used. A special wedding goblet made in Breslau in 1752 is engraved with an inscription, "The voice of the bridegroom, and the voice of the bride" (Jeremiah 33:11). Each couple has a *ketubbah* (marriage contract), which is in fact a legal document originating in talmudic times as a financial guarantee for the bride and stipulates the groom's other obligations to his wife as well. As when it was first instituted, the text of the ketubbah is still written in Aramaic. The standard text as we know it today was established in the Middle Ages in the Ashkenazi communities of central and western Europe. The minor variations found in the contracts give insight into some of the differences in customs among communities. Only in recent years has there been some attempt to modernize the text and make the ketubbah more egalitarian.

The tradition of illustrating ketubbot is known from fragments in the Cairo genizah to have existed in Eretz Yisrael and Egypt as early as the tenth to twelfth centuries. From medieval Europe there is only one extant illuminated ketubbah from the Austrian city of Krems. The groom presents the bride with a symbolically large ring. Originating in Spain before the expulsion in 1492, the illumination of ketubbot reached its apogee among the Sephardim in Italy in the seventeenth and eighteenth centuries.

Much about societal differences can be learned from these contracts because each has the date and place of the wedding and the names of the bride and groom. Furthermore, because each ketubbah is individually commissioned, the design and special conditions, including the size of the dowry, provide insight into both the patron's status and artistic sensibilities. Illuminated on parchment, many of the Italian ketubbot include decorative programs with such components as biblical scenes, representations of Jerusalem and symbols of the Temple, family emblems, zodiac signs, and a variety of flora and fauna. A ketubbah from Padua dated 1732 is a rich compendium incorporating all of these elements. Architectural references, mythological figures, and elaborately interlaced knots are borrowed from non-Jewish art; indeed, it seems that many of the artisans who illustrated the ketubbot were not Jewish but were working with the specifications of the commissioning family. A characteristic of ketubbah decoration in Rome in the late eighteenth and early nineteenth century was the use of such allegorical personifications as peace, fortune, goodness, and marital harmony. These reflect the contemporary ideals of marriage; the images are borrowed from Christian tradition. An 1816 ketubbah from Rome also represents the practice of including illustrations which refer to the names of the couple. In this instance, the groom's name was Elijah and

the scene of the prophet ascending to heaven in a fiery chariot is depicted on the cusped edge of the parchment.

The practice of illustrating ketubbot was also popular in the Sephardi communities of western Europe, the western Ottoman Empire, and North Africa. A very elaborate ketubbah from Hamburg dated 1690 portrays the actual wedding scene. The bride and groom, flanked by their parents, stand under the huppah, which is not free-standing but attached canopy-like to the wall. The officiating rabbis stand in front of them. In attendance is a large group of guests, all quite fashionably dressed, the men wearing elaborate wigs. An Istanbul ketubbah dated 1853 includes a lovely cityscape scene along the shore within an elaborate framework of rhythmic floral patterns. Jews living in the Islamic world also made ketubbot. One from San'a, Yemen, dated 1794, is unusual for the region in that it includes the figures of the bridal party, albeit very primitively rendered. There are ketubbot from India and the Far East with interesting motifs, emphasizing exotic birds and animals and local flowers. Unfortunately, as printed contracts became the norm in the late nineteenth century, the art of ketubbah illumination declined. Since the 1970s, however, there has been a renaissance of hand-illuminated ketubbot.

The wedding culminates with the breaking of a glass by the groom. In medieval Ashkenazi synagogues there was a special stone, called a *traustein,* embedded in the north wall of the synagogue at which the glass was hurled. While the custom likely originated from folk beliefs that the glass-shattering would ward off evil spirits, it was interpreted by the rabbis as a reminder that even in times of greatest joy, we recall the destruction of Jerusalem. The ceremony is followed by a wedding feast, including music and dancing and often the reciting of special poems dedicated to the bride and groom.

The home is the locus of personal experience and in day-to-day activities, as well as in the celebration of the Sabbath and holidays, many sacred acts take place among family and friends. The *mezuzah* is the hallmark of a Jewish home, identifying it as a sacred space. The mezuzah is used in accordance with the biblical imperative: "Inscribe them on the doorpost of your house and on your gates" (Deuteronomy 6:9 and Numbers 11:13–21). The mezuzah is a scroll with biblical passages from Deuteronomy (6:4–9 and 11:13–21) written by a scribe. *Shaddai,* one of the names for God, is written on the back of the parchment. The parchment is then rolled, so the *Shaddai* is visible through an aperture in the protective case used to house the scroll. Mezuzah cases take many different forms, some like little elongated houses; others, especially those from eastern Europe, may be elaborately carved in wood.

When the baby is blessed at the naming, one of the prayers expresses the hope that the child grow to a life of *ma'asim tovim,* good deeds. The Jewish approach to taking care of those in need is reflected in the Hebrew term *tzedakah* (charity). Indeed, it is one of the cardinal mitzvot and is considered an obligation of the individual and the community, as it is written in the Talmud, "All Jews are responsible for one another" (Shavuot 39). The great medieval philosopher Maimonides described eight levels of tzedakah, each progressively preferable, the highest being to help one to become self-sufficient. From the Middle Ages to modern times, assistance has been provided in a variety of ways, whether it be contributing to the physical welfare by directly giving money, food, or clothing or participating in one of the Jewish community's numerous mutual aid societies. Each *hevra* (association) took responsibility for a particular aspect of communal service, from providing care and education for poor children, to caring for the sick and the aged, to *hakhnasat kallah,* making sure that even poor brides had a proper wedding.

To raise money for their activities, the Holy Society for Visiting the Sick in Berlin held an annual banquet for which it commissioned a large beaker inscribed with the names of all of the members. Different groups also created tributes to donors, such as an illuminated document made in Eretz Yisrael by Wolf Heller in the late nineteenth century to honor Jonas Friedenwald of Baltimore. The imagery is typical of

the period, depicting sites in the Holy Land along with a monumental seven-branched menorah flanked by two lions, reminiscent of much traditional synagogue ceremonial art. The network of philanthropic agencies has evolved in contemporary times, but it is no less diminished in the sense of commitment and responsibility both for the individual and the community.

The emphasis in Jewish life on *gemilut hasadim*, on acts of loving kindness, is very much reflected in the reverence for taking care of the deceased and the needs of their families. The sense of loss is nowhere more powerfully conveyed than in an image of mourners in the fifteenth-century *Rothschild Miscellany*, where a man and a woman, dressed in black save for her white veil, standing over a small coffin draped in black. From the moment of a person's passing and for a full year thereafter, Judaism maintains an elaborate order of mourning to offer solace and consolation to the bereaved. Taking care of the preparations for burial in accordance with Jewish law is considered a sacred task. In each community there is a *hevra kaddisha* (holy society) whose members, both men and women, assume this duty. A burial society beaker from Prague dated 1783/84 shows a funeral procession with the men and women of the hevra kaddisha carrying the funeral bier, one member of the society carrying a container for tzedakah.

Memorials have an important significance in Jewish life. The first act of any new Jewish community is the purchase of land for a cemetery, and through the centuries, great care has been given to the carving of tombstones. The Hebrew anniversary of the day of death is commemorated annually. The Ashkenazi term for this is *yahrzeit*. A special candle which burns for twenty-four hours is lit on the eve of the yahrzeit. Sometimes, special holders are made for these candles. Other memorials include plaques of metal, parchment, or paper, some of which are ornamented and some which merely record the name of the person being remembered. An unusual custom in Mantua, Italy, was to make tombstone-shaped memorials of parchment to hang in the synagogue. Each was inscribed with the name of the deceased and records the custom of lighting a candle in their memory. Another personal memorial is a papercut yahrzeit made in Scranton, Pennsylvania, in 1902. A community memorial for Rabbi Abraham, "The Maker of Miracles," was made in Morocco in the early twentieth century.

Every stage of the life cycle is viewed as part of a continuum, as illustrated in a book of *Selihot* (penitential prayers) written and decorated for the hevra kaddisha of Frankfurt am Main in 1740, which depicts men and women literally from cradle to grave. Because life is a continuum, it is critical to constantly remember to make each day sacred, marking not only the special times but the ordinary ones as well.

(OPPOSITE, ABOVE)

Prayer Book. Germany. 1728. Parchment, gouache; velvet; silver cover. 3 3/4 x 2 3/4 in. (9.5 x 7 cm). The Gross Family Collection, Tel Aviv. *This small prayer book with twenty-eight miniature illustrations was probably made for a woman. Some of the images of court scenes indicate that it was likely made for a Court Jew.*

(OPPOSITE, BELOW)

GABRIEL VOEL FROM ALMEN. *A Book for a Mohel*. Amsterdam. Printed 1745; illustrated 1786, 1806. Frances-Henry Library, Hebrew Union Collection–Jewish Institute of Religion, Los Angeles. *This small volume was originally written in the seventeenth century by Rabbi David ben Arye Leib of Lida. Eight illustrations were added to this printed edition. Two refer to the man named in the dedicatory inscription, Jacob Hirsch: the scene of Jacob's Ladder and a deer, "hirsch" in Yiddish. Two others are contemporary scenes of the ceremony and the celebration which follow. The remaining four are scenes from the akeda story, the Binding of Isaac.*

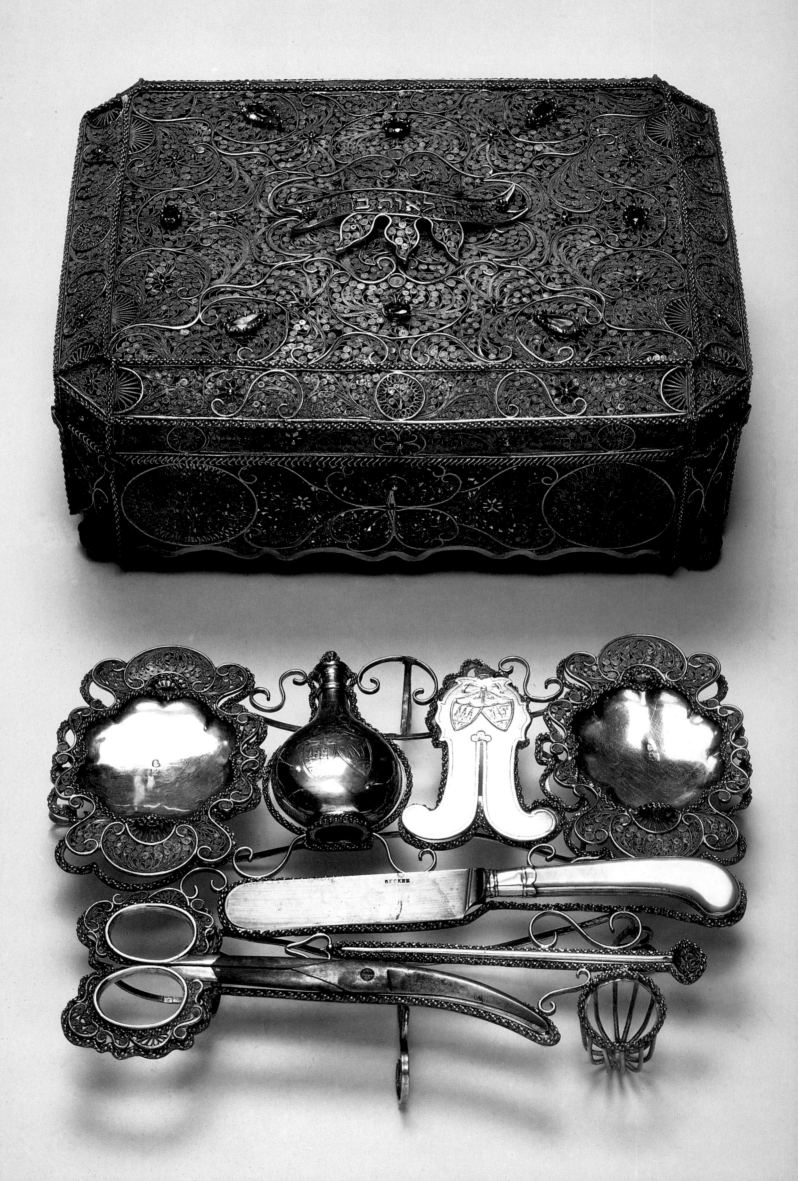

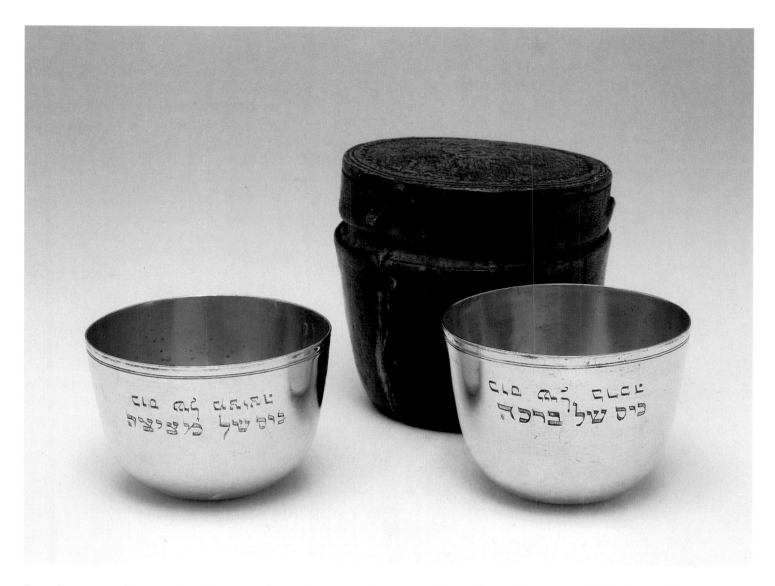

PAUL SOLANIER. *Circumcision Cups.* Augsburg, Germany. 1695–1710. Cups: silver, gilt, engraved. Height, 1 7/8 in.
(4.7 cm); diameter, 2 1/2 in. (6.4 cm). Case: wood, leather. Height, 2 7/8 in. (7.3 cm); diameter, 3 1/8 in. (7.9 cm).
Hebrew Union College, Skirball Museum, Los Angeles. Gift of Frank L. Weil, New York. *The inscriptions on the cups
refer to their ritual functions in the circumcision ceremony. Double cups for the berit milah, sometimes barrel-shaped,
are found in a number of collections. These cups nest together and fit within the case. The mohel, who was an ances-
tor of the donor, lived in Germany about 1730.*

(OPPOSITE)

Circumcision Set. Holland. 1827 and 1866. Box: silver, filigree, cast and hammered; inlaid with semiprecious stones.
Utensils: silver, cast, filigree and hammered; mother-of-pearl, carved. Box: 9 1/2 x 7 3/8 x 4 1/8 in. (24.1 x 18.7 x
10.5 cm). The Jewish Museum, New York. The H. Ephraim and Mordecai Benguiat Family Collection. *According to
the inscription on the vial, it was commissioned in 1826/27 by Jacob Nehemias Torres, whose family crest is also engraved
on the lyre-shaped shield made at the same time. Torres was no doubt a mohel, a trained specialist who performs
ritual circumcisions. The box, of finely crafted filigree work, as well the other implements and rack to hold them, were
made in 1866.*

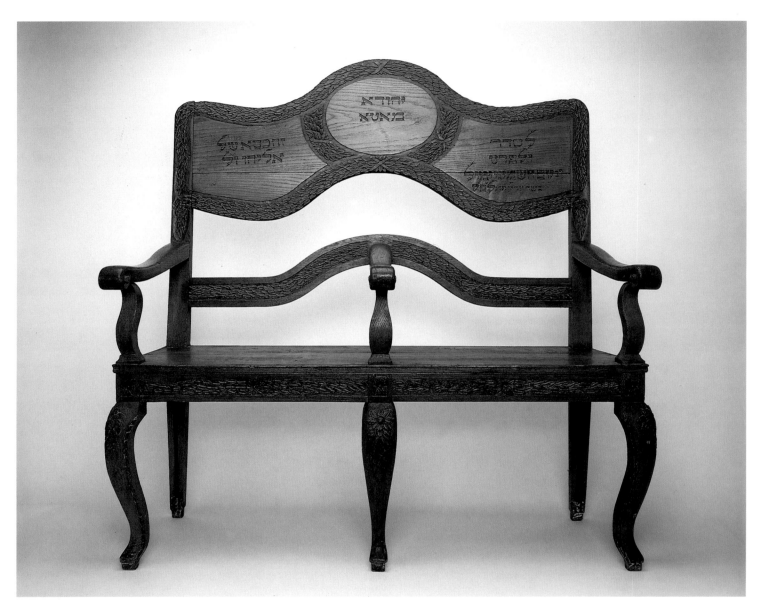

Chair of Elijah. Rheda, Westphalia. 1803. Carved wood. 53 x 52 x 20 1/2 in. (134.6 x 132.1 x 52.1 cm). Hebrew Union College, Skirball Museum, Los Angeles. Kirschstein Collection. *It was often customary for the Chair of Elijah to have two seats, one symbolic for the prophet and the second for the* sandek, *who holds the baby. This Chair of Elijah was the gift of Judah Mata.*

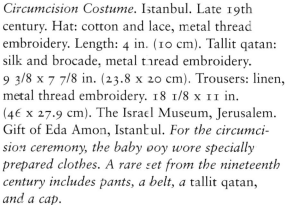

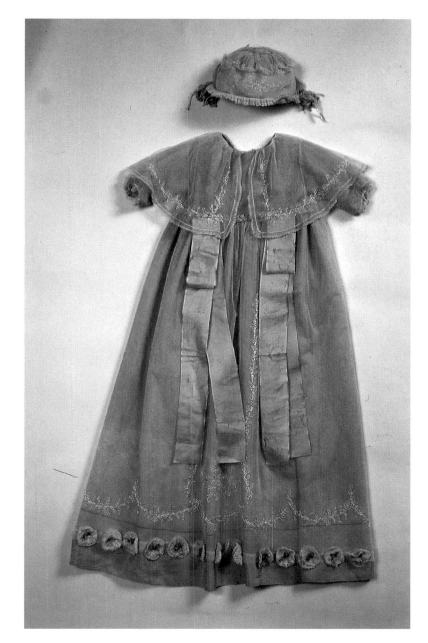

Circumcision Costume. Istanbul. Late 19th century. Hat: cotton and lace, metal thread embroidery. Length: 4 in. (10 cm). Tallit qatan: silk and brocade, metal thread embroidery. 9 3/8 x 7 7/8 in. (23.8 x 20 cm). Trousers: linen, metal thread embroidery. 18 1/8 x 11 in. (46 x 27.9 cm). The Israel Museum, Jerusalem. Gift of Eda Amon, Istanbul. *For the circumcision ceremony, the baby boy wore specially prepared clothes. A rare set from the nineteenth century includes pants, a belt, a tallit qatan, and a cap.*

Costume for a Girl's Name-Giving Ceremony. Salonika. Early 20th century. Silk, tulle, silk thread embroidery. The Israel Museum, Jerusalem. Gift of Salonika Jewry Research Center, Tel Aviv. *A zeved habat, a special naming ceremony for girls, was the norm in most Sephardi communities of Turkey and the Balkans. The baby girl wore an elaborate dress, a head covering, and a transparent gold-embroidered scarf to cover her head. In the late nineteenth and early twentieth centuries, the dresses were silk decorated with lace and tulle in the European style. This dress may have been a kamiza lárga, a long gown regarded as having protective qualities, "para vida lárga" (for a long life), which was sewn by the mother during her pregnancy.*

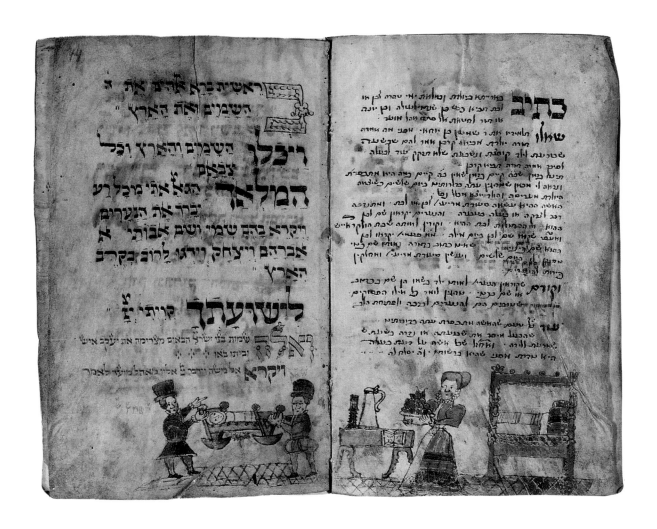

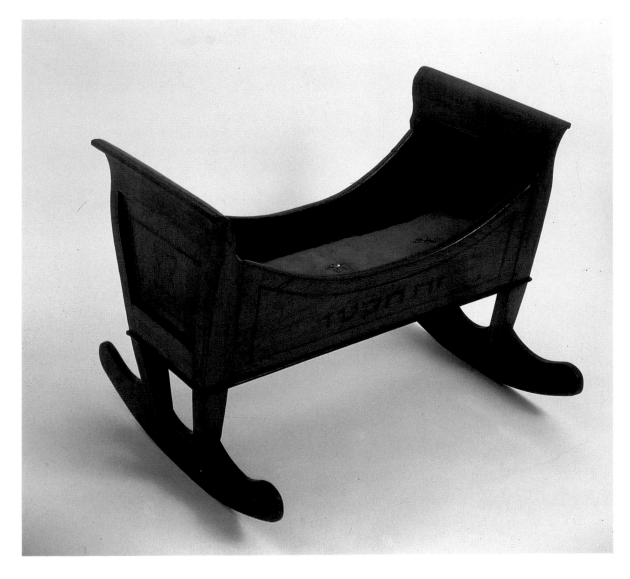

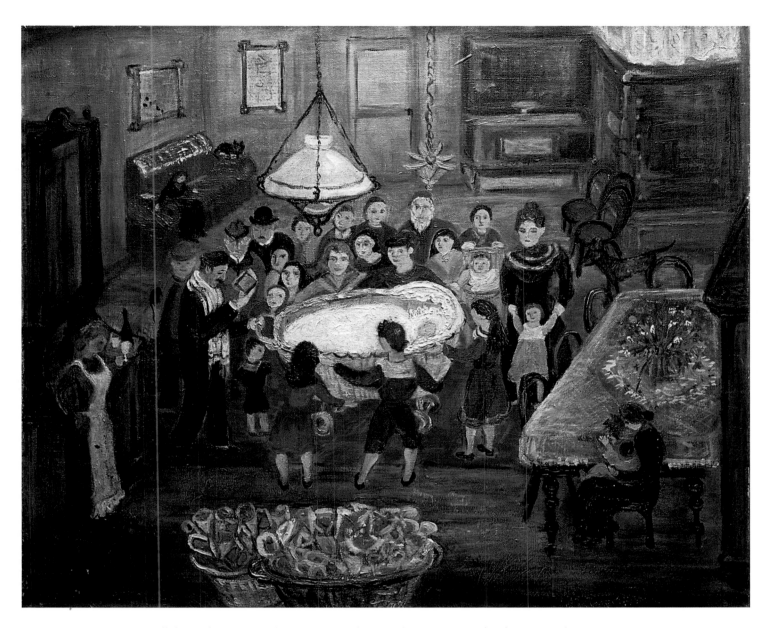

ALIS GUGGENHEIM. *Hollekreisch*. 1950. Oil on canvas. The Israel Museum. Gift of Siegmund Weiner
and Eva Weiner-Karo, Lucerne, Switzerland. *In this folk art depiction of the naming ceremony, as the neighborhood
children surround the baby's cradle, the cantor, who is wearing a tallit, reads biblical verses.*

(OPPOSITE, ABOVE)

ELIEZER BEN MORDECAI. *Prayer Book*. Germany. 1589. Parchment. 8 3/4 x 5 5/8 in. (22.2 x 14.3 cm). 8° Hs. 7058,
fols 43v–44. Bibliothek, Germanisches Nationalmuseum, Nuremberg. *A liturgical manuscript, this volume contains
prayers for the Jewish holidays and for life cycle events. The text is composed of the verses from Genesis recited at
the Hollekreisch ceremony. Typically, neighborhood children lifted the cradle and recited the baby's name. Here, two
men are raising the cradle.*

(OPPOSITE, BELOW)

Cradle. Moravia. Early 19th century. Carved, stained, inlaid wood; velvet embroidered with metal thread and glass
stones. 22 3/8 x 28 7/8 x 17 in. (56.8 x 3 x 43.2 cm). The Jewish Museum in Prague. *The cradle is ornamented
with carved rosettes, a popular folk art motif in Bohemia and Moravia, and is engraved and painted with a passage
from the circumcision service, "May this child [. . .]become an adult." This cradle is one of the objects that was
documented as having been in the Old Jewish Museum in Prague.*

138

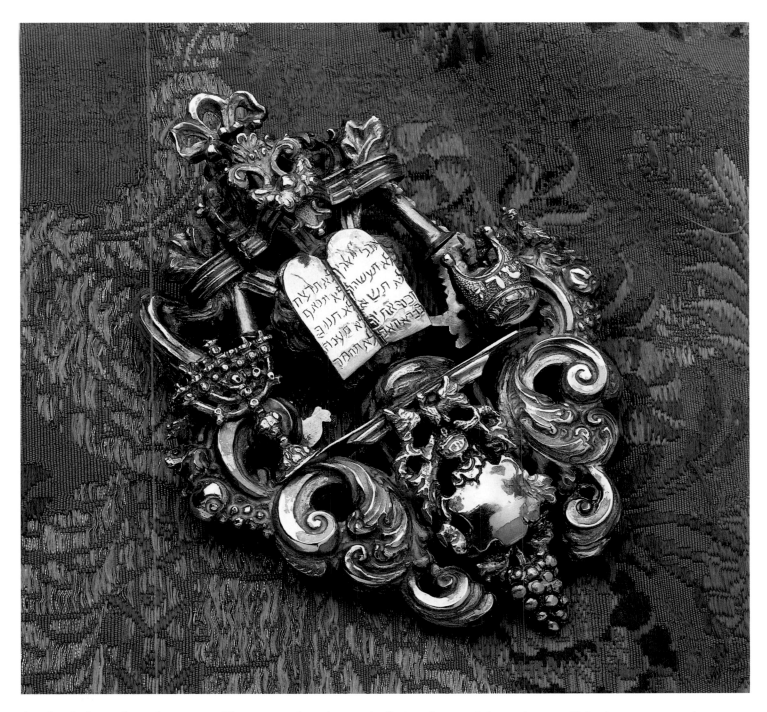

Amulet. Italy. 18th–19th century. Silver, cast, chased, parcel gilt; parchment, ink. 4 1/2 x 3 1/8 in. (11.4 x 7.9 cm). Hebrew Union College, Skirball Museum, Los Angeles. Gift of the Jewish Cultural Reconstruction, Inc. *A tradition in Italy was to have cradle amulets. On this amulet, there are gilt symbols of the Temple—the menorah, Ten Commandments, High Priest's miter, and censer—similar to those found on other types of Italian Judaica. At the bottom are cartouches with eagles, one of which opens to insert a tiny rolled amulet scroll.*

(OPPOSITE)

Amulet. Kurdistan. c. 1920. Silver. Cotton embroidered with silk. Diameter: 1 5/8 in. (4.1 cm). The Gross Family Collection, Tel Aviv. *Though the amulet has an unusual embroidered holder, it was made to be worn around the neck.*

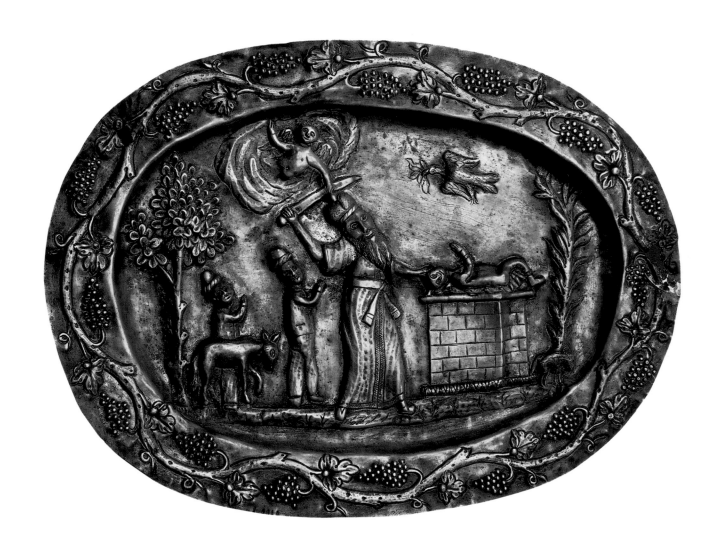

(OPPOSITE, ABOVE)

Plate for Pidyon Ha-Ben. Galicia, Poland. 19th century. Brass, repoussé. 7 1/2 x 10 in. (19 x 25.4 cm). Hebrew Union College, Skirball Museum, Los Angeles. From the collection of The Jewish Museum, New York. *It was a nineteenth-century Polish custom to make plates for pidyon ha-ben, redemption of the firstborn, depicting the akeda scene. Most are made in silver and the silversmith's punchmarks identity some, such as this example, as having been made in Lvov. Some examples also have the signs of the zodiac around the rim of the plate.*

(OPPOSITE, BELOW)

Torah Binder. Halberstadt, Germany. 1731. Undyed linen, embroidered with polychrome silk thread. 123 1/2 x 7 1/2 in. (313.7 x 19 cm). Hebrew Union College, Skirball Museum, Los Angeles. Kirschstein Collection. *This wimpel was made for Eliakum, son of Joe of Halberstadt, born on Wednesday, the 27th of Adar 5491 (=1731). Eliakum's zodiac sign, Pisces, is depicted, as are a Torah scroll, marriage canopy, and symbols that identify his parents' personal hopes for him.*

Leipzig Maḥzor. Upper Rhine, Germany. 1320. Parchment. 19 1/2 x 14 1/2 in. (49.5 x 36.8 cm). Ms V. 1102, vol I, fol 131. Universitätsbibliothek, Leipzig. *In this scene, young students are being introduced to the study of Torah on Shavuot. The three vignettes picture children being given honey by their teacher, a child wrapped in a Torah binder, and the lesson being taught that a person without Torah is like a fish without water. The adults wear the distinctive medieval Jew's hat.*

141

AARON WOLF HERLINGEN. *Kriyat Shema*. From the *Seder Berakhot*. Vienna. 1724. Vellum. 3 1/4 x 2 3/8 in. (8.3 x 6 cm). Library of the Jewish Theological Seminary of America, New York. *A woman recites the Shema prayer before retiring at night, but first she recites a special private prayer. Among the other prayers in this book of blessings are the grace after meals and prayers blessing God as the creator of human diversity and healer of the sick. Aaron Wolf Herlingen of Gewitsch, active until about 1760, was a well-known artist-scribe who served as scribe to the Imperial Library in Vienna. He made a number of commissions for wealthy Court Jews. Many of his works are monochrome pen and ink drawings which simulated engravings in printed books.*

Tallit, Tallit Bag, Tefillin Bag. Shanghai. 1904. Silk with silk embroidery. Tallit: 84 x 29 1/2 in. (213.4 x 74.9 cm). Tallit bag: 7 x 8 3/4 in. (17.8 x 22.2 cm). Hebrew Union College, Skirball Museum, Los Angeles. Gift of Mr. Revan Komaroff. *This type of embroidery is similar to that done by French nuns in China. This set was made for the Bar Mitzvah of Revan Komaroff, whose family had left Russia and remained in China for several years en route to the United States.*

(OPPOSITE)

ISRAEL BEN MEIR (SCRIBE). *Darmstadt Haggadah*. Germany. Late 15th century. Vellum. 14 x 9 3/4 in. (35.6 x 24.7 cm). Cod. Or. 8, fol 37v. Hessische Landes- und Hochschulbibliothek, Darmstadt. *The manuscript was written by the scribe Israel ben Meir of Heidelberg, but the artist is unknown and the illuminations may be the work of several hands, perhaps even by Christian artists. The elaborate, fanciful architectural structure and the treatment of figures and drapery are characteristic of the Gothic International Style. This page contains an initial-word panel with the Hebrew word "Az," the beginning of a poem recited from the haggadah at the Passover seder—"How many the wonders you have wrought." Significant in this depiction is the inclusion of women as well as men engaged in text study.*

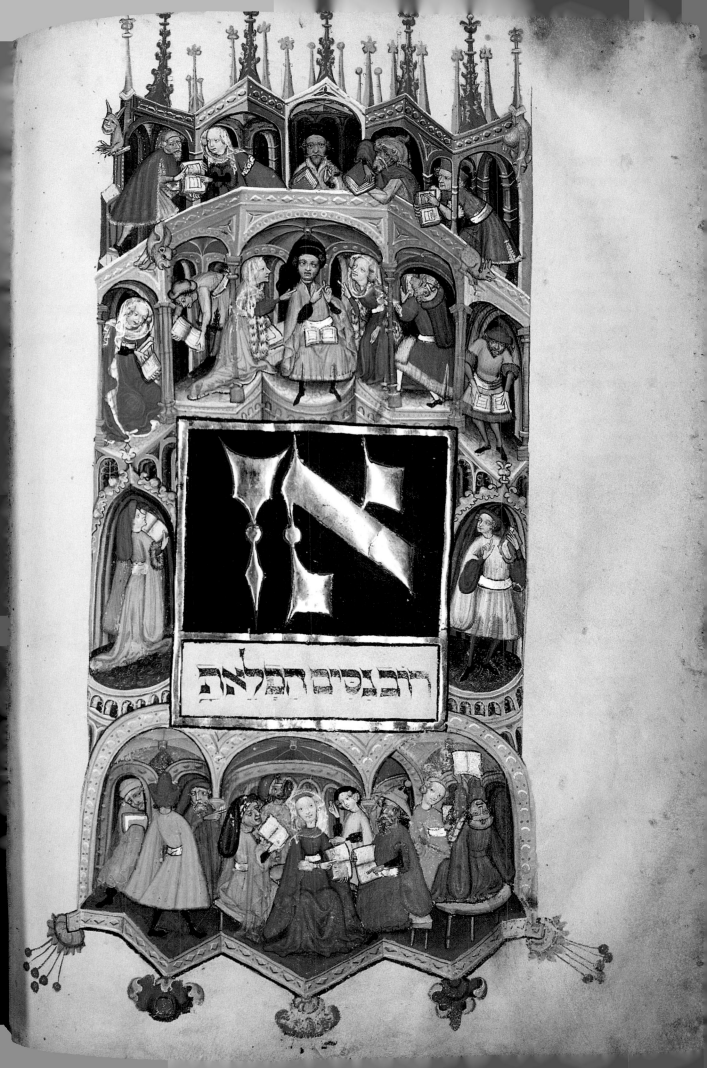

אלהים רבים

ANNA BANKS. *Tallit Qatan*. Portsmouth, England. 1901. Crocheted cotton. 36 x 8 7/8 in. (91.4 x 22.5 cm). Hebrew Union College, Skirball Museum Los Angeles. Gift of Susan Moyse Richter in honor of the Moyse Family. *Anna Banks crocheted this arba kanfot for her husband, Noah Bank, in celebration of the birth of their daughter Carrie, incorporating the date on one side and his initials on the other. It remained in the family for seventy years and later passed on to the son of Carrie Banks Moyse. This arba kanfot is quite unusual with wonderful folk art motifs of birds flanking a tree and rosettes on the straps.*

Bar Mitzvah Caftan. Bokhara. 19th century. Linen weave embroidered with silk. The Israel Museum, Jerusalem. *The festive Bokharan caftans were usually made of colorful Ikat-dyed silk or velvet embroidered with gold metallic thread and silk. The fabric of this coat is completely covered with silk embroidery. It is extremely rare to find a coat of this size for a Bar Mitzvah boy.*

(OPPOSITE)

JOEL BEN SIMEON AND OTHERS. *Feibusch Haggadah*. South Germany. c. 1460–75. Parchment. Add. Ms. 14762, fol 8v. The British Library, London. *The "wise son" described in the Passover haggadah, symbolically shown holding a thick book, is depicted with his arba kanfot prominently visible over his robe. The scribe and artist was variously identified in his manuscripts, here as "Feibusch, called Joel, [who] painted it," giving the haggadah its title.*

JOSEF ISRAELS (1824–1911). *A Jewish Wedding.* 1903. Oil on canvas. 53 15/16 x 58 1/4 in. (137 x 148 cm). Rijksmuseum, Amsterdam. *The work of the Dutch artist Josef Israels was influenced by his visits to France and by the work of Rembrandt. Israels' palette is dark, the focus on gradations of light and shade. In* A Jewish Wedding, *he tenderly captures the moment when the groom clasps the bride's hand to place the ring on her finger. The whiteness of the tallit which envelops the couple sets them apart and contributes to the intimacy of the moment.*

(OPPOSITE)

Wedding Rings. Italy. 17th century. Gold. The Israel Museum, Jerusalem. *These gold rings, with delicate filigree and enamel work, are known to be wedding rings. The house-like structure may symbolize the Temple in Jerusalem or the home the couple will build and share. The authenticity of other so-called "community" marriage rings, with "hidden" ceremonial objects, which have come on the market, is dubious.*

Coffee Service. Staffordshire, England. 1789. Salt-glazed stoneware, painted with overglaze polychrome enamels. Tray: diameter, 13 in. (33 cm). Coffee pot: 8 5/8 x 7 1/2 in. (21.9 x 19.1 cm). Pitcher: 5 x 4 in. (12.7 x 10.2 cm). Waste bowl: 2 1/2 x 5 5/8 in. (6.4 x 14.3 cm). Sugar bowl: diameter, 3 1/4 x 3 15/16 in. (8.3 x 10 cm). The Jewish Museum, New York. Gift of the Felix M. and Frieda Schiff Warburg Foundation. *A unique set, this coffee service, depicting a wedding ceremony, was dedicated in 1789 in Amsterdam by Zvi Hirsch, son of Abraham, in honor of Hillel, son of Tuvia of blessed memory, and his wife, Brendele, daughter of Elazar Segel of blessed memory. In addition to the wedding scene, the decoration of the coffee set is similar to salt-glazed English pottery of the period, which was very much influenced by Chinese porcelains.*

(OPPOSITE)

Prayer Book. Halberstadt. 1761. Silver, brass. 7 1/2 x 5 1/4 in. (19 x 13.3 cm). The Gross Family Collection, Tel Aviv. *Prayer books with silver covers were given as gifts from bride to groom or vice versa. The recipient of this book was Leib Eiger, the Rabbi of Halberstadt and the great uncle of the famed Rabbi Akiba Eiger.*

Ketubbah. Krems, Austria. 1391–92. Parchment. 22 7/8 x 16 1/2 in. (58.1 x 41.9 cm). Cod. Hebr. 218. Austrian National Library, Vienna. *This is the earliest known ketubbbah with figurative imagery. It is particularly significant because the tradition of illuminating marriage contracts did not develop among Ashkenazim as it did in the Sephardi community. Dressed in wedding attire, the bride wears a crown and the groom the required Judenhut. The groom is holding a large ring as a symbol of the wedding.*

(OPPOSITE)

Ketubbah Padua. 1732. Parchment, tempera, gold powder, pen and ink. 35 x 23 1/4 in. (88.9 x 59.1 cm). The Israel Museum, Jerusalem. Acquired with the help of Bambi and Roger Felberbaum, New York, in memory of Mr. and Mrs. William Olden. *This ketubbah is a veritable compendium of biblical stories, Jewish and secular symbols, and wedding imagery. Pictured are the family crests of the couple; the bride and groom; the signs of the zodiac; Moses and Aaron; the Binding of Isaac; Jacob and the Ladder; and six miniatures illustrating Psalm 128. Alluding to the ever-present hopes for redemption, prominent in the center is a vision of Jerusalem, with the Holy Temple shown as an octagonal building, as is the Dome of the Rock, the mosque built on the Temple site. The menorah and other Temple implements, including the altar, laver, and shewbread table, are depicted as well.*

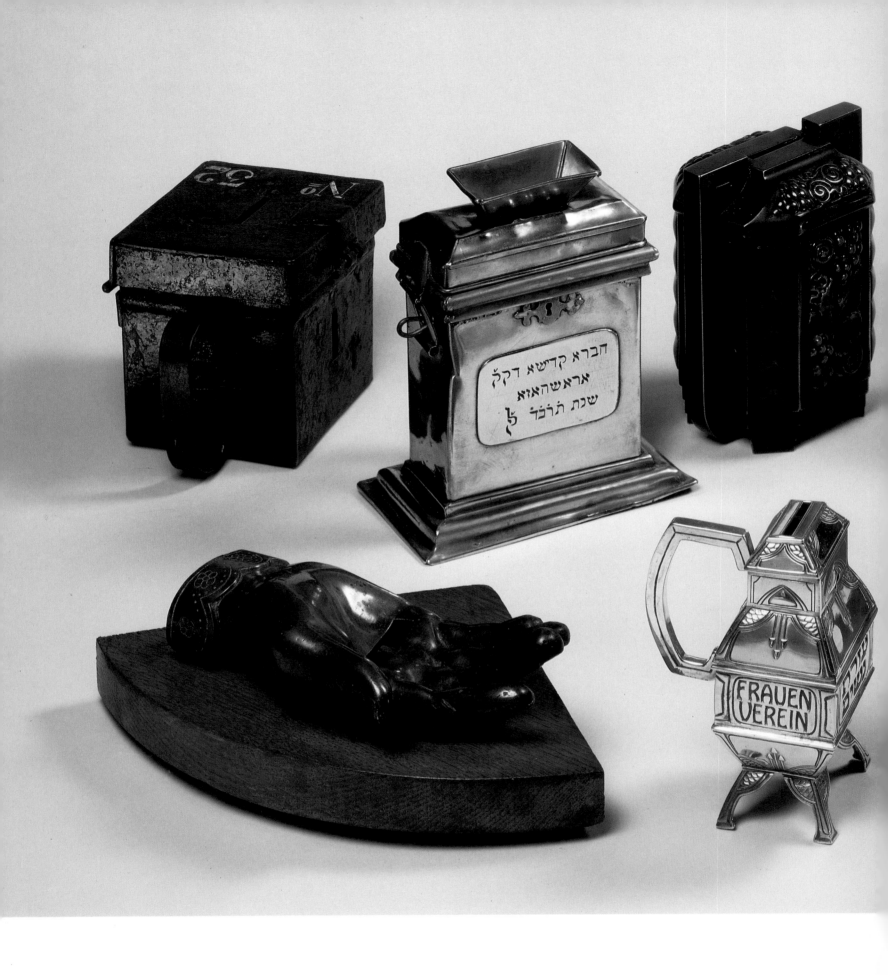

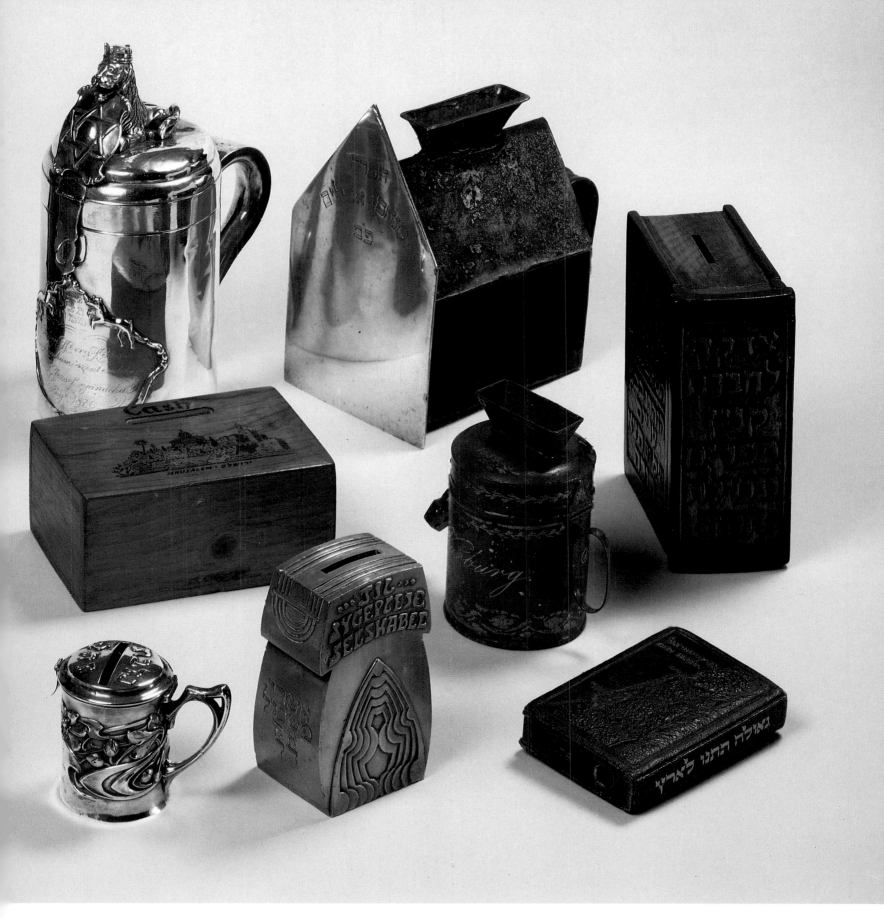

Charity (Tzedakah) Boxes. Michael and Judy Steinhardt Collection. These boxes for tzedakah are made in various media— brass, bronze, tin, silver, and wood—and range in date from the early eighteenth to the mid-twentieth century. Originating in Czechoslovakia, Hungary, Great Britain, Denmark, Germany, and Eretz Israel, the boxes represent a number of different causes. Those specifically identified by inscriptions include burial societies and groups who console mourners, a Women's Society, the Jewish National Fund, and a Society for Buying Books and Acts of Kindness [such as granting loans].

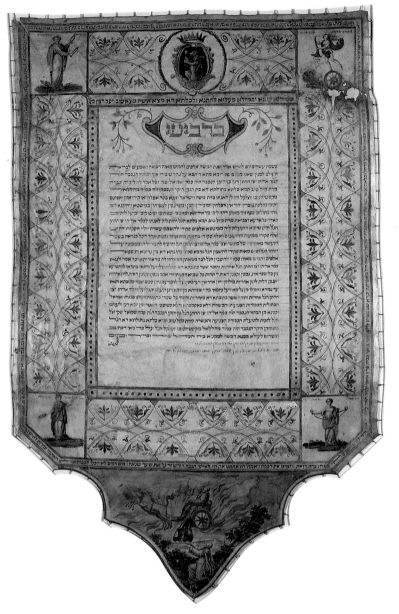

Ketubbah. Rome. 1816. Parchment, ink, gouache. 33 1/2 x 21 in. (85.1 x 53.3 cm). National Museum of American History. Smithsonian Institution, Washington, D.C. Museum purchase by G. Brown Goode. *The Roman style of illuminated ketubbot was very distinct. Roman ketubbot are shaped at the bottom, unlike other Italian ketubbot which are generally shaped along the upper edge. Characteristically, the text is framed in some type of portal motif, likely symbolizing the gateway to a new life for the couple. Also typical of ketubbot from Rome in the late eighteenth and early nineteenth centuries is the use of allegorical personifications which reflect contemporary ideals of marriage. The imagery is borrowed from Christian tradition and specifically from Cesare Ripa's* Iconologia. *What distinguishes this ketubbah is the powerful scene of Elijah ascending to heaven in a fiery chariot as described in the Book of Kings.*

Ketubbah. Hamburg. 1690. Parchment, watercolor, tempera, ink. 27 1/2 x 23 1/2 in. (69.9 x 59.7 cm) in frame. Private collection, the Netherlands. Photograph courtesy of the Jewish Historical Museum, Amsterdam. *With its elaborate wedding scene, the participants and guests dressed in the style of the period, this ketubbah provides a rare glimpse of contemporary Jewish life among wealthy Sephardi families in northern Europe in the late seventeenth century.*

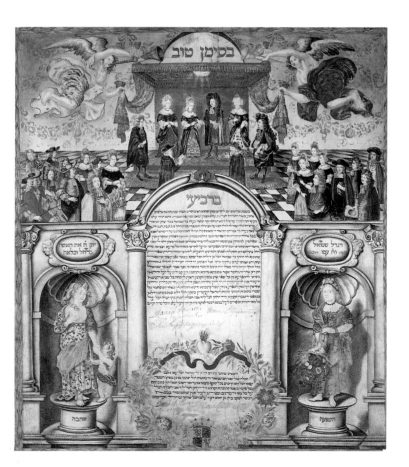

Ketubbah. Istanbul. 1853. Paper, gouache, gold powder, ink. 42 1/2 x 28 3/4 in. (108 x 73 cm). The Israel Museum, Jerusalem. Purchased by courtesy of fund in honor of Ari Ackerman, 1987. *A standard format for many ketubbot from the middle-class Sephardi community in Istanbul and its environs was to divide the ketubbah in two horizontal sections with the text in the lower half framed by impressionistic flowers and the upper part filled with crowded floral patterns. This ketubbah is a variation of that type and includes a miniature, a characteristic scene set on the shores of the Bosphorus with boats floating on the river. The buildings resemble the Ottoman Kosk, a small building used by the Turkish nobility for special occasions. This imagery, adapted from wall paintings in the palaces and private homes of Turkish nobility, was then adapted for decorative programs in synagogues.*

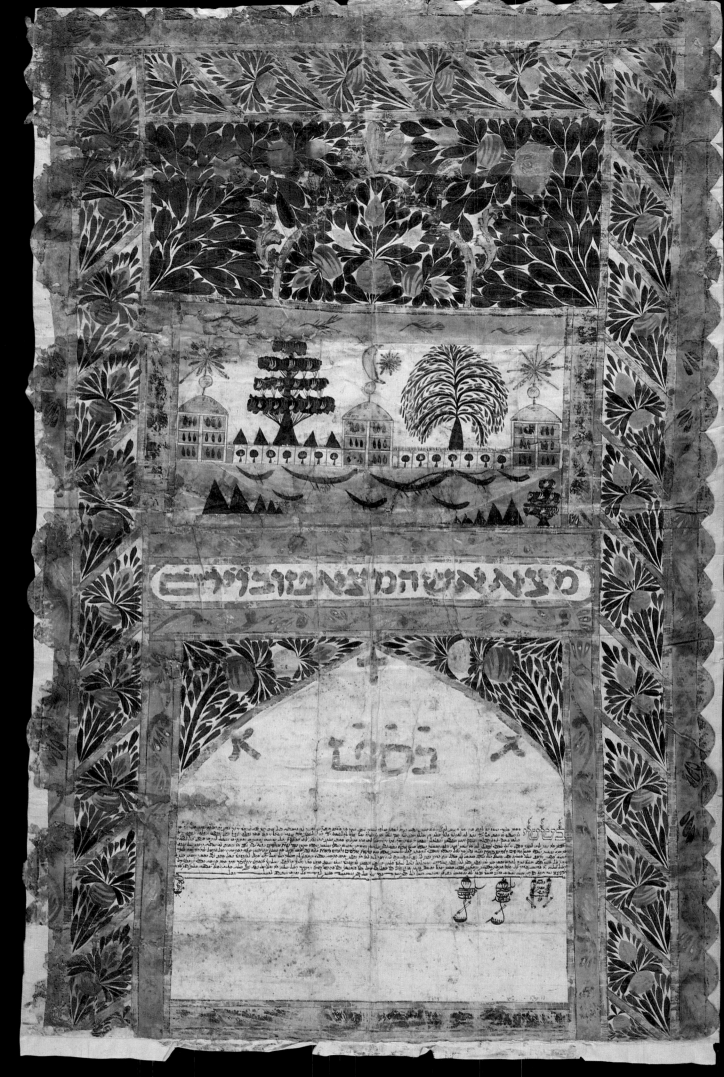

Mikveh Items. Wrapper for the ritual bath and towels: silk, linen, cotton, metal-thread embroidery. Wrap: silk, metal thread. Washing bowl: silver. Clogs: wood, inlaid mother-of-pearl. Israel Museum, Jerusalem. *According to Jewish law, the bride is required to purify herself prior to the wedding in a mikve (ritual bath). In Turkey, this act was celebrated in a very festive way, with all the women of the family participating at the* hammam *(bathhouse). All the articles required for the ritual, including beautifully embroidered towels, a brass or silver bowl, and clogs, were sent to the bride as a gift from the groom.*

(OPPOSITE)

Ketubbah. Corfu. 1781. Parchment, watercolor, gold paint, and ink. 31 3/4 x 20 5/8 in (80.6 x 52.4 cm). Hebrew Union College, Skirball Museum, Los Angeles. Kirschstein Collection. *In the eighteenth century the most important center of ketubbah illumination in Greece was on the island of Corfu, where there was a relatively wealthy Jewish merchant community. The ketubbah, with its elaborate field of flowers and scrollwork framing a biblical episode, is patterned after ketubbah illustration in Ancona, also a port city and mercantile center, with which Corfu maintained strong ties. The groom's name was Joseph and the episode of Joseph greeting his brother Benjamin was undoubtedly selected for that reason. Joseph, whose biblical namesake held an important position in the Pharaoh's court, is dressed in noble garb, his turban demonstrating the influence of the neighboring Ottoman culture.*

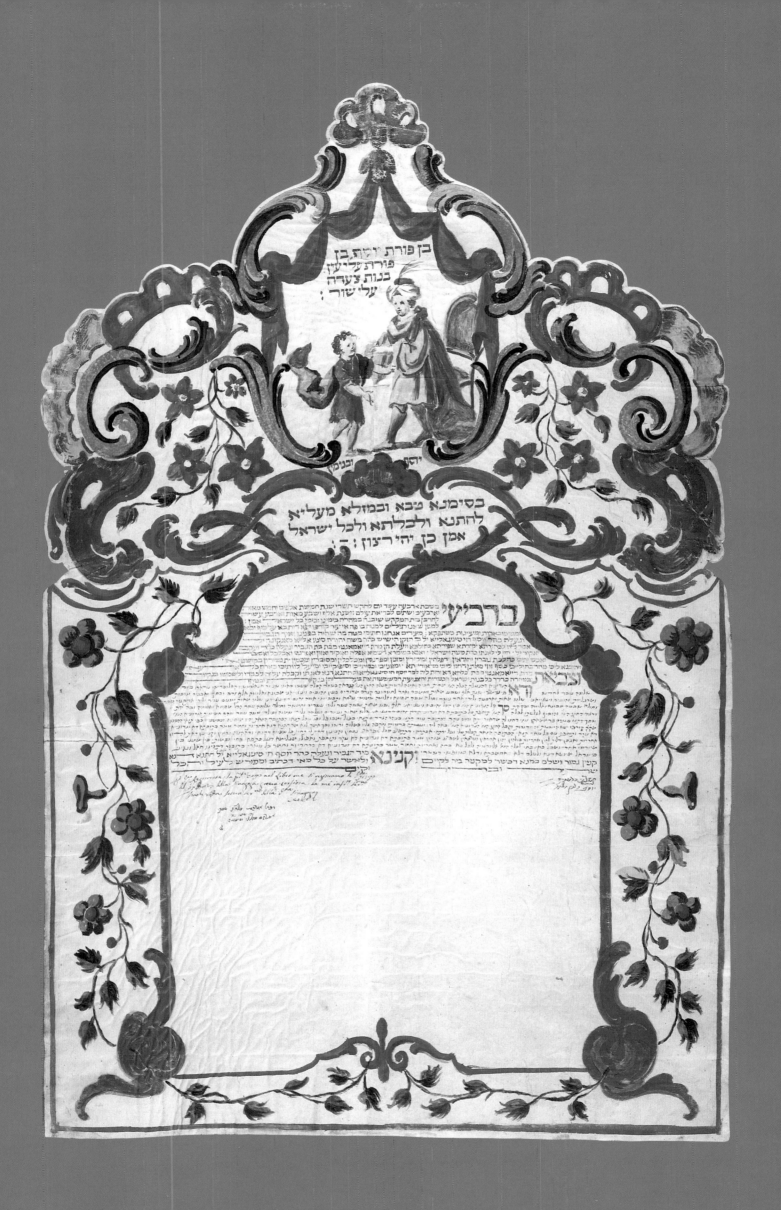

בן פורת יוסף בן
פורת עלי עין
בנות צעדה
עלי שור:

יוסף
ובנימין

בסימנא טבא ובמזלא מעליא
להתנא ולכלתא ולכל ישראל
אמן כן יהי רצון : ה':

ברביעי בשבת ברבעה עשר יום לחדש תשרי שנת חמשת אלפים וחמש מאות

ועבאת

קננא

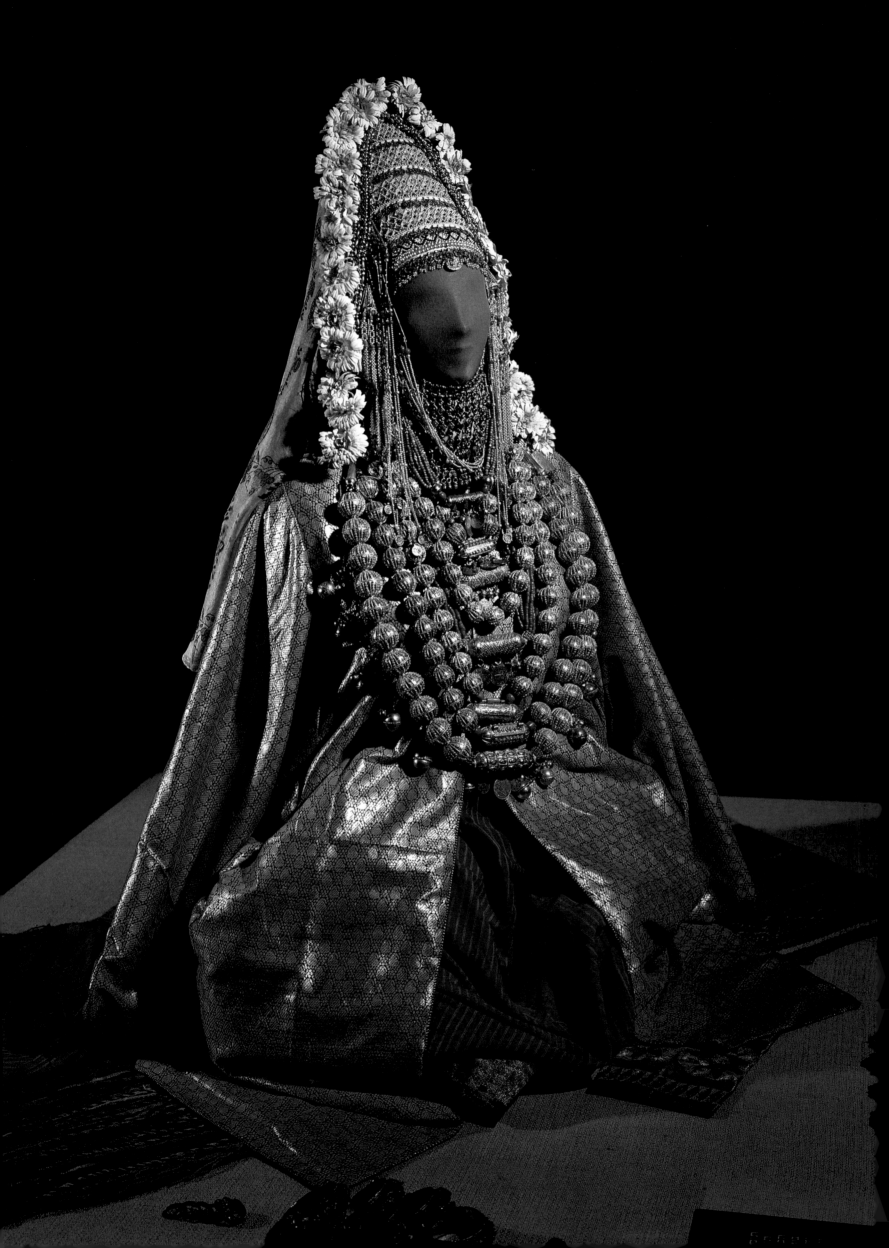

(OPPOSITE)

Yemenite Bride. Yemen. 19th–20th century. The Israel Museum, Jerusalem. *The bride is dressed in traditional ceremonial attire, which consists of a dress (ranje), robe (jalayeh mezahar), leggings (kebīr) and a special headdress. The triangular headdress, embedded with pearls and coral and embellished with silver, is the most elaborate part of the costume. The bride also wears a specific array of jewelry with ten necklaces, ten bracelets, and ten rings.*

Ketubbah. San'a, Yemen. 1794. Parchment, gouache, ink. 16 1/2 x 10 1/4 in. (41.9 x 26 cm). The Israel Museum, Jerusalem. *While there are numerous instances of images of the bridal couple depicted on ketubbot, it is quite unusual for figures to appear on a Yemenite ketubbah. The figures are rather primitive, making the simplistic handling of the flowering vines in the borders seem much more sophisticated. The meaning of the scene is unclear, although it has been suggested that it is the wedding banquet.*

Ketubbah. Damascus, Syria. 1864. Ink, watercolor and metallic paint on paper. 26 x 17 3/4 in. (66 x 45.1 cm). Smithsonian Institution, Washington, D.C. Deinard Collection. *Ephraim Deinard claimed to have found a genizah in Damascus although it has never been proved. However, it is possible that he was referring to the treasure trove of ketubbot that he found there. Dating from 1738 to 1864, these fifty-one ketubbot represent the majority of known extant Damascus ketubbot of the period. Most of the ketubbot in the collection are based on the design of a monumental gateway. Some have an appliqué of decorative paper, imported from Augsburg, Germany, which forms an archway around the text. This late example is similar in design to other ketubbot from the Ottoman Empire, with a portal design and field of flowers.*

MAX KOHLER THE YOUNGER. *Wedding Goblet*. Breslau. 1752. Silver gilt, repoussé, punched, engraved. Courtesy of the Max Stern Collection. *Appropriately ornamented with hearts, the goblet is inscribed "The voice of the bridegroom, and the voice of the bride."*

(BELOW)

Wedding Poem. The Netherlands. c. 1670. Parchment, gouache. 15 3/4 x 23 1/4 in. (40 x 59.1 cm). The Gross Family Collection, Tel Aviv. *Both manuscript and printed wedding poems were popular in The Netherlands and Italy in the eighteenth century. This poem, written in the form of a riddle, includes portraits of the bride and groom.*

Ketubbah. Herat, Afghanistan. 1895. Paper, watercolor, gold paint, ink. 17 1/2 x 13 15/16 in. (44.5 x 35.4 cm). Hebrew Union College, Skirball Museum, Los Angeles. Nancy E. and Herbert A. Bernhard Purchase Fund. *Herat was the center of ketubbah illustration in Afghanistan in the nineteenth century. The Jewish population grew significantly when many Persian Jews sought refuge there, and Persian influence is evident in ketubbah decoration. The typical illuminated ketubbah from Herat features an arcade in the upper register, containing two arches with blessings and biblical quotes, three with vases of flowers, and, in the lower register, five quatrefoils for signatures. The outer border of the ketubbah is inscribed with good wishes for the bridal couple, and the text is framed with bands of flowers in alternating colors.*

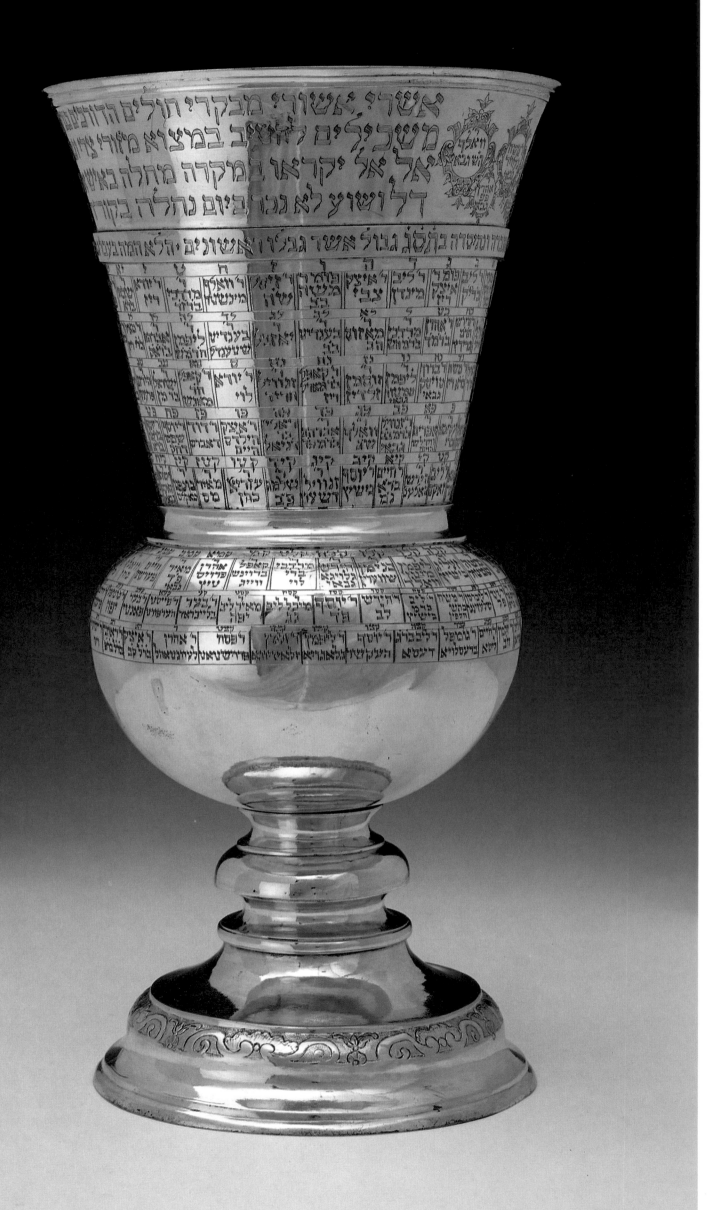

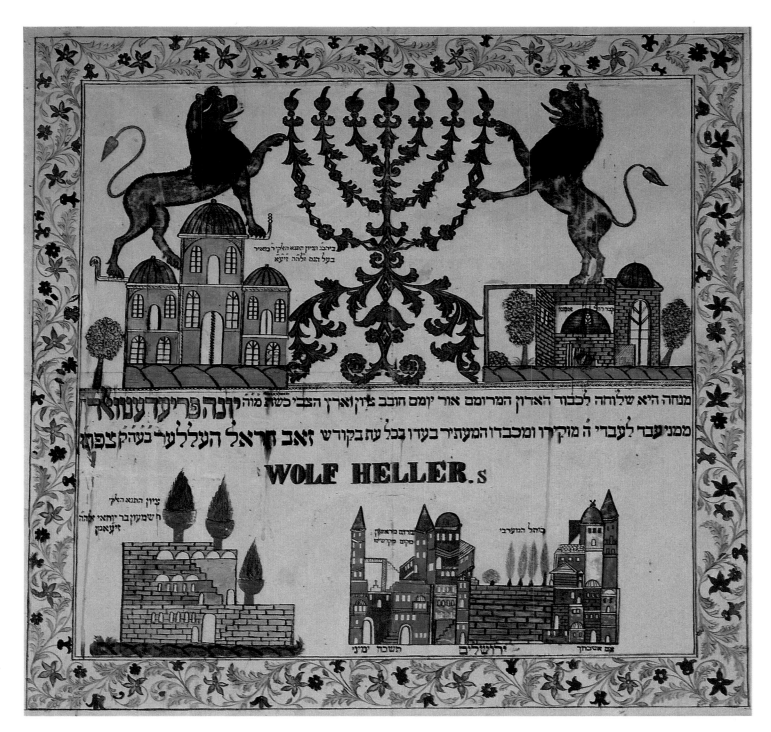

WOLF HELLER. *Jonas Friedenwald Tribute Document.* Safed, Eretz Yisrael. Late 19th century. Ink, gouache, gold leaf on paper. 21 1/4 x 23 in. (54 x 58.4 cm). Smithsonian Institution, Washington, D.C. *Jonas Friedenwald (1803–1893) was born in Germany and settled in Baltimore in 1832. He became a successful businessman and was well known for his philanthropic deeds. The tribute document includes the conventional representations of Jerusalem and other holy sites in Eretz Yisrael, including the tomb of Rachel, the western wall, and Temple mount.*

(OPPOSITE)

Beaker of the Holy Society for Visiting the Sick. Berlin. 1779. Silver, chased, engraved. Height, 14 5/8 in. (37.1 cm); diameter, 5 1/2 in. (14 cm). Hebrew Union College, Skirball Museum, Los Angeles. Gift of the Jewish Cultural Reconstruction, Inc. *In 1703 the Jewish community of Berlin established a Holy Society for Visiting the Sick. Forty years later, the leaders of the society commemorated the event by commissioning a large beaker inscribed with all the members' names, designed for use at the society's annual banquets. This is the second such beaker to be made and lists two hundred and twenty members.*

Mourners. From the *Rothschild Miscellany.* Northern Italy. c. 1450–80. Vellum, pen and ink, tempera, gold leaf.
8 1/4 x 6 1/4 in. (21 x 15.9 cm). Ms. 180/51, fol 121v. The Israel Museum, Jerusalem. Gift of James A. de Rothschild, London.

Memorial Label. Mantua, Italy. Early 19th century. Parchment, ink. 4 3/4 x 3 3/8 in. (12.1 x 8.6 cm). Smithsonian Institution, Washington, D.C. Deinard Collection. *The commemoration of the death of a loved one by lighting a candle identified with a parchment memorial plaque in the synagogue may have been a localized custom in Mantua, as very few have survived. Each varies in shape, but they have a similar dedicatory formula, giving the name and date of death and a blessing for the repose of the soul. This memorial is inscribed for Sarah Minzi, daughter of Mrs. Simha, who died in 1809.*

Memorial Label for Rabbi Abraham, "The Maker of Miracles." Morocco. Early 20th century. Silver, engraved, die-stamped, pierced. 21 x 10 7/8 in. (53.3 x 27.6 cm). Hebrew Union College, Skirball Museum, Los Angeles, *The memorial plaque pays tribute to Rabbi Abraham Moul Ness (Hebrew for "miracle"), who was renowned for his great "miracles." The name Mordechai, son of Ezra, either the maker or donor, is inscribed on the back of the plaque.*

J. STRETTI-ZAMPONI. *Old Jewish Cemetery in Winter.* c. 1910. Colored aquatint. 14 1/8 x 12 5/8 in. (35.9 x 32.1 cm). The Jewish Museum in Prague. *Behind the Altneuschul in Prague is the Old Jewish Cemetery, established in the fourteenth century and in use until 1787. Long before then, all the available space had been used up the existing graves were covered, creating a second tier. All the tombstones were then placed on top. This process was repeated as many as twelve times, so that the tombstones are tightly packed. It is therefore possible to know the names and dates of the deceased but not the exact place of burial.*

Burial Society (Hevra Kaddisha) Beaker. Prague. 1783–84. Enameled glass. 7 1/2 x 5 1/2 in. (19.1 x 14 cm). The Jewish Museum in Prague. *Men and women of the burial society are pictured in a funeral procession. One of the men holds a tzedakah box aloft. The inscription refers to a "cup of benediction for feasting and rejoicing, for drinking our fill of love." A variety of beakers, pitchers, and silver cups was made for use at yearly banquets held to raise funds for services to the community.*

Memorial Papercut. Scranton, Pennsylvania. 1902. Craft paper, tempera, gold leaf. 20 x 24 in. (50.8 x 61 cm). Hebrew Union College, Skirball Museum, Los Angeles. Gift of Rebecca and Leo Weinberger. *This rare hand-crafted American "yahrzeit," or memorial, honors the parents and grandmother of the maker. The artist records the place and date but does not give his own name, although the family name in the inscription is given as Weinberger. The lush imagery and delicate artistry of the papercut, with painted apple, pear, and eucalyptus trees and oversize herons, along with the prominent gold-leaf weeping willows, contrasts sharply with the black ink and primitive calligraphy of the memorial inscription. Around the border are biblical and liturgical quotations.*

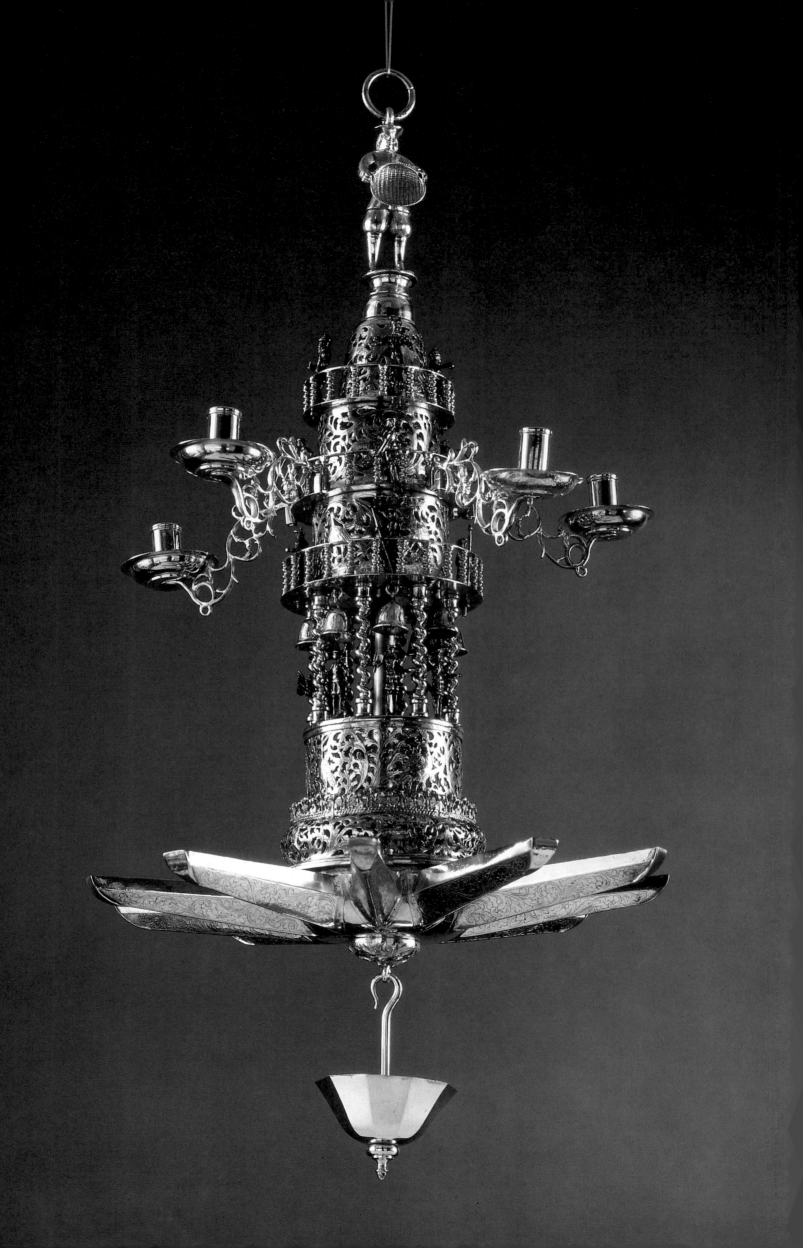

The Sabbath: "Day of Delight"

The heaven and earth were finished . . . and on the seventh day God finished the work which he had been doing and God rested. And God blessed the seventh day and declared it holy (GENESIS 2:1–3).

THE SABBATH (*shabbat*) is a very special time, referred to by the prophet Isaiah as the Day of Delight (58:13). From the moment the Sabbath begins on Friday at sundown until darkness falls on Saturday is a time for spiritual renewal, free from the tedium of routine responsibilities and the trials and tribulations of daily life. The Bible also enjoins the Jewish people to observe the Sabbath throughout the ages as a covenant for all time (Exodus 31:16). To fulfill the covenant between God and Israel, the shabbat is celebrated in the tradition of biblical and rabbinic law. The singular mood of peacefulness and tranquility, of a time set apart, is captured in Isidor Kaufmann's *Friday Evening*. The many details of preparation have been attended to; all is in readiness as the woman of the house waits for the return of her husband from the synagogue service welcoming the Sabbath (*kabbalat shabbat*).

A number of ceremonial objects enhance the shabbat observance and mark its sanctity in Jewish life. A fifteenth-century *cofanetto* (casket) from northern Italy represents the putting aside of everyday tasks. Perhaps a gift to a Jewish bride from her bridegroom, the casket was used on the Sabbath to store the keys to all the linen cabinets. The woman wore the key to the cofanetto as a piece of jewelry pinned to her clothing. Illustrations on the front of the casket portray the three responsibilities of women dating back to antiquity. The first is *hadlakat ha'ner* (kindling of lights) to inaugurate the Sabbath and festivals. The second is, when baking bread, to separate out and burn an olive-sized piece of dough, hallah, as an offering of thanksgiving to God (Numbers 15:19–21), a custom traced back to the ritual in the Temple in Jerusalem, from the biblical mandate to set aside a portion of the "first yield of your baking." The third is *niddah,* to observe the laws of family purity, which includes monthly purification in a *mikve* (ritual bath).

Traditions vary as to the number of lights to be kindled; the minimum number generally cited to fulfill the ritual is two, based on variation of the wording of the Fourth Commandment regarding the sabbath day (Exodus 20:8 and Deut. 5:12). Lamps utilized for the ritual vary with time and place.

In central Europe, a special form of hanging lamp known as a *Judenstern* (Jewish star) is known from

(OPPOSITE)

JOHANN ADAM BOLLER. *Sabbath and Festival Hanging Lamp.* Frankfurt-am-Main. Early 18th century. Silver, embossed, cutout, chased, castings, traces of gilt. Length, 31 in. (78.7); diameter of basin, 15 1/2 in. (39.4 cm). Congregation Emanu-El of the City of New York. Bequest of Judge Irving Lehman, 1945. *Boller became a master silversmith in 1706 and joined the Frankfurt workshop of Valentin and Michael Schuler, already known for making Judaica. This lamp represents a development of the star-shaped Judenstern, now silver and based on the form of fountains found in German village squares. The use of this imagery has been associated with the introduction in Frankfurt at the beginning of the seventeenth century of "Lecha Dodi," a hymn welcoming the Sabbath, and describing the day as "forever a fountain of blessing." The cast figures include a finial which may represent the owner of the lamp; at the top tier, David and Moses alternating with captains of guard; then four trumpeters, a level with four watchmen, and finally, eight figures holding ceremonial objects symbolic of the Sabbath and holidays. The lowest tier has a cut-out and chased hunting scene, which may be based on the mnemonic "YaKNeHaZ" from the haggadah, the correct order of blessings when the beginning of Passover coincides with the end of the Sabbath.*

Hebrew manuscripts from Germany and Italy to have been in use since at least the fifteenth century. The Judenstern hung from the ceiling and could be lowered to light the oil contained in spouts that formed a star shape. A woodcut illustration from a *Sefer Minhagim* (Book of Customs) from Amsterdam, dated 1707, portrays a woman about to bless the candles. Hanging lamps of this type were used throughout Europe in the Middle Ages, and their association with Jewish ritual use persisted. By the sixteenth century, the term *Judenstern* became conventional.

The Judenstern was usually brass, but some pewter examples exist, and some more elaborate lamps were made of silver. An example from Frankfurt-am-Main incorporates a male figure on the shaft. Also from Frankfurt is a five-tiered, tower-shaped lamp with a ten-pointed star-shaped reservoir for the oil, one of a group based in part on the form of village public fountains. Interestingly, the lamp also has candle-holders, which are also found on some brass lamps, perhaps an indication that the old custom persisted even as a new custom evolved. A variant of the star-shaped lamp developed in Italy. Made of silver, it has no central shaft, and the oil container is a deep central bowl hung from ornamental chains. Another adaptation, found in the Sephardi communities of Holland and England, is composed of variously shaped elements hung one above the other with the star-shaped receptacle for the oil being the central feature.

From about the seventeenth century, many women lit candles either in candlesticks or different types of candelabra. The number of candles varied with local custom, among them the addition of one candle for each child. Candlesticks range from simple turned brass, as was the custom in eastern Europe, to elaborate silver examples. Some have inscriptions, such as *shabbat kodesh*, the Holy Sabbath. A pair of silver repoussé candlesticks from Danzig from the late seventeenth century bears three biblical scenes on each base.

The shabbat table is set with two loaves of bread (hallah), sometimes placed on a special decorated plate. Like the kindling of lights, the use of two is again in accordance with the biblical spirit, in this instance referring to the double portion of manna which the Israelites, wandering in the wilderness after the liberation from Egypt, received on Fridays so they would not have to gather food on the Sabbath (Exo-

cus 16:22–26). The hallah is covered by a decorative cover during the recitation of the kiddush, the blessing for wine, and the *ha-motzi*, the blessing for the hallah. Hallah covers may include inscriptions and symbolic images, such as the late nineteenth-century example lovingly embroidered by Marianna Kirschstein, which depicts twin loaves of braided hallah. Other hallah covers and tablecloths are simply decorative, like an example from Iran dated 1806, embroidered with a field of abstracted flowers and geometric motifs.

The words of the kiddush also refer to God's rest after the six days of creation and God's blessing of the Sabbath. Any cup can be used for kiddush, but it is customary to use a special cup, and traditional forms developed among different communities. Hexagonal or octagonal cups were popular in Augsburg. At times, the cups used for kiddush were ornamented with inscriptions and decorative imagery. Special wine bottles were sometimes used, but very few have been preserved. A rare etched, glass bottle from the Near East from the nineteenth century is inscribed with the quotation from Genesis (2:1–2), recited as part of the kiddush, referring to God's resting after completing the Creation.

The shabbat is celebrated both in the synagogue and the home; there is a special synagogue liturgy, beginning with the recitation of Psalms before the evening service on Friday. The highlight of the morning service is the reading of the weekly portion from the Torah. A section of the Torah reading for the next week is read at the afternoon service as well. Men, women, and children are depicted standing outside a German synagogue in *Der Samstag*, painted around 1800. The men wear a traditional costume dating from an earlier period.

In the spirit of *oneg shabbat* (Sabbath joy) meals in the evening, at lunch, and a third meal, the *se'udah shlishit*, are very festive. It is customary, whenever possible, to invite guests, and it is traditional to sing special *zemirot* (songs). The peace and serenity of the day are personified in Moritz Oppenheim's painting entitled *Sabbath Afternoon*.

As darkness falls, the Sabbath is over. The end of the shabbat and the transition to the new week is met with a certain sorrow and observed by the recitation of *havdalah* (separation). This ceremony marks the conclusion of the holy Sabbath and the return to the everyday. Blessings are recited over wine, spices, the besamim, and light. Any cup can be used, but occasionally there are cups, like one from Afghanistan,

Sabbath Plate. Bohemia. Early 20th century. Porcelain. 9 x 13 3/4 in. (22.9 x 34.9 cm). The Jewish Museum in Prague. *Decorated with wheat imagery, this plate probably held the hallah loaves. The Yiddish inscription reads "Gut Shabbes."*

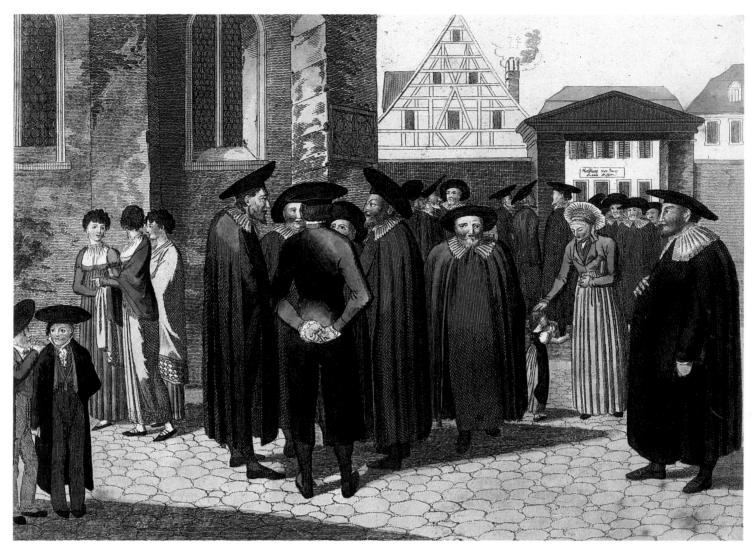

Der Samstag (Saturday). Germany. c. 1800. Handcolored engraving. Hebrew Union College, Skirball Museum, Los Angeles. *Based on a painting by Frederich Campe, men, women, and children are shown gathered outside the synagogue on the Sabbath. The women wear fashionable clothing, but the men wear their traditional eighteenth-century garb to the synagogue, including the distinctive baretta, the flat round hats. Visible on the corner of the synagogue wall is the star-shaped traustein. At the conclusion of a wedding ceremony, which in Ashkenazi communities was usually held in the synagogue courtyard, the bridegroom threw a glass against the traustein rather than stamping it with his foot.*

made around 1900, inscribed with a portion of the blessings recited during the havdalah ceremony. According to rabbinic legend, each Jew receives a *neshamah yeterah* (additional soul) on the Sabbath. Traditionally, the spices are interpreted as a means of comfort as the shabbat ends and the extra spiritual strength departs. In Sephardi communities, a fresh sprig is generally used for the spices. In Ashkenazi communities, the spices used for havdalah are kept in a spice container. The spice box take many forms, from flowers to miniature trains, but the tower form is the most popular, stylistically influenced by the local architecture. A particularly ornate example, decorated with enamel plaques with biblical characters, was made in Austria in the eighteenth century.

A special candle is used for havdalah, a custom that emanates from a rabbinic interpretation of the blessing recited over the light, which in the Hebrew is plural. Typically, the havdalah candle is created from several twisted wicks, so that when it is lit, it looks like a torch. The week begins, but in the timeless rhythm of Jewish life, the Sabbath will soon return.

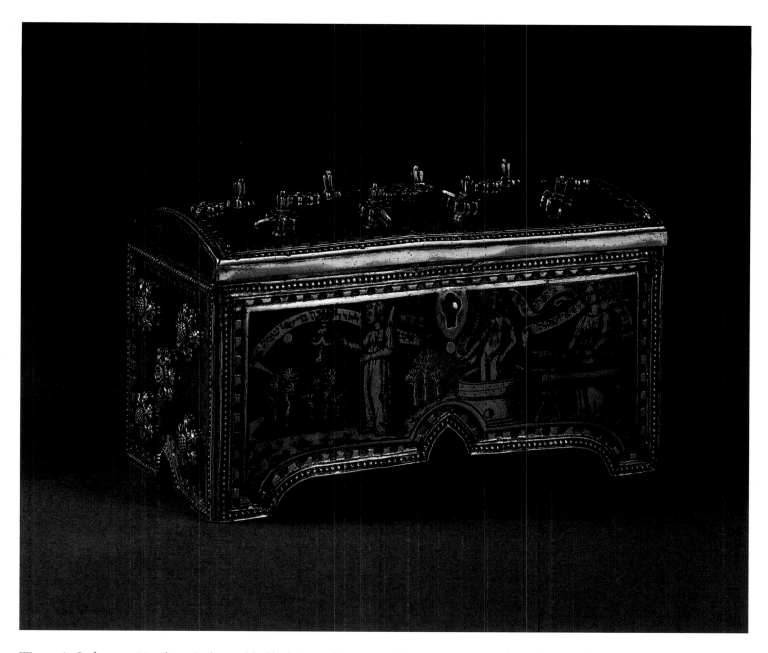

Woman's Cofanetto. Northern Italy. 2nd half of the 15th century. Silver, cast, engraved, niello, parcel gilt. 2 9/16 x 5 x 2 3/8 in. (6.5 x 12.7 x 6 cm). The Israel Museum, Jerusalem. Gift of Astorre Mayer, Milan. *This rare woman's cofanetto serves both a practical need and a religious function. The dials at the top, with inscriptions in Italian written with Hebrew letters, provide an inventory of such household linens as sheets, tablecloths, and shirts. Each of the cabinets for these domestic items would have had a separate key and it is surmised that on the Sabbath, the woman stored all the keys in the cofanetto and wore the silver or gold key, as a piece of jewelry, symbolically putting aside the everyday household tasks. The illustrations on the front portray the three duties which are specifically incumbent on Jewish women.*

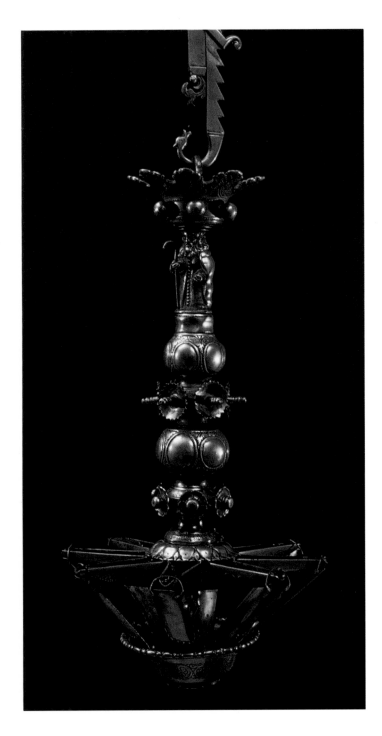

Sabbath Lamp. Germany. c. 1800. Brass. Length, 24 in. (61 cm); diameter, 12 5/8 in. (32.1 cm). The Gross Family Collection, Tel Aviv. *Probably from Frankfurt-am-Main, this lamp is derived from the type of star-shaped lamp first used in the Middle Ages. This example is very unusual because it includes a cast figure wearing the typical Sabbath garb of the eighteenth century.*

(OPPOSITE, ABOVE)

Lighting the Candles. Bohemia. c. 1800. Glass. The Jewish Museum in Prague. *Similar to imagery in illuminated manuscripts, this unusual painting is done on glass. Also unique is that the candelabrum which the woman kindles for the Sabbath is similar in form to the seven-branched Temple menorah, though the inscription makes it clear that this is the* ner shel shabbat, *the Sabbath light.*

(OPPOSITE, BELOW)

ISIDOR KAUFMANN. *Friday Evening.* c. 1920. Oil on canvas. 28 1/2 x 35 1/2 in. (72.4 x 90.2 cm). The Jewish Museum, New York. Gift of Mr. and Mrs. M.R. Schweitzer. *In* Friday Evening, *Kaufmann portrays an intimate, quiet moment, when the woman of the house has just lit the Sabbath candles. All is in readiness. The table is set with the wine cup and hallah, and she waits, it is presumed, for her husband to return from the synagogue. Painted about 1920, late in Kaufmann's career, this unfinished work depicts a bygone world.*

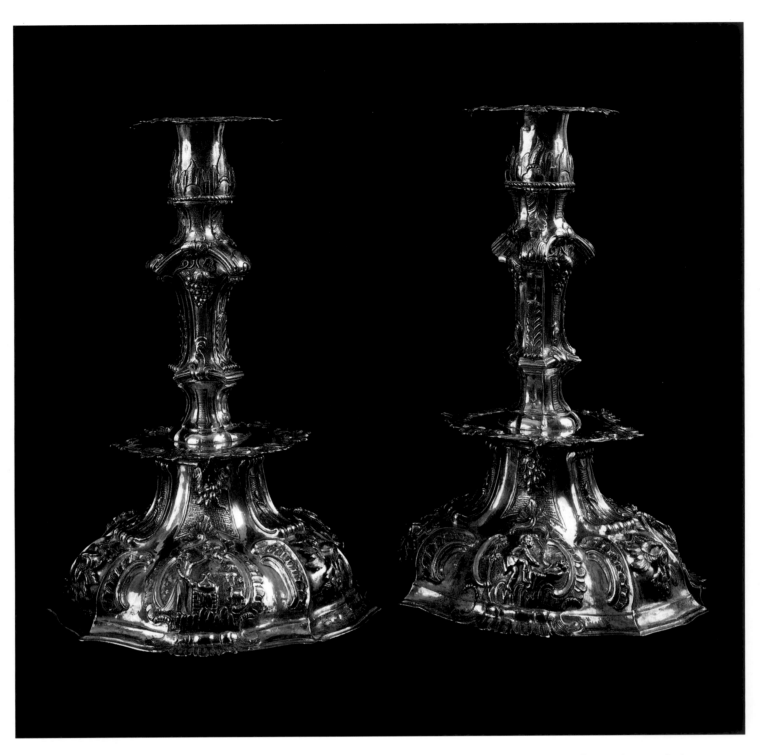

Sabbath Candlesticks. Danzig (Gdansk). c. 1670–1700. Silver, parcel gilt, cast, repoussé, engraved. 11 7/8 x 8 1/4 in. (30.2 x 21 cm). B'nai B'rith Klutznick National Jewish Museum, Washington, D.C. Collection of Joseph B. and Olyn Horwitz. *On the bases of these ornately embellished candlesticks are cartouches with biblical scenes, three on each. Five have been identified: the Judgment of Solomon, Jacob's Dream, and Cain and Abel on one; Jacob Wrestling with the Angel and the Binding of Isaac on the second. The last scene depicts a king extending his arm and pointing his scepter at a strange, bird-like creature with a tail like a serpent. An inscription indicates that at some point these candelesticks were owned by Naftali and Zipporah Herz.*

MARIANNA KIRSCHSTEIN. *Hallah Cover.* Germany. Late 19th century. Silk, silk and wool embroidery, silk chenille. 21 1/2 x 21 1/2 in. (54.6 x 54.6 cm). Hebrew Union College, Skirball Museum, Los Angeles. Kirschstein Collection. *Marianna Kirschstein, wife of the pioneering collector of Judaica, Salli Kirschstein, embroidered this hallah cover, proudly incorporating her name into the design in beautiful script. The Hebrew blessing is more primitive and includes several mistakes. Most unusual is the naturalistic rendering of the twin twisted hallah loaves. As is typical of Victorian era embroidery work, the flowers are meant to be recognizable as well. An exotic bird is perched in the vines in the upper right corner.*

Sabbath Cloth. Persia. 1806. Cotton, embroidered with polychrome silk. Diameter: 32 5/8 in. (82.9 cm). The Jewish Museum, New York. Gift of Dr. Harry G. Friedman. *A special type of Sabbath cloth was embroidered by Kurdistani women from the region of Sakiz. The cloths are typically embroidered with flowers, Hebrew inscriptions, and motifs which are similar to those found or metal amulets for protection and blessing.*

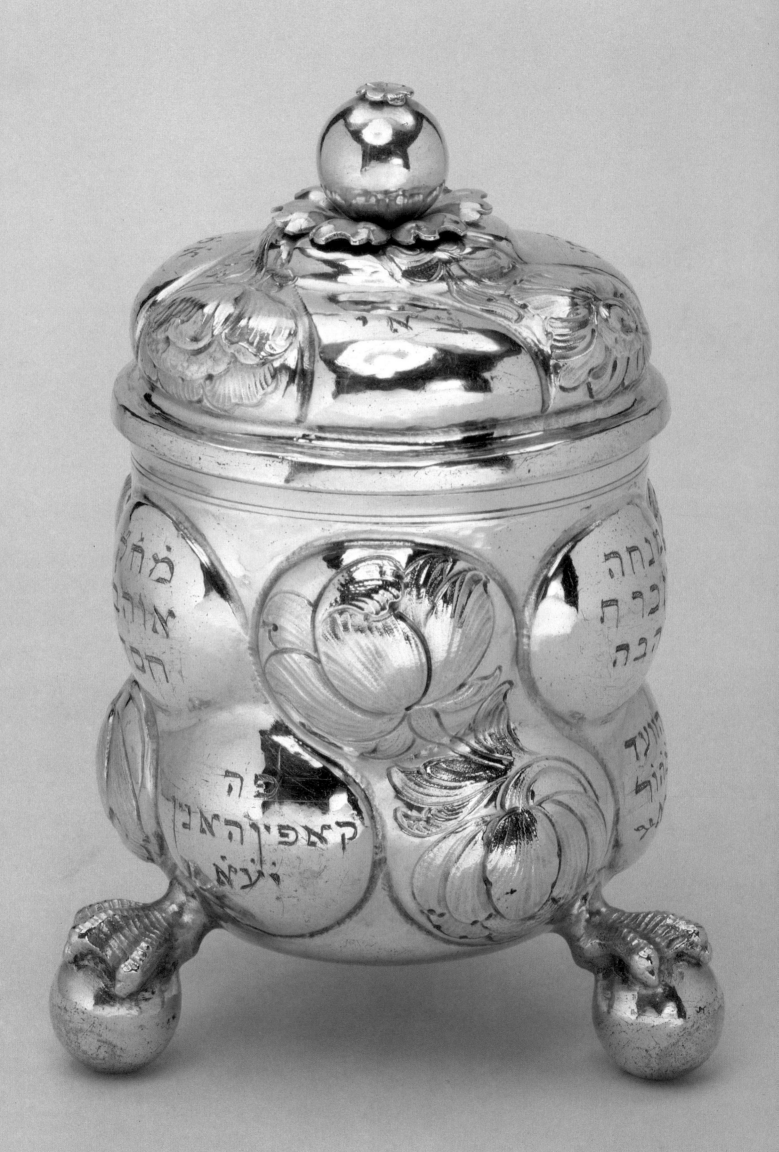

MORITZ OPPENHEIM. *Sabbath Afternoon.* Frankfurt-am-Main. c. 1866. Oil on canvas. 19 5/8 x 22 5/8 in. (49.8 x 57.5 cm). Hebrew Union College, Skirball Museum, Los Angeles. Gift of the Jewish Cultural Reconstruction, Inc. Sabbath Afternoon *is one in a series of remarkable works by Oppenheim entitled* Scenes from Traditional Jewish Family Life *painted between the 1850s and his death in 1882. Important to Oppenheim was that these works were not simply nostalgic genre paintings depicting Jewish life, but that they in some way contributed to the preservation of Jewish identity in its encounter with modernity. Set in a comfortable Jewish home, a warm glow enveloping the family members, the painting evokes the wonderful serenity of the spirit of the Sabbath.*

(OPPOSITE)

Covered Kiddush Cup. Nurnberg, Germany. Mid-17th century. Silver, parcel gilt. Height, 5 1/8 in. (13 cm); diameter, 2 7/8 in. (7.3 cm). Victoria and Albert Museum, London. Gift of Dr. Edith Novak. *Originally, the cup was made so that each of the alternating gadroons was unadorned and the others embossed with a tulip motif arranged in two rows. The Hebrew inscriptions were subsequently added in the undecorated spaces. The lid is inscribed in Hebrew with the initial letters of the words of the kiddush blessing. The dedication on the cup reads "A memorial present from the fraternal society Ohave Chesed [Lovers of Mercy] which was established in the year [5]492 [=1731/32] here in Copenhagen in commemoration of the centenary of the Society in [5]592 [=1831/32]."*

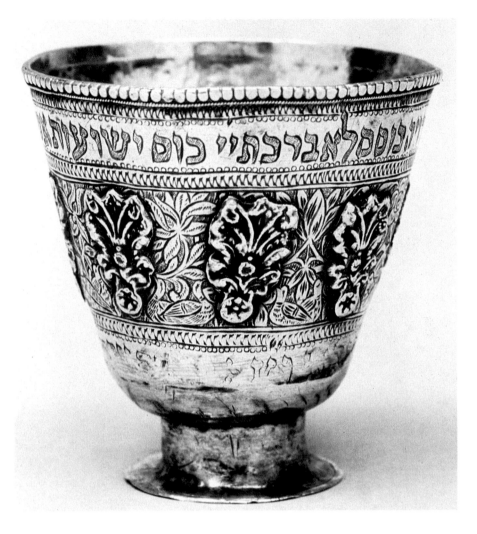

Havdalah Cup. Afghanistan. c. 1900. Silver. Height, 3 in. (7.6 cm); diameter, 2 7/8 in. (7.3 cm). The Gross Family Collection, Tel Aviv. *The inscription on the cup identifies it as being used specifically for havdalah. This very fine example of Afghan work includes applied cast medallions.*

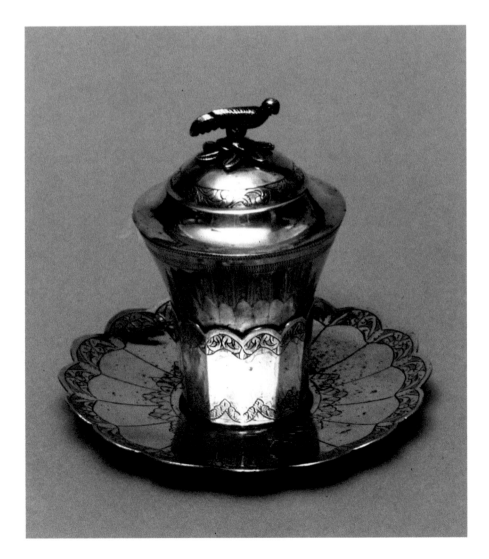

Kiddush Cup. Iraq. c. 1925. Silver. Height, 5 1/4 in. (13.3 cm); diameter, 3 1/4 in. (8.3 cm). The Gross Family Collection, Tel Aviv. *The Iraqi kiddush cup comes with both a cover and a saucer. The bird finial is a typical Iraqi motif.*

Hieronymos Mittnacht. *Kiddush Cup*. Augsburg. 1763. Silver, gilt. The Gross Family Collection, Tel Aviv. *The octagonal form was very typical for eighteenth-century German kiddush cups.*

Sabbath Wine Bottle. Syria(?). 19th century(?). Etched glass. 7 7/8 x 5 1/2 in. (20 x 14 cm). Hebrew Union College, Skirball Museum, Los Angeles. Kirschstein Collection. *Only a few bottles of this type remain, and several hanging lamps of etched glass have also survived. The inscription on this bottle is the kiddush for the Sabbath. The Arabic writing around the neck seems to be only decorative.*

181

Spice Container. Austria, probably Vienna. 18th century. Silver filigree, semiprecious stones, enamel plaques. Height, 11 3/4 in. (29.8 cm). Musée national du Moyen Age–Thermes de Cluny, Paris. Don Rothschild, Coll. Strauss N° 15. *The spice container, in the form of a two-tiered square tower, is inset with semiprecious stones and decorated with enamel plaques. At each corner there is an unusual flame-like motif of twisted metal, perhaps referring to the flame of the havdalah candle. The enamel plaques with biblical subjects have no apparent unifying theme. The scenes include, on the spire, Samson at the Philistine temple, Elijah and the ravens, Moses on Mount Sinai, and Moses and the burning bush; on the top tier, Jacob wrestling the angel and Jacob's dream, Hagar and Ishmael in the desert, and an unidentified person with a fish; on the lower tier, Abraham and Melchezedik and Esther and Ahasuerus; on the base, Samson and Delilah, Jonah and the whale, Judith with the head of Holofernes, and Daniel in the lion's den.*

Spice Boxes (from left):

Central Europe. 19th century. Silver, cast, engraved, parcel gilt. Height, 11 1/2 in. (29.2 cm).

Prague. Early 19th century. Silver, pierced and engraved. Height, 7 7/8 in. (20 cm). Bequest of the Hanfeld Collection.

Brno, Moravia. Early 19th century. Silver, pierced, engraved, cast, parcel gilt. Height, 10 1/4 in. (26 cm). Shalom Asch Collection.

JOHANN CONRAD WEISS(?). Nuremberg, Germany. Early 18th century. Silver, pierced and engraved. Height, 11 5/8 in. (29.5 cm). Feuchtwanger Collection. Purchased and donated by Baruch and Ruth Rappaport, Geneva, 1969.

JOHANN CONRAD WEISS(?). Nuremberg, Germany. Silver, pierced and engraved. Height, 12 5/8 in. (32.1 cm). Gift of Jewish Cultural Reconstruction, Inc. 1952. The Israel Museum, Jerusalem.

The most popular form of spice box is the tower, first known from the sixteenth century. Sometimes realistic details are used, making it possible to identify the structure on which the spice box is modeled. The towers incorporate actual architectural components such as spires, domes, balustrades, and turrets, but they also demonstrate the inventiveness of the artisans, who embellished the spice boxes with animal and floral motifs and a variety of decorative elements.

Celebrations: The Jewish Holidays

We will all go, young and old; we will go with our sons and daughters . . . for we must observe God's festival (EXODUS 10:9).

THE JEWISH YEAR is filled with celebrations, feast and fast days, festive occasions and solemn holy days. What is perhaps most remarkable is that the commemoration of Jewish holidays is not only about remembering but also about experiencing the history of the Jewish people by symbolically reenacting the past. Observing the customs and rituals allows Jews to become part of the event: on Passover, eating the matzah; on Sukkot, building a sukkah like the booths the Israelites used in the desert; on Hanukkah, reliving the miracle of kindling the Temple menorah; and during the High Holy Days, from Rosh Ha-Shanah to Yom Kippur, hearing the sound of the shofar and its call for renewal in the New Year. Ceremonial objects are integral to the participatory nature of Jewish celebration, and special ritual artifacts have been created in the spirit of *hiddur mitzvah*, the quest to enhance the performance of each commandment.

The ten days between Rosh Ha-Shanah and Yom Kippur are traditionally called the Days of Awe. This is a solemn time, the ten days of penitence, when each person stands before divine judgment for the actions of the previous year. Rosh Ha-Shanah is a time of new beginnings. It marks the dawn of the new year and is considered the birthday of the world. Rosh Ha-Shanah has other names as well: *yom hazikaron*, the Day of Remembrance, dedicated to reflecting on one's actions of the past year; *yom hadin*, the Day of Judgment; and *yom t'ruah*, the Day of the Sounding of the Shofar, the call to awaken the individual to personal responsibilities, both ethical and ritual.

The shofar is one of the earliest of musical instruments. Its form has been preserved as it was in the Temple in Jerusalem. The shofar may be shaped, and it is permissible to incise it with inscriptions and ornamental patterns, though this is not typically done. The ancient ritual of sounding the shofar is portrayed as early as the fourteenth century in a manuscript from Germany decorated with contemporary figures engaged in ceremonial activities. An Italian Torah binder depicts not only shofars but also curved trumpets, a typical seventeenth-century form of the instrument.

The shofar may be the horn of any animal ritually acceptable according to biblical law. The ram's horn is a figurative reminder of the story of the *akeda*, the Binding of Isaac, when Abraham was permitted to spare Isaac and sacrifice a ram in his stead (Genesis 22:13). The akeda is the portion from the Torah read in the synagogue on the second day of Rosh Ha-Shanah. A dramatic akeda scene on a Torah mantle from Rheims, France, dated 1878, portrays the angel swooping down to stop Abraham, who is poised to perform the sacrifice.

(OPPOSITE)

Hanukkah Lamp. Morocco. 18th century. Brass, cast, pierced, and engraved. 19 x 9 1/2 x 2 3/4 in. (48.3 x 23.5 x 7 cm). The Israel Museum, Jerusalem. Ticho Collection. *The backwall of this lamp is made of two separately cast pieces. The triangular upper section has birds perched on its "branches." The lower part has two arcades of horseshoe arch windows that reflect local architecture. This influence is most evident in the overall decorative quality of the lamp, a characteristic of the design on domes of many richly ornamented mosques.*

The liturgy of the High Holy Days is contained in a special prayer book, generally referred to as the mahzor (cycle), a term that traditionally alludes to special festival volumes in general. Many of these in manuscript form are illuminated. The power of Yom Kippur as a day of judgment is conveyed in a highly elaborate Gothic portal depicting the "Gate of Mercy" in a fourteenth-century mahzor from southern Germany. Many printed editions of prayer books have woodcuts or engravings.

During the synagogue services on both Rosh Ha-Shanah and Yom Kippur, it is customary for the rabbi and cantor to wear a white robe called a *kittel*. A nineteenth-century kittel has an embroidered collar and a *yarmulke* (skullcap) made of *spanier arbeit* (Spanish work), a technique of weaving silver and gold metallic threads which was a popular handicraft among Polish Jews. A nineteenth-century Ashkenazi custom was to wear a special silver buckle on the belt of the kittel. On the High Holy Days, the Torah mantles and ark curtain are generally white as well, as seen in the Torah binder by Leonora Colorni.

A number of Rosh Ha-Shanah customs reflect the hope for a good year. The customary greeting of the season is "May you be inscribed [in the book of life] for a good year." Before the festival meals, slices of apple or pieces of hallah are dipped in honey and a prayer recited asking that God "renew unto us a good and sweet year." In the twentieth century it has become the practice to send greeting cards with good wishes for the New Year.

The symbolic *tashlikh* ceremony takes place on the afternoon of the first day of Rosh Ha-Shanah, and is based on a verse from the prophet Micah which says that God will cast (*ve-tashlikh*) the sins of Israel into the sea (Micah 7:19). The custom is to go to a body of water, recite the text from Micah and other selected biblical readings and prayers, then symbolically empty pockets of any crumbs, representing one's sins, into the water. The ritual is intended to convey repentance by ridding oneself of sin.

Yom Kippur, the Day of Atonement, is the most sacred day of the year. Also known as the Sabbath of Sabbaths, it is observed with prayer and fasting. At this culmination of the season of judgment, one is required to ask forgiveness from family and friends before asking God for forgiveness. The greeting now said is "May you be sealed" in the book of life. Before the chanting of the haunting solemn *Kol Nidre* prayer in the synagogue, one eats a holiday meal. Candles are lit for the holiday, but no *kiddush* blessing is recited. In India, it was customary to have a special oil-burning lamp in the synagogue which would remain lit the entire day. Services are held in the synagogue on the eve of Yom Kippur and throughout the following day. The solemnity of the holiday is captured in Maurycy Gottlieb's monumental painting *Jews Praying in the Synagogue on Yom Kippur*. Though a community of worshipers, each one seems isolated, yet all display an intensity of feeling reflecting the seriousness of the day. Gottlieb's self-portrait, the young man in the foreground, seems to reveal his personal skepticism by his outward glance, with slightly scornful expression.

In addition to the High Holy Days, three major festivals are described in the Bible. Sukkot, Passover, and Shavuot are called the *shalosh regalim*, the three pilgrim festivals when all Jews were to go to Jerusalem. Each of these holidays has both a relationship to a historical experience recounted in the Bible and to the agricultural cycle.

Sukkot, the Feast of Tabernacles, comes just five days after Yom Kippur. After the solemnity of the High Holy Days, Sukkot is a time of great festivity, referred to in rabbinic literature as the *ḥag*, the holiday. At this time, a *sukkah* or booth is constructed to commemorate both the autumn harvest and the wanderings of the Israelites in the Sinai Desert after the liberation from Egypt. The sukkah must have at least three free-standing walls and a flat roof covered with branches in a manner that produces more shade than light but permits stars to be seen. The sukkah is trimmed with fruits and vegetables in thanksgiving for the bountiful harvest and with decorations to honor the *ushpizin*, the ancestors of the Jewish people

who are symbolically welcomed during the holiday. Because of exposure to the elements during the holiday, very few sukkah decorations have been preserved. A remarkable wooden sukkah made in Fischach, Germany, in the early nineteenth century for the Deller family was smuggled out of Germany in 1935. The entire interior is painted with a wealth of images: scenes of the town, including the Deller home; images of biblical events; and a visionary view of Jerusalem. A textile sukkah decoration made in Venice in the eighteenth century depicts the *Simḥat bet ha-sho-evah*, the festival of the drawing of water, celebrated in the Jerusalem Temple during Sukkot. The Talmud describes the celebration of Sukkot, a time of great joy, as including songs and dances and even acrobatic acts.

The symbols of Sukkot are the *lulav* and *etrog*, which represent the *arba'ah minim* (four species), which have an agricultural significance linked to ritual in the holy Temple. The lulav is a bundle of palm shoots bound together with *hadas* (myrtle sprigs) and *aravah* (willow branches). The etrog, a type of citron, is the fourth component. Special containers are used to protect the etrog. Some of these, like a silver and gilt example made in Augsburg around 1670, are patterned after the shape of the fruit itself. Others are more fanciful, like the container in the form of a duck.

During the week of Sukkot, at the morning synagogue service, the lulav and etrog are ritually used during the *hallel* (prayer of thanksgiving) and are carried around the synagogue with a Torah scroll during prayers called the *hoshanot*, a prayer of supplication, literally, "please save (us)." The seventh day of Sukkot is called *Hoshana rabba* and is considered to be the end of the judgment period begun on Rosh Ha-Shanah. The last day of Sukkot is *Shimini Azeret*, the assembly of the eighth day, when special prayers for rain are recited, linking the holiday to the agricultural cycle in Israel.

On Simḥat Torah, the yearly cycle of Torah reading is completed and immediately begun again. In Israel, and among Reform Jews, Simḥat Torah and Shimini Azeret are celebrated on the same day. The *ḥatan Torah* (bridegroom of the Law) is the person given the honor of saying the blessing for the closing verses; the *ḥatan bere'shit* (bridegroom of Genesis) for the first verses. As depicted in Alexander Hart's *The Feast of the Rejoicing of the Law at the Synagogue in Leghorn, Italy*, all the Torah scrolls are removed from the Ark during the service and seven *hakafot* (circles) are made in a procession around the synagogue. After each, in the joyous spirit of the holiday, it is customary to sing and dance with the scrolls.

Passover, which begins on the fourteenth of Nisan, marks the beginning of springtime and the rebirth of the land. Passover is the festival of freedom and represents the covenant between God and the Jews as a people. According to the biblical text, God tells Moses:

> *I have now heard the moaning of the Israelites because the Egyptians are holding them in*
> *bondage, and I have remembered my covenant. Say, therefore, to the Israelite people: I am the*
> *Lord. I will free you from the burdens of the Egyptians and deliver you from the burdens of*
> *the Egyptians and deliver you from their bondage. . . . And I will take you to be My people*
> *and I will be your God. . . . (Exodus 6:5–7)*

The event of the liberation from Egypt is recalled numerous times in Jewish liturgy to convey the message that in every generation we must look upon ourselves as if we personally had been freed from slavery in Egypt. Cognizance of that experience means too a special sense of social justice, understanding, and compassion for the plight of those in need, those who suffer inequities. Remembering the redemption from slavery is also an expression of the hope for the future final redemption.

As prominently displayed on an unusual fifteenth-century Italian haggadah composed of sixty-four roundels, the primary symbol of the liberation is the matzah, the bread of affliction, "You shall eat unleavened bread . . . for you departed from the land of Egypt hurriedly so that you may remember the day of

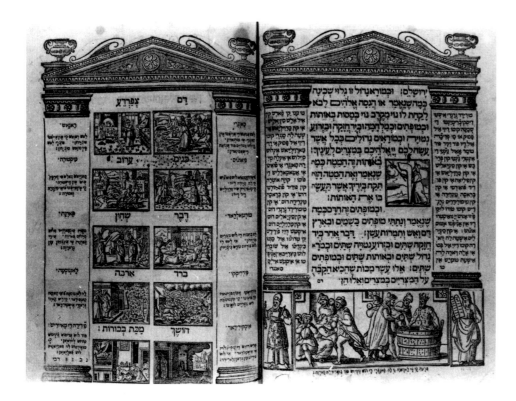

GIOVANNI DA GARA (PRINTER). *Ten Plagues.* From the *Venice Haggadah.* Venice. 1609. Ink on vellum. 11 1/8 x 7 5/8 in. (28.3 x 19.4 cm). Moldovan Family Collection, New York. *Because of the diversity of the Venetian Jewish community, which had Italian, Sephardi, and Ashkenazi groups, the* Venice Haggadah *was published in three separate editions—Judeo-German, Judeo-Spanish and Judeo-Italian—to meet their linguistic needs. The imagery of the* Venice Haggadah *was very innovative and served as an important model for subsequent haggadahs. This is the first time the Ten Plagues were depicted in this manner.*

your departure from the land of Egypt as long as you live" (Deuteronomy 16:3). Passover is also called *ḥag ha-mazzot* (holiday of unleavened bread). The preparation for Passover commences with clearing *ḥametz,* anything leavened, from the home. Getting ready for the holiday also means that the needy are provided with the special Passover foods, as illustrated in a scene from the fourteenth-century Spanish *Golden Haggadah.* On the evening of thirteenth of Nisan there is a ritual *bedikat ḥametz* (search for leaven). The late fifteenth-century German *First Cincinnati Haggadah* depicts the rite being performed by a man who brushes the crumbs out of a cabinet into a bowl. The remnants of ḥametz are burned the next morning, and a declaration is made nullifying all leaven still in the home which has not been found. For the duration of the holiday, any hametz remaining is sold by a representative of the Jewish community.

The Passover festival begins with the seder, the special ceremonial meal, and the high point of the holiday, reliving the Exodus. The haggadah is the liturgical text which retells the story of the Exodus and interprets the seder. The haggadah is a compendium, developed over the centuries, containing quotations from the Bible and Talmud, the blessings for the seder ritual, as well as songs and poetry that reflect popular customs. Illuminated manuscript haggadahs are known as early as the thirteenth century and there are more than three thousand printed editions of the haggadah. The illustrations of the Passover haggadah can be grouped into four categories: illustrations of the text, such as the Four Sons as portrayed by Joseph bar David Leipnick of Moravia in 1740; depictions of the seder ritual, exemplified in a family scene in an eighteenth-century Bohemian home on the frontispiece of the *Sister of the Van Geldern Haggadah*; scenes from a biblical story, such as the Israelites building the pyramids; and eschatological scenes, such as the prophet Elijah approaching Jerusalem on a donkey in the *Washington Haggadah* dated 1478. A very unusual nineteenth-century haggadah in scroll form from Iraq is decorated only with stylized flowers, an indication of the persistent avoidance of representational illustrations in Jewish art from Islamic lands.

The entire seder is designed to be educational for young and old alike. Seder literally means order, and the service is meant to involve all who are present. The youngest child traditionally recites the *mah nishtanah* (Four Questions) that ask why this night is different from all others.

The focal point of the seder table is a *k'arah*, a plate or container to display the symbolic foods—the *zeroah* (roasted shankbone), representing the sacrifice of a paschal lamb at the first Passover; *maror*

(bitter herbs), for the bitterness of slavery; *haroset* (a mixture of fruits, nuts, and wine), representing the mortar used by the slaves; and *karpas* (green vegetable) for spring and rebirth. The karpas will later be dipped in salt water, which symbolizes the tears of the Israelite slaves. The *beitzah* (roasted egg) is also a reminder of the paschal sacrifice, and there may also be another bitter herb.

Seder plates have been made of many different materials and fashioned in a wide variety of styles. Most seder plates that have survived date from the eighteenth century on. However, the oldest extant seder plate is from Spain, made of lusterware, a type of decorated ceramic used also by Moslems and Christians, and predates the Expulsion. The plate is inscribed with the word "seder" and essential components of the seder service. The mistakes in the Hebrew indicate that the artist may have been unfamiliar with the language. Chinese porcelain served as the inspiration for both decorative motifs and color scheme on a seder plate made in Vienna around 1900. A three-tiered container for the matzah is incorporated into a seder plate made in Vienna in 1815. The figures bear vessels for the symbolic foods and Elijah, reminiscent of Michelangelo's *Moses*, balances a holder for the Cup of Elijah. The scene of the Exodus is portrayed on an ornate platter made in Lvov in 1830.

Numerous Passover textiles have been made to enhance the seder. These include matzah covers, tablecloths, and decorative towels for the ritual handwashing. A seder show towel, from Alsace, made in 1821, makes reference to the song *Had Gadya*, "An Only Kid," sung as the seder comes to a close. As it is the custom for the person leading the seder to recline like royalty, there are also special pillow covers embroidered for this purpose.

According to rabbinic law, it is necessary to drink four cups of wine during the seder. These are linked to the four expressions of redemption: "I will *free* you and *deliver* you. . . . I will *redeem* you . . . and I will *take* you to be my people" (Exodus 6:6–7). Special cups inscribed with the word *Pesah* or with an appropriate biblical verse are often used. The future redemption is represented by a fifth cup, *kos shel Eliyahu*, set out for the prophet Elijah, the messenger of the messiah.

Passover is also known as the *hag ha-aviv*, the festival of spring. In terms of the agricultural cycle, it was celebrated at the beginning of the barley harvest, *omer*. Seven weeks are counted from the second night of Passover to the holiday of Shavuot, the Feast of Weeks. Special books and calendrical devices have been made for the counting of the omer. A scroll from eighteenth-century Holland displays the numbers in fields of flowers. The day of the omer is at the top, the week in the center, and the day of the week in the bottom tier. An omer calendar of silver and semiprecious stones was crafted in Paris in the mid-nineteenth century by Maurice Mayer, a silversmith and jeweler who worked under the patronage of the court of Napoleon III. Probably made in Philadelphia in the late nineteenth century, an omer calendar of ink on parchment is drawn in the form of a heraldic gateway. A device on the back is used to rotate the scroll with the numbers.

Shavuot, on the sixth of Sivan, commemorates the revelation of the Torah to Moses on Mt. Sinai. In an image from the *Rothschild Mahzor* from Florence, dated 1492, Moses receives the Ten Commandments that are descending from the heavens as awestruck Israelites gaze upward at the mountain. Also known as *yom habikkurim*, the Day of the First Fruits, Shavuot recalls the ancient custom of bringing first fruits of the harvest to the Temple in Jerusalem (Numbers 28:26). The Book of Ruth is read on Shavuot because the story takes place during the harvest season, and because Ruth, a Moabite who converted to Judaism to follow her mother-in-law Naomi, symbolizes the willing acceptance of Torah. The opening panel of the Book of Ruth from the *Tripartite Mahzor* from southern Germany (c. 1320) shows Ruth and the harvest. Although distortions of human features are typical in German Hebrew illuminated manuscripts of this period, in this instance, only the women are depicted with animal or bird faces.

Hanukkah commemorates the victory in 165 B.C.E. of the Jews, led by Judah the Maccabee, over the Syrian Greeks, led by Antiochus IV Epiphanes. Hanukkah is a post-biblical and minor holiday. According to the description in the Talmud (Shabbat 21b), the Temple had been desecrated by the invaders and the sacred oil to light the Temple menorah had been defiled. As the Jews cleaned and prepared to rededicate the Temple, they found but a single cruse of uncontaminated oil with the seal of the High Priest. A miracle occurred, and the small amount, sufficient for only a single day, lasted for eight days. So, the Talmud recounts, the following year these days were designated as festive days with praise and thanksgiving.

To observe both the victory of the Maccabees and the miracle of the oil, Hanukkah lights are kindled for eight nights beginning on the twenty-fifth of Kislev. One light is lit on the first night and another is added on each subsequent night. Because the lights are sacred and are not to be used for any other purpose, such as reading, the custom developed of kindling the Hanukkah lights with a special *shammash* (servitor) light, which would provide illumination for any secular need.

Hanukkah lamps exist in a multitude of styles and materials, and tremendous creativity has been shown in their manufacture. Historically, there are two characteristic forms of the Hanukkah lamp. The first is patterned after the seven-branched menorah of the Temple, exemplified by the design of a lamp by Valentin Schüler which follows the biblical description of "cups and petals" (Exodus 25:31). Another example of the branched type is the "Oak Tree" Menorah made in Lemberg, Poland, around 1800, so-called because of its naturalistic representation. While Hanukkah is celebrated at home, it also became customary as early as the thirteenth century to kindle Hanukkah lights in the synagogue, and special large-standing branched candelabra were made for synagogue use. Typically, these were placed to the right of the Torah ark as a reminder of the location of the Temple menorah. The second category of Hanukkah lamp is the "bench" or back-walled lamp. The earliest extant examples of this type date to the fourteenth century.

The symbolism on Hanukkah lamps is often connected with the Temple. It would seem that for this reason the design of many Hanukkah lamps would exemplify a clear relationship with architecture. However, it should be recognized that because of the peripatetic nature of Jewish experience and the impulse to adapt styles from the local community, stylistic interpretation should not be confined solely to symbolic meaning without artistic analysis of the time and place in which the lamp was made, as many decora-

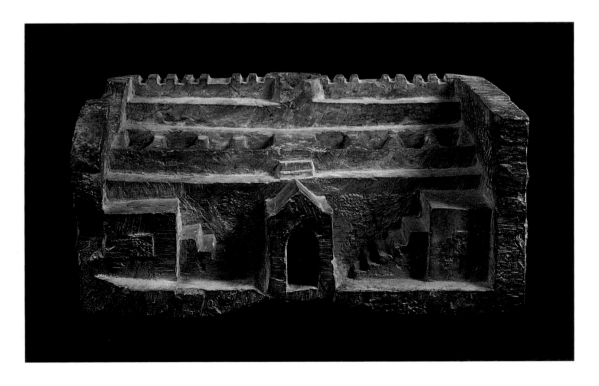

Hanukkah Lamp. Eretz Yisrael or Yemen. 20th century. Stone, carved. 6 3/8 x 14 3/4 x 8 1/8 in. (16.2 x 37.5 x 20.6 cm). The Israel Museum, Jerusalem. *Made of Jerusalem stone, this Hanukkah lamp depicts a two-storied building surrounded by a wall. The gabled structure on the lower story is similar in form to numerous depictions of Torah arks and may appropriately serve as a reference to the Temple.*

ARYEH LOEB BEN DANIEL OF GURIA.
Esther Scroll. Italy. Mid-18th century.
Ink on parchment. Height: 9 in.
(22.9 cm). Hebrew Union College,
Skirball Museum, Los Angeles.
Kirschstein Collection, formerly the
Frauberger Collection. *This scroll is
the work of a Polish scribe-artist
who traveled to Italy. A separate
prayer sheet has the figures of Aaron
and Moses framing the text. On the
megillah itself, the figures in the spaces
between the columns are Esther and
Mordecai dressed in the regal garb
of contemporary nobility. The upper
border is ornamented with birds and
circular medallions with profiles of
characters from the Esther story.
In the lower border, flanked by lions,
are smaller medallions with scenes
from the story.*

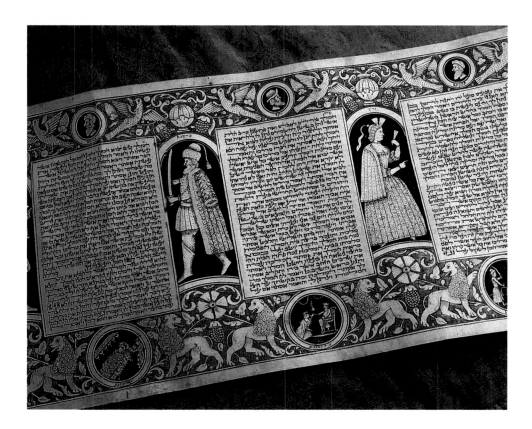

tive objects are influenced by architecture. Examples of architecturally inspired Hanukkah lamps abound, from fourteenth-century Gothic to the wooden folk architecture of eighteenth-century Poland to the onion-shaped domes of Eastern Orthodox Churches.

Other motifs on Hanukkah lamps include heroic figures, Judah, Maccabee and Judith, who slew the mighty Holofernes; Aaron, the High Priest, is sometimes shown lighting the Temple menorah and at times paired with Moses. Many other scenes, including some with mythological beings, and all types of animals and birds, appear as well, along with all manner of floral elements. An eighteenth-century lamp from Morocco reflects its origin with an overall lacy pattern combining arcades of key-shaped arches and intertwining vines. An ingenious and inventive lamp from nineteenth-century Vienna is made of individual chairs. In some instances, notably with examples in bronze from Italy, the variety of ornamental motifs derives from the fact that the back walls of the lamps have been reused from secular items such as mirrors or decorative boxes. Hanukkah lamps have often been made as a tribute to a local authority and feature an emblem or image related to that individual.

Folk customs associated with Hanukkah include eating foods made with oil such as *latkes* (potato pancakes) and *sufganiyot* (jelly donuts). Children traditionally played games on Hanukkah, the best known of which is played with the Ashkenazi spinning top called *sivivon* in Hebrew and *dreidle* in Yiddish. Each side of the top has a Hebrew letter which relates to the phrase "a great miracle happened there." Depending on which letter faces up when the top falls, the player gets nothing, half, whole, or pays into the pot. An intimate family scene in a painting by Felsenhardt depicts some of the children playing dreidle as the father lights the candles. In Israel, the last letter on the top is changed so that the phrase is "a great miracle happened *here.*"

A second minor holiday is Purim, the story of which is told in the *megillat Esther*, the Scroll of Esther. Purim is celebrated on the fourteenth of Adar and commemorates the triumph over the prime minister of King Ahasuerus, the evil Haman who planned to destroy all the Jews of the Persian Empire. Haman's efforts were foiled by Mordecai and his niece Esther, who became the Queen. Purim comes from the word *pur*, meaning lots, for it was by casting lots that the day the Persian Jewish community was to be exter-

minated was decided. An eighteenth-century megillah makes reference to the notion of fate by illustrating a zodiac wheel, for the constellations are called *mazalot* (luck) in Hebrew.

Purim is celebrated with the reading of the megillah in a carnival-like atmosphere in the synagogue in the evening and again in the morning of the holiday. During the reading, the attempt is made, especially by the children, to blot out the name of the wicked Haman each time it is mentioned, by shouting or using noisemakers, known as groggers.

The megillah read in the synagogue is a scroll written on parchment or leather and wound on a single rod. The scrolls used for the synagogue reading are not illustrated, but those commissioned for private use are very often decorated. The most elaborate megillot include miniatures with each episode of the story.

The *Ardašîr Book* is not a megillah but a manuscript composed in Judeo-Persian in 1332 by the Jewish poet Maulānā Šāhîn, whose work was shaped after a classic work of Persian culture, the *Šāhnāmeh*, written in the tenth century. The first chapter of the *Ardašîr Book* is excerpted from the *Šāhnāmeh* and combined with the story of Esther as well as elements from Jewish and Muslim legends, demonstrating the integration of cultural traditions. In a seventeenth-century illuminated manuscript, elements of the Esther story are shown, including the scene when King Ahasuerus seeks a new queen after deposing Vashti.

The scroll is sometimes housed in a specially made case. Made of a variety of materials, some of these are decorated with floral or geometric motifs. Some in silver from the nineteenth century also illustrate scenes from the Purim story. Often the roller is ornamented as a filigree roller from the Ottoman Empire.

A Purim tradition, emanating from the Esther story (9:22) is *shalaḥ manot*, the sending of gifts to friends and relatives, as well as the poor. Special plates are used for this custom. The images on the plates again include the figures from the story; among the most popular is Mordecai seated on Haman's horse with the humiliated Haman leading him. Here, the headgear is the critical stylistic element: Mordecai wears an elaborate plumed chapeau and Haman wears his signature three-cornered cap.

Many other days in the Jewish calendar have special commemorations. There are happy times like *Tu B'shevat*, the new year of the trees. Based on a sixteenth-century kabbalistic custom, the holiday is celebrated with a special seder of new fruits. Annually, three weeks of "mourning" customs recall the destruction of the Temple, beginning with the breaching of the walls of Jerusalem and culminating on *Tisha B'Av*, the ninth of the Hebrew month of Av, when the Temple was destroyed. Even in contemporary times, new observances have been added to the Jewish calendar, *Yom Ha-Shoah Ve Ha-Gevurah*, Holocaust Remembrance Day, and *Yom Ha'Atzmaut*, Israel Independence Day. Indeed, the cycle of the Jewish year continually reconnects the Jewish past to the Jewish present and future.

(OPPOSITE)

Biblical and Halakhic Miscellany. Germany. 1393. Parchment. Klau Library, Hebrew Union College-Jewish Institute of Religion, Cincinnati. *Among the illustrations in this manuscript are images of figures engaged in carrying out ceremonial activities, such as these men, who accompany the text "to blow the shofar" which begins in the architectural-form, initial-word panel.*

לתקוע

Shofar and Case. Shofar: Germany. 19th century. Case: Oakland, California. c. 1870. Case: 3 1/4 x 16 1/2 in. (8.3 x 41.9 cm). Hebrew Union College, Skirball Museum, Los Angeles. Gift of Mrs. Felix Jonas. *When Marcus Jonas emigrated from his native Bavaria to the United States, his father entrusted him with the family shofar, the only ceremonial object he brought with him. When he arrived in California, Jonas handcrafted this unique case, which gently conforms to the shape of the shofar, to protect his precious family heirloom.*

(OPPOSITE)

Torah Mantle. Rheims, France. Dedicated 1878. Silk, embroidered with silk and metal thread, metal spangles; fringe, coiled metal thread. 34 1/4 x 17 1/4 in. (87 x 43.8 cm). Smithsonian Institution, Washington, D.C. Gift of Mrs. Karl B. Bretzfelder in memory of Mr. Karl Bretzfelder. *With unusual vividness and detail, the Torah mantle depicts the climactic moment of the akeda, when the angel, here literally, stays the hand of Abraham. This mantle was dedicated by Naphtali, son of Samuel Klein and his wife, Feigele Rachel, daughter of the honored Rabbi Toutros Weill. According to the accession records, Karl Bretzfelder, who was serving in the U.S. Army during World War I, found the mantle in the Rheims synagogue after a bombing raid.*

(ABOVE, LEFT)

Jerusalem Maḥzor. Southern Germany. c. 1340. Parchment. 9 x 5 7/8 in. (22.9 x 14.9 cm). Ms. Hebr. 8, 5214 fol 83. The Jewish National and University Library, Jerusalem. *The artist has created here a highly elaborate, fanciful German Gothic portal to accompany the blessing "Blessed be you God, Ruler of the Universe, who opens for us the gates of mercy."*

(ABOVE, RIGHT)

LEONORA COLORNI. *Torah Binder.* Italy. 1692. Linen, embroidered with silk threads. 15 x 127 in. (38.1 x 322.6 cm). Smithsonian Institution, Washington, D.C. Deinard Collection. *When Deinard wrote to the Smithsonian about his important finds in Italy, this rare Torah binder was the first item he mentioned, and he discussed it in detail, clearly reveling in his great success. The Torah binder is significant for a number of reasons. It is a Torah binder of an early date identified as well with the name of the maker, and it is distinctly a Torah binder for Rosh Ha-Shanah, with the striking motifs of the shofarot and the seventeenth-century trumpets.*

(OPPOSITE)

LEAH WESELLEY. *Kittel and Yarmulke.* Warsaw. c. 1880. Linen, silver and gold metal thread embroidery. Kittel: length, 46 in. (116.8 cm). Yarmulke: circumference, 21 in. (53.3 cm). Hebrew Union College, Skirball Museum, Los Angeles. Gift of Ruth Terrace Hailparn. *This* kittel *and* yarmulke *were made for Ya'akov Weselley by his wife, Leah Weselley. The collar of the* kittel *and the cap are made of* spanier arbeit, *literally "Spanish work," a type of woven metal thread work popular among Polish Jews in the nineteenth century. Weselley brought the* kittel *and* yarmulke *with him when he immigrated to the United States and passed them down in the family.*

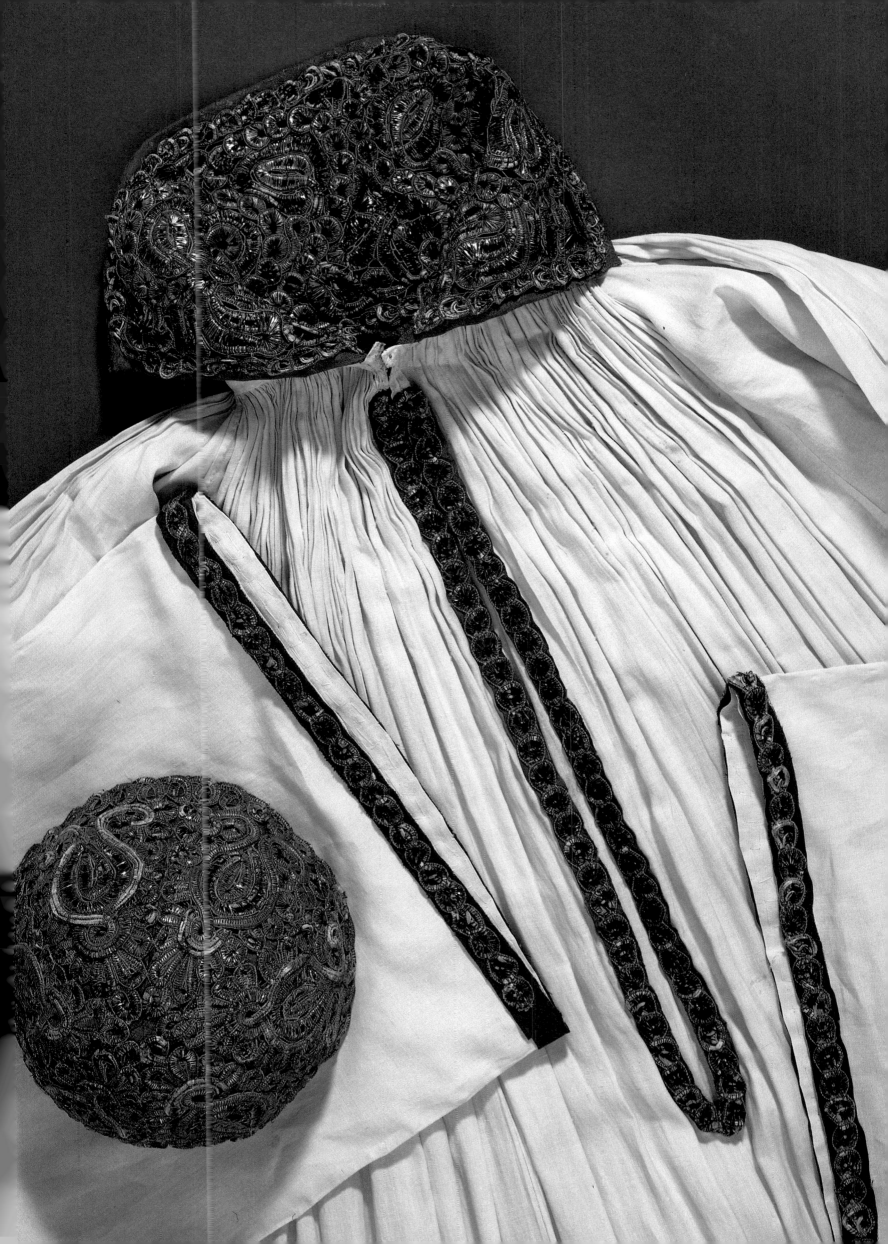

Belt Buckle. Vienna. c. 1870. Silver; cotton, metal thread. 3 1/8 x 3 5/8 in. (7.9 x 9.2 cm). The Gross Family Collection, Tel Aviv. *Often, a* kittel *was worn with a silver belt buckle. The owner was a* kohen, *a descendant of the priestly class in the Temple symbolized by the hands giving the priestly blessing.*

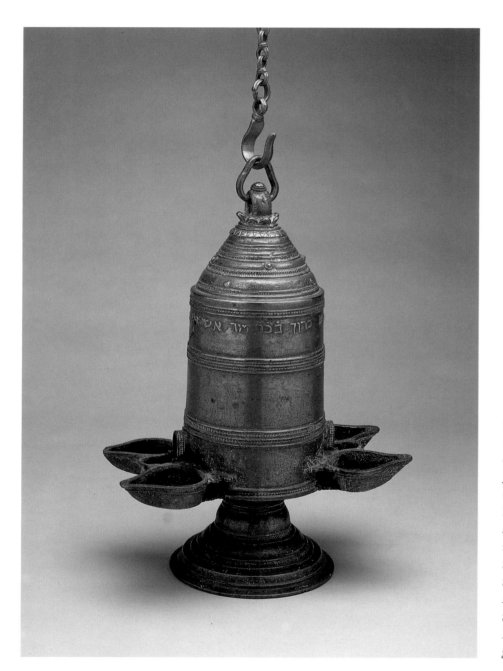

Oil Lamp for Yom Kippur. Cochin, India. 1670. Bronze. Height, 18 in. (45.7 cm); circumference, 19 in. (48.3 cm). The Judah L. Magnes Museum, Berkeley. Gift of the Jewish community of Parur, India. *It was the custom in Cochin to have a special oil lamp for Yom Kippur which remained lit the entire day. According to the inscription, this lamp was dedicated to the synagogue in Parur by David Ashkenazi in memory of his mother. As the name indicates, the family had European roots; David Ashkenazi's grandfather had come from Germany.*

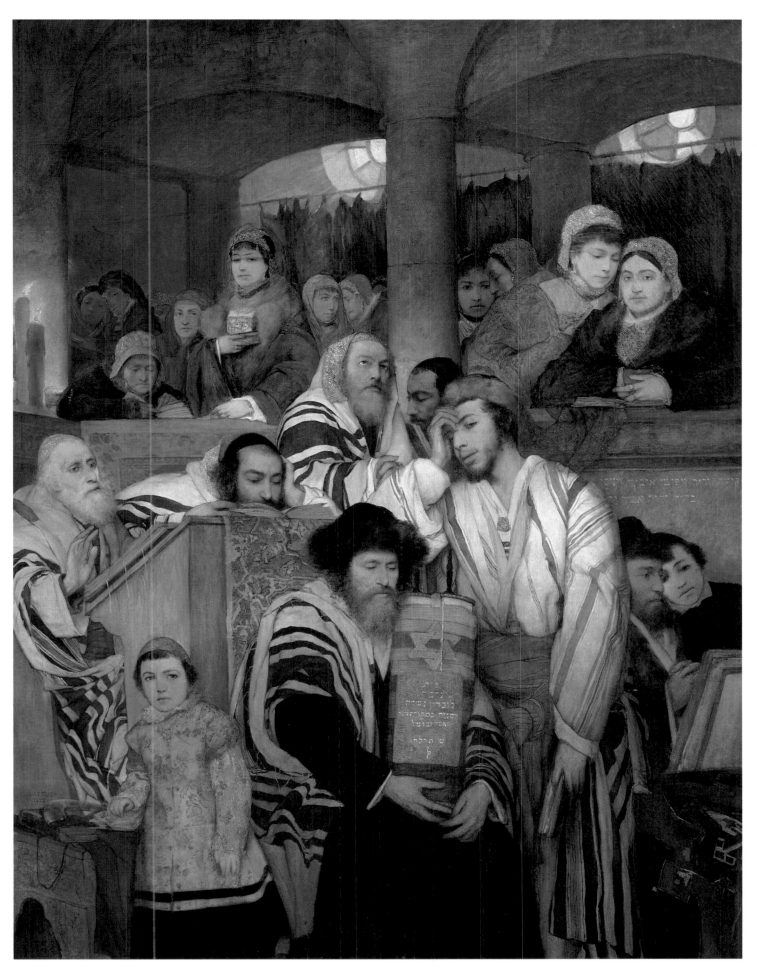

MAURYCY GOTTLIEB (1856–1879). *Jews Praying in the Synagogue or Yom Kippur.* Vienna. 1878. Oil on canvas. 96 1/2 x 75 1/2 in. (245.1 x 191.8 cm). Tel Aviv Museum of Art. *Though only twenty-three years old when he died, Gottlieb reveals a brilliance and depth far beyond his years. Anti-Semitic incidents at the art school in Cracow led him to leave there. This work reveals his complex struggle. This painting, with a wealth of detail about traditional Jewish dress and the synagogue, but the artist's self-portrait, with its outward glance, shows a man not yet comfortable in his surroundings. The inscription written on the Torah scoli reads "Donated in memory of our late honored teacher and rabbi Moshe Gottlieb of blessed memory 1878."*

SOLOMON ALEXANDER HART (1806–1881). *The Feast
of the Rejoicing of the Law at the Synagogue in Leghorn,
Italy.* England. 1850. Oil on canvas. 55 5/8 x 68 3/4 in.
(141.3 x 174.6 cm). The Jewish Museum, New York. Gift
of Mr. and Mrs. Oscar Gruss. *In Hart's romanticized
portrayal of the Leghorn Synagogue, a number of the
participants are depicted in richly embroidered caftans
and elaborate turbans, an "orientalizing" approach
typical of artists of the period who visited the Near East.*

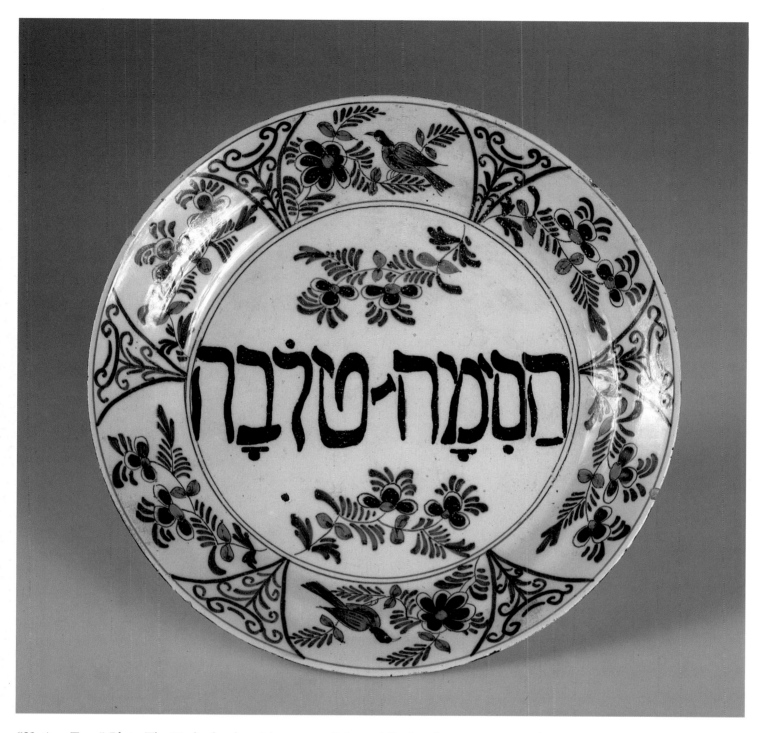

"Hatima Tova" Plate. The Netherlands. 18th century. Faience. The Israel Museum, Jerusalem. *Plates like this were made with appropriate inscriptions for the Sabbath and holidays. Here, the Hebrew inscription is "hatima tova," the wish expressed at Yom Kippur that one will be sealed in the Book of Life.*

(OPPOSITE)

Hoshana. From The Rothschild Miscellany. *Northern Italy. c. 1450–80. Pen and ink, tempera, and gold leaf on vellum. 8 1/4 x 6 1/4 in. (21 x 15.9 cm). Ms. 180/51, fol 147r. The Israel Museum, Jerusalem. Gift of James A. de Rothschild, London. Accompanying the Hoshana prayer, an elderly, bearded man is shown holding a lulev and etrog.*

Sukkot Plate. England and United States. 1910. Porcelain, hand-painted. Diameter: 9 in. (22.9 cm). National Museum of American History, Smithsonian Institution, Washington, D.C. Gift of Miss Mary M. Cohen. *The plate was manufactured in England by Johnson Brothers and the special Sukkot motif, designed by Katherine M. Cohen, was added by the Tatler Decorating Company of Trenton, New Jersey. The plate was made to use for communal meals served in the sukkah at Congregation Mikve Israel, Philadelphia.*

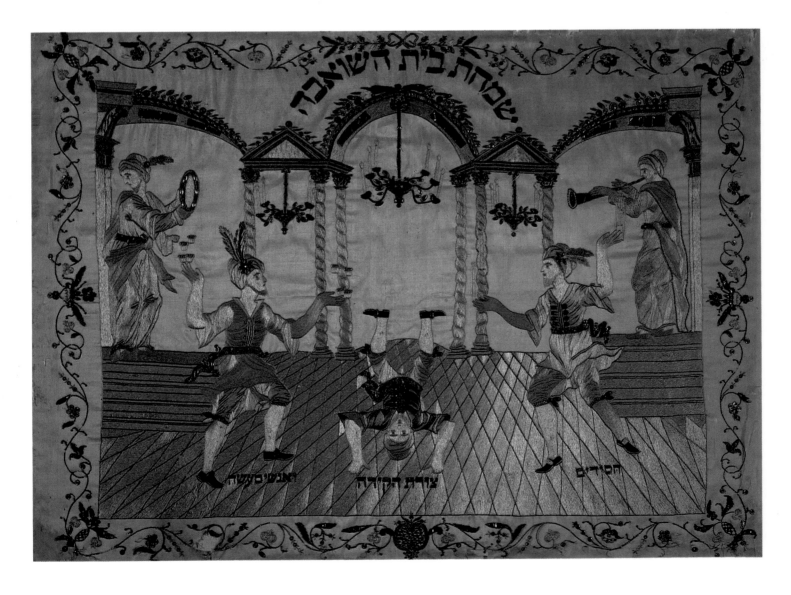

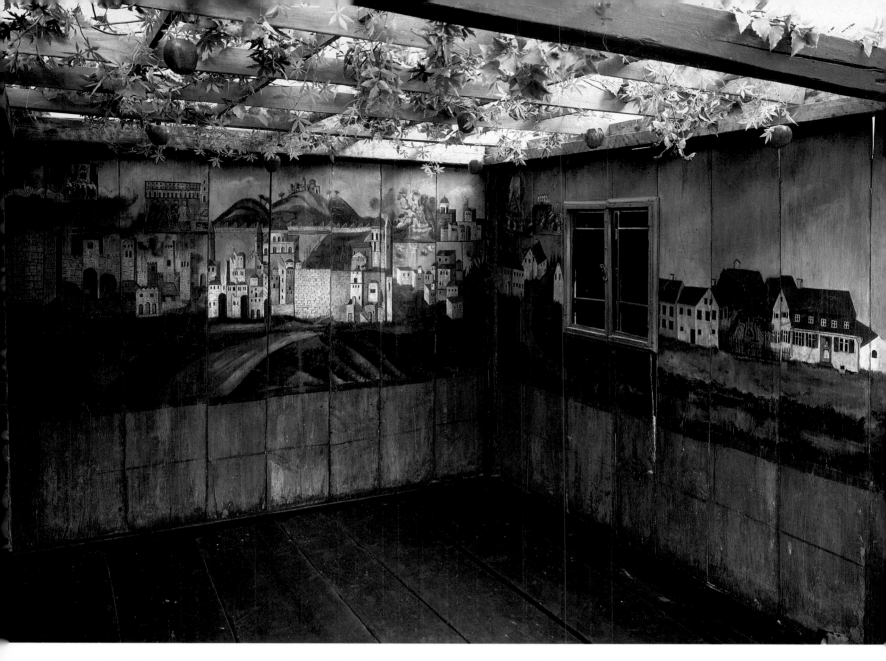

Sukkah. Southern Germany. After 1836. Painted wood. Height, 78 in. (198.1 cm); length, 114 in. (289.6 cm); width, 114 in. (239.6 cm). The Israel Museum, Jerusalem. *This extraordinary sukkah, made for the Deller family of Fischach, includes wonderful genre scenes of village life, including the family's home, and a visionary portrayal of the city of Jerusalem. A maḥzor printed in Suzbach in 1826 served as a model for some of the images. The sukkah was discovered by Dr. Heinrich Feuchtwanger in 1935 in the attic of the Deller family. It was cleverly smuggled out of Germany with the painted side facing inward in a wooden crate being shipped to Eretz Yisrael by relatives of Dr. Feuchtwanger. A Deller family descendant presented the sukkah to the Israel Museum.*

(OPPOSITE)

Sukkah Decoration. Italy. 18th century. Silk taffeta, embroidered with silk and metal thread. 20 x 27 1/8 in. (50.8 x 68.9 cm). Cooper-Hewitt Museum, Smithsonian Institution National Museum of Design, New York. Gift of Ehrich Galleries in memory of Mrs. Louis B. Ehrich. *This lively, carnival-like scene is identified by a Hebrew inscription as being the* Simhat bet ha-sho-evah, *the festival of the Drawing of the Water. This holiday originally took place in the Temple in Jerusalem during Sukkot. The representation here is drawn from a description in the Babylonian Talmud (Sukkot 5:1–4) that there were three golden candlesticks in the courtyard and "Men of piety and good works used to dance before them with burning torches in their hands, singing songs and praises." The great scholar, Rabbi Simeon ben Gamliel, was said to have juggled eight such torches at a festival celebration.*

Etrog Container. Augsburg. c. 1670–80. Silver, gilt, hammered and chased. 7 1/2 x 9 in. (19.1 x 22.9 cm). The Jewish Museum, New York. Gift of Dr. Harry G. Friedman. *The shape of the fruit is echoed in this beautiful seventeenth-century etrog container.*

Etrog Container. Ottoman Empire. 19th century. Silver. The Israel Museum, Jerusalem. *While etrog containers are found in a variety of forms, often adapted from such secular objects as sugar boxes, this example in the form of a duck is quite unusual.*

Crown for Simḥat Torah. Langensoultzbach. 19th century. Paper; tissue; wood; metal wire. 8 1/4 x 7 1/4 in. (21 x 18.4 cm). Les Musées de la Ville de Strasbourg. Collection Société d'histoire des Israélites d' Alsace et de Lorraine, Strasbourg. *It was customary among the Jews of Alsace to make elaborate flower-embellished crowns to be used on the Torah scrolls for Simḥat Torah. Made of very fragile materials, this is one of the remaining few crowns of this type.*

(OPPOSITE)

RABBI ABRAHAM BEN JACOB ANAV (ANAU). *Poem for Simḥat Torah.* Rome. 1766. Gouache and ink on parchment. 23 1/2 x 18 in. (59.7 x 45.7 cm). Smithsonian Institution, Washington, D.C. Museum purchase. *This poem is an original cantata written in honor of Isaac Berakyah Baraffael, son of Mordecai Baraffael, on the occasion of Simḥat Torah. In the register above the text of the poem is a historical note which praises the student Isaac's family and the study of Torah. Isaac Berakyah was from a wealthy family of spice importers and merchants who came from Ancona to Rome at the beginning of the eighteenth century. The text is written for three singers, who represent Wealth, Honor, and Life. Three allegorical figures illustrate these themes.*

Roundels Haggadah (detail). Italy. 15th century. Parchment, ink, paint, gold leaf. Each roundel, diameter: 1 1/2 in. (3.8 cm). Hebrew Union College, Skirball Museum, Los Angeles. Gift of Mr. and Mrs. Felix Guggenheim, formerly Salli Kirschstein Collection. *This unusual haggadah consists of sixty-four round parchment leaves which fold up to fit into a coin-shaped receptacle, evidently for travel. The text includes the Passover haggadah and Psalms 113 and 114. Decorative red and black frames are used to highlight the inital-word panels. The manuscript also includes illustrations of the matzah and maror. The round matzah is typical of the period.*

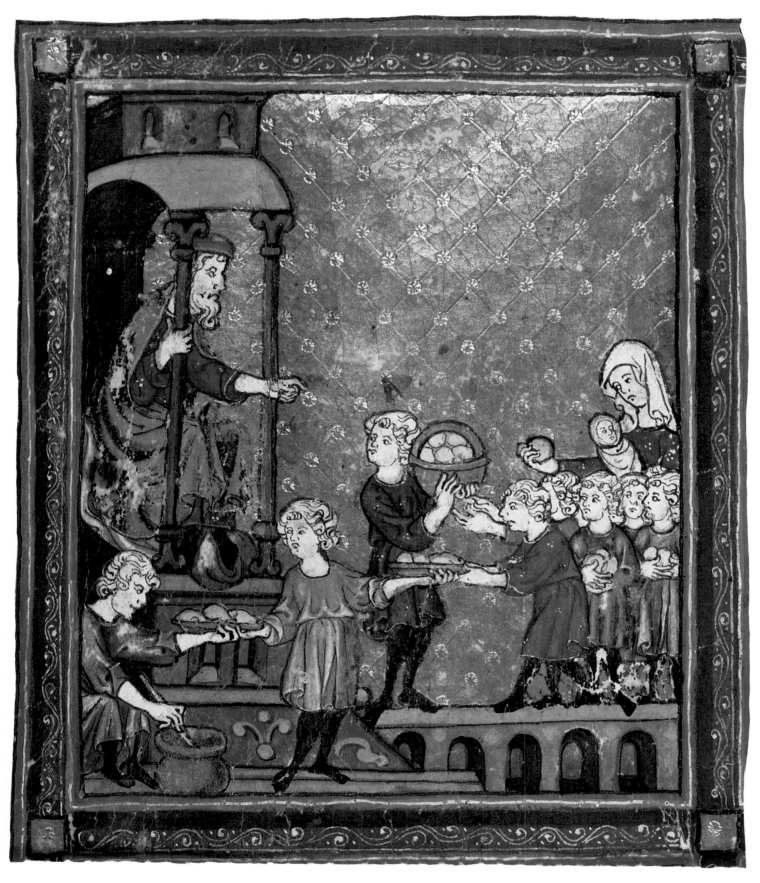

Ma'ot Hittim. From the *Golden Haggadah. (detail, left upper register).* Barcelona, Spain. Early 14th century. Vellum, ink, gold leaf. Add. Ms. 27210, fol 15r. The British Library, London. *Prior to Passover, it is customary to provide for the poor so that they will have matzah for the holiday. This scene depicts the distribution to the needy.*

עשר בורקין את החמיץ לאור הנר מלא
לאור החמה ולא לאור האביקה אלא לאור
של שעוה וחפך עיניך ומך

ברוך אתה

אלהינו מלך העולם אשר קדשנו במצותיו
וצונו על ביעור חמץ

כל

חמירא וחמיעא דאיכא ברשותי דלא חמיתיה
ודלא בערתיה

(LEFT)

JOSEPH BAR DAVID LEIFNICK OF MORAVIA (ARTIST-SCRIBE). *The Hebrew Slaves Built Store Cities for Pharoah.* From the *Leipnick Haggadah.* Altona. 1740. Vellum. Sloane Ms. 3173. The British Library, London. *The Hebrew slaves building the store cities of Pithom and Ramses for Pharoah as described in Exodus 1:11 are depicted as contemporary Jews at work in a German town.*

(ABOVE, RIGHT)

JOSEPH BAR DAVID LEIPNICK OF MORAVIA (ARTIST-SCRIBE). *Four Sons.* From the *Leipnick Haggadah.* Altona. 1740. Vellum. Sloane Ms. 3173 fol 6v. The British Library, London. *In the eighteenth century, the art of illuminating manuscripts for Jewish ritual use flourished once again. This phenomenon was due to the emergence of a wealthy bourgeoisie and especially the Court Jews, who were traditionally observant, yet whose integration into Christian society influenced their cultural tastes. Leipnick played a significant role in continuing the tradition of illuminating haggadahs, though printed editions had long since become popular. Indeed, Leipnick and others used images from these printed haggadahs as a sources for their illustrations. Leipnick's interpretation of the Four Sons derives from the printed Amsterdam Haggadah,* which *depicts the sons—the Wise, the Wicked, the Simple, and He Who Does Not Know How to Ask—according to stages of life, with an old man representing wisdom and a child the fourth son.*

(OPPOSITE)

MEIR B. ISRAEL JAFFE OF HEIDELBERG (SCRIBE). *First Cincinnati Haggadah.* Southern Germany. c. 1480–90. Vellum. 13 3/8 x 9 7/8 in. (34 x 25.1 cm). Klau Library, Hebrew Union College-Jewish Institute of Religion, Cincinnati, Ohio. *The marginal illustration which accompanies the appropriate text depicts the "search for leaven" which is performed the evening before Passover begins. As is customary, a man brushes crumbs from a cupboard with a feather. The next morning any leaven found is burned.*

(ABOVE)

LEON (YEHUDAH) BAR YEHOSHUA (DE ROSSI) (SCRIBE). *Maḥzor.* Northern Italy. 2nd half of the 15th century. Ink, gouache, and gold leaf on vellum. 10 1/8 x 7 1/4 in. (25.7 x 18.4 cm). Ms. Heb. 8° 4450, fols 115v–116. The Jewish National and University Library, Jerusalem. *This manuscript is the first half of a maḥzor containing prayers for the entire year; the second half is in a private collection in Jerusalem. The illustration style is like that of Joel ben Simeon, scribe and artist of the* Washington Haggadah. *The text begins with* Ha lahma anya *("this is the bread of affliction"), above which is a seder scene with seven men around a table holding a basket with matzah and leafy vegetables. This is followed by* mah nishtanah, *the four questions traditionally asked by the youngest child at the seder. At the bottom is the Exodus from Egypt, with Pharoah's army in pursuit of the Israelites as Moses parts the Red Sea. All the figures are garbed in contemporary Italian costume except Moses.*

(LEFT)

JOEL BEN SIMEON (ARTIST-SCRIBE). *Washington Haggadah.* Northern Italy. 1478. Vellum. 9 1/8 x 5 7/8 in. (23.2 x 14.9 cm). Fol 19v. Hebraic Section, The Library of Congress, Washington, D.C. *Joel ben Simeon was a prolific scribe and illuminator. Also known as Feibush Ashkenazi of Bonn, he arrived in Italy in the mid-fifteenth century and opened a workshop. The scene depicts the arrival of Elijah, who heralds the coming of the Messiah. With him is a contemporary Italian family, indicating their personal redemption.*

(OPPOSITE)

MOSES LEIB WOLF OF TREBITSCH. *"Sister of the Van Geldern Haggadah.* 1716–1717. Mss. 4441. Klau Library, Hebrew Union College–Jewish Institute of Religion, Cinncinnati, Ohio. *In the 18th-century there was a revival of the art of illuminating Hebrew manuscripts, primarily as commissions by Court Jews for gifts for weddings and other special occasions. Presented as if in an ornately carved frame, the image on the frontispiece of this haggadah is a seder in an eighteenth-century Bohemian home, a rococo scene with elegant décor. The participants are handsomely dressed, the husband and wife in silks and lace. The table is well-laid with the Passover foods and each of the adults holds a large silver goblet. In the background a young man fills a fifth cup. The lovely appointments in the room, the view to the lush garden and even the dog and birdcage give evidence to the status of the family.*

Haggadah Scroll. Iraq. 19th century. Ink and tempera on paper. Klau Library, Hebrew Union College-Jewish Institute of Religion, Cincinnati, Ohio. *Made in a characteristic Iraqi style of the nineteenth century, with the columns of text separated by colorful stylized flowers, the scroll form of this haggadah is very unusual.*

(OPPOSITE)

Passover Plate. Spain. c. 1480. Earthenware. Diameter: 22 1/2 in. (57.2 cm). The Israel Museum, Jerusalem. Gift of Jakob Michael, New York, in memory of his wife Erna Sondheimer-Michael. *One of the rare objects predating the expulsion of the Jews in 1492, this Passover plate is related in style to Spanish lusterware of the period and was probably made by a non-Jewish craftsman. This is further evidenced by the mistakes in the Hebrew spelling, often a sign that the work was done by a copyist unfamiliar with the language. The inscription includes the word seder, referring to the order of the ritual, and lists the three key elements required, the paschal lamb, matzah, and bitter herbs.*

Josef Vater. *Seder Plate*. Vienna. c. 1900. Ceramic, glazed. 14 3/4 in. (37.5 cm). The Jewish Museum in Prague. *The design elements of flowering vines and birds and the blue and white colors characteristic of Chinese porcelain are combined with traditional folk art motifs to create a lovely, captivating seder plate.*

"Exodus" Plate. Lvov. c. 1800. Silver, parcel gilt. 9 1/2 x 13 1/2 in. (24.1 x 34.3 cm). The Gross Family Collection, Tel Aviv. *The illustration on this Passover plate is taken from the* Amsterdam Haggadah, *with the ten plagues depicted around the rim.*

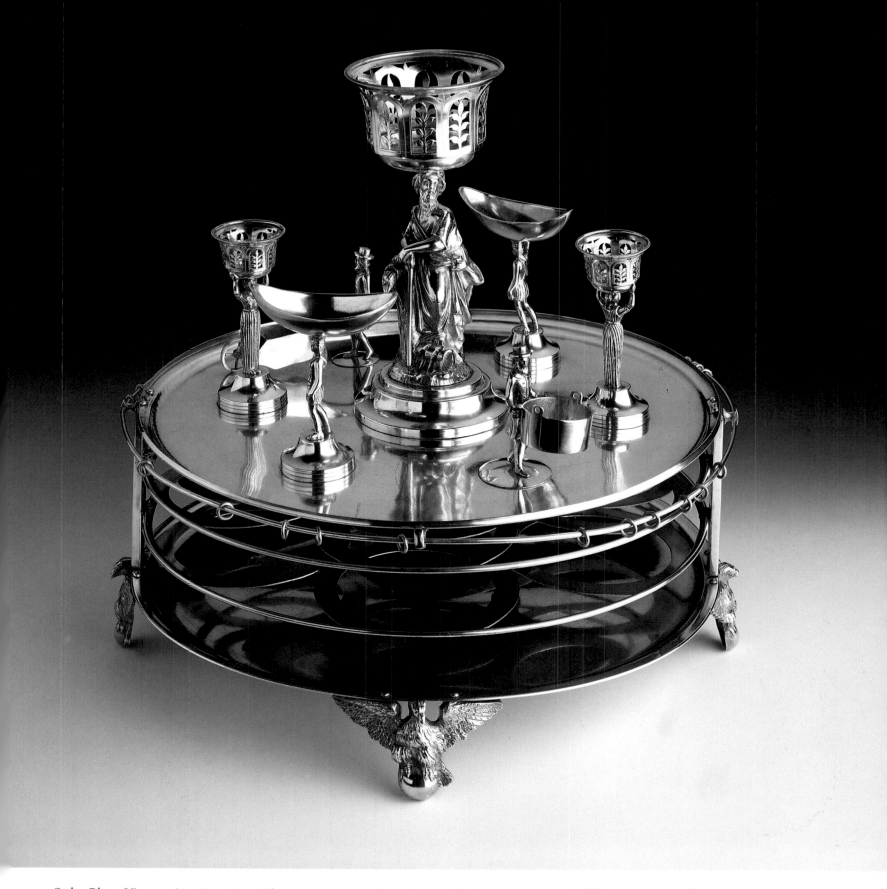

Seder Plate. Vienna, Austria. 1815. Silver, cast, engraved. 14 3/4 x 16 in. (37.5 x 40.6 cm). Hebrew Union College, Skirball Museum, Los Angeles. *Incorporating tiers for the three matzahs used during the seder service became popular in Europe in the nineteenth century. At one time, a textile curtain was hung from the rings at the top, so that the matzahs were covered. The symbolic foods are placed in vessels carried and supported by three-dimensional cast figures, which is unusual. The reason for the differences in the dress of these figures, from the slave loincloths to the classic dresses of the females to the contemporary clothing of two of the men, is unknown. The prophet Elijah in the center wears yet another type of clothing, oriental drapery and a turban.*

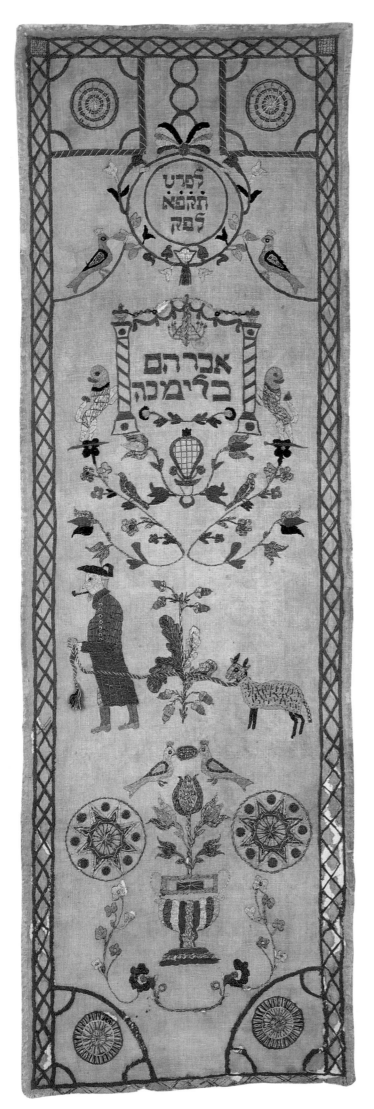

Seder Towel. Alsace. 1821. Undyed linen embroidered with polychrome silk threads; silk ribbon trim. 50 x 15 1/2 in. (127 x 39.4 cm). Hebrew Union College, Skirball Museum, Los Angeles. Gift of Rabbi Folkman. *During the course of the Passover seder, the hands are ritually washed twice. This ceremonial show towel, known in Judeo-Alsatian as a sederzwëhl, borrows the Alsatian custom of using show towels to cover soiled ones. The inscription on the towel includes the date and the name Abraham Blumche. It is conjectured that the man leading the goat refers to the Passover song Had Gadya, "One Kid." The remainder of the motifs are very typical of Alsatian folk embroideries, specifically the vase with tulips surmounted by birds and the geometric star-shaped design in the roundels alongside the flowers. The tricolor of the vase demonstrates the owner's patriotism.*

(OPPOSITE)

Passover Cup. Warsaw. 18th century. Silver, gilt, embossed, engraved. 7 7/8 x 4 1/8 in (20 x 10.5 cm). Jewish Museum, Budapest. *The goblet is decorated with images of the Ten Plagues and is inscribed, "These are the ten plagues with which the Holy One, blessed be He, punished the Egyptians." Because it is a large goblet and so elaborately decorated, it may have been used as a Cup of Elijah.*

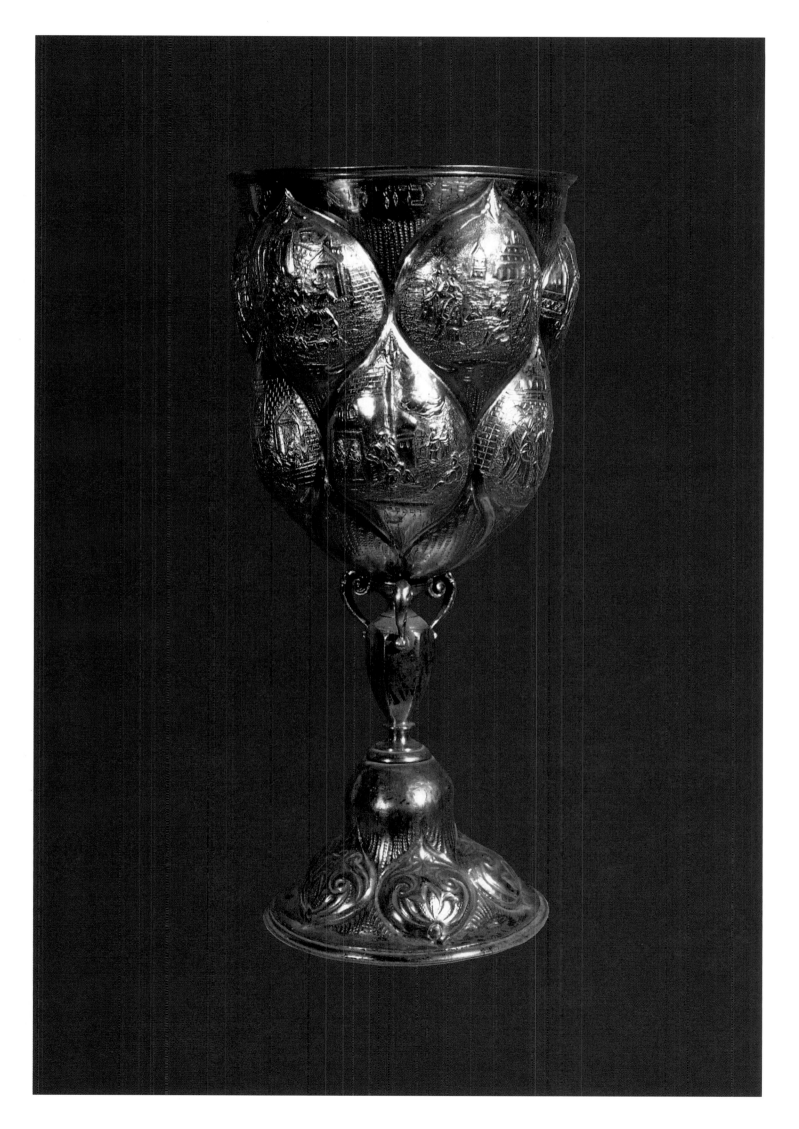

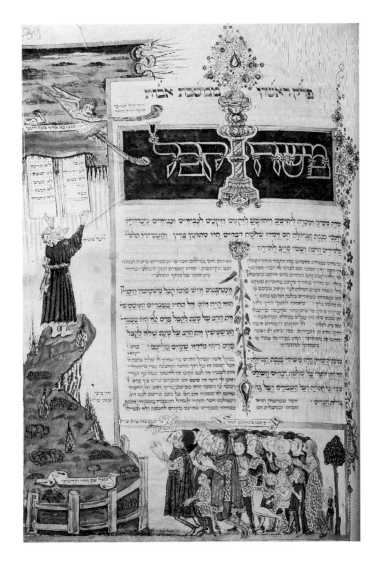

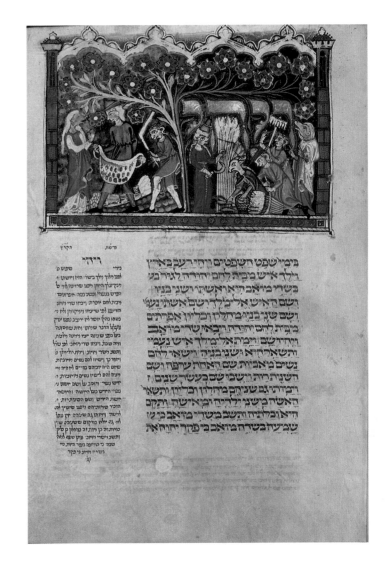

(ABOVE, LEFT)

ABRAHAM JUDAH BEN JEHIEL OF CAMERINO (SCRIBE). *Rothschild Maḥzor.* Florence. 1492. Watercolor and ink on vellum, 11 1/4 x 8 3/8 in. (28.6 x 21.3 cm). Fol 139r. The Library of the Jewish Theological Seminary of America, New York. *Variations in the style of the images suggest that three different workshops participated in the illumination of the maḥzor. The scene depicted here is Moses Receiving the Tablets of the Law, which accompanies the opening passage of Sayings of the Fathers "Moses received the Torah from Sinai and handed it down to Joshua." Moses has ascended the mountain, which is surrounded by a fence, and holds the two tablets. Joshua and the Israelites, dressed in contemporary Italian garb, watch from below. According to the colophon, this manuscript was written for Elijah ben Joab ben Abraham of Vigevano of the Gallico family. However, as the coat of arms of the Norsa family also appears, it is possible that the volume was made as a gift celebrating a marriage of these families.*

(ABOVE, RIGHT)

HAYYIM (SCRIBE). *Tripartite Maḥzor, Volume II.* South Germany. c. 1320. Vellum. 12 1/2 x 8 3/8 in. (31.8 x 21.3 cm). Add. Ms. 22413, fol 71r. The British Library, London. *The story of Ruth is read on Shavuot. Illuminating the initial word are two scenes from the story, separated by a canopy of flowering trees, set within an architectural framework of cusped arches supported by medieval fortification towers. The episodes refer to Ruth who, among other needy individuals, was gleaning the corners of Boaz's field. A curious feature of this manuscript is that some of the figures are distorted with animal heads and others are not.*

(OPPOSITE)

MAURICE MAYER. *Omer Calendar.* France. c. 1870. Case: Wood; silver, parcel gilt; enamel; glass; coral; amber. Scroll: ink, gouache and bronze paint on parchment. 13 3/4 x 10 1/4 x 3 in. (34.9 x 26 x 7.6 cm). Hebrew Union College, Skirball Museum, Los Angeles. *Maurice Mayer served as goldsmith to Napoleon III of France, and in style, this omer calendar is related to decorative arts objects of the Second Empire. On the Ten Commandments, there are palm branches which apparently derived from a similar motif used on the Torah ark at the Rue de la Victoire Synagogue in Paris and which Mayer used on other Judaica as well. The calendar is on a parchment scroll, rolled on two rods, with handles below the main box. It is arranged with numerals in three rows of square frames: the upper for the forty-nine days of the omer; the middle one for the seven weeks; and the bottom one numbered for the six days of the week with a seventh decorative square for the Sabbath. The H for "homer," as the Sephardim refer to the omer, should be at the top; the two other initials, S for semanas (weeks) and D for días (days), are missing.*

Omer Scroll. The Netherlands. c. 1680 . Ink and paint on parchment. 10 3/4 x 128 in. (27.3 x 325.1 cm). The Jewish Museum, New York. Gift of Dr. Harry G. Friedman. *In this omer calendar, using variations of flowering plants and birds, the artist developed each framed panel independently; no two are alike. The three tiers represent the day of the omer, the week, and the day of the week.*

Omer Calendar. United States. 19th century. Ink on parchment. 32 x 26 1/2 in. (81.3 x 67.3 cm). Smithsonian Institution, Washington, D.C. Gift of David Sulzberger. *The legacy of the Sephardi tradition in the United States is reflected in the H referring to the "homer" (omer). The omer calendar is here integrated into an architectural framework. While there is a wheel on the back of the calendar to change the dates, it was framed and must have been quite cumbersome to use. David Sulzberger, though Ashkenazi, was a member of the Sephardi Congregation Mikve Israel in Philadelphia. One of the first objects acquired by the Smithsonian, it was exhibited at the World's Columbian Exposition in 1893.*

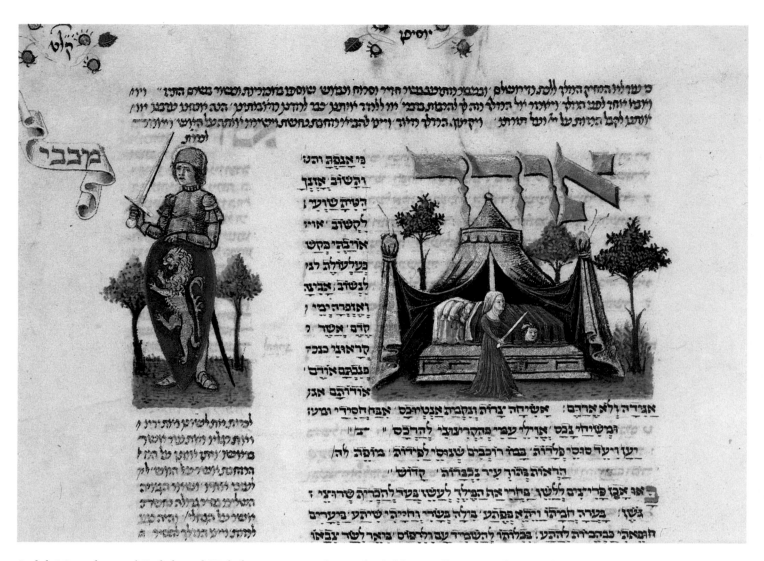

Judah Maccabee and *Judith and Holofernes*. From *The Rothschild Miscellany*. Northern Italy. c. 1450–80. Pen and ink, tempera, and gold leaf on vellum. 8 1/4 x 6 1/4 in. (21 x 15.9 cm). Ms. 180/51, fol 217. The Israel Museum, Jerusalem. Gift of James A. de Rothschild, London. *Judah and Judith are the heroes of Hanukkah. The young, beautiful, and righteous Judith invited the enemy Holofernes to a feast. Overcome by wine, he fell asleep and she slew him. Judah Maccabee led the fight against the Syrian Greeks to restore and rededicate the Temple.*

(OPPOSITE)

VALENTIN SCHÜLER (1650-1720). *Hanukkah Lamp*. Frankfurt-am-Main. Late 17th century. Silver gilt. 20 x 14 in. (50.8 x 35.6 cm). Jüdisches Museum, Frankfurt. *For nearly eighty years the Schüler workshop, established by Valentin Schüler and his brother Michael, produced the core of the most magnificent silver Judaica from Germany. There are six known Hanukkah lamps of similar form from the Schüler workshop. The branches are similar to the biblical description of the knobs and flowers of the seven-branched menorah, but here the knobs are bell-shaped. Judith holding the head of Holofernes stands atop the lamp. On each burner there is an animal—a squirrel, stag, eagle, and pelican. It has been theorized that these represent emblems of Jewish families from the Frankfurt ghetto. On the base of the lamp are medallions with architectural engravings and appliqué angels. Rampant lions holding shields form the feet of the lamp. This lamp was probably made for a wedding in the Judengasse in Frankfurt in 1681.*

Hanukkah Lamp. Lemberg, Poland. c. 1800. Silver, cast, repoussé, chased, parcel gilt. 26 x 11 in. (66 x 27.9 cm). Hebrew Union College, Skirball Museum, Los Angeles. *The "Oak Tree" Hanukkah lamp takes its form from the seven-branched Temple menorah. The naturalistic representation includes a hunting scene, perhaps referring to those who tried to destroy the Jews. There are several animals, most prominently a bear who climbs toward a honey pot replete with bees. A Polish folk motif used in other examples of eastern European Jewish ceremonial art, this image has been given a Jewish interpretation, in which the Torah is likened to honey that we must strive to reach.*

Rothschild Hanukkah Lamp. Frankfurt-am-Main. c. 1850. Silver, repoussé, cast. 21 x 19 in. (53.3 x 48.3 cm). Hebrew Union College, Skirball Museum, Los Angeles. Gift of the Jewish Cultural Reconstruction, Inc. *This Hanukkah lamp, a branch type with neoclassical and rococo elements, bears the Rothschild coat of arms. The shield found on the base of the lamp is composed of an eagle, a reference to Imperial Austria, which granted the Rothschilds baronial status in 1822; an arm grasping five arrows, a family symbol indicating the unity of the five Rothschild brothers, repeated twice; a rampant lion; and in the center, a medieval Jew's hat which declares the Jewish lineage of this illustrious family. The rampant lion and rearing unicorn are generally found supporting the shield in the usual versions of the coat of arms. The lamp was a gift from Baron Wilhelm Karl von Rothschild (1829–1901), to his wife Baroness Hannah Mathilde von Rothschild (1832–1924), possibly on the occasion of their marriage.*

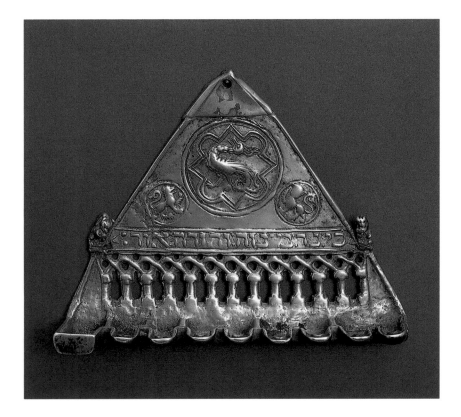

Lehman/Figdor Hanukkah Lamp. Italy (?). 14th century. Bronze. 5 3/8 x 6 11/16 x 2 in. (13.7 x 17 x 5.1 cm). Congregation Emanu-El of the City of New York. Bequest of Judge Irving Lehman, 1945. Formerly in the collection of Dr. Albert Figdor, Vienna. *Cast in a mold in a single piece, this is one of several rare medieval bronze Hanukkah lamps of this type to have survived. The grotesque animal in the central medallion has been identified as either a salamander, phoenix, or dragon, all of which are symbolically associated with fire and are thus appropriate to the rededication and rekindling of the Temple menorah. The squirrels holding nuts are probably a reference to mystical writings of the Cabala. The shell and the kernel are compared in the* Zohar *(Splendor) to the levels of meaning of the study of Torah. As with many Hanukkah lamps, there is an architectural reference to the Temple, here articulated by intersecting arcades.*

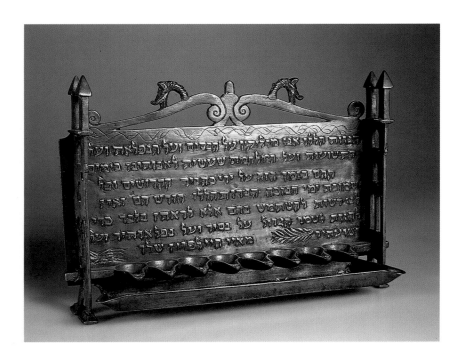

Hanukkah Lamp. Germany. Dated 1574. Bronze, cast, engraved. 9 1/8 x 13 1/2 x 4 in. (23.2 x 34.3 x 10.2 cm). The Israel Museum, Jerusalem. *This very early, dated Hanukkah lamp is also an early example of the use of architectural elements, here the double turrets at the sides. Another influence on the form of the lamp seems to be manuscript illumination. Here, the text of the Hanukkah hymn "These lights we kindle" is framed on the backwall, with volutes and a dragon's head along the top.*

(OPPOSITE)

Hanukkah Lamp. Metz, France. Mid-18th century. Silver, repoussé, engraved, cast, pierced. 11 3/8 x 10 3/8 x 2 in. (28.9 x 26.4 x 5.1 cm). The Israel Museum, Jerusalem. Gift of Françoise and Bernard Steinitz, Paris, 1975. *The overall form of this Hanukkah lamp with two towers is based on the shape of a donjon, a tower in France commonly used as a residence in medieval fortresses. The text on the back wall contains the blessings recited when lighting the Hanukkah lamp and a Hanukkah hymn. The pine-cone finial and the cast figures, including two soldiers in rakish poses, may be later additions.*

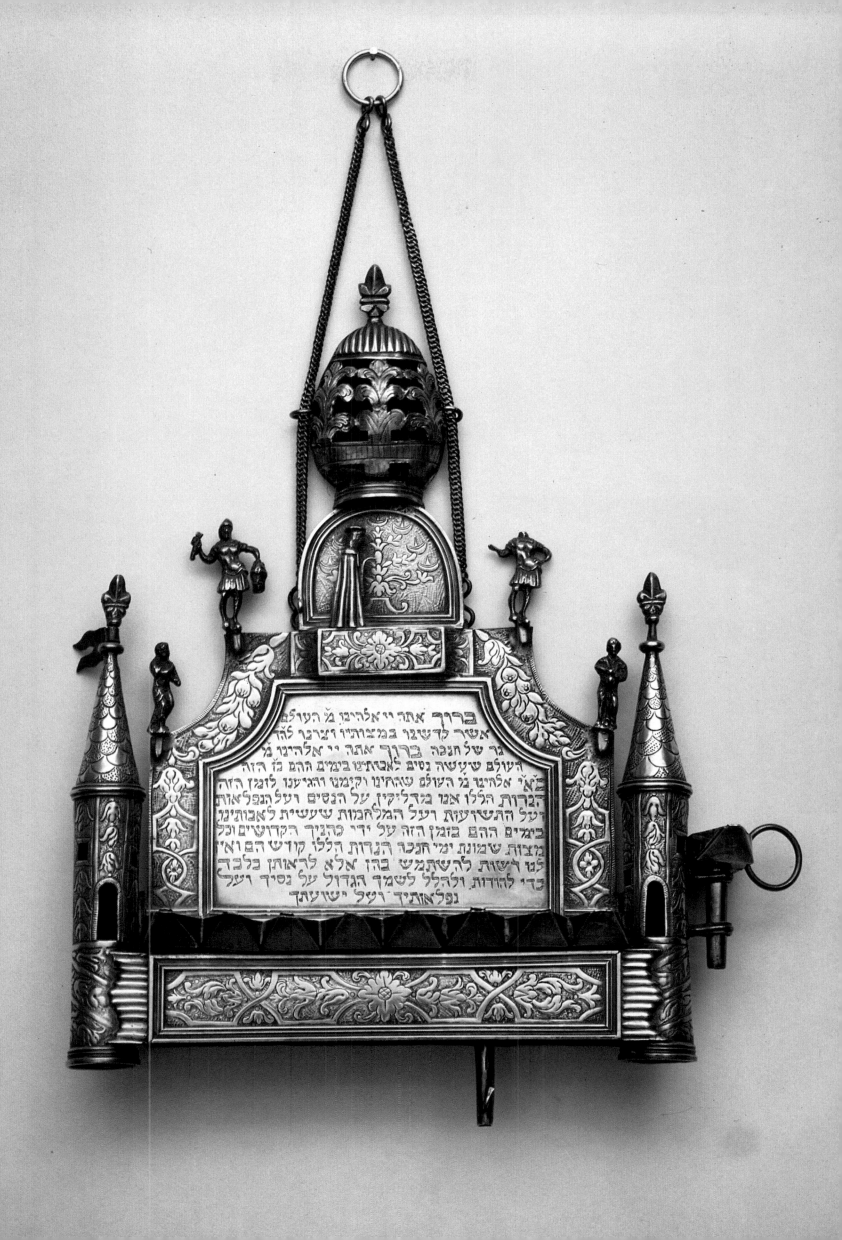

ברוך אתה יי אלהינו מ' העולם
אשר קדשנו במצותיו וצונו לה
נר של חנכה ברוך אתה יי אלהינו מ'
העולם שעשה נסים לאבתינו בימים ההם בז' הזה
בא"י אלהינו מ' העולם שהחינו וקימנו והגיענו לזמן הזה
הנרות הללו אנו מדליקין על הנסים ועל הנפלאות
ועל התשועות ועל המלחמות שעשית לאבותינו
בימים ההם בזמן הזה על ידי כהניך הקדושים וכל
מצות שמונת ימי חנכה הנרות הללו קודש הם ואין
לנו רשות להשתמש בהן אלא לראותן בלבה
כדי להודות ולהלל לשמך הגדול על נסיך ועל
נפלאותיך ועל ישועתך

(OPPOSITE)

Hanukkah Lamp. Germany. 1814. Silver, repoussé, chased, engraved, cast ornaments. 28 x 22 1/4 x 5 1/2 in. (71.1 x 56.5 x 14 cm). Hebrew Union College, Skirball Museum, Los Angeles. *This monumental lamp in the shape of a neoclassical building is a prime example of architectural symbolism. The date of the lamp may be calculated by adding the numerical value of the Hebrew letters marked by gilt dots along the architrave of the triangular pediment. The inscription, in part from 1 Samuel 10:1, reads: "Then Samuel took a vial of oil and poured it on the branches of the menorah." The choice of biblical inscription provides a repeated allusion to the name of Samuel, which is also found on two stags at the top. The Judeo-German word for stag is "Hirsch." In all probability, the lamp's owner was Samuel Hirsch. A second inscription on the back panel includes a reference to the heroine Judith and includes dot notations on the last four words indicating the name Gittel, who it is assumed was Samuel Hirsch's wife. The blessings recited when kindling the Hanukkah lights are inscribed in the lunette on the base.*

Hanukkah Lamp. Poland. 18th century. Brass, cast, pierced, engraved, punched. 14 x 10 1/4 x 7 in. (35.6 x 26 x 17.8 cm). The Israel Museum, Jerusalem. Gift of E. Burstein Collec-tion, Lugano, 1955. *This Hanukkah lamp in the form of a multi-story building is reminiscent of Polish wooden synagogues. The lamp is footed so that it can either be hung on the wall or rest freestanding. In the center of the back wall there is a central arched dooway flanked by two pillars, possibly a reference to Jachin and Boaz, two bronze pillars that stood near the Temple entrance. The upper section may refer to the women's gallery.*

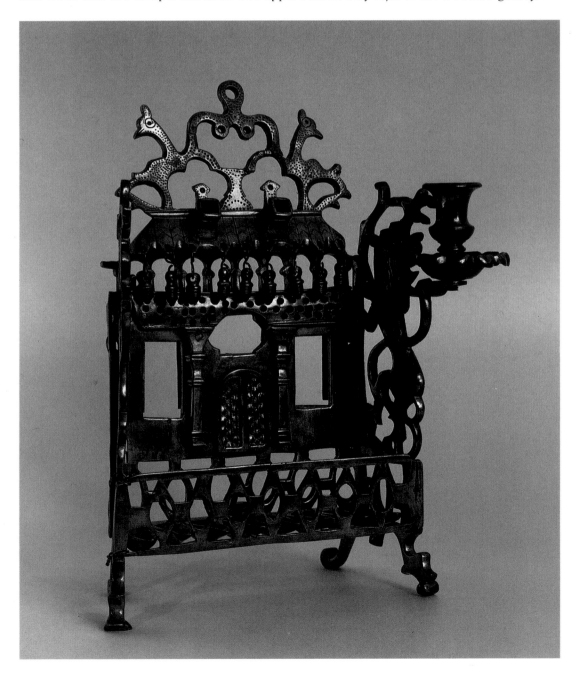

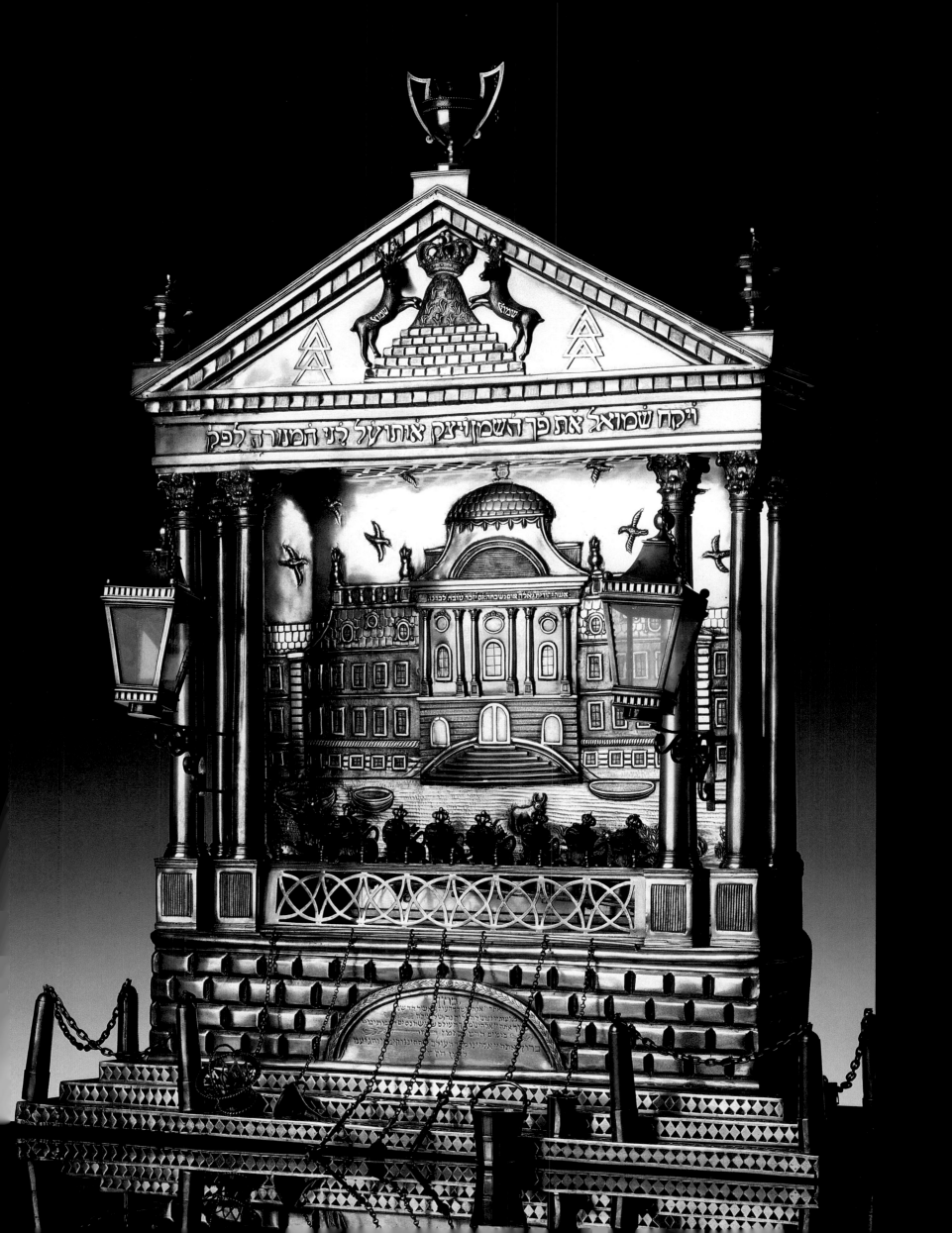

K. Felsenhardt. *Lighting the Hanukkah Lamp.* 1893. Colored chalk and gouache on paper. 5 7/8 x 9 3/4 in. (14.9 x 24.8 cm). Hebrew Union College, Skirball Museum, Los Angeles. Kirschstein Collection. *Felsenhardt did a series of drawings of traditional Jewish family life in Poland at the turn of the century. Here, in what would have been a typical Hanukkah scene, the candles are being lit, and two of the children play dreidle.*

(OPPOSITE, ABOVE)

Hanukkah Lamp. Iraq. 19th century. Brass, cast. 10 7/8 x 18 in. (27.6 x 45.7 cm). Smithsonian Institution, Washington, D.C. Deinard Collection. *The architectural design of this lamp reflects its origins in an Islamic country. The overall form of the back wall is the facade of a domed building resting on four pillars, the scalloped arch providing a decorative element. The ḥamsa, or hand, relating in Hebrew and Arabic to the number five, is a popular amuletic device to ward off evil. The ḥamsa is used five times on the lamp, thereby increasing its power fivefold. The inscription in Hebrew reads "Joseph is a fruitful vine" (Genesis 49:22). This is a popular quote on amulets because the second phrase of the verse is "a fruitful vine by a fountain." Since the word for both fountain and eye is "ayin," this text was thought to afford good protection against the Evil Eye.*

(OPPOSITE, BELOW)

Baal Shem Tov Hanukkah Lamp. Germany (?). Early 20th century. Silver, filigree, cast, die-stamped, engraved, parcel gilt. 14 x 12 7/8 x 5 1/4 in. (35.6 x 32.7 x 13.3 cm). Hebrew Union College, Skirball Museum, Los Angeles. Kirschstein Collection. *According to tradition, the great eighteenth-century Hasidic master, the Baal Shem Tov, used this type of lamp, and it was therefore widely used in the Ukraine and Poland. The elaborate filigree lamp is architectural in form, influenced by the onion-shaped domes of Eastern Orthodox churches. Cast figures of birds and sometimes griffins perch on the lamps. Because of the popularity of this Hanukkah lamp, it was apparently also copied in Germany in the early twentieth century.*

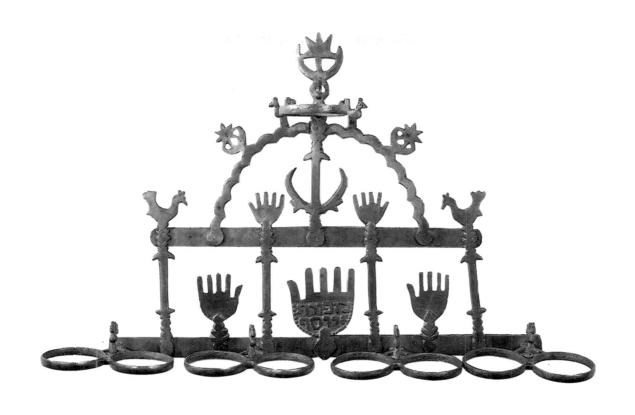

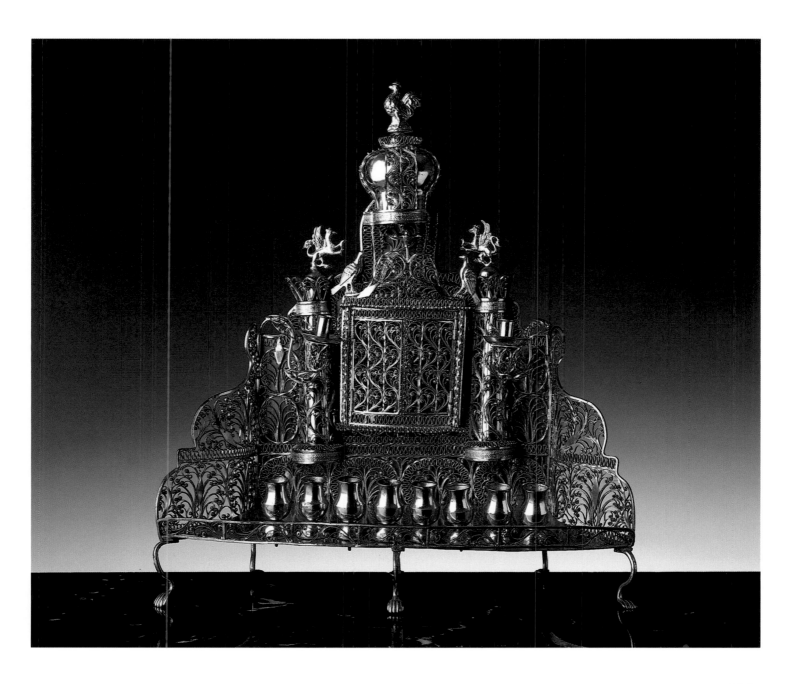

Hanukkah Lamp. Germany. Late 19th–early 20th century. Pewter. 3 x 1 1/8 x 1 3/8 in. (7.6 x 2.9 x 3.5 cm). Hebrew Union College, Skirball Museum, Los Angeles. Kirschstein Collection. *Sets of chair Hanukkah lamps such as these were probably intended for children rather than as the family's primary ceremonial lamp. The earliest examples were made in the second half of the nineteenth century.*

Hanukkah Lamp. Italy. Early 17th century. Bronze, cast and engraved. 8 3/8 x 5 3/4 x 2 7/8 in. (21.3 x 14.6 x 7.3 cm). Smithsonian Institution, Washington, D.C. Gift of Virginia Hillyer. *In the seventeenth century a variety of bronze Hanukkah lamps was created in Italy which, over the next two centuries, would be replicated again and again. A number of lamps reflect architectural models; others incorporate images such as cornucopias, scrolled vines, and mythological figures typically used on secular Renaissance bronzes. Some of the lamps even include elements directly copied from patterns found on domestic objects such as jewelry boxes. The details on this lamp include both secular motifs and a crown and family coat of arms.*

Esther Scroll and Sheet of Blessings. Izmir. 1873. Silver, parcel gilt; ink on parchment. Height: 11 3/4 (30 cm); diameter: 1/ 3/8 (3.5 cm). The Gross Family Collection, Tel Aviv. *The megillah and special gold filigree case were made as a wedding gift for the son-in-law of a wealthy Izmir merchant. This type of filigree originated in Izmir.*

(BELOW)

SALOM D'ITALIA (C. 1619–C.1655). *Esther Scroll.* Amsterdam. Etching and manuscript on parchment. 4 7/8 x 71 5/8 in. (12.4 x 181.9 cm). Jewish Historical Museum, Amsterdam. *Descended from a well-known family of printers, Salom d'Italia was born in Mantua about 1619. A decade after the Jews were expelled from the city following the Austrian invasion, he settled in Amsterdam, after having spent some time in Venice. Salom d'Italia made several different designs of Esther scrolls, the best known of which is a portal type that influenced many other artists. In this megillah, the text is written in round medallions. The architectural elements are not prominent but are part of the repeating motif in the spaces between the text roundels, along with vases of flowers and rabbit heads. Above each medallion a lion or bear menacingly eyes a lamb. The story of Esther is illustrated in the panels beneath the text.*

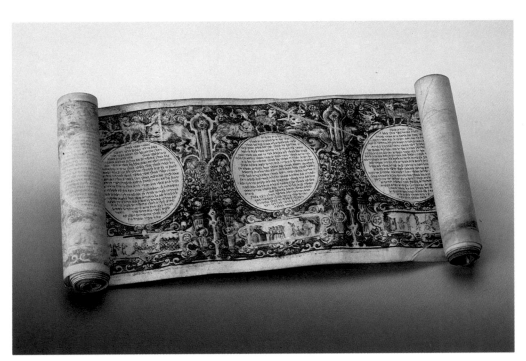

(OPPOSITE)

Scroll of Esther. Northern Italy. Mid-18th century. Ink, gouache, gold and silver paint on parchment. 21 1/2 x 202 5/8 in. (54.6 x 514.7 cm). Michael and Judy Steinhardt Collection. *The elaborate architectural composition of this megillah is related to the design format of many northern Italian illuminated marriage contracts of the period, the text framed in a highly decorated archway. Above the entablature of the arcade, scenes from the Purim story alternate with allegorical figures, also typical of ketubbot. Below the text are additional scenes from the Esther story.*

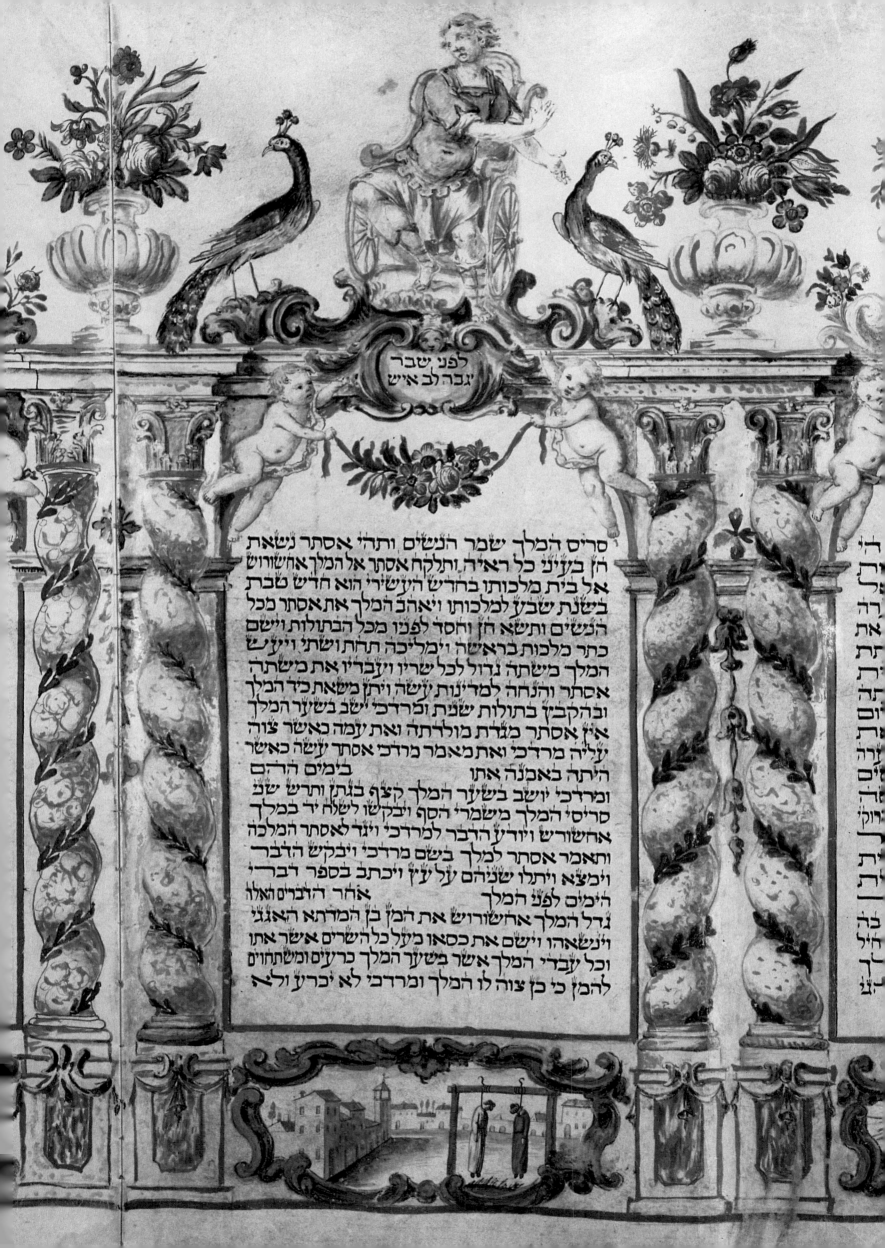

לפני שבר
יגבה לב איש

סריס המלך שמר הנשים ותהי אסתר נשאת
חן בעיני כל ראיה ותלקח אסתר אל המלך אחשורוש
אל בית מלכותו בחדש העשירי הוא חדש טבת
בשנת שבע למלכותו ויאהב המלך את אסתר מכל
הנשים ותשא חן וחסד לפניו מכל הבתולות וישם
כתר מלכות בראשה וימליכה תחת ושתי ויעש
המלך משתה גדול לכל שריו ועבדיו את משתה
אסתר והנחה למדינות עשה ויתן משאת כיד המלך
ובהקבץ בתולות שנית ומרדכי ישב בשער המלך
אין אסתר מגדת מולדתה ואת עמה כאשר צוה
עליה מרדכי ואת מאמר מרדכי אסתר עשה כאשר
היתה באמנה אתו
בימים ההם
ומרדכי יושב בשער המלך קצף בגתן ותרש שני
סריסי המלך משמרי הסף ויבקשו לשלח יד במלך
אחשורש ויודע הדבר למרדכי ויגד לאסתר המלכה
ותאמר אסתר למלך בשם מרדכי ויבקש הדבר
וימצא ויתלו שניהם על עץ ויכתב בספר דברי
הימים לפני המלך
אחר הדברים האלה
גדל המלך אחשורוש את המן בן המדתא האגגי
וינשאהו וישם את כסאו מעל כל השרים אשר אתו
וכל עבדי המלך אשר בשער המלך כרעים ומשתחוים
להמן כי כן צוה לו המלך ומרדכי לא יכרע ולא

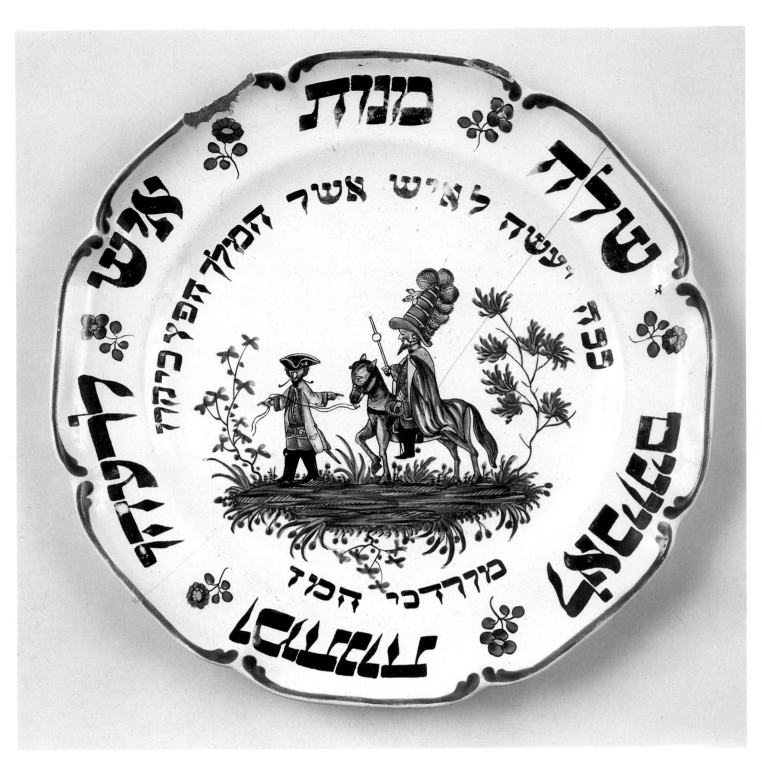

Plate for Shalaḥ Manot. Lunéville, France. 18th century. Faience. The Israel Museum, Jerusalem. Gift of Eliahu Siddi in memory of his parents Raphael and Hanna Siddi. *The text around the outer border refers to the mandate given in Esther 9:22 to "send portions one to another and gifts to the poor" on Purim. In the center, Mordecai, wearing Haman's royal apparel, is led on horseback through the streets by a humiliated Haman, wearing his signature three-cornered hat. The figures are identified by name and by the verse "Thus shall be done to the man whom the king delights to honor" (Esther 6:11).*

(OPPOSITE)

Ardašĭr Book. Persia. 17th century. Paper. 9 7/8 x 7 5/8 in. (25.1 x 19.4 cm). The Library of the Jewish Theological Seminary of America, New York. *In this Judeo-Persian book, the Esther story is interwoven into a classic tenth-century tale about the history of Persia. The heroes are Ardašĭr, who is identified with King Ahasuerus, and his sons. In this scene, the king seeks a new queen after banishing Vashti.*

בוש או חו הוואן יוכתר כוב הריך בצנא צו אבתר כוב

דר שוש בין ווסל בורדנר הרו טי יך כל מורדני

בהמן צושער קצר משכוי סר שד ומה בתאן מה רו

דרפרהוד בתאן מינ ראכרת אומר דרץ בור בנורּאכת

רפתן שאה, בהן במישבוי
דכתראן ועשרת כרדן

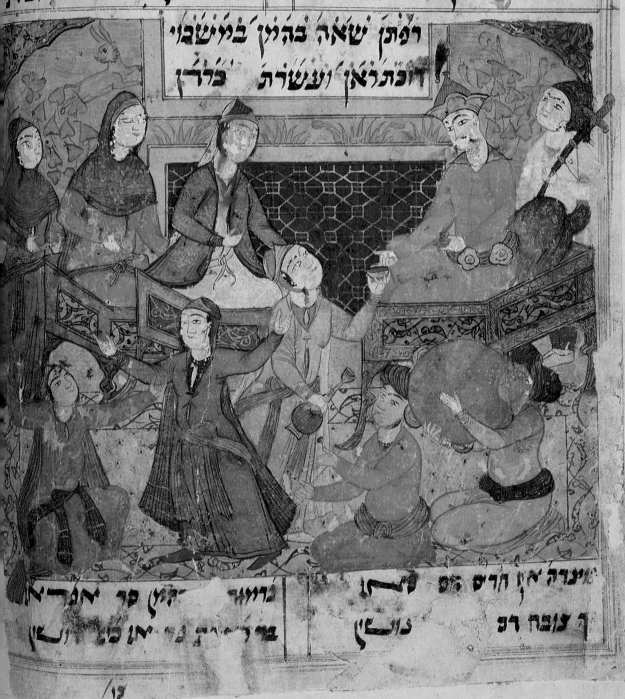

שיגרה אין הרס הם כאן
ך צובה הם גושן

נהאן כר אמרא נמוד
בריית צר אן מירושין

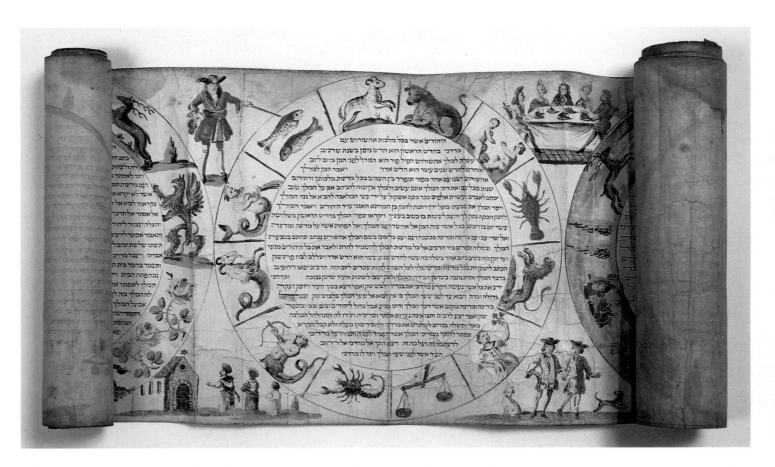

Esther Scroll. Germany (?). Early 18th century. Pen and ink, and gouache on parchment. 10 x 117 in. (25.4 x 297.2 cm). The Israel Museum, Jerusalem. *The identity of the artist is unknown, but there are three other known scrolls done in a similar hand. The scrolls are wonderfully rich in illustrations of the Esther story, both from the text and from the midrash. The characters in the Purim story are portrayed in eighteenth-century dress. The texts are framed by roundels, here by the zodiac. A man points with a stick to Pisces, the sign corresponding to the Hebrew month of Adar, when Purim is celebrated. Use of the zodiac in this way likely refers to the lots that were cast to determine the month in which Haman wanted to annihilate the Jews.*

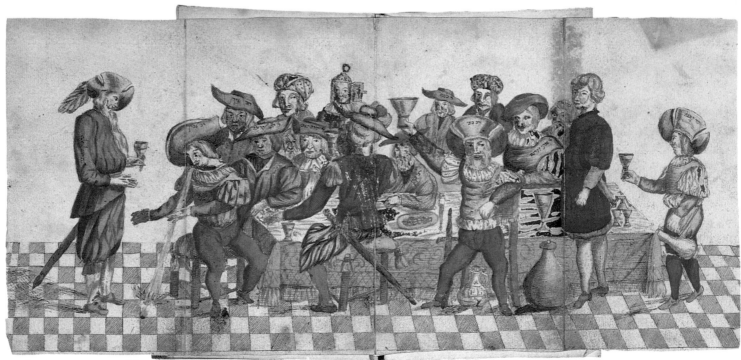

Megilat Setarim. Masekhet Purim. Amsterdam. 1734. Paper. Bibliotheca Rosenthaliana, Amsterdam. *A Purim custom is to organize a Purim parody in the festive spirit of the holiday.* Masekhet Purim *is a parody on the Talmud, with a text on the theme of drinking wine which was first written in the fourteenth century. The* Megilat Setarim *(Scroll of Secrecy) was written by Levi ben Gershom of Provence in the same period. Here, Purim revelers are following the dictum that on Purim you should drink wine until you cannot tell the difference between Mordecai and Haman.*

Purim Plates. Amsterdam. Dated 1785. Faience. Diameter of each: 9 5/8 in. (24.4 cm). Hebrew Union College, Skirball Museum, Los Angeles. Kirschstein Collection. *This unique set of Purim plates was made in honor of Rabbi Moses ben Aaron, of blessed memory, and his wife, Bayla, by his daughter and son-in-law in accordance with the custom of exchanging gifts on Purim. They are dated 13th of Adar [5]545 (1785).*

New Directions: Interpreting Jewish Ceremonial Art for Modern Times

The old renewed, the new made holy.
(CHIEF RABBI KOOK, 1865–1935)

IN A SHORT STORY entitled "The Menorah," written by Theodor Herzl in 1897, a frustrated artist, estranged from his Jewish roots, decided to buy a menorah for Hanukkah to light with his children. This simple act changed his life. No longer alienated from his heritage, his creative crisis passed. The menorah, an emblem of redemption for the Jewish people since antiquity, became a personal symbol of hope for the artist.

Like Herzl's character in the story, seeking a way to fuse tradition with contemporary relevance and meaning has been the quest of modern Jewish ceremonial artists. Furthermore, there has been the perception that this union could lead to a heightened state of creativity and artistic production.

This was certainly the case with the utopian idealists of the Bezalel School for Arts and Crafts, which was established in Jerusalem in 1906. Boris Schatz, founder of the school and its driving force, was quite explicit in his goals for the artisans who would come together at the academy. He sought nothing less than to bring together the strands of Jewish art that had existed in the Diaspora and weave them together to form a new "Hebrew style in the Hebrew spirit." In fact, the early Bezalel "style" is characterized by a strong strain of romantic orientalism blended with Judgendstil, the German version of Art Nouveau. Indeed, even the Yemenite craftsmen, with their long tradition of delicate filigree work, were urged to work in the new style.

At Bezalel, there was a focus on making ceremonial objects, and the first major school collaborative work was a Torah ark. Designed by Ze'ev Raban, a Bezalel instructor, the elaborate iconographic program consciously drew from ancient sources, both literary and visual—the dome symbolizes the planets, with ivory carvings below representing the twelve tribes, the columns refer to the pillars Jachin and Boaz which stood outside the Temple; the cloisonné work on the steps was meant to give the effect of an oriental carpet; panels on the side depict biblical scenes, and of course the ark include quotations in Hebrew. The plan for the ark also called for the use of as many local materials as possible. Thus, for example, the lions are

(OPPOSITE)

ZE'EV RABAN (DESIGNER) (1890–1970). YICHYA YEMINI (ARTISAN). (1896–1983). *Torah Finials.* Jerusalem. Mid-1940s. Silver, precious stones. The Israel Museum, Jerusalem. Fiftieth Anniversary Fund in honor of Issacar Heimovic. *Members of the Yemini family have been silversmiths for generations in Yemen and in Eretz Yisrael. Though most of their work is completely their own, at the Bezalel workshops they also fabricated objects designed by others. This pair of* rimmonim *combines the motif of a palm tree, part of the landscape of Eretz Yisrael; a late version of the* Jugendstil *popular at Bezalel earlier in the century; and Yemini's brilliant technique, which retains elements of traditional Yemenite work.*

Ze'ev Raban and the Bezalel Torah Ark. Jerusalem. c. 1924. *Ze'ev Raban studied at Bezalel beginning in 1912 and in 1914 became an instructor and the head of the repoussé department. The Torah ark was basically his design, and he supervised the many students who worked to fabricate it.*

carved from stone found only near the Dead Sea. Over one hundred students are said to have participated in the creation of the ark. Yet it is significant that like the *ḥalutzim*, the pioneers who were tilling the soil to find fulfillment, Schatz himself had a nationalist aim, not a spiritual one in any conventional sense. The works of the Bezalel School were meant to be the culmination of the Zionist ideal—made in the Jewish homeland, creating a new Jewish presence with a unique Jewish perspective.

A very different nationalist bent was represented by the Jewish artists aligned with the avant-garde movement in Russia. What these artists shared ideologically with their fellow artists in Eretz Yisrael was the quest to preserve traditional Jewish expression as a source for Jewish cultural renewal. An example of this idealism is El Lissitzky's 1919 *Ḥad Gadya, Tale of a Goat*, the illustrations for the popular Aramaic song sung at the end of the Passover seder. El Lissitzky used an abstracted architectural setting and integrated Yiddish folk art typography to help frame the image. The tempo of the song is quick and lively and that energy is immediately felt in El Lissitzky's interpretation. It has been suggested that El Lissitzky's *Ḥad Gadya*, which was completed after the Russian Revolution, was meant to represent a universal message of the triumph of good over evil.

In the same era in western Europe, modern design was beginning to come to the fore. A most remarkable group of ceremonial objects was crafted by Friedrich Adler for an exhibit at the Cologne Werkbund in 1918. Adler brilliantly synthesized classical designs for the ceremonial objects with the prevalent Jugendstil, as seen in his seder plate and Cup of Elijah. The entire group created by Adler was purchased by Julius Cohn, a lawyer. The Cohn family managed to take the entire collection out of Germany after Hitler's rise to power, though one prominent item, a candelabrum for the Sabbath, was lost en route. Friedrich Adler perished in Auschwitz in 1942.

The interest in creating contemporary interpretations of ceremonial art is evidenced in the special gallery which was in the Jewish Museum in Berlin for these new designs. Moreover, especially in Germany, many objects were commercially made which reflected current trends. Art Deco was especially popular. But there are also examples of stellar pieces made by artists who were very consciously applying the tenets of modern art to ceremonial objects. One such object is a modern version of the seven-branched menorah made by Hungarian-born artist Gyula Pap in 1922. For the candelabrum, Pap interpreted the menorah

symbol with the aesthetic of the Bauhaus school of design. Pap made four of these by hand, but they were intended for mass production.

The Bauhaus stressed the synthesis of craftsmanship, technology, and design aesthetics, beautifully integrated in Ludwig Wolpert's Passover set of 1930, fabricated of silver, ebony, and glass. The design reduces an earlier type of three-tiered seder plate to its essential functions for holding the symbolic foods, and providing space for the three matzahs used during the service. A hallmark of Wolpert's work was the inclusion of the Hebrew letter as a design element, which he does here very simply and elegantly on the Cup of Elijah. Wolpert left Berlin for Jerusalem in 1935 and became a professor of metalwork at Bezalel. After training a generation of students in Israel, in 1956 he agreed to move to New York to direct the Tobe Pascher Workshop at The Jewish Museum, thus further extending the influence of his modernist approach.

Among the artists who escaped from Nazi Europe were a number who created Jewish ceremonial objects. Hana Geber fled her native Prague one day before the Germans arrived. In her new home in America, Geber, who came from an assimilated family, sought to reestablish herself by studying her Jewish heritage—"the biblical sages and prophets became my family." To express her newfound Jewish identity, Geber began to create ceremonial objects. A sculptor, she was influenced both by the Bohemian Baroque style of the city of her youth and what she called the vitality and energy of her adopted country. Geber's silvered bronze kiddush cups reflect her bond with Jewish tradition.

Otto and Gertrud Natzler came from Vienna to the United States in 1938. In Europe, the Natzlers, who formed a true creative collaboration in the production of ceramic vessels, had made but a single ceremonial object, a Hanukkah lamp. In the late 1950s, while artists-in-residence at the Brandeis Camp Institute in California, they were asked to create a yahrzeit memorial lamp. At that time, Otto Natzler began to make hand-built Hanukkah lamps. The architectonic form of the lamps refers to the meaning of Hanukkah as the festival of rededication of the Jerusalem Temple.

Ilya Schor, who managed to leave Europe in 1941, was the standard bearer for the folk art images of life in the small Jewish towns, in the shtetl. In his paintings and ceremonial objects, with images of men,

ILYA SCHOR (1904–1961). *Torah Crown.* New York. 1958. Silver. Temple Israel, Brookline, Massachusetts. Gift of Sarah and Peter Leavitt in honor of their Golden Wedding anniversary. *Ilya Schor was born in Zloczoq, Poland, in 1904. The son of a Hasidic folk painter, he was apprenticed in his youth to an engraver and goldsmith before attending the Academy of Fine Arts in Warsaw; he then studied in Paris before coming to the United States in 1941. Schor's work celebrates the memory of the shtetl culture of eastern Europe, combining folk traditions and modernism. Narrative, figurative, humorous, lyrical, tender, and pious, yet informed by the geometry and fragmentation of Cubism, his work unites the special spirit of Hasidic culture with European art. Effusively ornamented, this crown is part of one of two sets of Torah ornaments that Schor made for Temple Israel. Schor enlivened a traditional crown form by alternating biblical figures with two tiers of bells. Three thin bands of text provide balance to the design.*

women and children, he vibrantly and nostalgically recreated a world that was no more, synthesizing folk tradition and twentieth-century western modernism.

The post-World War II era in the United States brought a major demographic change for the Jewish population from urban centers to the suburbs, and with the move came tremendous growth in the building of synagogues. The emerging modernist aesthetic strongly influenced synagogue design, which tended to avoid historical references in preference for simplicity and functionality. While many synagogues continued to use commercially made ceremonial objects, there were some enlightened commissions for original works. In 1951, Adolph Gottlieb, who was later recognized as an important figure in the Abstract Expressionist movement, designed a Torah curtain for a new synagogue in Millburn, New Jersey. The style of the curtain is akin to other "pictographic" works he did during this period—here incorporating Jewish symbols, some more abstracted, some more readily identifiable.

In the period after World War II, artist Ben Shahn, known for his penetrating works of universal social realism, was working in a more personal vein, and began to incorporate more elements from his Jewish heritage in his work. One aspect of this was his fascination with Hebrew letters, which, along with English letters, became essential elements in his work. In 1954, he published *The Alphabet of Creation*, a legend about the origin of the Hebrew alphabet. Based on his work for the book, Shahn created a "chop," a personal seal, from the Japanese custom, comprising the twenty-two letters of the Hebrew alphabet. Among Shahn's late religious paintings is a calligraphed rendering of *The Decalogue*. The text is written on a field of delicate vines and flowers like that which he had earlier used in creating a modern *ketubbah* in 1961.

Leonard Baskin, noted sculptor, painter and graphic artist, has often turned to Jewish themes in his work. Baskin's illustrations for *The Five Scrolls*, the *Megillot: Ruth, Song of Songs, Lamentations, Ecclesiastes* and *Esther*, rendered in his expressive figurative style, reflects his deeply felt humanist convictions. He is a master of capturing the essence of the character's emotional makeup. Baskin's portrayal of the wicked Haman, who wanted to destroy all the Jews, is the archetype of evil brutality. The zoomorphic letters of his name, which include equally nasty images of animals and a shark, reinforce the threatening quality of the portrait.

The biblical description of the vestments worn by the High Priest Aaron was the source for a set of Torah ornaments made by Kurt Matzdorf. The Torah finials are bulbous in form, reminiscent of the pomegranates and bells on the hem of Aaron's robe, so that his well-being could be known when he was alone ministering in the holy place (Exodus 28:33–35). The Torah shield is Matzdorf's interpretation of the breastplate worn by Aaron, with twelve stones symbolizing the tribes of Israel.

Bernard Bernstein was inspired to create Judaica after studying with Ludwig Wolpert at the Tobe Pascher Workshop of The Jewish Museum. Subsequently, he received a doctoral degree at New York University, where the subject of his dissertation was the history and style of traditional Torah ornaments and a creative project involving the design and fabrication of ten contemporary silver Torah ornaments. A Torah crown from this group, made in 1969, epitomizes Bernstein's simple, subtle, and restrained style, which emphasizes purity of form, the only ornamentation being the Hebrew inscription.

Moshe Zabari first trained at Bezalel and then moved to New York in 1961, where he worked for over twenty-five years at the Tobe Pascher Workshop before returning to his native Jerusalem. One of the few artists of his generation to have devoted his entire career to the creation of Jewish ceremonial art, Zabari has created a wealth of creative and innovative objects. Zabari has often cited specific influences on his work, and had a late Canaanite stele with an image of "praying hands" in mind when he made a memorial lamp which captures the powerful meaning of the gesture.

"Praying Hands" Stele. Hazor. Late Canaanite.
16th–13th century B.C.E. Basalt. Courtesy of the
Israel Antiquities Authority.

With the establishment of the State of Israel in 1948, there was a tremendous expansion in the production of ceremonial art, both for the Israeli population and the growing tourist market. The old Bezalel School, removed from the ideological weight of the Schatz years, became a modern Academy of Arts and Design. An experimental philosophy of education provided the opportunity for young artists to experience many different techniques, approaches, and ideas and to develop their own artistic statements. Thus, numerous Israeli artists began to create Judaica.

Jerusalem-born Zelig Segal was trained at Bezalel and later became head of the Department of Gold and Silversmithing. Segal's work is the quintessential paradigm of modernism's striving for purity of form. Segal intensively seeks to find the essence of form and material. His reinterpretation of the traditional two-handled vessel for the ritual washing of hands is immediately recognizable, forging a link with tradition, but at the same time it is modern and highly sophisticated in form, a completely new version.

Arie Ofir, who also studied at Bezalel, succeeded Segal as head of the Department of Gold and Silversmithing. Ofir has described his personal understanding of *ḥiddur mitzvah* as "glorification of the commandment; tradition and form; thing and spirit; past and present—these are the elements that go into designing ceremonial objects." Ofir strives for a "harmony out of disharmony" in his work. As exemplified in his candlesticks for Shabbat, Ofir creates a dialogue of form using both the straight and amorphous, the organic and geometric, silver and colorful titanium.

A remarkable renascence began after the Six-Day War in 1967, which was a watershed in Jewish history, a time of crisis that caused many people to question and explore their own Jewish identity. An unprecedented number of artists began to turn their talents to Jewish art in general and Jewish ceremonial art in particular. Artists have focused on Jewish themes and objects of Jewish ceremony as a vehicle for seeking their own roots, exploring and finding their personal expression of ancient rites.

One approach among artists seeking to link their work to tradition has been through the exploration of the legacy of older, and sometimes forgotten, techniques in their work. Yehudit Shadur has played a major role in the revival of the Jewish folk tradition of papercutting, an art form which was popular especially among the Ashkenazim of eastern Europe and the Sephardim who settled in North Africa. For these traditional Jews, the papercuts served a religious, ritual or mystic purpose. Shadur's own work draws on

her extensive knowledge of traditional imagery and techniques but is infused with her own creativity. An effusively designed *mizrah* made in 1984 with a traditional iconographic program—crowned menorah, flanked by lions and gazelles, the Ten Commandments, and Hebrew inscriptions—is imbued with the artist's vibrant personal energy.

David Moss began as a Judaic artist as a pioneer in the revival of the manuscript ketubbah. In just over two decades, what started as an experiment to renew a traditional Jewish art form has become a widespread custom, with many artist/calligraphers making ketubbot. Moss expressed his own aspirations as a Jewish artist by explaining that "Our entire tradition is awaiting a careful, thoughtful and loving search for the wealth of inspiration it can provide the Jewish artisan. A visual midrash is waiting to be expounded. . . ." He has created many other forms of Judaica, including a handwritten and richly illuminated haggadah. All his work is characterized by a firm intellectual foundation combined with a creative approach that synthesizes a diversity of media to accomplish his artistic statement.

Jay Greenspan, who also led the movement to renew the art of Hebrew calligraphy, has continued to strive to be innovative and experimental in his works. His aim is to make each marriage contract unique to the special interests of the couple. Drawing on his intensive and extensive study of Jewish sources, both textual and visual, he is able to personalize the ketubbah and continually find new expressions.

In Israel, a new generation of artists began to explore their Jewish identity by making ceremonial objects. Yaakov Greenvurcel was interested in exploring the ways of treating the ceremonial object as both a work of art and in accordance with *halakha* (Jewish law). His havdalah set of 1980 accomplishes that goal, with each individual unit a separate sculpture and all of the components forming a sculptural entity.

Working in an astonishing range of materials, artisans creating Judaic ceremonial objects have imbued their work with a spirit of modernity infused with intensely personal feelings and rooted in traditional idioms. This commitment is conveyed in objects as diverse as Katya Apekina's folk art mezuzah, Jeanette Kuvin Oren's huppah, Laurie Gross's Torah ark, Kerry Feldman's handblown glass seder plate, and the work of Lorelei and Alex Gruss, who create ceremonial art in exotic woods with delicately crafted inlays.

Some artists, known for their work in other fields, have become involved in making Judaica because of special exhibitions or commissions. Richard Meier's Hanukkah lamp is an architectural progression related to Jewish experience over the centuries. Peter Shire's Judaica expresses the spirit of contemporary Los Angeles—Hanukkah lamps which are adventurous and high-spirited, with charged color, geometric forms, and industrial materials. In creating a tzedakah box, Tony Berlant used his distinctive medium of found, decorative metal collaged onto a houselike form, thus merging his own artistic practice with the Jewish tradition of a boxlike tzedakah container.

This survey of ceremonial objects, which specifically represents the encounter with modernity, includes but a fraction of the many fine artists strengthening the Jewish cultural heritage through their work. In every field and working in every media, there are artists who continue to explore the traditions of Judaism as a source for Jewish renewal.

(OPPOSITE)

Torah Ark. Jerusalem. 1916–25. Brass, enamel, ivory, mixed materials. 69 x 35 in. (175.3 x 88.9 cm). Spertus Museum of Judaica, Chicago. Gift of the Spertus Foundation. *It was highly significant that the first collaborative work made by the students at the Bezalel School of Arts and Crafts was a Torah ark. The approach of Boris Schatz was that the school could represent the interests of nationalism and pragmatism, in terms of livelihood for the artisans, and could serve to forge a new link in the continuity of the Jewish people through artistic expression.*

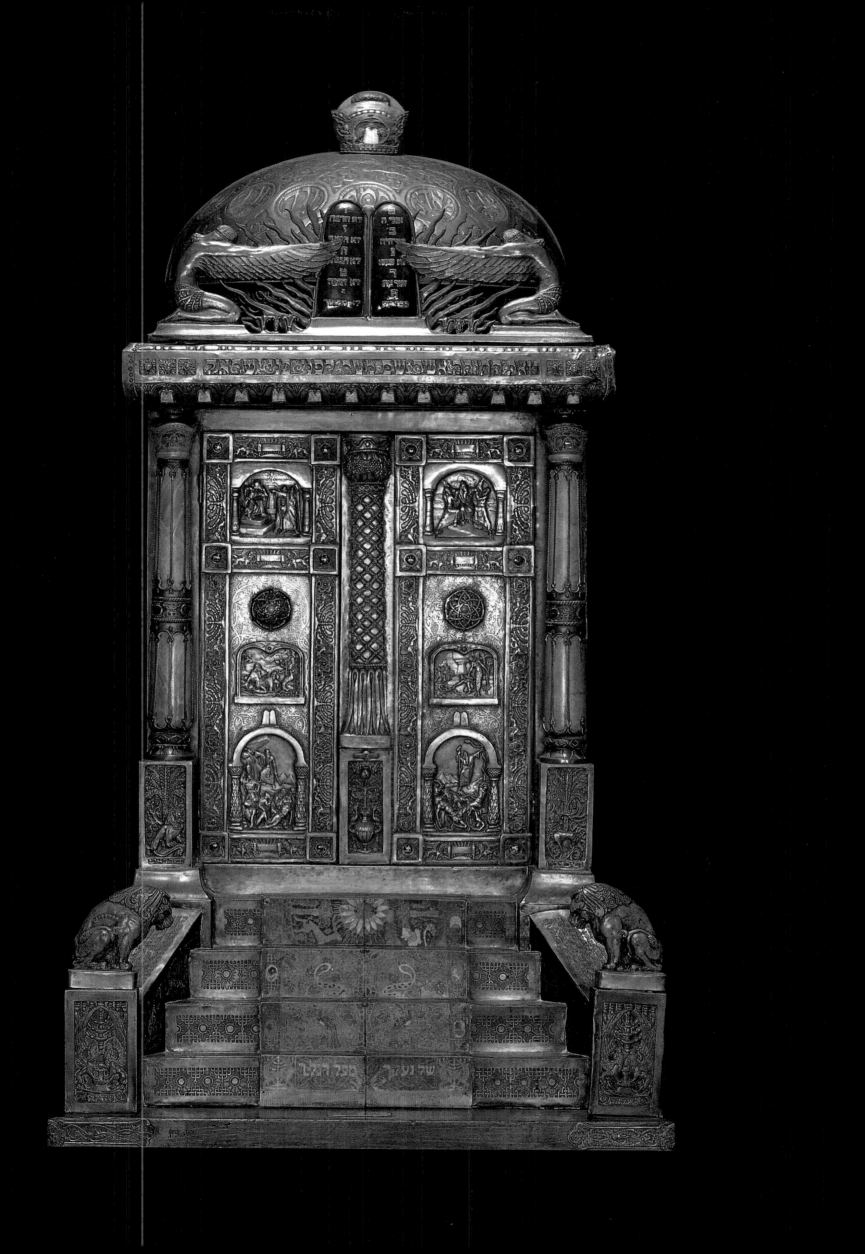

GYULA PAP (1899–1983). *Menorah*. Weimar. 1922. Brass. 16 1/2 x 16 7/8 in. (41.9 x 42.9 cm). The Jewish Museum, New York. Museum purchase: The Judaica Endowment Acquisition Fund; Mrs. J.J. Wyle, gift by exchange; The Judaica Acquisition Fund: The Peter Cats Foundation; Helen and Jack Cytryn; and Isaac Pollak. *The seven-branched candelabrum made by Gyula Pap represents the aesthetic principles of the Bauhaus, which aimed to create well-designed objects, simple in form and reflecting fine craftsmanship, but which could be mass-produced. Pap made four of these lamps, two of which survived World War II.*

EL LISSITZKY. (1890–1921). *Illustration from Had Gadya Suite.* 1917. Gouache and India ink on paper. 9 3/8 x 7 7/8 in. (23.8 x 20 cm). The Tel Aviv Museum of Art. *"Had Gadya (Tale of a Goat),"* *the Aramaic song sung at the end of the Passover seder, recounts the tale of a goat consumed by a cat. The ten verses list a succession of assailants until finally God destroys the final perpetrator, the Angel of Death. This song is generally interpreted as an allegory for the experience of the Jewish people, who have faced many enemies and yet have survived with God's help. It has been suggested that El Lissitsky similarly saw "Had Gadya" as an analogy for the triumph of good over evil.*

FRIEDRICH ADLER. (1878–1942). *Seder Plate and Cup of Elijah*. Germany. Early 20th century. Seder plate: silver, embossed and cut out glass. Height, 4 in. (10.2 cm); diameter, 17 5/8 in. (44.8 cm). Cup: silver, repoussé and cut out; moonstones. Height, 9 5/8 in. (24.4 cm); diameter, 6 1/16 in. (15.4 cm). The Spertus Museum of Judaica, Chicago. Gift of Ann E. Cohn Hirschland (Hill), Eleanor A. Cohn-Pagener (Page), and Ernest J. Cohn Hirschland (Hill). *Adler was a master of applied arts whose designs included architecture and furniture as well as smaller functional ware. He was first encouraged to make Judaica by the prominent Hamburg Rabbi Jakob Sonderling. For the Cologne Werkbund of 1918, Adler created a design for a synagogue interior and Torah ornaments, as well as an entire group of ceremonial objects to meet the ritual needs for the observance of the Sabbath and holidays in the home.*

(OPPOSITE, ABOVE)

LUDWIG WOLPERT (1900–1981). *Seder Set*. Frankfurt. 1930. Silver, ebony, glass. Height, 10 in. (25.4 cm); diameter, 16 in. (40.6 cm). The Jewish Museum, New York. Promised gift of Sylvia Zenia Weiner. *This Passover set was the work of the young Ludwig Wolpert, trained at the School of Arts and Crafts, Frankfurt-am-Main, where his silversmith teacher introduced him to the design concepts of the Bauhaus. Originally a sculptor, Wolpert decided to devote his talents to creating ceremonial objects in the modern style. In this elegant work, Wolpert looked to traditional models of three-tiered seder plates and simplified the design to essentials. He harmoniously used contrasting materials, ebony, silver, and glass, to link the elements together. Wolpert would later become well known for his focus on the Hebrew letter. A hint of the importance of the letter for him is evidenced here in the cut-out inscription on the Cup of Elijah.*

(OPPOSITE, BELOW)

KERRY FELDMAN (b. 1953). *Seder Plate*. Los Angeles. 1987. Hand-blown colored glass. Diameter: 17 in. (43.2 cm). Hebrew Union College, Skirball Museum, Los Angeles. Museum purchase with funds provided by Jesse R. and Sylvia M. Gross in honor of their grandchildren. *The bright colors and pictogram-type symbols of Kerry Feldman's seder plate reflect his very personal approach to linking tradition and modernity. Working very intuitively and purely with color and form, Feldman continually works to refine the craft of glassmaking while simultaneously exploring his spiritual roots through the ceremonial objects he creates.*

HANA GEBER (1910–1990). *Kiddush Cup.* New York. 1982. Silvered bronze. Height: 7 1/2 in. (19.1 cm). Hebrew Union College, Skirball Museum, Los Angeles. Gift of the artist. *Geber was born in Prague to a family who were "Zionists, but without any religion." Trained as a sculptor, she began, as a refugee during World War II, a spiritual exploration in her work. Geber truly thought of her art as "hiddur mitzvah," of enhancing the ritual. To Geber, creating liturgical objects was really an attempt to heighten the religious experience. She worked in the lost-wax method of casting, achieving a remarkable sense of naturalism.*

(OPPOSITE, ABOVE)

OTTO NATZLER (b. 1908). *Hanukkah Lamp.* Los Angeles. 1985. Ceramic, celadon reduction glaze with sang and orange. 13 1/2 x 18 x 1 3/4 in. (34.3 x 45.7 x 4.4 cm). Hebrew Union College, Skirball Museum, Los Angeles. Museum purchase with funds from the Audrey and Authur N. Greenberg Acquisition Fund. *Otto Natzler worked for nearly four decades in collaboration with his wife, Gertrud, creating ceramic vessels which focused on the refinement of form and surface. Gertrud, who made wheel-thrown objects, concentrated on the form. Otto's focus was the surface, continually experimenting with glaze chemicals and firing techniques. After Gertrud's death in 1971, Otto's work was transformed as he now began to create handmade vessels of his own that reflect his spiritual and poetic sensibility. In this lamp Natzler synthesizes the organic quality of the glaze with slab-built geometric construction.*

(OPPOSITE, BELOW)

RICHARD MEIER (b. 1935). *Hanukkah Lamp.* Designed 1985. Fabricated 1990. Tin. 12 1/4 x 13 3/4 x 2 in. (31.1 x 34.9 x 5.1 cm). Hebrew Union College, Skirball Museum, Los Angeles. Museum purchase with funds provided by the Audrey and Arthur N. Greenberg Acquisition Fund. *With this lamp Meier, an architect known for the elegant simplicity of his buildings, continued the long-standing tradition of relating style to architecture. Each of the eight candle-holders is an architectural metaphor for places and events in Jewish history, from ancient Egypt to the twentieth century.*

ADOLPH GOTTLIEB (1903–1974). *Torah Ark Curtain.* 1950–51. Velvet, appliqué, embroidered with metallic thread. Upper section: 80 1/2 x 112 3/4 in. (204.5 x 286.4 cm). Lower section: 81 1/2 x 121 3/4 in. (207 x 309.2 cm). The Jewish Museum, New York. Gift of Congregation B'nai Israel, Millburn, New Jersey. *Adolph Gottlieb received the commission to make a Torah curtain for a new synagogue in Millburn, New Jersey, from architect Percival Goodman, one of the major figures in the post-World War II building of suburban synagogues. At the time, Gottlieb was among the avant-garde artists increasingly working toward the abstract. In this Torah curtain, Gottlieb did include major symbols of Judaism—the Ten Commandments, the Twelve Tribes, the Ark of the Covenant, the Lion of Judah, the Star of David, and images of synagogue ceremonial objects, the Torah mantle and shield. Yet the traditional images are transformed by his modernist vision.The curtain was made by the Women of Congregation B'nai Israel under the supervision of Esther Gottlieb.*

(OPPOSITE)

LEONARD BASKIN (b. 1922). *Haman.* From *The Five Scrolls.* United States. 1980. Watercolor on paper. 22 x 15 1/8 in. (55.9 x 38.4 cm). Hebrew Union College, Skirball Museum, Los Angeles. Museum purchase with funds provided by the Gerald M. and Carolyn Z. Bronstein Fund for Project Americana. *Baskin grew up in a rabbinical family and was educated through high school in a yeshiva. The rigorous training in the Yeshiva, with its intense intellectual demands, was an important influence on him. As a youth, he grew to love books and the Yeshiva gave him a solid background in traditional Jewish texts. Baskin knew early on that he wanted to be an artist and began at age fifteen to study sculpture. But that meant a break with his orthodoxy. With the same rigorous approach, he now tackled secular culture, a quest he would continue in his formal studies at New York University and later at Yale, where he learned to be a printmaker. Throughout his career, in the variety of themes which he has explored, Baskin has continued to demonstrate an acute sensitivity to the human condition. His work on the* five megillot *is more than an illustration, it is a modern* midrash, *expressing Baskin's own insightful commentary on the text.*

BEN SHAHN (1889–1969). *The Deca-logue*. 1961. Gouache and gold leaf on paper. 41 x 26 1/2 in. (104.1 x 67.3 cm). The Jewish Museum, New York. Gift of Mr. and Mrs. Albert A. List and Family. © 1995 Estate of Ben Shahn. Licensed by VAGA, New York, N.Y. *Ben Shahn was born in Kovno, Lithuania; his family came to the United States when he was eight. As a teenager, he became apprenticed to a lithographer and studied at night at the Educational Alliance. Later he studied at the National Academy of Design. During the 1920s Shahn made two trips to Europe and North Africa. Returning to the United States in 1929, he began working in photography with Walker Evans, with whom he shared a studio. Beginning in 1932, when he exhibited a series of works on the Dreyfus Affair and then a series of paintings on the Sacco-Vanzetti trial, Shahn became known as a social realist. Late in his career Shahn often turned to religious motifs, frequently integrating his own imaginative depiction of Hebrew letters. The familiar shape of the Ten Commandments is formed here by a delicate flowering vine motif with more plant-like tendrils framing the letters. On the left, all of the initial letters are the* lamed, *which begins "Thou shalt not." Shahn has ingeniously varied the letters, heightening the quiet power of the image by delicately enlarging each subsequent one.*

(OPPOSITE)

MOSHE ZABARI (b. 1935). *Yahrzeit Lamp*. New York. 1972. Silver, hammered, welded; glass. 8 x 6 in. (20.3 x 15.2 cm). Hebrew Union College, Skirball Museum, Los Angeles. Gift of Nina and Moshe Zabari in memory Amikam Dvir and Yigal Japko who fell in the Yom Kippur War, October 1973. *One of the important resources for Moshe Zabari's work has been the archaeology of Eretz Yisrael. One such image that fascinated Zabari was the "Praying Hands" stele uncovered at the excavations at Hazor. Though the stele is part of the Canaanite culture, Zabari saw the universality in this act of prayer and transformed its presumed pagan meaning into a Judaic image. Yet the lamp conveys not only a gesture of prayer but also of grief.*

BERNARD BERNSTEIN (b. 1928). *Torah Crown*. New York. 1969. Silver, parcel gilt. 9 x 9 x 2 1/2 in. (22.9 x 22.9 x 6.4 cm). Hebrew Union College, Skirball Museum, Los Angeles. Museum purchase with funds provided by the estate of Tutty Lowens and the estate of Fay Rossin Lewbin and Hyman Lewbin. *Artist and professor, what distinguishes Bernard Bernstein's approach to the crafting of Jewish ceremonial art is his unique background in synthesizing the academic and creative. Born and raised in New York City, Bernstein began his formal training as a silversmith in the 1950s at the Rochester Institute of Technology. When he received a doctoral degree at New York University in 1970, it was the first time that an advanced degree was granted for research and artistic production in the field of Jewish liturgical art. Bernstein selected an appropriate verse from the prophets to augment the serene elegance of this Torah crown, "For the work of righteousness shall be peace. . ." (Isaiah 32:17).*

KURT MATZDORF (b. 1922). *Torah Ornaments*. New York. 1963. Silver, enamel. Shield: 12 x 8 in. (30.5 x 20.3 cm). Finials: height, 16 in. (40.6 cm); diameter, 4 in. (10.2 cm). *Born in the town of Stadtoldenforf, Matzdorf left Germany in 1939 as a teenager for England. After finishing high school he took a defense job and studied part-time with the sculptor Benno Elkan, the English-Jewish sculptor who made the Knesset menorah in Jerusalem. After the war, Matzdorf took a degree in sculpture at the Slade School at the University of London. After coming to the United States in the 1950s he did graduate work at the University of Iowa, where he changed directions in his career and became a silversmith. These Torah ornaments were made as a commission for Temple Beth Emeth in Albany, New York. Matzdorf's interpretation of the Torah ornaments derives from the biblical description of the Tabernacle and the vestments of the High Priest Aaron. The finials are pomegranate-shaped and hung with bells, as was the hem of Aaron's robe. The colors of the shield are those closest to the precious stones representing the Twelve Tribes on the breastplate worn by Aaron.*

(OPPOSITE)

LAURIE GROSS (DESIGNER-WEAVER) (b. 1952). PHILIP SMITH (CABINETMAKER) (b. 1954). *Torah Ark*. California. 1986. Linen; wood; monofilament, brass hardware. Cabinet: 84 x 48 x 22 in. (213.4 x 121.9 x 55.9 cm). Woven panels: each 92 x 22 1/2 in. (233.7 x 57.2 cm). Commissioned by the University of Southern California Hillel Jewish Center, Los Angeles. Underwritten by Barbra Streisand. *This ark is part of a series of works by Laurie Gross which utilize the form and meaning of the shelter-ing wings of the cherubim that were above the Ark of the Covenant of the Tabernacle. There are thirteen wings on each panel, symbolizing the thirteen attributes of God. When the doors of the ark are closed, there are twelve inverted wings visible on each door, representing the Twelve Tribes of Israel. The artist interprets these, not as wings, however, but as hands reaching upward to God in prayer. When the doors are open, revealing the Torah, the hands disappear as they meld with the heavenly wings of the panel.*

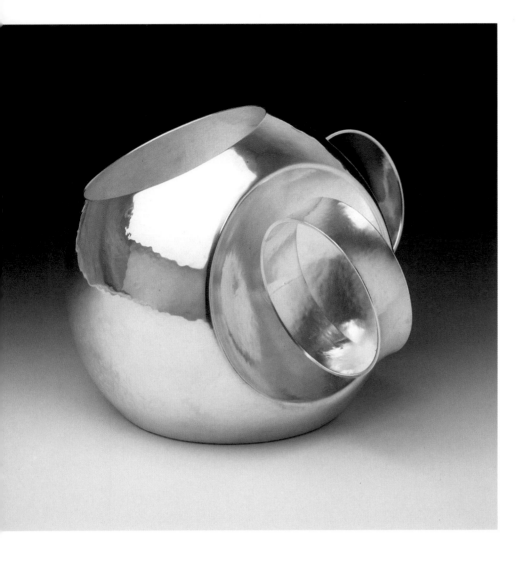

ZELIG SEGAL (b. 1933). *Laver.* Jerusalem. c. 1980. Silver. 7 1/8 x 6 5/8 x 5 1/2 in. (18.1 x 16.8 x 14 cm). Hebrew Union College, Skirball Museum. Los Angeles. Museum purchase with funds provided by the Audrey and Arthur N. Greenberg Acquisition Fund. *Zelig Segal is known for both his sculptural work and his ceremonial objects. The absolute simplicity and elegance of design found in his ritual objects transform the traditional and functional into works of art.*

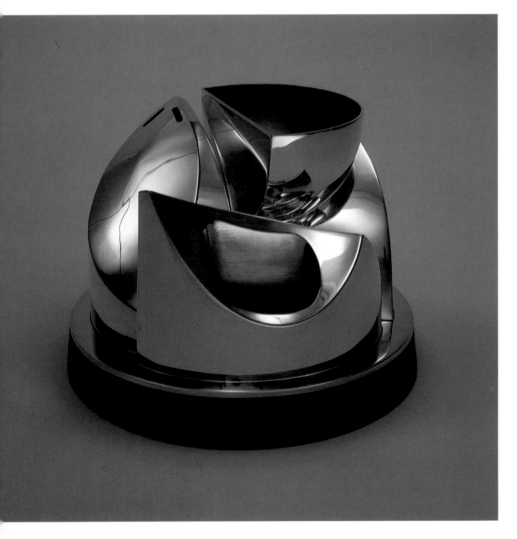

YAAKOV GREENVURCEL (b. 1952). *Havdalah Set.* Jerusalem. 1980. Silver, wooden tray. Height, 4 in. (10.2 cm); diameter, 5 1/2 in. (14 cm). Courtesy of the artist. Collections of the Jewish Historical Museum, Amsterdam, and Spertus Museum of Judaica, Chicago. *In making the havdalah set, which consists of a candlestick, spice box, cup, and tray, Greenvurcel's intention was to create a sculptural entity with each piece maintaining its independence as a separate sculpture and yet in keeping with halakha, Jewish Law.*

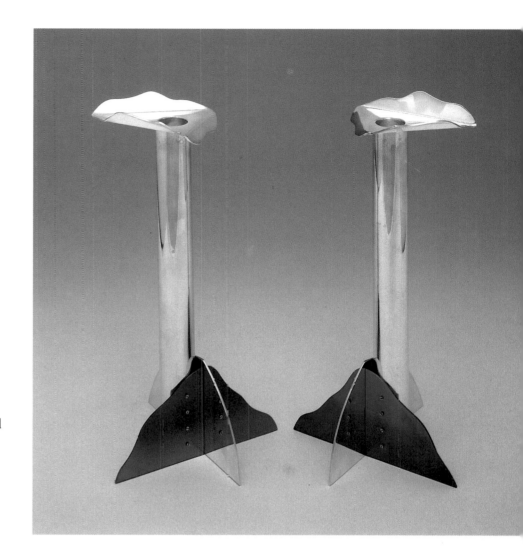

ARIE OFIR (b. 1939). *Candlesticks*. Jerusalem.
Designed 1986. Fabricated 1990. Silver; titanium,
iodized. Hebrew Union College, Skirball Museum,
Los Angeles. Museum purchase with funds provided
by Howard Friedman, in memory of his mother
Emma F. Friedman. *Ofir's work is characterized by
extraordinary expressiveness. His work in recent
years, combining silver with titanium, has under-
scored this play of contrasts in materials as well
as in form.*

PETER SHIRE (b. 1947). *Hanukkah Lamp*. Los
Angeles. 1986. Anodized, painted and chrome steel.
Hebrew Union College, Skirball Museum, Los
Angeles. Museum purchase with funds provided by
Marvin and Judy Zeidler. *Los Angeles artist Peter
Shire is best known for his creative and whimsical
ceramic compositions, furniture, and sculpture. He
received a commission to make a series of large-
scale Hanukkah lamps and began to look at
traditional examples. Since the lamps clearly reflect
the styles and symbols of their time, Shire felt that
he, too, could make Hanukkah lamps that would
express both the contemporary Jewish and the
LA experience. Subsequently, he has continued
making some Judaica, including a three-dimensional
mezuzah.*

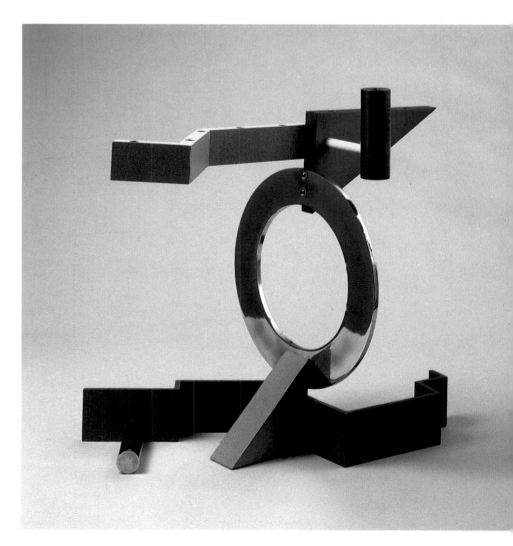

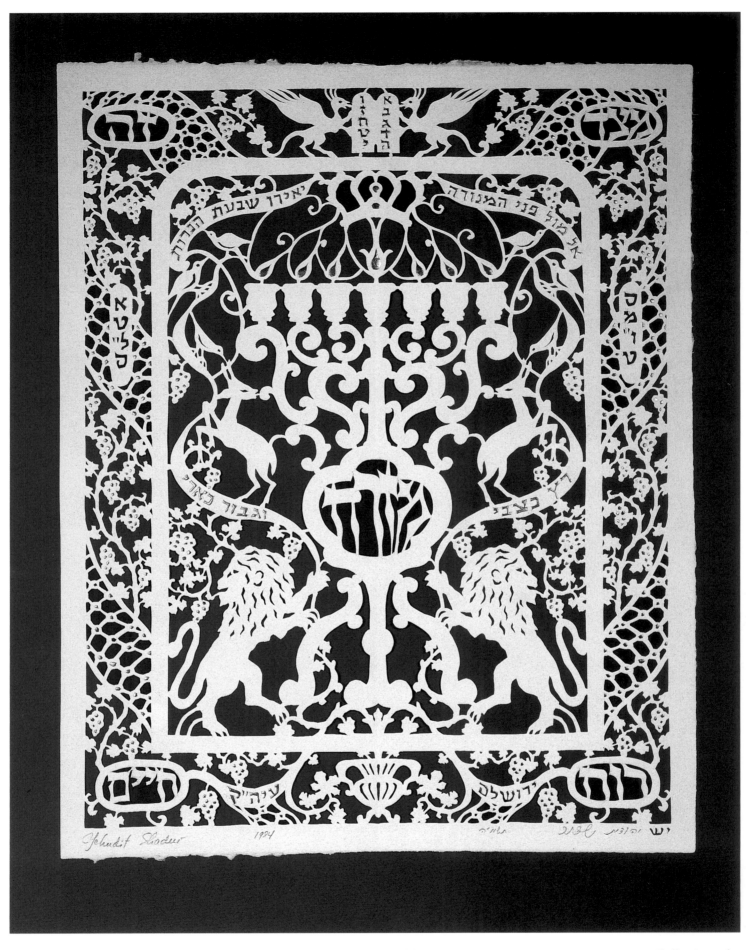

YEHUDIT SHADUR (b. 1928). *Mizraḥ. Jerusalem. 1984. Papercut, gold paint. 17 x 13 3/4 in. (43.2 x 34.9 cm). Collection of the artist. Yehudit Shadur has played a major role in the revival of the Jewish folk art tradition of papercutting, and her work draws on her extensive knowledge of traditional imagery and techniques. The central element, a crowned menorah, is surmounted by the Tablets of the Law, which bears the word* mizraḥ *in its stem. Along the top is a biblical quote from Numbers 8:2, . . . let seven lamps give light at the front of the candlestick. The menorah is flanked by lions and gazelles. In Hebrew, the word* mizraḥ *forms an acronym of the phrase "From this side is the spirit of life," and these four words are found in roundels at each corner. Shadur uses intertwining grapevines to unify the design.*

DAVID MOSS (b. 1946). *The Order of the Seder Ritual. A Mnemonic "Map" from a Song of David. Facsimile edition of the Moss Haggadah.* Rochester, New York. 1987. Ink, gouache, and gold leaf on vellum. Original haggadah, collection of Beatrice and Richard D. Levy, Boca Raton, Florida. Permission of Bet Alpha Editions. © 1995. Rochester, New York, pp. 6b-7a. *In 1980 David Moss received a commission from Richard and Beatrice Levy to create a handwritten illuminated haggadah on parchment for their personal Judaica collection. Moss spent three years intensively studying the textual and artistic traditions of the haggadah, searching for a way to bring fresh insights which have special meaning for contemporary times, then created a truly unique work with Hebrew calligraphy, micrography, papercuts, and inventive drawings.*

JAY GREENSPAN (b. 1947). *Ketubbah.* New York. 1992. Black ink, gold ink, watercolor and gouache on paper. Private collection. *Jay Greenspan began doing Hebrew calligraphy in the early 1970s. He designs and illuminates a wide variety of Judaic documents and prints and has produced over 2,000 ketubbot. He approaches each ketubbah as a creative joint venture with the couple, an act he sees as a new beginning and as a hiddur mitzvah, of enhancing the commandment. The text of this ketubbah is egalitarian in the traditional style. The imagery reflects how highly personalized each ketubbah becomes. All the basic elements are suggested by the couple and then interpreted by Greenspan, who melds the diverse elements into a harmonious whole, along the way making suggestions based on his extensive knowledge of Jewish textual and visual sources.*

Jeanette Kuvin Oren (b. 1961). *Huppah*. 1995. Painted silks, appliquéd and quilted with beads. 84 x 84 in. (213.4 x 213.4 cm). Collection of the artist. *Jeanette Kuvin Oren began making Judaica by exploring the traditional Jewish art forms of calligraphy and papercutting. The intricate appliqué work on this huppah reflects the artist's fascination with papercuts; a Hebrew text is integrated into the design as a border.*

Katya Apekina (b. 1953). *Mezuzah.*
Boston, Massachusetts. 1993. Ceramic,
glazed, hand-painted. Hebrew
Union College, Skirball Museum, Los
Angeles. Gift of Robert J. Avrech.
*Katya Apekina emigrated from the
Soviet Union to the United States.
A ceramicist by training, she had
never made ceremonial objects in her
native country. Only when she arrived
in the United States did she feel
comfortable doing so. Her mezuzah is
a charming folk art portrayal of a
Jewish family from the world of
the shtetl.*

TONY BERLANT (b. 1941) *Tzedakah Box.*
Los Angeles. 1994. Found tin collage over
plywood with steel brads. 8 1/4 x 8 1/4 x
6 3/4 in. (21 x 21 x 17.2 cm). Hebrew
Union College, Skirball Museum, Los
Angeles. Museum purchase with funds pro-
vided by the Musuem Membership, Purim,
1994. *In creating this extraordinary
tzedakah box, Berlant was interested in
conveying what he perceived to be the Jew-
ish concepts of charity. The secretness of
the box relates to the higher value of help-
ing the poor through anonymous giving.
The imagery has the sense of the bounti-
ful harvest which should be shared and
which alludes to the fact that besides spiri-
tual sustenance, one needs the tangible. The
box in inscribed with the Hebrew word
tzedakah.*

LORELEI AND ALEX GRUSS. *Etrog Container.*
New York. 1989. Ebony, purpleheart,
silver, shell. 6 x 8 in. (15.2 x 20.3 cm).
Courtesy of the artists. *Lorelei and Alex
Gruss, husband and wife, have been
working together in the United States since
1987 to create Jewish ceremonial art. Lorelei
was born in New York in 1961 and raised
in Jerusalem. Alex was born in Argentina in
1957. The Grusses work in a rainbow of
rain forest woods such as ebony, rosewood,
and purpleheart, carefully chosen for their
texture and color. The inlays are original
compositions made of rare and sometimes
vanishing materials such as ivory, abalone,
black oyster shell, mother-of-pearl, precious
stones, and metals. Each scene is an original
composition. The artists are concerned both
with* halakha, *the proper observance of
Jewish law, and with the functionality of
their works. A seven-sided etrog container is
decorated with images of the seven* ushpizin,
*the ancestral guests, who symbolically come
to visit on the holiday of Sukkot. Each is
identified by name in Hebrew beneath their
images.*

Jewish Expression in Twentieth-Century Fine Arts

Were I not a Jew (with the content that I put in the word), I would not be an artist at all, or I would be someone else altogether. (MARC CHAGALL)

THE QUESTION of what is Jewish art and who is a Jewish artist is nowhere more problematic than in the fine arts. Despite the persistent doubts and objections, Jewish artists joined in virtually all the art movements of the twentieth century. Though many artists do not make an association between their art and their Jewish birth, there have been numerous artists who acknowledge their Jewishness and the role being Jewish plays in their work. There are many whose work has mirrored the momentous events of Jewish experience in modern history. Certainly, while some artists portray Jewish subject matter or explore Jewish themes, not all do, and though many are not even representational, the work conveys both the personal expression of the artist and links to issues of Jewish life and Jewish identity. In the final analysis, perhaps the most justifiable criterion for considering a work to be Jewish art is the issue of identity, perceived or real. In certain instances, it is clear that the artist grappled with the issue of Jewish identity in creating the work of art; in others, the questions persist.

Moritz Oppenheim has been called the first Jewish painter, and his work has been characterized as a watershed in Jewish cultural expression. While his nostalgic images seem to typify a sentimental yearning for an earlier age, Oppenheim's paintings represent the effort to preserve Jewish identity, reflecting his conscious encounter with the challenges of emancipation and assimilation in Germany. When he portrayed the great eighteenth-century Jewish philosopher, Moses Mendelssohn, with Johann Caspar Lavater, a zealous Swiss Lutheran clergyman, Oppenheim was alluding to an encounter that represented a decisive juncture in Mendelssohn's life as he searched for an intellectual path for Judaism in the modern world. Mendelssohn knew that Lavater's dare to disprove the Christian faith or renounce his Judaism was actually yet another episode in a long line of polemics against Jews. Mendelssohn finally took up the challenge by writing the book *Jerusalem* to demonstrate his belief that indeed Jews could be full participants in the modern world. Oppenheim's paintings were immensely popular and, ironically, reproduced again and thus again and removed from the context of the struggle to which Oppenheim gave witness. It is the romanticism that remains, and Oppenheim's pioneering efforts as a champion of Jewish identity are little remembered.

The spirit of emancipation which fostered Oppenheim's work in the nineteenth century reached a turning point as the century drew to a close. The ideals of the Enlightenment which had emphasized tolera-

(OPPOSITE)

LARRY RIVERS (b. 1923). *Europe I.* 1956. Oil on canvas. 72 x 48 in. (182.9 x 121.9 cm). The Minneapolis Institute of Arts. Anonymous gift. © 1995 Larry Rivers. Licensed by VAGA, New York, N.Y. *Born in New York, Larry Rivers came to artistic maturity in the era of Abstract Expressionism and was a part of the New York School. Yet Rivers challenged the non-representational mainstream, moving beyond the painterly focus, and made a personal foray into the realm of history and everyday life. Often autobiographical in his canvases, Rivers incorporates portraits from an old family photograph in* Europe I.

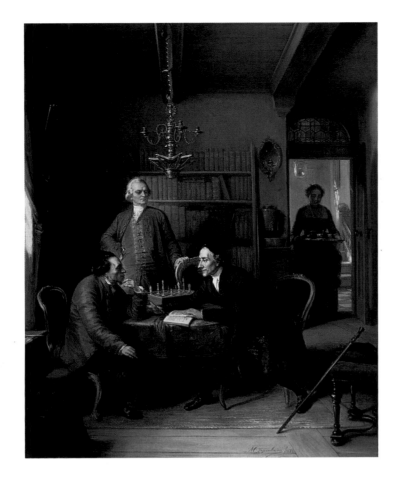

MORITZ DANIEL OPPENHEIM (1800–1882). *Lavater and Lessing Visiting Moses Mendelssohn.* 1856. Oil on canvas. 33 x 28 in. (83.8 x 71.1 cm). The Judah L. Magnes Museum, Berkeley, California. Gift of Vernon Stroud, Eva Linker, Gerta Nathan, and Ilse Feiger, in memory of Frederick and Edith Straus. *In this historical genre painting, Oppenheim chronicled a critical encounter in the quest for Jewish emancipation. The game of chess is used as the metaphor for the intellectual sparring between Moses Mendelssohn (1729–1786) and Johann Caspar Lavater (1741–1801), a Swiss clergyman who had challenged the German-Jewish philosopher to either disprove the truth of the Christian faith or renounce his Judaism. Gotthold Lessing (1729–1781), the onlooker, encouraged his friend Mendelssohn to publish his response to Lavater.*

tion and individual freedom seemed to be crumbling. While removal of some of the legal restrictions on Jews had stimulated the hopes that Jews could fully enter European society, progress was impeded with the renewal of anti-Jewish sentiment.

Jewish life in Europe was undergoing radical change. In 1881, when seventy-five percent of the world Jewish population lived in eastern Europe, a series of pogroms broke out that would eventually strike at over two hundred Jewish communities. The hostility of the mobs was unchecked by the government. Disillusioned with the status quo, eastern European Jews took drastic measures. Over two and a half million would leave for the United States to seek economic stability and political freedom. Others joined the socialist movement to try to help build a just society for all in eastern Europe. A number joined the small but determined group of pioneers who were resolute in their aim of building a modern national state in the Jewish homeland in Eretz Yisrael.

The work *After the Pogrom* by Maurycy Minkowski captures the trauma felt by eastern European Jews. The painting powerfully characterizes the fear and hopelessness of the refugees. Due to his own physical disability, Minkowski was able to neither hear or speak, the painting has a sense of isolation which is perhaps heightened by the artist's own acute perception of complete and profound separation and detachment. Another politically charged painting dealing with profound loss is Samuel Hirszenberg's *The Black Banner (Czarny Sztandar).* While the scene specifically portrays the funeral of a revered rabbinic leader, the mourning is truly for the entire community, whose way of life was rapidly changing. Quite a different attitude is portrayed in *Birth of Jewish Resistance* by Lazar Krestin. Painted after the infamous Kishinev pogrom in 1903, Krestin's work depicts a new, young breed of Jewish nationalists who do not languish in grief over the horrors they have experienced but are determined to fight back and find new direction and meaning in their lives.

In central Europe the shock waves of the trial of Captain Alfred Dreyfus provided a rude awakening for assimilated Jews. Dreyfus was accused of treason in 1894, falsely convicted and not exonerated until

274

1906. It was the Dreyfus trial, which Theodor Herzl covered as a journalist for the Vienna *Neue Freie Presse*, that eroded Herzl's confidence in liberalism and led him to political Zionism. Yet no one could ever have predicted what would come in just another generation. Max Beckmann's *The Synagogue* of 1919, which refers to the *Hauptsynagogue* (Main Synagogue) of Frankfurt-am-Main, is an almost prophetic work, portraying what once was the proud symbol of the "emancipated" Jew in a garish, topsy-turvy predawn environment. The solidity and strength represented by the synagogue when it was dedicated in the mid-nineteenth century was quickly eroding. Max Liebermann, known as the father of German Expressionism, is but one representative of a generation of intellectual, acculturated Jews who personally would experience the drastic change. Before his death in 1935, the elderly Liebermann, who became president of the Berlin Academy of Fine Arts, was to see all his canvases removed from German museums by the Nazis. His 1926 *Portrait of the Artist's Wife and Granddaughter* is a tender portrayal of normalcy in German-Jewish family life that would soon be no more.

The patterns of migration and change in the late nineteenth and early twentieth centuries are paralleled in the world of art. Almost simultaneously, there was major activity among Jewish artists in Russia, Paris, the United States, and Eretz Yisrael. There were even serious attempts made to create a Jewish art. Boris Schatz had come to Jerusalem to establish the Bezalel School, where painting and sculpture were taught along with training in crafts. Artists in Eretz Yisrael in the 1920s, many from eastern Europe, portrayed their allegiance to the Zionist ideal through works characterized by a buoyant optimism. They sought to create a "Hebrew" rather than a "Jewish" art and depicted the everyday world around them. Works like Nahum Gutman's *The Small Town*, which depicts the young Tel Aviv, is suffused with light and lyricism, with an almost childlike naiveté in drawing technique. But this soon changed, impacted by the artists who traveled to Paris and the United States. Yosef Zaritsky's *Safed*, one in a series of watercolor landscapes in which he tries to balance form and subject, reflects the influence of Cézanne.

In Russia, from about 1915 to the mid-1920s, there was a Jewish cultural renaissance. Swept up in the nationalist impulses of the time, Jewish artists, as well as Jewish writers and musicians, optimistically believed that they could forge a Jewish cultural rebirth and sought a distinctive Jewish aesthetic. The leading figures in creating a new, modern Jewish art were El Lissitzky, Nathan Altman, Issachar Ryback, Joseph Tchaikov, and Boris Aronson. Marc Chagall, who returned to his native Vitebsk from Paris during World War I, also reveals many of the same impulses in his work of this period.

The movement was invigorated in part by the work of S. An-Sky (Shlomo Zainwil Rapoport) and his 1912–1914 expedition to Volhynia, Podolia, and the Kiev area. An-Sky's quest was to study Jewish life in the Pale of the Settlement, the area to which Jewish communities were restricted beginning in 1772 at the first partition of Poland, when more than half a million Jews came under Russian rule. By 1897 there were five million Jews in the Pale. An-Sky wanted to rescue and preserve some remnant of the Jewish spiritual and cultural heritage before it was lost due to the profound changes taking place not only in political realities but in transformation of traditional society in the face of modernization. His goal was to bring about a cultural renewal rooted in Jewish tradition but constantly facing and growing toward the future. Ironically, An-Sky's perspective was already outmoded by the time he undertook his study. He was searching for what he perceived as the "authentic" Jewish experience in the world of the shtetl, but in the years preceding World War I, much of the folk heritage he sought was already disappearing. Nonetheless, An-Sky's discoveries and later exploratory trips by El Lissitzky and Issachar Ryback to record motifs in wooden synagogues provided substantial imagery for the works of the Jewish avant-garde group.

It was in the fields of book illustration and theater design that these artists were most active, and the style they favored reveals Cubist and Futurist influences known to them from Paris. *The Dybbuk*, written

by An-Sky and based on legends gathered as part of his folklore research, is perhaps the best-known play of the Jewish theater in Russia and established the reputation of Habimah, the first Hebrew theater company, which later moved to Tel Aviv. In a painting by Leonid Pasternak, An-Sky is portrayed reading from his play.

El Lissitzky was in the vanguard of the group. Among his best-known works are illustrations for Yiddish books, including children's books, the genre to which his 1919 *Had Gadya* for the Passover haggadah is related. As the hopes for the creation of a national Jewish culture faded and the publication of Jewish books was restricted by the government, El Lissitzky turned away from Jewish subjects and toward the Constructivist compositions devoid of content for which he became well known. At this juncture in 1922, he illustrated Ilya Ehrenburg's *Six Stories with Easy Endings* and made one last work entitled *Shifs Karta* (boat ticket) in which he incorporated Jewish imagery. A cryptic design, there is a dichotomy of meaning, for the ticket to America normally meant freedom, and yet El Lissitzky prominently stamps the image with the Hebrew letters found on gravestones to mean "here is buried."

For many artists, fleeing the ghetto meant artistic liberation. This was certainly true for many Jewish artists who went to Paris, where they were introduced to the world of modern art. A revolutionary new vision had been forged by the Impressionists in the late nineteenth century in France, and Paris soon became a veritable mecca for artists of many diverse backgrounds. The city was the major center of the avant-garde for the visual arts as well as for music and literature. Within a few short years a rapid succession of modernist movements—Fauvism, Cubism, Dadaism, Surrealism—would radically alter the world of art.

Many, but not all, of the Jewish artists who went to Paris fit the stereotype of the youths fleeing the poverty of the eastern European shtetl and the Orthodox faith of their parents. Others, like Amedeo Modigliani, Jules Pascin, and Louis Marcousis, came from financially stable homes, modern European and American cities, and assimilated Jewish families. From the first decade of the twentieth century until the German invasion of Paris, there were scores of Jewish artists who flocked to Paris, and the art community also included Jewish critics, dealers and collectors.

While there is no discernible Jewish style that emerged in the "School of Paris," many of the Jewish

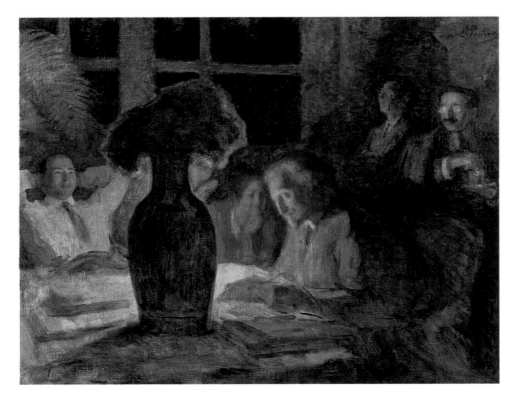

Leonid Pasternak (1862–1945). *An-Sky Reading from The Dybbuk.* Oil on canvas. 27 3/4 x 36 3/8 in. (70.5 x 92.4 cm). The Israel Museum, Jerusalem. *Born and raised in Odessa and trained in Moscow and Munich, Pasternak led quite a cosmopolitan life. He traveled through Europe, lived in Berlin for a number of years, and from 1935 to 1945 he lived in Oxford, England. Pasternak is best known as a portraitist, and his sitters included Tolstoy, Rachmaninov, Einstein, and Lenin. His portraits range from very formal oils to more intimate charcoals and pastels with the sitter involved in different activities.*

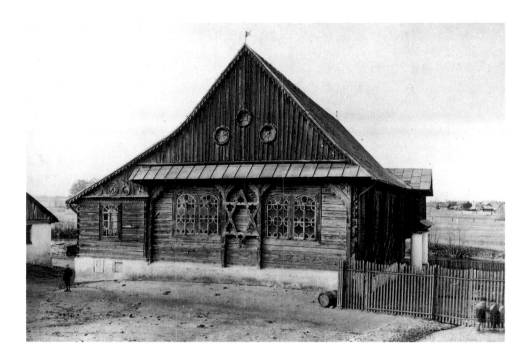

artists were part of the community in Montparnasse and frequented the café La Rotonde and the Café du Dôme. Some also shared studio space in La Ruche ("the beehive"), an artists' residence established in 1902 to serve as a place for creative individuals to live and work together. There were to be many changes that occurred over time, the pre-World War I optimism, challenges in the postwar decade of renewed anti-Semitism, the mounting fears of the 1930s as Hitler rose to power in Germany. Yet, it was a remarkable era and within the unique and vibrant Parisian environment, the Jewish artists were indeed confrères who were aware of and recognized for their Jewishness even if they sought to overcome it, and even as they pursued their singular ideals, their individual sensitivities and talents, and aligned themselves with a number of different movements.

Jules Pascin is characteristic of this phenomenon. When he arrived in Paris in 1905, Pascin had already studied in Vienna, Berlin, and Munich, where he was known for his drawings published in the satirical weekly *Simplicissmus.* Son of a wealthy Sephardi family from Bulgaria, he had a cosmopolitan bearing and his dynamic personality made him an early leader. Pascin served as a galvanizing force for many of the other Jewish artists in Paris who arrived in that first decade. He was forced to leave France during World War I, emigrating to the United States before returning to France in 1920. Unfortunately, excesses of his own paralleled those of the unsavory life he portrayed in his works, such as *Girl with Boots*; despondent despite his success, he committed suicide in 1930.

Among the artists, only Marc Chagall, who came to Paris in 1910, painted Jewish themes in a unique fusion of the Jewish folkways of his youth and modern art. As he absorbed the heady Parisian world, he also drew on the experiences of his youth in Vitebsk. A tension and biting wit are expressed in *Self-Portrait with Seven Fingers.* Chagall, who portrays himself smartly dressed, clearly enjoys his status as an artist. He is in Paris, for the Eiffel Tower is visible through the window. The work on the easel, however, is a very complex composition replete with Yiddishisms conveyed through visual metaphors. The work in progress is *To Russia, Asses and Others,* which he completed in 1912 and originally titled *La Tante au Ciel* ("the aunt in the sky"). The reference to seven fingers means to do something wholeheartedly; he was consumed with the intensity of being a painter.

Lithuanian-born Chaim Soutine was also a very influential figure among Jewish artists in Paris. None of his paintings have Jewish subject matter nor, in contrast with Chagall, is there any reference to his youth or family history. Yet because of the intensity of his personal style he has, perhaps more than any other of

the Jewish artists in Paris, been characterized as representing the anxiety and tortured spirit of the persecuted, of the victim, and therefore the Jew.

Amedeo Modigliani was from a respected Italian-Jewish family and despite his family's subsequent financial reverses, he was well educated in both secular and Jewish subjects and received classical art training in Venice and Florence before going to Paris in 1906. While there are only sporadic references in his work in terms of Jewish content, occasional use of Jewish symbols and Hebrew letters in his drawings, it is noteworthy that the first work which Modigliani ever exhibited at the Salon des Indépendants was *La Juive (The Jewess)* in 1908. The artists often painted one another; Modigliani painted a portrait of the sculptor Jacques Lipchitz and his wife. The painting is characteristically Modigliani, a sensitive portrayal, the figures identifiable but elongated and linear.

Chana Orloff, born in the Ukraine, immigrated with her family to Eretz Yisrael in 1905, then traveled on her own to Paris in 1910. By the 1920s Orloff's reputation was well-established, especially for her portraits.

Born in Lithuania, Chaim Jacob Lipchitz was the son of a successful building contractor. Soon after arriving in Paris in 1909, he promptly changed his name to Jacques. Lipchitz met Picasso in 1913 and soon began to make Cubist sculptures. In the 1930s Lipchitz's art was to change radically, as he moved from the geometry of Cubism to a more organic, baroque manner of expression. During this period, his subject matter expanded to include mythological scenes, biblical stories and personalities, and socially relevant themes. Lipchitz was forced to flee Paris and settled in New York in 1941.

Among those who went to Paris were also Americans. Max Weber, who was born in Bialystok, moved with his family to New York when he was ten. In 1905, he went to Paris, returning to New York in 1909. While his work clearly had been influenced by Cubism, he maintained a strong sense of the representational, as in his spiritually powerful *Invocation*.

In the first decades of the twentieth century, a surprisingly large number of American-Jewish artists had either been brought as children to the United States or were born of eastern European immigrant parents. Many of the artists studied at the Educational Alliance School on New York's Lower East Side, founded by the already established German Jews as a means to promote the acculturation of the new immigrants. While the diversity of artists led to a diversity of themes and styles, the work of a significant number of Jewish artists was a vehicle for social comment, especially during the years of the Depression. In documenting the world around them, the works can also be very personally revealing. Raphael Soyer, known for his portrayal of urban realism, reveals in *Dancing Lesson* the generation gap between the immigrant parents and their children. William Gropper's *The Tailor*, a biting work of social commentary, emerged from Gropper's own experience as a youth working in a garment industry sweatshop. The *Roosevelt Mural* was painted by Ben Shahn in 1937 for a community in Roosevelt, New Jersey, founded by the predominantly Jewish members of the International Ladies' Garment Workers Union. The mural encapsulates the immigrant experience from the most humble to Albert Einstein, prominently pictured at the front of the masses teeming in. The pens of Ellis Island are echoed in the warrens of the sweatshop and even in the coffins of Sacco and Vanzetti. The mural was done for a housing development sponsored by the Farm Security Administration. Jack Levine, whose work is typically satirical in its social commentary, makes a very private statement in *Planning Solomon's Temple*. In this homage to his late father, Levine interestingly reverted to a biblical theme, likening his father to the great King Solomon.

The idyllic childhood of Chaim Gross was brutally ended with the savage beating of his parents by Russian troops. In 1921, at the age of seventeen, Gross immigrated to America. From his father, a forester in his native Carpathian mountains, Gross inherited a love of wood which would become integral to his works as a sculptor.

The gash through the very fabric of human civilization caused by World War II and the destruction of European Jewry had a profound impact on the world of art. There are numerous works which relate to the Holocaust. Marc Chagall's *White Crucifixion*, begun in 1938, is a powerfully foreboding message of the devastation to come. All is in turmoil. The village is being destroyed, the synagogue is in flames, refugees flee, sacred books are burned. Chagall's Christ is a Jew, wearing a tallit as his loincloth.

Some European artists like Chagall were able to flee and find safe haven in the United States. Jacob Epstein's bust of Albert Einstein was sculpted in 1933, when Einstein had resigned his position at the Royal Prussian Academy of Sciences and settled in the United States. Some, like Jakob Steinhardt and Mordecai Ardon were able to go to Eretz Yisrael. Many perished. A few, like Felix Nussbaum and Charlotte Salomon, were able to inform us of their experiences through artworks left behind and preserved, even as they went to their deaths. In the aftermath of the war, many artists would memorialize the victims. Jacques Lipchitz began his powerful *Mother and Child* in 1939 and completed it just after the war. The plaintive, primeval cry of the disabled mother, her child clinging to her back, resonates as a universal gesture of anguish, yet honors the resilience of the human spirit.

In the half century since the end of the war, many artists have struggled to find ways both to remember the victims and grapple with and give expression to the unfathomable reality of the Holocaust. Mordecai Ardon's triptych *Missa Dura* chronicles the Nazi rise to power, *Kristallnacht*, the Night of Broken Glass on November 9, 1938, and the ultimate plight of the victims. Moshe Gershuni's *The Little Angels* is a poignant remembrance of the youngest of those to die. Gershuni's work recollects not only the vast numbers of children who perished but evokes the memories of each child by inscribing the name of just a few, as if the canvas is calling after them down the black vortex into which they have disappeared. George Segal's *The Holocaust* was made as a public Holocaust memorial. Using his signature technique of casting living persons directly in plaster, he gave form to images of the corpses known through photographs taken shortly after the Allied liberation of the concentration camp. The lone figure standing by the barbed wire fence is based on a Margaret Bourke-White photograph; the model was a friend of Segal's who was a survivor. In its own way, the *Polish Village Series* by non-Jewish artist Frank Stella pays homage to a bygone world by transforming the images of the destroyed wooden synagogues of eastern Europe into works of art that echo their creativity and vitality.

Jewish life and Jewish art have undergone many changes in the post-World War II era. The State of Israel was born and Israeli art as a distinct entity came into maturity as part of the international art scene

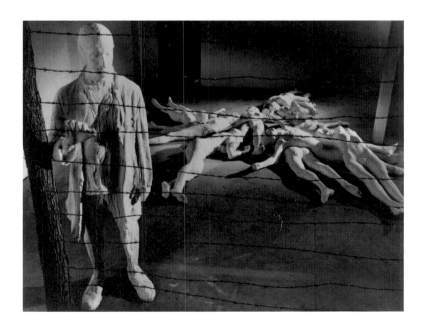

GEORGE SEGAL (b. 1924). *The Holocaust*. 1982. Plaster, wood, wire. 10 x 20 x 20 ft (3 x 6.1 x 6.1 m). The Jewish Museum, New York. Museum purchase with funds provided by the Dorot Foundation. © 1995 George Segal. Licensed by VAGA, New York, N.Y. *George Segal echoes in his works the social realism of the generation that preceded him. His signature technique of figures in white plaster focuses on ordinary people and everyday life. In his memorial* The Holocaust, *Segal has given form to images that have become seared in our collective post-World War II memory from photographs of the liberation of concentration camps.*

with artists with varying styles, aesthetic approaches and political ideologies about the role of art in society. Themes vary from such penetrating works such as Reuven Rubin's *First Seder in Jerusalem,* pondering the ingathering of Jews to Israel, to a connection to the ancient past of Eretz Yisrael, as in Itzhak Danziger's abstracted Negev sheep called *The Lord Is My Shepherd.* Other works focus on the land, such as Anna Ticho's sensitive landscape study *Jerusalem.* The range broads, from a metaphorical mythological work like Menashe Kadishman's *Prometheus,* to Gabi Klasmer's intense, probing *Shimshon* or Samuel Bak's *Pardes,* which return to the Bible and biblical interpretation to question aspects of contemporary Israeli life. Moreover, there are, of course, many artists whose work is nonrepresentational. YaacovAgam, for example, has developed a unique expression through kinetic and optical art.

Jewish life and Jewish art also merged in a movement of Jewish artists working underground in the Soviet Union beginning in the 1970s who came together to express their Jewish identity. The artists were young and bold and vulnerable. In the wake of the collapse of the Soviet Union, it is somewhat difficult to comprehend the enormity of the risks they took in order to voice their Jewishness, but it was very real. Evgeny Abesgauz was a leader of the group. His painting *My Old Home,* linked stylistically to Russian folklore tradition, expressed the hope of these artists that they be allowed to leave the Soviet Union and emigrate to Israel.

In the post-World War II era, New York became the art capital of the world and among the ranks of artists were many Jews. To be sure, there were many, including Ben Shahn and Leonard Baskin, whose works continued to have some Jewish content or were expressive of the artist's Jewishness. But the goal for most Jewish artists was to be accepted in the general art world, and few focused solely on Jewish subject matter. Occasionally, an autobiographical work revealed an artist's heritage, such as Larry Rivers's *Europe I,* a painting dealing with his eastern European antecedents.

A number of Jewish artists were important figures of the Abstract Expressionist movement, yet the Jewish intent of their work is subject to interpretation. Can one parallel Rothko's thoughts when he painted his highly personal, signature nonobjective compositions and a work like *Street Scene XX,* painted in the 1930s, which recalls his childhood and the protective embrace of a bearded patriarchal figure? How much can we conjecture about Adolph Gottlieb's paintings from his synagogue commissions, such as the Torah curtain made for a Millburn, New Jersey temple?

There has, however, in the past two decades been a renewed quest by a number of Jewish artists to explore their Jewish identity and to infuse their work with a particularly Jewish consciousness. Of course, this work is extremely personal in approach and style. Some works are highly spiritual like Tobi Kahn's *Shrine Series.* Others probe contemporary Jewish life, among them Adam Rolston's *Matzo Box Series* on ethnicity and popular culture or Robin Schwalb's choice of the biblical theme of the Tower of Babel for her work. Some works reflect the collective history of the Jewish people, as in R.B. Kitaj's *The Jewish School (Drawing a Golem),* which explores Jewish response to persecution; others draw from memory, like Irving Petlin's *Street in Weissewald,* where history is personalized.

When the study of Jewish art began a century ago, the major concern was the preservation of the Jewish cultural heritage. Jewish art was documented, collected, studied, and interpreted, not for its sake alone but rather as the potential source for renewing Jewish cultural life. So it is today. Whether in the realm of ritual, custom and ceremony, or fine arts, those creating Jewish art look to the past in order to look toward the future.

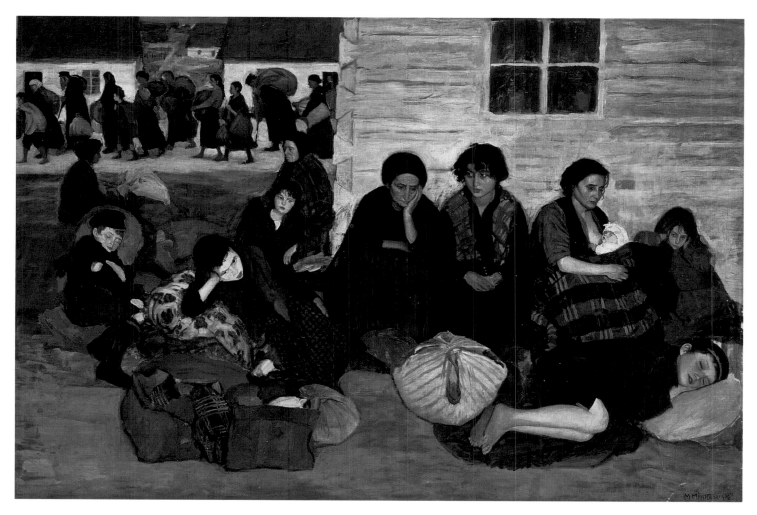

MAURYCY MINKOWSKI (1881–1931). *After the Pogrom.* c. 1910. Oil on canvas laid on board. 39 1/2 x 59 1/2 in. (100.3 x 151.1 cm). The Jewish Museum, New York. Gift of Mr. and Mrs. Lester S. Klein. *Minkowski gained reknown for the dramatic realism of his works, which portray Jewish life in Poland before the Russian Revolution. Here, recording the flight of refugees after the pogrom, he faithfully chronicled the sheer weariness and utter dislocation of a group of women and children who have stopped to rest.*

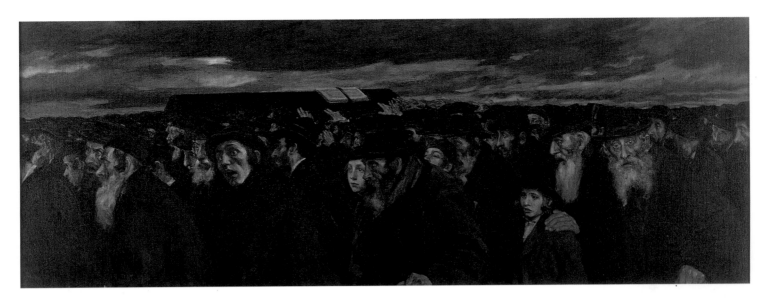

SAMUEL HIRSZENBERG (1865–1908). *The Black Banner (Czarny Sztandar)*. 1905. Oil on canvas. 30 x 81 in. (76.2 x 205.7 cm). The Jewish Museum, New York. Gift of the Estate of Rose Mintz. *Samuel Hirszenberg, a native of Lodz, Poland, studied in Krakow, Munich, and Paris and was well aware of modern art movements at the turn of the century. Yet, in his representational works, he remained the faithful standard bearer of Polish Jewry, revealing their poignant plight in his politically charged paintings. The Black Banner portrays the powerful surge of a sea of Hasidim carrying a coffin, their faces, young and old, reflecting the depth of their mourning. The title of the painting has given rise to several interpretations: The Black Banner has also been called Funeral of the Zadik, representing the trauma of the community's loss of its revered leader. But given the harsh realities of eastern European Jewry, the tragedy reflected here is not only for a single individual but for a whole way of life.*

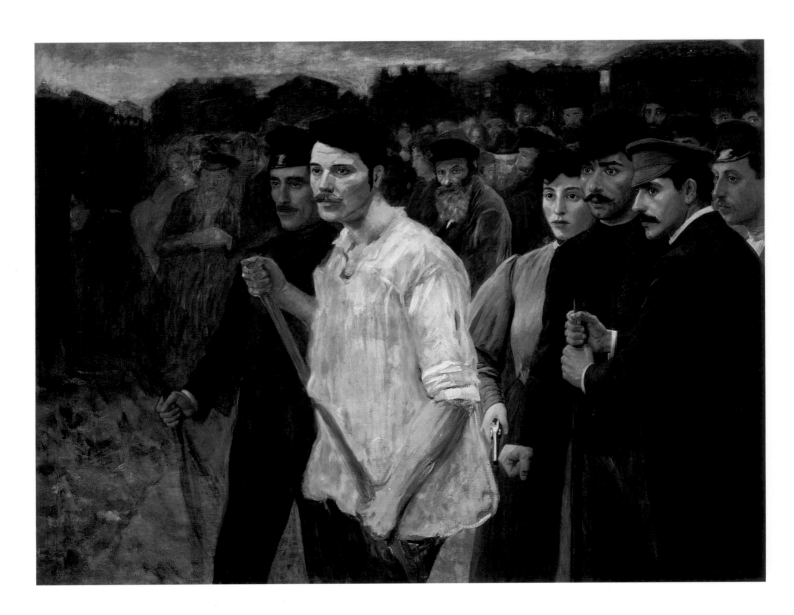

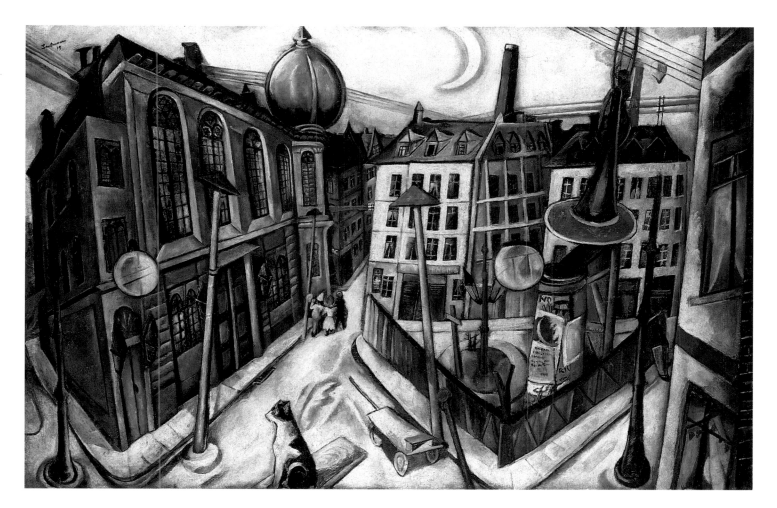

MAX BECKMANN (1884–1959). *The Synagogue.* 1919. Oil on canvas. 35 1/2 x 55 in. (90.2 x 139.7 cm). Städelsches
Kunstinstitut und Städtlische Galerie, Frankfurt. © 1995 Artists Rights Society (ARS) New York/ADAGP, Paris. Acquired in
1972 by gifts from citizens and the city of Frankfurt. *Beckmann was born in Leipzig and trained in Weimar and Paris. He
settled in Berlin and then taught in Frankfurt until 1933, when he moved to the United States. When the new* Hauptsyna-
goge *(Main Synagogue) was dedicated in March of 1860, it was hailed as the symbol of the end of the "Jewish Middle Ages"
and the beginning of a new, brighter, emancipated era. But all that had changed by 1919, in the aftermath of World War I,
and with the continued rise of anti-Semitism Beckmann depicted the synagogue in a cityscape now fragmented and disjoint-
ed. The quest of German Jewry for normalcy had been elusive. In the early dawn, only three revelers and a cat inhabit the
foreboding scene. The synagogue was destroyed by the Nazis on Kristallnacht, November 9, 1938.*

(OPPOSITE)

LAZAR KRESTIN (1868–1938). *Birth of Jewish Resistance.* 1905. Oil on canvas. 55 x 74 1/4 in. (139.7 x 188.6 cm). The
Judah L. Magnes Museum, Berkeley, California. Gift of Alan Sternberg. *Krestin, born in Lithuania, studied in Vienna and
Munich and was known for his impressionistic landscapes as well as for portraiture and genre painting. Birth of Jewish
Resistance was painted after the infamous Kishinev pogrom in 1903. Though Jewish communities had long suffered the
ravages of brutal attacks, the Kishinev pogrom gained worldwide notoriety and provided the catalyst for Jewish resistance
groups to mobilize. With the bearded shtetl Jews in the background, Krestin portrays young men and one young woman
who, though appearing stunned and wary, step forward to defend themselves.*

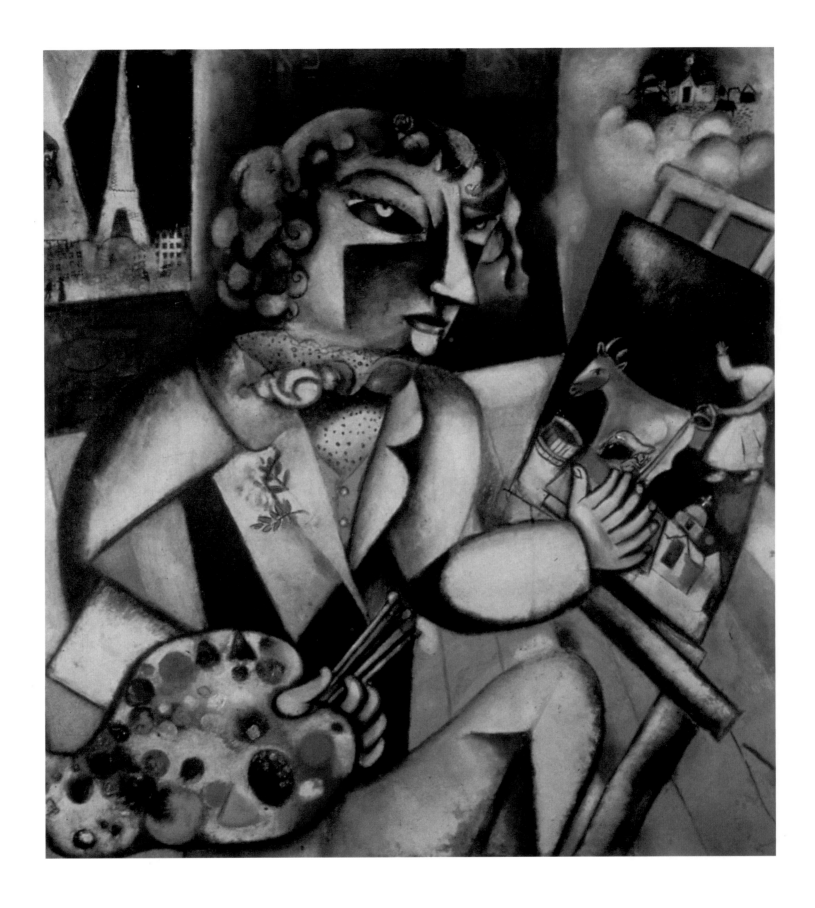

MARC CHAGALL (1887–1985). *Self-Portrait with Seven Fingers* (detail). 1913–14. Oil on canvas. 50 3/8 x 42 1/8 in. (128 x 107 cm). Stedelijk Museum, Amsterdam. © 1995 Artist's Rights Society (ARS), New York/ADAGP, Paris. *Born in the small Russian town of Vitebsk, Marc Chagall went from a childhood steeped in the mysticism of eastern European Hasidic lore to the Paris of 1910. Paris opened whole new worlds of artistic freedom for him as he absorbed everything from the treasures of the Louvre to the new works of the Salon des Indépendants. Stylistically, Chagall's works of this period reflect the influence of Fauvism and Cubism, but the poetic world he created was his own. In Self-Portrait with Seven Fingers, Chagall demonstrated his mixed allegiance. Dressed as a dandy, with flowing curls, the canvas he has painted on the easel is of Vitebsk, as is the image from his memory depicted in the clouds. The church is prominently emphasized. Yet through the window, the view is of Paris and the Eiffel Tower. Chagall made clear what he intended to represent by including labels in Yiddish for Russia and Paris.*

MAX LIEBERMANN (1847–1935). *Portrait of the Artist's Wife and Granddaughter.* Berlin. 1926. Oil on canvas. 44 1/2 x 36 3/4 in.
(113 x 99.3 cm). Hebrew Union College, Skirball Museum, Los Angeles. Gift of the Jewish Cultural Reconstruction, Inc.
*Liebermann trained in Berlin and later traveled to Paris, where he became acquainted with the Barbizon painters and the
Impressionists, an influence which formed the basis of his Germanic version of the Impressionist style. From 1875 on, he
summered in Holland, which provided equally important sources for his work. In 1898 Liebermann became a founding
member and later the president of the Berlin Secession. In 1920 he became president of the Berlin Academy of Fine Arts. With
the Nazi rise to power, his paintings were removed from German museums. Liebermann, known for his incisive portraits,
here reveals a rare tender aspect of his work in the sensitive portrayal of the interaction between his wife and granddaughter.*

NAHUM GUTMAN (1898–1980). *The Small Town*. Collage, ink, gouache. 12 1/8 x 22 5/8 in. (30.8 x 57.5 cm). The Tel Aviv Museum of Art. Donated by the artist's family to the TV Fund-Raising Project for Handicapped Children in Israel. Purchased by Mr. Josef Buchmann. *Gutman was born in Romania, brought to Eretz Yisrael as a child of five, and grew up in a literary household. His father, a poet and novelist, was the editor of* Haomer. *Trained at Bezalel, Gutman also studied in Paris, Berlin, and Vienna, where he lived from 1920 to 1924. He was part of the first generation of Israeli artists consciously trying to forge a new cultural identity. Gutman was well known as an illustrator and this work was a design for a book,* Ir Qetanah Ve'anashim Bah Me'at *(The Small Town and Few People in It). Gutman, in fact, grew up in the first Jewish quarter outside Jaffa, so this was landscape he knew well. He was also the favorite illustrator of Chaim Nachman Bialik, the Hebrew "poet laureate." His illustrations have a wonderful sense of spontaneity, and Gutman maintains a sense of precociousness and naive idealism in his work.*

YOSEF ZARITSKY (1891–1985). *Safed*. 1924. Watercolor over black chalk. 25 1/4 x 24 7/16 in. (64.1 x 62.1 cm). The Israel Museum, Jerusalem. *Zaritsky was born in the Ukraine and graduated in 1914 from the Academy of Arts in Kiev. He emigrated to Eretz Yisrael in 1923. This early painting, which was influenced by the watercolors of Cézanne, prefigures Zaritisky's later tranformation to a purely abstract artist. From 1927 to 1929 he studied and worked in Paris and for many years primarily painted landscapes and still lifes. In 1948 the New Horizons group was established by artists who sought to make Israeli art shed its regionalism and become more universal in its outlook. Zaritsky emerged as the dominant figure of the group. His lyrical style was an important influence on many artists.*

EL LISSITZKY (1890–1941). *Illustration for Shifs Karta (Boat Ticket)* Berlin. 1922. India ink and collage on paper. 17 1/8 x 9 1/2 in. (43.5 x 24.1 cm). The Israel Museum, Jerusalem. Boris and Lisa Aronson Collection. Purchased through a bequest from Dvora Cohen, Afeka, Israel, 1989. *In 1922 Lissitzky produced a series of illustrations for Ilya Ehrenburg's* Six Stories with Easy Endings. *This collage, also known as* Journey to America, *was done for "The Boat Ticket," a story of an old man waiting for a boat ticket from his son in America. Lissitzky's combination of various elements produces a powerful and enigmatic work. The boat ticket, symbol of hope for eastern European Jews, is juxtaposed with the Hebrew letters used on gravestones to indicate "here lies buried." It is not clear whether the image represents the tragic message of Ehrenburg's story alone or if it also reflects the artist's disillusionment with the possibility of creating a national Jewish culture. This is the last work in which Lissitzky used Jewish symbols.*

JULES PASCIN (1885–1930). *Girl With Boots.* c. 1927. Oil on canvas. 35 x 27 1/2 in. (88.9 x 69.9 cm). Hebrew Union College, Skirball Museum, Los Angeles. Gift of Jane K. Ransohoff and S.J. Freiberg. *Pascin, born in Bulgaria, studied in Vienna, Berlin, and Munich before arriving in Paris in 1905. With the outbreak of World War I, he was forced to leave France and emigrated to the United States, where he became a citizen. Pascin's sensitive observations are often of the unsavory low life. His works are at once cynical and tender, suffused with both pathos and sensuousness.*

(OPPOSITE)

CHAIM SOUTINE (1893–1943). *Carcass of Beef.* Paris. 1925. Oil on canvas. 17 3/4 x 12 1/4 in. (45.1 x 31 cm). Minneapolis Institute of Arts. Gift of Mr. and Mrs. Donald Winston and an anonymous donor. *Soutine was born in Smilovitchi, Lithuania, the tenth of eleven children in an impoverished home. He ran away from home at fourteen to attend art school in Vilna. From there he went to Paris. Although successful, Soutine was unhappy, and his anguish is manifest in his paintings—his tortuous use of violent, penetrating color and heavy impasto. The model for this image was the well known* Slaughtered Ox *by Rembrandt, which Soutine saw in the Louvre.*

289

AMEDEO MODIGLIANI (1884–1920). *Jacques and Berthe Lipchitz*. Paris. 1916. Oil on canvas.
31 1/2 x 21 in. (80.2 x 53.3 cm). The Art Institute of Chicago. Helen Birch Bartlett Memorial
Collection. *While there is very little to identify Jewish artists working in Paris in the first decades
of the twentieth century in terms of their artworks, they were still known as Jews, and there were
many close relationships among them. On the occasion of his marriage to Berthe, Jacques Lipchitz
commissioned Modigliani to paint a wedding portrait.*

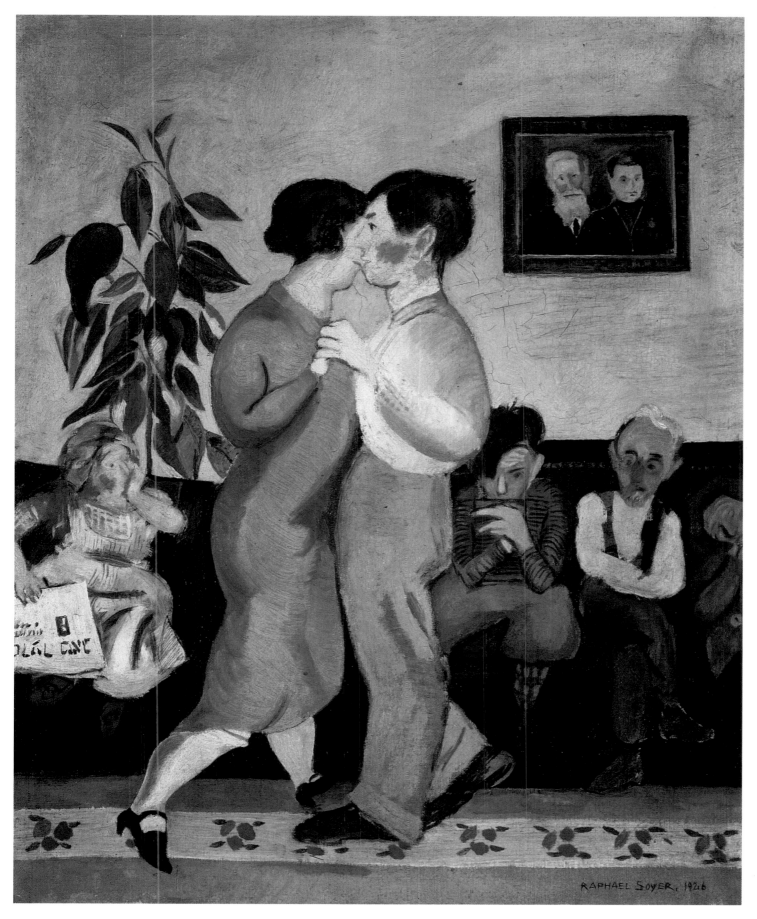

RAPHAEL SOYER (1899–1987). *Dancing Lesson*. New York. 1926. Oil on canvas. 24 x 20 in. (61 x 50.8 cm). The Jewish Museum, New York. Promised Gift of Renee and Chaim Gross Foundation. *Born in Russia, Soyer immigrated to the United States at thirteen. He studied at the National Academy of Design and the Art Students League in New York, where he later taught. Soyer, who described himself as a humanist, is best known for his graphic portrayal of urban realism. This painting is one of his autobiographical "mementos." Soyer described the scene as taking place in the apartment in which he grew up in the Bronx, with its blue walls, flowered rug, and oversize rubber plant. Accompanied by the artist's youngest brother Israel, playing the harmonica, his sister Debbie teaches his twin brother Moses how to dance. His parents, appearing somewhat bewildered, look on. A portrait of his grandparents hangs on the wall.*

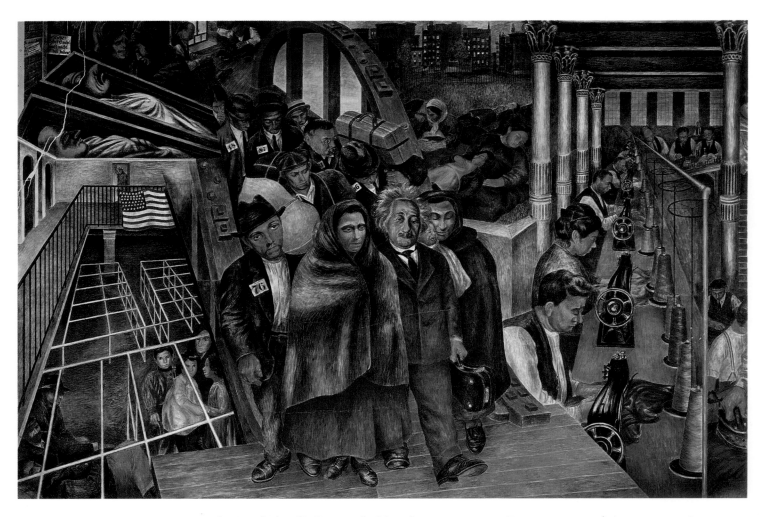

BEN SHAHN (1898–1969). *Roosevelt Mural* (detail). Roosevelt, New Jersey. 1937–38. Fresco. 12 x 45 ft (3.7 x 13.7 m). © 1995 Estate of Ben Shahn. Licensed by VAGA, New York, N.Y. *Beginning with his works in the 1930s, Shahn achieved his reputation as a major voice of social realism, and he was active in Public Works of Art Projects. From 1935 to 1938 Shahn worked for the Farm Security Administration (FSA), traveling to the South and Midwest to record rural life. This mural for a housing project at the Jersey Homestead, later renamed Roosevelt, was painted for the FSA and reflects both his social commentary and distinct style. While the first section depicts immigration and the harsh labor conditions the immigrants endured, the mural continues with the forces of reform, beginning with the efforts of the labor unions, until at the end of the image, the struggle has been won with new buildings, homes, and schools represented by a ground plan of the Jersey Homestead site itself.*

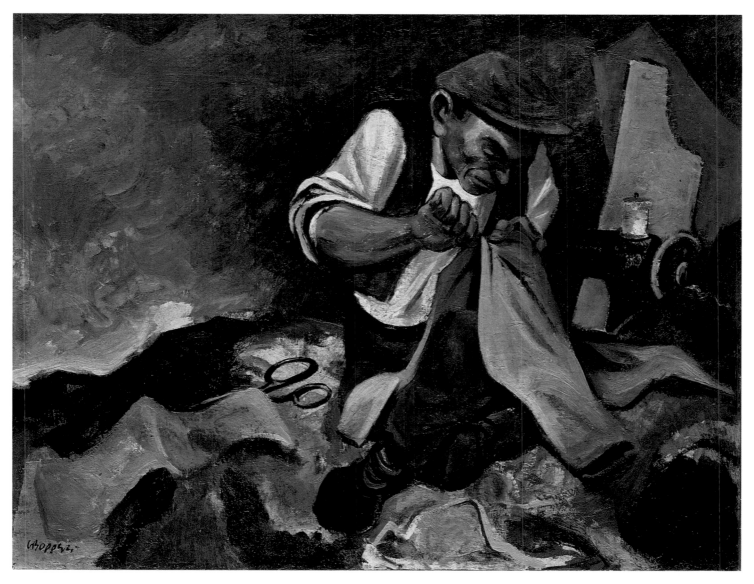

WILLIAM GROPPER (1897–1977). *The Tailor.* 1940. Oil on canvas. 20 1/4 x 26 1/4 in. (51.4 x 66.7 cm). Hirshhorn Museum and Sculpture Garden, Smithsonian Institution, Washington, D.C. Gift of Joseph H. Hirshhorn, 1966. *Gropper was born and raised on New York's Lower East Side. As a young man, he worked in a garment industry sweatshop and learned firsthand of the plight of the workers. In his incisive cartoons and paintings, Gropper was a voice of social consciousness for the working people. In* The Tailor, *Gropper unmasks the harsh and exhausting circumstances which characterized work in the garment trades. There is no end to the pile of clothes on which the tailor sits and though there is a sewing machine in the background, he arduously does the finishing work by hand.*

SIR JACOB EPSTEIN (1890–1959). *Albert Einstein.* 1933. Bronze. Edition of six. 17 1/2 x 12 1/2 x 10 in. (44.45 x 31.75 x 25.4 cm). Collection of Dr. and Mrs. Robert Einstein, Los Angeles. *Though Jacob Epstein lived in London for most of his life, he grew up on the Lower East Side of New York City, the son of Orthodox immigrants from Russia. His early training was at the Art Students League and the Educational Alliance. In his early works, Epstein often depicted the teeming life of his Hester Street community, and his drawings were used to illustrate Hutchins Hapgood's The Spirit of the Ghetto. Epstein went to Europe in 1902, first studying in Paris where he was very much drawn to archaic Greek and primitive art, his work of the time bearing an affinity to Brancusi and Modigliani. Epstein is perhaps best known for his portrait busts which are characterized by thick impressionistic modeling. At the time this portrait was made, Einstein had already resigned his academic position in Germany because of the rise of National Socialism. Epstein himself had experienced anti-Semitism first-hand beginning in 1925 in a critique of his work in the British press, and he was not to receive any large-scale public commisions between 1929 and 1953.*

CHANA ORLOFF (1888–1968). *Hayyim Nachman Bialik.* 1926. Bronze. Hebrew Union College, Skirball Museum, Los Angeles. *Orloff, born in the Ukraine, emigrated to Eretz Yisrael in 1905 and then left for France in 1910, where she later became a citizen. Most of her career was spent working in Paris, where she was a part of the Montparnasse circle. Orloff traveled to Palestine in 1925 and it is likely that it was then that she did this portrait of the author Ḥayyim Nachman Bialik, who had settled in Tel Aviv in 1924. The cast was made in Paris. Orloff's work projects the intense vigor and power of the writer, reflecting the nearly mythic role he played in shaping modern Jewish culture.*

CHAIM GROSS (1904–1991). *The Ten Commandments.* New York. 1970–71. Bronze relief. Courtesy the Chaim Gross Foundation. *Born in the Carpathian Mountain region of Austrian Galicia, Chaim Gross spent his first decade steeped in the traditions of Orthodox Jewish life. After his parents were violently attacked by Russian troops he fled, and by 1921 was in New York. Once there, Gross studied at the Educational Alliance, the Beaux-Arts Institute of Design, and at the Art Students League. A prolific draftsman, painter, and printmaker as well as a sculptor, he was a beloved teacher as well. Gross made* The Ten Commandments *for the synagogue at the John F. Kennedy International Airport. This section is the Tenth Commandment, "Thou shalt not covet. . . ."*

JACQUES LIPCHITZ (1891–1973). *Mother and Child.* Europe and United States. 1939–45. Bronze. Height: 50 in. (127 cm). The Israel Museum, Jerusalem. *Lithuanian-born Jacques Lipchitz spent two decades working in Paris, establishing himself as a leading modernist sculptor. Lipchitz planned* Mother and Child *as he traveled through Europe in flight from the Nazis; he began to execute it when he arrived in New York in 1941. The mother is an amputee, her legs and hands cut off. The child clings to her neck. Her head is thrown back and her arms are upraised in a gesture of sup- plication. Yet, though she has been mutilated, her body is muscular and firm; she is still strong. Lipchitz characterized this work as one of despair and yet one of hope and optimism and even aggression. Only after he made it did he realize that the sculpture was based on an encounter he had in 1935 when he saw a crippled beggar woman sitting on a cart in a railroad station, singing, her arms outstretched in an abject plea.*

MORDECAI ARDON (1896–1992). *Missa Dura. The Knight, Kristallnacht, House No. 5.* 1958–60. Oil on canvas. Triptych. Side panels, 76 3/4 x 51 1/4 in. (194.9 x 130.2 cm); center panel, 76 1/2 x 102 1/2 in. (194.3 x 260.4 cm). The Tate Gallery, London. Presented by the Miriam Sacher Charitable Trust through the Friends of the Tate Gallery. *Polish-born Ardon studied at the Bauhaus school of design and in Berlin before immigrating to Eretz Yisrael in 1933. He taught and served as Director of the Bezalel School of Arts and Crafts, instituting changes in its approach to art training. Ardon developed a unique personal style that combined rationalism and mysticism. Missa Dura, which he also called Black Sermon, is a major work on the theme of the Holocaust. The Knight represents Hitler, who thought of himself as such. This is the beginning of his rise to power, though he is depicted here as being small. Ringing bells allude to the church bells which rang in the new Reich. The bright colors are an ironic commentary. Kristallnacht, the "Night of Broken Glass" on November 9, 1938, when hundreds of synagogues and Jewish businesses were looted and burned, here reflects all the turmoil and suffering of the Nazi era, the dark colors appropriately conveying the evil events. These culminate in the plight of the victims in House No. 5, a house in a concentration camp. A stove-like form with six flames represents the 6,000,000 who perished. The only sign of hope is the yellow badge which the woman wears, no longer bearing a six-pointed star, but the symbol of the sefirot, the kabbalistic spheres describing God's creative power.*

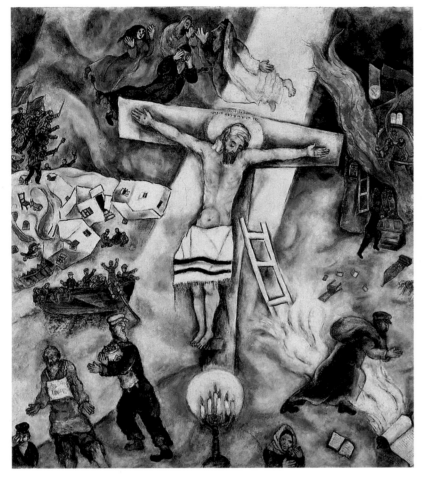

MARC CHAGALL (1887–1985). *White Crucifixion.*
1938. Oil on canvas. 61 x 55 in. (154.9 x 139.7 cm).
The Art Institute of Chicago. Gift of Alfred S. Altshuler.
© 1995 Artist Rights Society (ARS), New York,
ADAGP, Paris. *Painted in 1938,* White Crucifixion *has
a prophetic air. The imagery of the pogrom is sadly
familiar: the marauding mob charges forward; the
houses are destroyed; the synagogue is in flames; the
refugees flee in desperation. Flying overhead, ancestors
despair at the scene. Christ himself is depicted as a
Jew. His loincloth is a tallit, a prayer shawl. Inscribed
above his head is the Latin abbreviation INRI and in
Hebrew the words of Pilate, "Jesus of Nazareth, King
of the Jews." At his feet is a candelabrum. Though
missing one light, its form is that of the seven-branched
menorah. The turmoil and devastation are under-
scored in the tumultuous composition, with swirling
movement pierced by the powerful diagonal of the
cross. Chagall's message is that the Jew as martyr is
a timeless tale.*

JAKOB STEINHARDT (1887–1968). *Noah Blesses the
Beasts.* 1965. Woodcut. 19 3/8 x 14 in. (49.2 x
35.6 cm). The Jewish Museum, New York. Gift of
Mr. and Mrs. Albert A. List and Family. *Steinhardt,
a painter and print-maker, was born in Poland
and in 1906 left to study in Berlin and and then
Paris. In 1914, he was a founding member of the
Expressionist group, the* Pathetiker *in Germany. His
experiences as a soldier during World War I had a
major impact on him. He was among a number of
artists who were able to leave Germany after the
rise of National Socialism and settle in Eretz
Yisrael. Steinhardt arrived in Jerusalem in 1933.
A keen student of the human condition, Steinhardt
continued in the Expressionist spirit with social
and biblical themes. His major medium was the
woodcut. He served as the director of Bezalel from
1953 to 1957.*

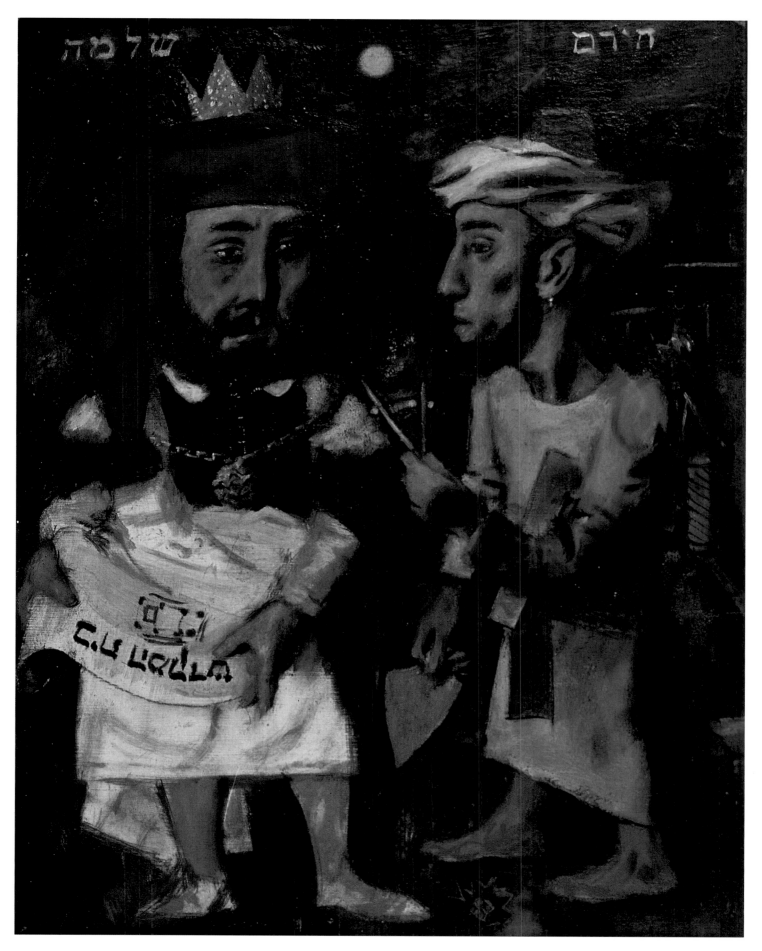

Jack Levine (b. 1915). *Planning Solomon's Temple.* c. 1940. Oil on masonite. 10 x 8 in. (25.4 x 20.3 cm). The Israel Museum, Jerusalem. Gift of Mrs. Rebecca Schulman, New York, 1955.© Jack Levine. Licensed by VAGA, New York, N.Y. *Born in Boston of immigrant parents, Levine is best known for his satirical works of social commentary. This painting, of the biblical King Solomon planning the Holy Temple with the architect King Hiram of Tyre, has been identified as a posthumous tribute to his father who, though a poor shoemaker, was known among his friends as Reb Sholomoh Hachacham (Rabbi Solomon the Wise). The image of Hiram is probably a self-portrait.*

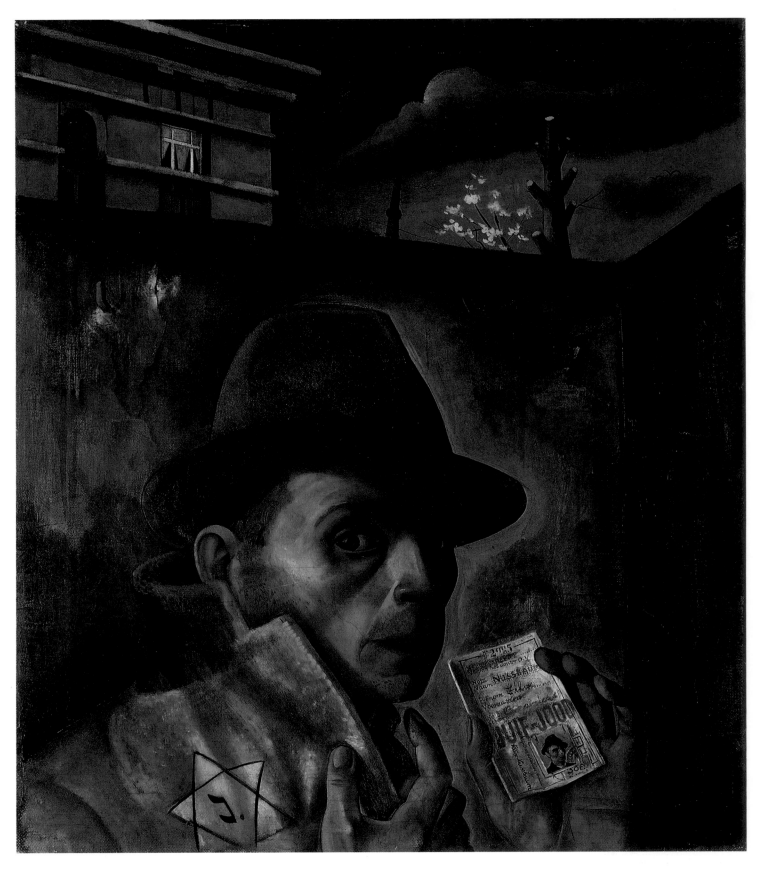

FELIX NUSSBAUM (1904–1944). *Self-Portrait With a Jewish Identity Card.* 1943. Oil on canvas. 22 7/16 x 19 5/8 in.
(57 x 49.8 cm). Kulturgeschichtliches Museum, Osnabrück, © Auguste Moses-Nussbaum and Shulamit Jaari-Nussbaum.
*The German-born Nussbaum, from a financially comfortable home, gained encouragment as an artist early on. With the
Nazi rise to power in 1933, Nussbaum left Germany, never to return. From 1935 to 1940 he lived in Belgium, before being
interned at St. Cyprien. Nussbaum managed to escape and went underground in Brussels. This work was painted while he
was in hiding. It captures the sense of constant anxiety which he felt. The yellow badge and passport stamped "Juif-Jood"
are the symbolic emblems of his doomed fate. Nussbaum and his wife were arrested in 1944, and both perished in Auschwitz.*

CHARLOTTE SALOMON (1917–1942). *Self-Portrait.* 1940. Gouache on paper. 15 1/4 x 13 1/2 in. (38.7 x 34.3 cm). The Jewish Historical Museum, Amsterdam. *In her compelling autobiographical work* Charlotte: Life or Theater? *with 759 paintings, accompanying text, and musical notations, young Charlotte Salomon desperately strived to overcome personal adversity and the looming threat of Nazism. Born in Berlin, Charlotte had a difficult childhood, losing her mother when she was nine and having a conflicting relationship with her stepmother. As Nazi persecution increased, Charlotte was sent to her maternal grandparents in the south of France. There her grandmother committed suicide and the fact of her mother's suicide was revealed to her. To save herself from an inheritance of madness, she painted, trying to recreate for herself a new and different life. Shortly before she was deported to Auschwitz, where she perished, Charlotte entrusted the portfolio to a friend. Her parents, who survived with the help of the Dutch underground, later recovered the work.*

REUVEN RUBIN (1893–1974). *First Seder in Jerusalem.* 1950. Oil on canvas. 10 1/2 x 64 in. (26.7 x 162.6 cm). The Rubin Museum Foundation, Tel Aviv. *Romanian-born Reuven Rubin studied in Europe before emigrating to Eretz Yisrael in 1922. Like others of that generation, Rubin used a bright palette in his lively and optimistic depictions of the daily life of the early settlers. After the establishment of the State of Israel in 1948, he returned to Romania as a diplomat and during the next eighteen months helped to obtain exit visas for many Romanian Jews.* First Seder in Jerusalem, *painted shortly after he returned, is a homage to the ingathering of Jews from many nations to Israel. Yet, though he uses the clear, expressive colors of his early works, the mood is not cheerful. Though gathered around the seder table, this is not yet a cohesive community; the participants seem distant and detached from one another. Rubin himself sits at one end of the table, dressed in the clothing of a pioneer, with open shirt and sandals. His self-portrait is a counterpoint to the figure at the other end, who with stigmata on hands and feet has been identified as Jesus. Both are lost in their own dreamlike thoughts. It is the first seder in Jerusalem, but it is not yet the Seder of Redemption.*

YAACOV AGAM (b. 1928). *Star of Peace*. 1994. Oil on aluminum. Collection of the artist. *Yaacov Agam was born in Eretz Yisrael and trained at Bezalel. In 1951, he went to Paris, where he first began to make kinetic art. In this work, a Star of David and an Islamic Star together create a Star of Peace. A copy of this piece was given by Prime Minister Rabin to President Clinton.*

(OPPOSITE, BELOW)

MAX WEBER (1881–1961). *Invocation*. 1919. Oil on canvas. 46 7/8 x 41 in. (119.1 x 104.1 cm). Collezione d'Arte Religiosa Moderna del Musei Vaticani, Vatican City. *Max Weber was born in Bialystok, Poland, and came to New York when he was ten. Like many other Orthodox Jews, his family disapproved of his artwork. Nonetheless, Weber persisted, studying first in New York, and later joining the many eastern European Jewish artists who had flocked to Paris. Weber returned to the United States in 1909 having absorbed the new "modern" trends in Europe, which he synthesized with his own personal expression. Invocation is a work at once abstract and yet quite real. The powerful presence of the figures and the directness of spiritual intensity is very tangible, but, influenced by Cubism, the figures are angular, blocky, and planar, with caricature-like elongated features. Like the Cubists, Weber collapses distinctions between figures and setting, though here he maintains some sense of traditional pictorial space by seating them around a table.*

FRANK STELLA (b. 1936). *Nasielsk II (Polish Wooden Synagogues Construction)*, 1972. 110 x 89 1/2 x 6 in. (279.4 x 227.3 x 15.2 cm). Painted canvas, felt and kachina board on wood. Courtesy Knoedler & Co., New York. © 1995 Frank Stella/Artists Rights Society (ARS) New York. *In the* Polish Village Series, *Frank Stella created a remarkable tribute to the wooden synagogues of eastern Europe, which dated from the seventeenth to the nineteenth century, and were almost all destroyed in World War II. Stella learned of these structures in the book* Wooden Synagogues *by Maria and Kazimierz Piechotka, published in Warsaw in 1959, which through architectural drawings and photographs documents a significant number of the synagogues. Stella transformed the drawings with his own artistic vision, echoing in his series of drawings, paintings, collages, and constructions, the originality and creativity of design of the original synagogue buildings.*

(OPPOSITE, ABOVE)

ITZHAK DANZIGER (1916–1977). *The Lord Is My Shepherd (Negev Sheep)*. 1964. Bronze. 33 3/4 x 90 x 67 3/4 in. (85.7 x 228.6 x 172.1 cm). Hirshhorn Museum and Sculpture Garden, Smithsonian Institution. Gift of Joseph H. Hirshhorn, 1966. *Itzhak Danziger was born in Berlin, and his family moved to Jerusalem when he was seven. He studied at the Bezalel School of Arts and Crafts and later spent four years studying in London. After World War II, Danziger spent a year working in Paris. In the postwar period, his work became increasingly more abstract. In this work,* Negev Sheep, *although it is highly abstracted, Danziger maintained a bond with a representational subject linked to the life and land of Eretz Yisrael. One of Israel's most influential sculptors, he also turned in his later years to town planning and ecological and environmental projects.*

(OPPOSITE, BELOW)

MENASHE KADISHMAN (b. 1932). *Prometheus*. 1986–1987. Cor-ten steel. 147 1/4 x 226 3/8 x 114 1/8 in. (374 x 575 x 289.9 cm). The Tel Aviv Museum of Art. *Born in Tel Aviv, Kadishman trained both in Israel and in England and gained prominence with his early minimalist sculptures in glass and metal which seem to defy gravity.* Prometheus *is an outdoor installation of a very different order. No longer nonrepresentational, Kadisman's sculpture explores the Greek myth of the hero who took pity on helpless primitive people, for which he was punished by Zeus. Prometheus was chained to Mount Caucasus and attacked every day by an eagle, who tore out his liver, which yet continued to regenerate. Prometheus suffered for thousands of years and was freed at last when Hercules killed the eagle.*

MARK ROTHKO (1903–1970). *Street Scene XX.* New York. c. 1936–1939. Oil on canvas. 29 x 40 in. (73.7 x 101.6 cm). National Gallery of Art, Washington, D.C. Gift of the Mark Rothko Foundation. © 1995 Kate Rothko-Prizel & Christopher Rothko/Artists Rights Society (ARS) New York. *Born Marcus Rothkowitz in Dvinsk, Russia, Rothko came to the United States as a child of ten, his family settling in Portland, Oregon. Rothko attended Yale University on scholarship for two years, leaving to move to New York, where he studied at the Art Students League. Rothko is best known for his highly personal post-World War II nonobjective compositions of luminous diffuse rectangular shapes which appear to float on the canvas. Street Scene XX was painted at a time when Rothko worked for the WPA and also taught at the Brooklyn Jewish Center. At a time when Nazism was on the rise, Rothko was recalling his childhood and the protective embrace of an elderly but heroic, bearded Jew.*

Evgeny Abesgauz (b. 1939). *My Old Home.* Leningrad. 1976. Oil on pasteboard. Collection of Ronald and Felice Andiman.
This is one of a series of works done by Abesgauz when he was part of a movement of Jewish underground artists who were seeking to reclaim their Jewish heritage in the face of Soviet oppression. In his characteristic folk art style, Abesgauz portrays himself as the "wandering Jew," but now, as Abesgauz longed to do, he is leaving his town to return to Israel. The inscription in Hebrew reads "And I look one last time at the land of my birth and I go home to my land."

ANNA TICHO (1894–1980). *Jerusalem*. Jerusalem. 1969. Charcoal. 27 5/8 x 39 1/2 in. (70.2 x 100.3 cm). The Museum of Modern Art, New York. Anonymous gift. *Austrian-born Anna Ticho came to Jerusalem at sixteen. With her husband, a pioneering opthamalogist, Anna Ticho spent two years in Damascus during World War I while Abraham Ticho served with the Austrian army. Ticho visted Paris in 1930 and was well aware of the artistic currents in Europe. But for sixty years, Ticho's major focus was the landscape of Jerusalem. Ever-varying, deeply sensitive, and acutely perceptive, she continually renewed her interpretation of every hillside, the changing sky, each flower and thistle.*

GABI KLASMER (b. 1950). *Shimshon*. Israel. 1982. Superlac on chrome paper. Diptych. Each panel: 27 5/8 x 39 1/2 in. (70.2 x 100.3 cm). Hebrew Union College, Skirball Museum, Los Angeles. Gift of Lydia and Benjamin Kukoff Purchase Fund in memory of Celia and Arthur Kukoff. *Gabi Klasmer was born in Jerusalem and trained at Bezalel. Shimshon is from a series of Expressionist works done in the early 1980s. Klasmer has merged the biblical Samson with the modern-day Israeli, seeming to allude to Israel's destiny. The biblical Samson, used his last bit of power to bring down the Philistine temple. This Shimshon warily eyes the pillars, which could also be a gateway, and therefore a new beginning.*

ADAM ROLSTON. (b. 1962). *Untitled, From the "Matzo Box Series."* New York City. 1993. Synthetic polymer paint on canvas. 72 x 72 in. (182 9 x 182.9 cm). Private Collection. Courtesy of the Fawbush Gallery. *Adam Rolston was born in Los Angeles and educated at Syracuse University in fine art and architecture. In the "Matzo Box Series," Rolston explores the connection between ethnic identity and popular culture. He has taken the matzah box, a Jewish consumer product, as the subject of his paintings and faithfully reproduced the labels by hand on large-scale canvases.*

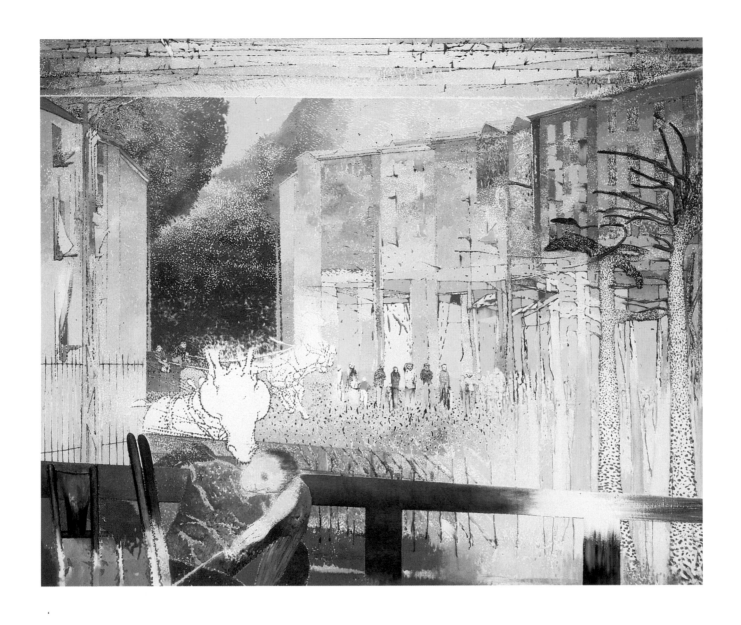

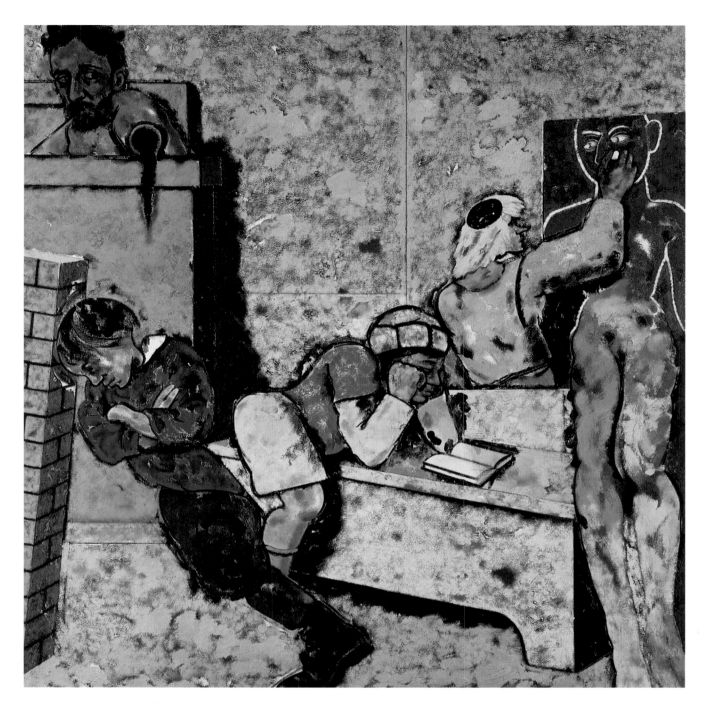

R.B. KITAJ (b. 1932). *The Jewish School (Drawing a Golem)*. London. 1980. Oil on canvas. 60 x 60 in. (152.4 x 152.4 cm). Private collection. *Born in Ohio, R.B. Kitaj studied in New York, Vienna, and London. In the 1970s, Kitaj embarked on a self-education in Jewish identity. Based on an anti-Semitic nineteenth-century German carica-ture of a Jewish classroom in chaos, The Jewish School is a metaphor for the Jewish response to persecution. The teacher's inkwell is spilling blood, and one boy resists his fate by hitting his head against a wall in an effort to escape. The child in the middle represents the continuum of Jewish learning.*

(OPPOSITE, ABOVE)

IRVING PETLIN (b. 1934). *Street in Weissewald*. New York. 1986–87. Oil on canvas. 60 3/8 x 75 1/4 in. (153.4 x 191.1 cm). The Jewish Museum, New York. Museum purchase through funds provided by S.H. and H.R. Scheuer Family Foundation. *The Weissewald (White Forest) series metaphorically chronicles the destruction of European Jewry. Petlin is bearing witness, and we too, separated by a wooden barrier and by barbed wire along the top of the canvas, are also witnesses. The wagon pulling ghostlike white horses refers to the wagon of his grandfather Abraham, whom the young Irving joined on his rounds delivering ice and coal.*

(OPPOSITE, BELOW)

MOSHE GERSHUNI (b. 1936). *The Little Angels*. Israel. 1987. Glass paint and lacquer on paper. 59 1/2 x 83 in. (151.1 x 210.8 cm). Hebrew Union College, Skirball Museum, Los Angeles. *Gershuni was born in Tel Aviv and received his training there at the Avni Art Institute. The Little Angels refers to the youngest victims of the Holo-caust. Gershuni records some of the names in graffiti-like fashion, using the diminunitive form as a grim reminder that they were young children. There is no mistaking the evildoers, whose swastika is the only really clear motif.*

Tobi Kahn (b. 1952). *Selections from the Shrine Series.* New York. 1985. Eccu: 15 1/2 x 11 1/2 x 12 in. (39.4 x 29.2 x 30.5 cm). Brun: 21 x 11 x 9 1/2 in. (53.3 x 27.9 x 24.1 cm). Eykhal: 15 1/2 x 12 x 11 in. (39.4 x 30.5 x 27.9 cm). Acrylic on wood and bronze. Private collection. *Tobi Kahn was born in New York and studied at Hunter College and the Pratt Institute. In his landscape canvases, Kahn keenly probes the complex beauty of the world. For the past fifteen years, Kahn has also been building shrines which recall ancient sacred spaces and figures that seem to have always been there. Meditative and reverent, they are sublime archetypes of spiritual architecture.*

Samuel Bak (b. 1933). *Pardes, III.* 1994. Oil on linen. 47 x 47 in. (119.4 x 119.4 cm). Courtesy of Pucker Gallery, Inc. Boston. *Born in Vilna, Samuel Bak survived the German occupation in the ghetto and in a work camp. After World War II, Bak was in a displaced persons camp in Germany and studied art in Munich before immigrating to Israel in 1948. Subsequently, he has lived and worked in the United States and Europe as well as Israel. The* Pardes *series exemplifies the passionate and poignant questioning in Bak's work. The Hebrew word* Pardes *means paradise and signifies in rabbinic tradition a heavenly garden of perfection. But PaRDeS is also an acronym for the way to reach perfection through the levels of scriptural interpretation. Bak's* Pardes *is a complex maze set in the shape of the Ten Commandments.*

(OPPOSITE)

Robin Schwalb (b. 1952). *The Gift of Tongues.* c. 1991. Quilted by Grace Miller, Mount Joy, Pennsylvania. Photo silk-screened, stenciled, marbleized and commercially available cottons and silk. Machine pieced, hand appliquéd. 98 x 54 in. (248.9 x 137.2 cm). Courtesy of the artist. *This quilt is the second of a series by the artist on the biblical story of the Tower of Babel. The randomly pieced, silkscreened text forms the backdrop for a cascade of symbols. The repeated image of a dynamited, collapsing skyscraper and the seismic cityscape provide sly visual counterparts to the text. Although sometimes interpreted as grim or apocalyptic, the artist sees the city cracking open to reveal its diverse human heart.*

BIBLIOGRAPHY

Adler, C. and I.M. Casanowicz. "Collections of Objects of Religious Ceremonial in the U.S. National Museum." *United States National Museum Bulletin* 148 (1929).

Altshuler, D., ed. *The Precious Legacy: Judaic Treasures from the Czechoslovak State Collections.* [Exhibition catalog.] Washington, D.C.: Smithsonian Institution, 1983.

Altshuler, L., ed. *In the Spirit of Tradition: The B'nai B'rith Klutznick Museum.* Washington, D.C., 1988.

Apter-Gabriel, Ruth, ed. *Tradition and Revolution: The Jewish Renaissance in Russian Avant-Garde Art 1912-1928.* [Exhibition catalog.] Jerusalem: The Israel Museum, 1987.

Avrin, L. *Hebrew Micrography: One Thousand Years of Art in Script.* [Exhibition catalog.] Jerusalem: The Israel Museum, 1981.

Barnett, R.D., ed. *Catalogue of the Permanent and Loan Collections of the Jewish Museum, London.* London, 1974.

Benjamin, C. *The Stieglitz Collection: Masterpieces of Jewish Art.* Trans. by M. Jagendorf. [Exhibition catalog.] Jerusalem: The Israel Museum, 1987.

Benjamin, C. and M.G. Koolik. *Towers of Spice.* [Exhibition catalog.] Jerusalem: The Israel Museum, 1982.

Berman, N.M. *Moshe Zabari: A Twenty-Five Year Retrospective.* [Exhibition catalog.] New York, The Jewish Museum and Los Angeles, Hebrew Union College Skirball Museum, 1986.

Bialer, Y.L. *Jewish Life in Art and Tradition: Based on the Collection of the Sir Isaac and Lady Edith Wolf-son Museum, Hechal Shlomo, Jerusalem.* London-Jerusalem-New York, 1976.

Cohen, E., ed. *Moritz Oppenheim: The First Jewish Painter.* [Exhibition catalog.] Jerusalem: The Israel Museum, 1983.

Dobroszycki, L. and B. Kirshenblatt-Gimblett. *Image Before My Eyes: A Photographic History of Jewish Life in Poland, 1864-1939.* [Exhibition catalog.] New York: YIVO Institute for Jewish Research, 1977.

Fisher, Y., ed. *Omanut ve-Umanut be-Eretz Yisrael ba-Me'ah ha-19.* [Exhibition catalog.] Jerusalem: The Israel Museum, 1979.

Fishof, I. *From the Secular to the Sacred: Everyday Objects in Jewish Ritual Use.* Trans. by R. Grafman. [Exhibition catalog.] Jerusalem: The Israel Museum. 1985.

Gold, L.S., ed. *A Sign and a Witness: Two Thousand Years of Hebrew Books and Illuminated Manuscripts.* [Exhibition catalog.] New York, The New York Public Library, 1988.

Goodman, S. *Artists of Israel: 1920-1980.* [Exhibition catalog.] New York: The Jewish Museum, 1981.

Gross, W.L. "Catalogue of Catalogues: Bibliographical Survey of a Century of Temporary Exhibitions of Jewish Art." *Journal of Jewish Art* 6 (1979), pp. 133-157.

Grossman, C. *The Collector's Room: Selections from the Michael and Judy Steinhardt Collection.* [Exhibition catalog.] New York: The Joseph Gallery, Hebrew Union College-Jewish Institute of Religion, 1993.

_____. *A Temple Treasury: The Judaica Collection of Congregation Emanu-El of the City of New York.* New York, 1989.

Grossman, G.C. *An Illustrated Catalog of Selected Objects.* [Exhibition catalog.] Chicago: The Maurice Spertus Museum of Judaica, 1974.

_____. *The French Connection: Jewish Artists in the School of Paris 1900-1940, Works in Chicago Collections.* [Exhibition catalog.] Chicago: The Maurice Spertus Museum of Judaica, 1974.

Gutmann, J. *Hebrew Manuscript Painting.* New York, 1978.

_____. *Jewish Ceremonial Art.* New York, 1964.

Hanegbi, G. and B. Yaniv. *Afghanistan: The Synagogue and the Jewish Home.* Jerusalem, 1991.

Herskowitz, Sylvia, ed. *The Sephardic Journey: 1492-1992.* [Exhibition catalog.] New York: Yeshiva University Museum, 1992.

Hirschler, G., ed. *Ashkenaz: The German Jewish Heritage.* [Exhibition catalog.] New York: Yeshiva University Museum, 1992.

Israeli, Y. and M. Tadmor, eds. *Treasures of the Holy Land: Ancient Art from the Israel Museum.* [Exhibition catalog.] New York: The Metropolitan Museum of Art, 1986.

Juhasz, E., ed. *Sephardi Jews in the Ottoman Empire.* [Exhibition catalog.] Jerusalem: The Israel Museum, 1990.

Kampf, A. *Chagall to Kitaj: Jewish Experience in 20th Century Art.* [Exhibition catalog.] London: Barbican Art Gallery, 1990.

Kanof, A. *Jewish Ceremonial Art and Religious Observance.* New York, 1969.

_____. *Ludwig Yehuda Wolpert: A Retrospective.* [Exhibition catalog.] New York: The Jewish Museum, 1976.

Karp, A.J. *From the Ends of the Earth: Judaic Treasures of the Library of Congress.* [Exhibition catalog.] Washington, D.C.: Library of Congress, 1991.

Kayser, S.S. and G. Schoenberger, eds. *Jewish Ceremonial Art.* Philadelphia, 1959.

Keen, M.E. *Jewish Ritual Art in the Victoria and Albert Museum.* London, 1991.

Kirshenblatt-Gimblett, B. and C. Grossman. *Fabric of Jewish Life: Textiles from the Jewish Museum Collection.* [Exhibition catalog.] New York: The Jewish Museum, 1977.

Klagsbald, V. *Catalogue raisonné de la collection juive du Musée de Cluny.* [Exhibition catalog.] Paris: Musée Cluny, 1981.

Kleeblatt, N.L. and S. Chevlowe. *Painting a Place in America: Jewish Artists in New York 1900–1945.* [Exhibition catalog.] New York: The Jewish Museum, 1991.

Kleeblatt, N. L. and V.B. Mann. *Treasures of the Jewish Museum.* [Exhibition catalog.] New York: The Jewish Museum, 1986.

Kleeblatt, N.L. and G. Wertkin. *The Jewish Heritage in American Folk Art.* [Exhibition catalog.] New York: The Jewish Museum and The Museum of American Folk Art, 1984.

Kölnischen Stadtmuseum. *Monumenta Judaica: 2000 Jahre Geschichte und Kultur der Juden am Rhein.* [Exhibition catalog.] Cologne, 1963.

Krinsky, C.H. *Synagogues of Europe: Architecture, History, Meaning.* Cambridge, Massachusetts, and London, 1985.

Landau, S. *Architecture in the Hanukkah Lamp.* Trans. by R. Grafman. [Exhibition catalog.] Jerusalem: The Israel Museum, 1978.

Mann, V.B., ed. *A Tale of Two Cities: Jewish Life in Frankfurt and Istanbul 1750–1870.* [Exhibition catalog.] New York: The Jewish Museum, 1982.

_____. *Gardens and Ghettos: The Art of Jewish Life in Italy.* [Exhibition catalog.] New York: The Jewish Museum, 1989.

Mann, V.B. and J. Gutmann. *Danzig 1939: Treasures of a Destroyed Community.* [Exhibition catalog.] New York: The Jewish Museum, 1980.

Mann, V.B., T.F. Glick, and J.D. Dodds. *Convivencia: Jews, Muslims, and Christians in Medieval Spain.* [Exhibition catalog.] New York: The Jewish Museum, 1992.

Morgenstein, S. and R. Levine, eds. *The Jews in the Age of Rembrandt.* [Exhibition catalog.] Rockville, Md.:The Judaic Museum of the Jewish Community Center of Greater Washington, 1981.

Muchawsky-Schnapper, E., ed. *Les Juifs d'Alsace: Village, Tradition, Emancipation.* [Exhibition catalog.] Jerusalem: The Israel Museum.

Muller-Lancet, A., ed. *La Vie Juive au Maroc.* [Exhibition catalog.] Jerusalem: The Israel Museum, 1973.

Narkiss, B. *Hebrew Illuminated Manuscripts.* Jerusalem, 1969.

Nechama, A. and G. Sievernich, eds. *Jüdische Lebenswelten Katalog.* [Exhibition catalog.] Berlin: Berliner Festspiele.

Piechotka, M. and K. *Wooden Synagogues.* Warsaw, 1959.

Roth, C., ed. *Jewish Art: An Illustrated History.* 2nd ed. Greenwich, Conn., 1971.

Rubens, A. *A History of Jewish Costume.* New York, 1973.

Sabar, S. *Ketubbah: Jewish Marriage Contracts of Hebrew Union College Skirball Museum and Klau Library.* Philadelphia, 1990.

Schachar, I. *Jewish Tradition in Art: The Feuchtwanger Collection of Judaica.* 2nd ed. Trans. by R. Grafman, [Exhibition catalog.] Jerusalem: The Israel Museum, 1981.

Schrire, T. *Hebrew Magic Amulets: Their Decipherment and Interpretation.* 2nd ed., London, 1966.

Schwarz, H.P., ed. *Die Architektur der Synagoge.* [Exhibition catalog.] Frankfurt am Main: Deutsches Architekturmuseum, 1988.

Shadur, J. and S. *Jewish Papercuts: A History and Guide.* Berkeley and Jerusalem, 1994.

Shilo-Cohen, N., ed. *Bezalel 1906–1929.* Trans. by E.R. Cohen. [Exhibition catalog.] Jerusalem: The Israel Museum, 1983.

Silver, K.E. and R. Golan. *The Circle of Montparnasse: Jewish Artists in Paris 1905–1945.* [Exhibition catalog.] New York: The Jewish Museum, 1985.

Sirat, C. *La Lettre Hébraïque et sa Signification.* Avrin, L. *Micrography as Art.* Paris and Jerusalem, 1981.

Städtische Kunsthalle Recklinghansen. *Synagoga: Kultgeräte und Kunstwerke von der Zeit der Patriarchen bis zur Gegenwart.* [Exhibition catalog.] Recklinghausen, 1960.

Ungerleider-Mayerson, J. *Jewish Folk Art: From Biblical Days to Modern Times.* New York, 1986.

Wischnitzer, R. *The Architecture of the European Synagogue.* Philadelphia, 1964.

INDEX

Page numbers in *italic* refer to illustrations.

PHOTO CREDITS

We especially wish to thank the following persons and institutions: Claudia Goldstein, Ita Gross/Art Resource, New York; Stephen Fine/Baltimore Hebrew University; Ori Soltes/B'nai B'rith Museum, Washington, D.C.; Reva Godlove Kirschberg/Congregation Emanu-El of the City of New York; Susanne Kester/Hebrew Union College Skirball Museum, Los Angeles; Arnona Rudavsky/Klau Library HUC-JIR, Cincinnati; Bezalel Narkiss, Shalom Sabar/Hebrew University, Jerusalem; Amalyah Keshet, Iris Fishof, Rivka Gonen/Israel Museum, Jerusalem; Anton Kras/Jewish Historical Museum, Amsterdam; Annette Weber/Jewish Museum, Frankfurt; Barbara Treitel, Susan Braunstein, Susan Chevlowe, Norman Kleeblatt, Vivian Mann/Jewish Museum, New York; Rivka Plesser/Jewish National and University Library, Jerusalem; Sharon Lieberman Mintz, Elka Deitsch/Library, the Jewish Theological Seminary, New York; Seymour Fromer/Judah Magnes Museum, Berkeley; Michael Grunberger/Library of Congress, Washington, D.C.; Anna Cohn/SITES, Washington, D.C.; Richard E. Ahlborn/Smithsonian Institution, Washington, D.C.; Olga Weiss, Mark Akgulian/Spertus Museum, Chicago; Cissy Grossman/Steinhardt Collection, New York; Evelyn Cohen/Stern College, New York; Olga Library, Emanuela Calo, Ahuva Israel/Tel Aviv Museum; Father Leonard E. Boyle/Vatican Museum, Vatican City; Estelle Fink/Wolfson Museum, Jerusalem; Bonni-Dara Michaels, Gabriel Goldstein, Sylvia Herskowitz/Yeshiva University Museum, New York; Susan Einstein; Rafi Grafman; Mark Gulezian; Bill Gross; Joseph Gutmann; William Kramer; Alfred and Jean Moldovan; Maria and Kazimier Piechotka; Zev Radovan.

Mark Akgulian: p. 264 bottom; Artothek, Peissenberg, Germany: p. 283; Art Resource, New York: pp. 18, 22 (accession no. JM S 242), 23 (no. N 28328), 86 (no. 1988-21), 104–105 (no. F5000), 112 (no. D254/D184A,B/031), 113 (no. F3685), 114 (no. 1991-124), 116 (no. JM 138-47), 117 (no. JM48-56), 119 (no. F2585), 121 (no. JM94-55), 132 (no. S232), 149 (no. JM26-59A-E), 175 bottom (no. JM4-63), 178 (no. 26087/M40-1959), 200–201 (no. JM28-55), 204 bottom (no. TX 1929-16), 206 (no. F4390), 224 (no. F3205) 252, 1991-105), 255 top, 258 (no. 1987-23 A-D), 260 (no. M136-72), 281 (no. JM 1986-80), 282 top (no. JM63-67), 291, 292 (no. K49491), 296–297 (no. T608), 298 bottom (no. JM 137-72A),310 top (no. 1987-100); John Back, p. 239; Bet Alpha Editions: p. 267; Dana Cabanová: pp. 64, 70 bottom, 107, 108, 109, 110, 122, 136 bottom, 166, 171, 175 top, 218 top; Lelo Carter: p. 234; Sheldon Collins: pp. 152–153; Sharon Daveaux: p. 68 bottom; Susan Einstein: pp. 78, 127, 133, 140 bottom, 145 left, 162, 167, 172, 181 bottom, 197, 243, 255 bottom, 256, 257, 259, 261, 262 top, 264 top, 265, 270, 271 top, 285, 288, 294, 308 bottom, 310 bottom; Pierre-Alain Ferrazzini: pp. 102, 205; John Reed Forsman: pp. 76 bottom, 120 top, 131 bottom, 134, 139, 140 top, 142 bottom, 177 top, 191, 194, 210, 219, 220, 223, 228, 229, 235 bottom, 236; David Harris: pp. 32, 33, 34, 80, 90, 91, 156, 173, 190, 202, 207, 230 bottom, 240, 242 top, 244; Avraham Hay: p. 199; John T. Hopf: p. 93; Suzanne Kaufman: pp. 67 bottom, 72, 83, 126 right, 142 top, 222 left, 241; Phil Licata: p. 79; Marlboro Gallery, London: p. 311; Kim Nielson: p. 95 right (Smithsonian negative no. 81–5002); John Parnell: p. 298 bottom (no. JM137-72A); Andrew Partos: p. 100 left; Zev Radovan, pp. 20, 28 bottom, 30, 35, 100 right, 115; Marvin Rand: pp. 74 left, 76 top, 157, 179, 262 bottom; Druce Reiley: pp. 193, 212, 215, 216; Allan Rokach: p. 71; Foto Roncaglia: p. 58; Pierce Schmidt: p. 254; Ursula Seitz-Gray: p. 227; Nachom Slapak: pp. 97, 106, 217; Smithsonian Institution: Richard Strauss and Ricardo Vargos, photographers: pp. 62 (neg no. 92-13003), 101 (neg. no. 93-13001-2), 118 (neg. no. 92-13010), 154 (neg. no. 92-13074), 159 bottom (neg. no. 92-13068), 163 (neg. no. 92-13113/4), 165 left (neg. no. 92-13083), 195 (neg. no. 92-13012), 196 right (neg. no. 92-13013-4), 204 top (neg. no. 92-13102), 209 (neg. no. 92-13124), 225 (neg. no. 92-13112), 235 top (neg. no. 92-13018), 237 (neg. no. 92-13019); Lee Stalsworth: pp. 293, 304 top; Laslo Susits: p. 221; Malcolm Varon: pp. 77, 92 right, 168, 230 top; Isaiah Wyner: p. 98; Martin Zeitman: pp.120 bottom, 198 bottom, 282 bottom.